# STOMPIN' TOM CONNORS

## The myth and the man — an unauthorized biography

### CHARLIE RHINDRESS

Formac Publishing Company Limited
Halifax

Copyright © 2019 by Charlie Rhindress

All rights reserved. No part of this book may be reproduced or transmitted in any form or by any means, electronic or mechanical, including photocopying, or by any information storage or retrieval system, without permission in writing from the publisher.

Formac Publishing Company Limited recognizes the support of the Province of Nova Scotia through the Department of Communities, Culture and Heritage. We are pleased to work in partnership with the Province of Nova Scotia to develop and promote our cultural resources for all Nova Scotians. We acknowledge the support of the Canada Council for the Arts, which last year invested $153 million to bring the arts to Canadians throughout the country. This project has been made possible in part by the Government of Canada. We acknowledge the support of Arts Nova Scotia for this project.

Cover design: Tyler Cleroux
Front cover image: CBC Still Photo Collection/Paul Smith
Back cover images: Photo provided by Bruce Cole. Copyright © Bruce Cole, 1973 (l); Photo courtesy of Al Widmeyer (c); Photo supplied by Tyler Fauvelle (r)

Library and Archives Canada Cataloguing in Publication

Title: Stompin' Tom Connors : the myth and the man : an unauthorized biography / Charlie Rhindress
Names: Rhindress, Charlie.
Description: Includes an index.
Identifiers: Canadiana (print) 20190141778 | Canadiana (ebook) 2019014050X | ISBN 9781459505384 (hardcover) | ISBN 9781459505391 (epub)
Subjects: LCSH: Connors, Stompin' Tom, 1936-2013. | LCSH: Country musicians—Canada—Biography. |
  LCSH: Singers—Canada—Biography. | LCSH: Composers—Canada—Biography.
Classification: LCC ML420 C743 R47 2019 | DDC 782.421642/092—dc23

Formac Publishing Company Limited
5502 Atlantic Street
Halifax, Nova Scotia, Canada
B3H 1G4
www.formac.ca

Printed and bound in Canada.

# Contents

| | |
|---|---|
| Prologue | 5 |
| **Chapter 1** The Son | 9 |
| **Chapter 2** The Orphan | 30 |
| **Chapter 3** The Drifter | 45 |
| **Chapter 4** The Troubadour | 71 |
| **Chapter 5** The Entertainer | 96 |
| **Chapter 6** The Star | 112 |
| **Chapter 7** The Businessman | 134 |
| **Chapter 8** The Rebel | 179 |
| **Chapter 9** The Recluse | 197 |
| **Chapter 10** The Legend | 226 |
| **Chapter 11** The Icon | 247 |
| **Chapter 12** The Myth | 270 |
| Epilogue | 303 |
| Acknowledgements | 320 |
| Sources | 322 |
| Index | 334 |

This book is dedicated
with much love
to Heather MacIntyre
whose constant encouragement
and endless support
made this book possible

and to my parents
Charlie and Judy Rhindress
and Devona Porter
who made me possible.

# Prologue

My first book, *I'm Not What I Seem,* a biography of Rita MacNeil, was published in 2016. Previous to that I had worked as an actor, director and playwright. I had written over a dozen plays, including one about Rita, but had never thought seriously about writing a book. Then a friend of mine, Gary Vermeir, recommended me to Formac Publishing when he heard they were looking for someone to write a biography of Rita.

I was thrilled when they approached me. I had been a Rita MacNeil fan for roughly thirty years. I had done tons of research about her life, already written a play about her and met her a number of times. She had even helped me do rewrites on the script about her life. I thought the book would be easy. I had no idea how many hours I would spend conducting interviews, doing additional research, securing photos, etc. I put more hours into that book than anything I had done in my life. When I finished I said I would never write another piece of nonfiction.

Then the book was published and, happily, it was quite well received. On the heels of that success, James Lorimer, the publisher at Formac, called and asked if I'd like to write another. He was very complimentary. I immediately said yes. Flattery gets me every time. This book, however, would be a different experience. Jim wanted me to write a book about a subject that I knew next to nothing about: Stompin' Tom Connors.

Growing up in Amherst, Nova Scotia, in the 1970s, I was aware of Tom as one of those Canadian things I was slightly embarrassed by: things like *The Beachcombers,* bagpipers and fiddle music. My cultural influences were more along the lines of *Happy Days, The Bionic Woman,* ABBA and disco. Tom was the kind of music I woke up to on a Sunday morning when I'd sleep over at my cousin Ricky's house and Aunt Carol would blast old style country tunes while vacuuming.

When I started this book I had a vague idea that Tom was born in New Brunswick, but raised on Prince Edward Island. I think I knew that he had been adopted and had a rough childhood. I believe my hockey-loving family had referenced "The Hockey Song," but having rarely been inside a stadium myself I honestly don't know if I'd ever heard the whole thing. I knew "Bud the Spud" and that was it.

More than two years later, I have done hours and hours of research, watched and listened to dozens of interviews, talked to a number of people who knew him, read hundreds of articles, visited the Stompin' Tom Centre and listened to almost all of his music. Not only did I learn a lot about Tom, but I think I learned even more about Canada. It would be impossible to understand Tom without also knowing the country he loved so much.

Tom's music sent me off to research things that I was only vaguely familiar with. I had to find out what INCO was, learn more about the Meech Lake Accord, research the history of the Black Donnellys, google Marten Hartwell, discover the origins of Big Joe Mufferaw and listen to the music of Wilf Carter and Hank Snow. And that was just the beginning.

Tom always believed that Canada had characters and stories worth singing about. He knew that by putting them into song he was immortalizing them. He wanted Canada to celebrate its history the way other countries do. He wanted Canadians to know about their country. Certainly, in my case, he was successful. He taught me more about Canada than I had ever learned in my first fifty-three years of life.

I also came to learn that behind Stompin' Tom was a much more interesting man named Tom Connors. He was a complicated, intelligent, surprisingly thoughtful singer/songwriter who knew that Canada deserved to be celebrated. He helped to create the mythology of Canada with characters like Bud the Spud, Big Joe Mufferaw and of course, his greatest creation, Stompin' Tom.

# Prologue

As I finish this book, I have a huge amount of respect for Tom and what he accomplished. Not only for how far he came personally, but for the impact he had on a country that was only just beginning to value its own worth as he began his career.

I hope in reading this book you'll enjoy learning about Tom and his "Stompin' Grounds" as much as I did.

<div align="right">
Charlie Rhindress<br>
Amherst, NS<br>
June 2019
</div>

## Chapter One
# The Son

I was born in old Saint John, New Brunswick, by the sea,
Back in 1936, it was just my mom and me
— "The Ballad of Stompin' Tom"

Thomas Sullivan's sixteen-year-old girlfriend was pregnant. When Thomas told his mother about his predicament, she gave him a bit of money and a bottle of whiskey and told him to get out of town.

The Sullivans were Catholic, while Thomas's girlfriend, Isabel Connors, was Protestant. In Canada in 1935, marrying outside of your religion was still considered taboo, and Rose Sullivan would rather never know her grandchild than have her son marry a Protestant. Rose was Métis, with a mix of French and Mi'kmaw ancestry, while Thomas's father, Aloysius Sullivan, had come to Canada from Ireland as a child.

At the stroke of midnight, on February 9, 1936, young Isabel gave birth to a son she named Charles Thomas Connors at the General Hospital in Saint John, New Brunswick. Where Thomas Sullivan's name should have been, the birth certificate simply said, "Father: Unknown." That baby, who had such an inauspicious start to life, would grow up to become one of Canada's best-loved storytellers.

"Stompin' Tom Connors," as he would eventually become known, related the story of his grandmother advising his father to get out of town in the first volume of his autobiography, *Before the Fame*, in 1995. However, there are a few problems with this version of events. A marriage certificate filed in the New Brunswick provincial archives shows that on September 9, 1938, Thomas Sullivan married Clara Hilden, who was a member of the United Church. If Rose was truly opposed to her son marrying a Protestant, it seems odd that she changed her mind just two years later. Thomas is listed as Roman Catholic on the marriage certificate, so it's clear he did not convert for his wife. The marriage certificate also indicates that Thomas was living in Saint John in 1938, so if he took his mother's advice and left town he didn't stay away long. It's quite possible that the story of Rose advising her son to hightail it out of town is apocryphal.

The marriage certificate shows that another detail of the story is wrong. Thomas's father, Aloysius Sullivan's birthplace is listed as Saint John, not Ireland. As well, Isabel did not get pregnant at sixteen as Tommy Connors thought. Her tombstone lists her birthdate as September 26, 1917, so she would have been almost eighteen when she became pregnant in 1935.

These discrepancies are not mentioned to suggest that Tom Connors purposely lied when telling the story of his birth. No doubt he believed this version of events. Rather, they are meant to highlight the way in which family stories, passed down through generations, are often shaped by the teller and filtered through a haze of memory. The picture is further obscured by the family's social standing. Both the Sullivans and the Connors lived in poverty. Poor people living before the advent of computers and the internet were often not afforded the luxury of a detailed family history. They passed on few photographs or written records. These are not the families who are written about in history books or whose lives are recounted in the press. These are the forgotten masses whose stories often disappear as soon as those who remember them are gone.

Tom Connors worked to change that. He spent much of his life telling the stories of poor people, of the working class, of people like him. He understood the importance of memorializing people through lyrics and the ability of a good story to mythologize its subjects.

Much of what is known of Connors's childhood comes from *Before the Fame*, the first volume of his autobiography. He rarely agreed to media interviews, and prior to committing his life story to paper he didn't share many specifics of his childhood. In his autobiography, however, he recounts a number of stories from his early life in great detail. And the story he tells is Dickensian. In fact, Tom's first few years would put most of Dickens's characters to shame. As TV host Valerie Pringle said when interviewing Tom, "No one had a harder start in life than you."[1] Tom agreed and seemed to feel a sense of pride in that assessment.

Some of the details of Tom's early life are hard to believe, and he was aware that his audience might need some convincing. He wrote in the introduction to *Before the Fame* that, "Every word is my own, and it's all true." He goes on to say that he didn't reference notes in writing the autobiography, but relied on his memory for 99 per cent of it. He states that because most people don't have any memories of their infancy, they may "come to the conclusion that either I have a remarkable memory, or I have fabricated the whole damn thing." He assures the reader that the former is the case and that his memory was fully operational at the age of nine months.

Studies have shown that very few people have memories from before the age of three or four. Parts of the brain, such as the hippocampus, that play a role in memory do not develop until later in childhood. Episodic memory, or recalling actual events, is more difficult in infants because they have not developed language functions that help in understanding and storing these memories. Amanda Onion, reporting on memory development in small children, wrote, "Chances are if you think your earliest memory dates

from your first year or even early in your second year, it's not real — or at least not one you formed from the actual experience."[2]

The first story that Tom tells in *Before the Fame* is of the day he learned to walk at nine months old. He not only remembers those first steps but also the furnishings and the layout of the room and how excited everyone was. He says that was the day he realized he enjoyed performing. As he writes in the book, "I had had an audience and I liked it. I was a showman back then and I loved it."

If Tom actually recalled this story as related, not only the details but what he was thinking at the time, he would indeed have had an unusually remarkable memory. But in the early 1970s, in an interview with Alden Nowlan, Tom stated that his earliest memory was hitchhiking with his mother, which would have been when he was four.[3] Whether or not Tom was embellishing his memories doesn't really matter. What is clear in his autobiographies is that he is telling the story of "Stompin' Tom" — a character that appears to be mythologized almost as much as those who populate his songs. Every story Tom told contributes to the image that he created for himself. These tales are the building blocks of the performer and the man he would become. They paint a picture of how he chose to manoeuvre through a world that seemed rigged against him.

***

When teenaged Isabel Connors found herself pregnant and alone in 1935, there were very few options available to her. Abortion was still decades from being legal and the thought of raising the child as a single mother was problematic. As Tom Connors wrote in his autobiography, "If you became an unwed mother in the thirties, both you and your child were considered to be the scum of the earth."

Luckily for Isabel, she had a supportive family. Her father had died years before, but her mother, Lucy, had left her hometown of Tusket Falls, Nova Scotia, and moved to Saint John, New Bruns-

wick, where she married Joe Scribner, a man twenty-one years her senior. Although Lucy was in her mid-fifties and Joe was in his mid-seventies when Tom was born, they agreed to help Isabel. Lucy and Joe were both in poor health and they struggled financially, but they did their best to make a home for their newborn grandson.

Canada was in the midst of the Great Depression and New Brunswick had been hit hard. There was a decreased need for lumber and fish, two of the province's main exports, meaning labourers in those industries were deeply affected. Two or three families often lived together, sharing a home. In 1933, approximately 14 per cent of the Canadian population required government assistance to make ends meet. But government funds were stretched to the limit as many people couldn't afford to pay their taxes. Although Tom's family was poor, they were not alone in their struggle.

Despite the financial challenges, the first few years of Tom's life were happy. He was loved by his mother and grandparents and was particularly close to his grandfather, Joe, who became a father figure. Tom loved spending time with older men who told him stories of days gone by. Even when he didn't completely understand the stories, he was still enthralled. Referring to those tales many years later, he stated in *Before the Fame* that "the wistful tone of voice in which they were told still lives in my mind and makes me wonder what it is about a small boy that makes an old man want so much to remember back."

Joe was responsible for teaching Tom his first song. Tom recounted bouncing on his grandfather's knee as the old man sang, "And in this loving letter I told her all my mind; that I'd be ridin' donkey on the Nicker Bunker line." Close to sixty years later Tom remembered the lyrics to this song and assumed that the "Nicker Bunker line" was a railroad in New Brunswick. It is more likely that the song is a variation of an old standard called "The Knickerbocker Line." Most of the lyrics, as recounted by Tom, are similar to this traditional song about the first trolley cars in New York City.

As was the custom in the nineteenth and early twentieth centur-

ies, songs often travelled from region to region and were adapted in order to localize them. The version of the song sung to young Tom included the lyrics, "When the Fredericton branches are open," citing another New Brunswick city. The song contained nonsense lyrics like "I wrote my love a letter and I sealed it with a wafer," as well as the local references. These two things clearly made an impression on the young boy and no doubt influenced him when he started writing songs a few years later.

Tom's grandfather may have taught him his first song, but he often credited his mother with being his strongest musical influence. Her love of country music was contagious and the young boy loved watching his mother when she'd sing along to songs from artists like Wilf Carter. Tom told Robert Everett-Green, "I used to watch her put on an old man's hat that she found somewhere, and take a broom, and stand in front of a mirror thinking she was a cowboy or something, and sing all these songs and yodel and everything. I learned a lot of songs from her. I could almost sing before I could talk."[4]

Canadians had been introduced to country music through American radio broadcasts starting in the 1920s. Programs like *National Barn Dance* from Chicago and Nashville's *Grand Ole Opry*, as well as the very popular WWVA radio station from Wheeling, West Virginia, were heard throughout Canada. In many parts of the country it was the most popular music of the day. Canadian radio soon caught on to the popularity of country music, and shows like *George Wade and His Cornhuskers* on CFRB in Toronto and Don Messer on CFBO in Tom's hometown of Saint John were on the airwaves.

Tom was part of the last generation to grow up before rock and roll music replaced country on the pop charts. Referring to Wilf Carter, Jimmie Rodgers, Hank Williams, Roy Acuff and other singers of the time, Alden Nowlan, a New Brunswick writer and contemporary of Tom's, wrote, "in the Wild East, when Tom Connors and I were growing up there, they weren't categorized as

'country' or 'western' or, God help us, 'hillbilly' singers: theirs was the only music in precisely the same sense that Cheddar was the only cheese."[5]

The traditional family life that Tom had enjoyed, full of music and stories, was shattered when his grandparents passed away within weeks of each other. According to their death certificates, Joe Scribner died on May 21, 1940, at the age of seventy-nine, and Lucy died on June 29, 1940, at just fifty-eight. Tom always believed that his grandparents died when he was three. The chapter of his autobiography that deals with this part of his life is called, "Three-Year-Old Hitchhiker." He even sang about this period in "The Ballad of Stompin' Tom" with the lyrics, "And as she wandered through the land, shunned by family, She often had to beg for bread while I was only three."

Lucy and Joe's death certificates show that Tom would have been closer to four and a half when they passed away. This small detail makes little difference in the overall story of Tom's life, but it does make it easier to believe the level of detail he recalls from this time in his life. A four-and-a-half-year-old's memory is considerably more developed than a three-year-old's. Because of this age discrepancy it is difficult to determine the exact chronology of Tom's life between three and five, but it is not an understatement to say that he experienced more hardship over the next few years than most people endure in a lifetime.

Left with few resources, Isabel was forced to give up the apartment that she and Tom had shared with her mother and Joe and move into a two-room flat. She reconnected with Tom's father, Thomas Sullivan, and became pregnant again. At this time he would either have still been married or very newly separated from Clara Hilden, whom he later divorced. Whatever his circumstances, he once again chose to walk away from Isabel.

Isabel started seeing Terrence Messer around this time. Like Isabel, Terrence enjoyed country music and he would often drop by with his guitar to sing and play. He would sometimes bring friends

with him, and on one occasion Hank Snow joined them. Snow was a touring musician at the time and still years away from becoming a country legend. Afterward, whenever Isabel heard Snow on the radio, she would talk about the night that he sang and played guitar in her home.

Isabel was not ready to make a commitment to Messer and had no idea how she would support young Tommy, let alone a new baby. She decided to visit the Connors family in Tusket Falls, Nova Scotia. With no money to pay for the journey, she and young Tom set out hitchhiking the almost seven hundred kilometres to her former home in southern Nova Scotia.

As Isabel stood on the side of the road with her thumb in the air, Tom noticed for the first time that half of it was missing. As a child, Isabel, whose family could not afford a real doll, had wrapped a brick in a blanket and pretended it was a baby. The brick fell and cut off the end of her thumb. This identifying characteristic would prove important in the years ahead. The constant walking exhausted the young boy. His mother would sometimes carry him down the highway and other times threaten to leave him on the side of the road when he claimed he couldn't continue. When they did get a ride, Tom would provide the entertainment. He told an interviewer, "when people picked us up, I'd be singing these ditties and trying to yodel, and they would get a great kick out of that."[6] Tom always referred to his mother as Isabel and it was indicative of their relationship, as he was often a sidekick in his mother's adventures.

In between rides they would stop at random homes and ask for some food or see if they might be able to spend the night. While some people turned the young mother and her son away, others would take them in and give them a place to lay their heads.

When Tom and Isabel finally arrived in Yarmouth, the biggest town near Tusket Falls, they were hungry and desperate. Before moving on to look for family they went into a Chinese restaurant and had a full meal. Isabel then instructed the young boy to go

outside to play. His mother soon rushed out of the restaurant, picked him up and ran until they were safely beyond the reach of the owners. It was Tom's first "dine and dash" experience, but it wouldn't be his last. Tom told Alden Nowlan, "Looking back on it, I can see that it must have been tough, being on the road like that. But it didn't seem that way at the time. For all I knew every little kid in the world was travelling down some dirt road with his mother. To a little kid what matters is having somebody to hold on to."[7] Life on the road, being hungry and relying on the kindness of strangers was already the norm for young Tommy.

Tom suspected that Isabel had taken him to Tusket Falls in the hopes that someone might look after him while she figured out how to deal with another baby. Although her extended family was welcoming, and offered some food and shelter, apparently no one was willing to take the young boy. They were soon back on the road, hitchhiking home to Saint John.

Once in Saint John, Tom and his mother moved in with some family friends long enough for Isabel to give birth to Tom's little sister, Marie. The baby was born with a large birthmark on the back of her neck, which doctors recommended she have removed. For this reason, Marie did not come home immediately, but spent the first few months of her life in the hospital.

At this point, Isabel decided to move in with Terrence Messer. At the time, unmarried couples could not get a hotel room together, let alone rent an apartment. According to Tom, landlords would usually ask potential tenants to provide a marriage certificate or at the very least a wedding picture. Terrence developed a scheme that often worked, enabling the family to rent an apartment: While they were inspecting their potential new home, Tom would ask Terrence, "Daddy, can I have a dime?" Apparently, the fact that the small boy called Terrence "daddy" was enough to convince the landlords that they were a respectable family and no more proof was requested. Tom would have to give the dime back once the apartment was secured. In order to appear more like a family, Tom

also adopted Terrence's last name and was called Tommy Messer for the next few years.

If Isabel had decided to live with Terrence because she was looking for some stability, she had chosen the wrong man. Although Terrence was often employed, he just as often spent his pay on liquor and the family would be unable to buy food or pay their rent. They were rarely in any one apartment for more than a couple of months.

Tom was also witness to Isabel and Terrence's violent fights. Isabel would call out Terrence for drinking away the money that should have gone to house and feed them, while Terrence would call Isabel a slut for having two children out of wedlock.

Isabel was a small woman, but she had a big temper and was often violent. She once threw a frying pan full of hamburgers at Terrence and sent a can of beans flying through a window before the police were called and the couple was evicted yet again. Terrence was also abusive towards Isabel and left her with black eyes on more than one occasion. He once punched her and sent her flying onto a hot stove where she burned her arm.

A common cause of their fights was Terrence's jealousy of Tom's father, Thomas Sullivan. He would often yell at Isabel, "You still love that bastard, don't you?" He was so jealous of Sullivan that he refused to say the name Tommy, and instead called the young boy Tammy.

When Isabel visited Marie in the hospital, Tom would be left in Terrence's care. He would be locked in the house and told to stay put while Terrence left to drink with friends. Tom would often manage to get out and roam the streets of Saint John. While being left alone at such a young age was dangerous, it was almost worse when Terrence stayed home with him. He once rolled a cigarette for little Tommy and watched him smoke it until the boy was sick. Terrence helped Tom celebrate his fifth birthday by encouraging him to drink wine. Tom drank so much that he became dizzy, fell and cut his forehead, narrowly missing his eye, before passing out.

He woke up long enough to vomit and then passed out again.

Isabel eventually got a job scrubbing floors. On the days when she and Terrence were both working Tom would be left alone and told to "stay around" the apartment. Sometimes they would leave food for him, other times he would go hungry. It was not uncommon for the family to go a day or two without a meal and as a result Tom never became a big eater, writing in *Before the Fame*, "I eat to live, not live to eat."

As any five-year-old left alone for the day would, Tom managed to get himself into a fair amount of mischief. On one occasion he started playing with some matches that he found in the apartment. He set the curtains on fire to see if they would burn. He tried to extinguish the blaze and burned himself before running out into the street. A stranger walking by realized what had happened and raced upstairs to put out the fire by dousing it with pails of water. The landlord was furious with Tommy and was still berating him when Isabel came home. Always the protective mother, she yelled at the landlord, "If I catch you putting your filthy hands on Tommy again I'll kill you, you slumpy looking weasel." They were evicted. The next morning they packed up their meagre belongings and set out in search of another place to live.

As they moved throughout the city, Tom found himself the perennial outsider. When he roamed the streets of a new neighbourhood, looking for other children to play with, he found they already had their cliques. As he wrote in his autobiography, "I no sooner got acquainted with the kids of one neighbourhood when I quickly found myself a stranger in another . . . no matter what happens you're always an outsider. Always unwanted . . . You hope that your smile, through the hidden tears and your feeling of low importance will bring a comment like, 'Hey kid, you wanna come and play ball with us?'" This had a huge impact on the little boy. Tom carried those feelings of being the outsider, of not being wanted, with him throughout his life.

The family moved into an apartment on Clarence Street in Saint

John, next door to a bag factory. When they arrived, Tom discovered that his bedroom would be a tiny room with a broken window that had no furniture. Terrence threw a big coat in the corner of the room and told Tom that would be his bed. Although Tom had been toilet trained before the age of two, he continued to wet the bed for many years afterward. The old coat that served as his bed eventually became soaked with urine, and because Tom had just one change of clothes he would sleep in the same clothes he wore every day. He would count on the warm sun to dry him, although it could hardly disguise the smell. Looking back Tom refused to say he went to bed at night. Instead he said he went to "pissy coat."

Their new apartment had a gas stove, so the landlord insisted that Tom not be left alone inside. This meant that when Isabel and Terrence were at work Tom was locked outside all day and sometimes late into the night. He noticed an old night watchman who worked at the nearby bag factory, a man named Fred. Once Fred realized that Tom had nowhere to go, he let the young boy sit on the front steps of the bag factory with him while they kept a lookout for Terrence and Isabel. Fred started bringing a larger lunch with him each night so he could share it. Tom loved listening to Fred's stories.

Tom would often fall asleep leaning against the older man. On occasion Fred would carry the young boy upstairs into the factory and let him sleep on a pile of burlap bags. When Fred saw Isabel or Terrence come in, he'd wake Tom and send him home. Eventually, he started letting Tom sleep through the night. Apparently, Isabel and Terrence weren't concerned enough to go looking for the little boy who had been left alone all day. As for Tom, he preferred the dusty burlap bags to the urine-soaked coat.

One day Isabel took young Tom to the armouries to see his father, who had joined the army. It was the first time Tom recalled meeting Thomas Sullivan. Isabel introduced the two and then asked Sullivan for money. He gave her a quarter, which is all he claimed to have with him, and told her to return the next day. Tom

did not see his father again for ten years.

Around this time, Tom's little sister, Marie, came home from the hospital for a short while, but went back in for a second operation on her birthmark. Unfortunately, she did not survive the procedure.

Based on the many stories in his memoirs, it seems remarkable that Tom made it through his childhood alive. Between diseases and mishaps he seems to have been constantly cheating death or serious injury. One day, while playing with some kids in Courtenay Bay, he almost drowned. He had been sliding down an upside-down dory when he fell backwards, headfirst into the water. He was unconscious by the time an older boy managed to get him to shore. At first the boy thought Tom was dead and put him in the basket of his bike, planning to take him to a hospital. Tom regained consciousness and pointed out where he lived and when they arrived home Isabel gave the boy twenty-five cents for saving her son's life. Tom was not only shocked to see his mother giving away a quarter, which he considered a large sum of money, but seemed surprised that his life was so valuable.

Things changed for Tom when Terrence decided to go to Truro, Nova Scotia, to follow up on a job offer. It was arranged that while he was away Tom would spend a month or two with Terrence's father Olivar, who was married to a woman named Mabelene and had a stepdaughter named Doreen. Olivar and his family lived on a farm in McAdam, New Brunswick, almost two hundred kilometres from Saint John.

When Tom told Fred that he would be moving away for a while, the old man had tears in his eyes. Tom asked why he was crying and Fred replied that he was just happy for the boy. He was thrilled that Tommy would be in a place where he was better cared for. But the old man added, "I'm gonna miss you, Tommy." It would be years before Tom realized that Fred's tears were probably less tears of joy than of sadness at the end of their unusual friendship. Tom never saw Fred again.

Olivar, Mabelene and Doreen came to visit Terrence and Isabel

and took Tom back with them on the train to McAdam. Arriving in McAdam, Tom was impressed by the thirty-acre farm that had a cow, a dog, hens and countless cats. There was also a large vegetable garden. To have food growing out of the ground must have seemed almost magical to Tom, who had spent years hungrily roaming city streets.

Tom immediately liked Olivar, whereas he always felt that Mabelene resented his presence. On his first day at the farm he fought with Doreen, who was a few years older than him. She was controlling and bossy and Tom would have none of it. After being told for the third or fourth time that he couldn't go to a certain area on the farm or touch this or that, he kicked the little girl. When Tom explained that he kicked Doreen because she wouldn't let him "pet the kitty," Mabelene, of course, defended her daughter. According to Tom's autobiography, Olivar defended the newcomer, saying, "Oh, leave the boy alone, Mabe. Dorie probably deserved what she got. She's always going around thinking she owns everything anyway." Tom liked Olivar even more.

Up until this point Tom had been called Tommy by everyone except Terrence, who referred to him as Tammy. Olivar was the first person to shorten Tommy to Tom, and the young boy liked it.

Even if Mabelene resented him and Doreen was a regular source of frustration, Tom was part of a family, and he came to enjoy doing chores around the farm and spending his evenings playing games and listening to country music on the radio. He had a nice bed to sleep in and ate regularly. One of the things that Tom loved most about being in McAdam was the fact that they had a gramophone. Tom would crank the old record player while Doreen carefully loaded and changed the LPs. One night after dinner, Olivar started to sing along to a recording of "Blue Velvet Band," a song made famous by Hank Snow. Tom immediately jumped up and said, "No! No! Don't sing it like that, sing it like this!" and proceeded to perform the entire song. Even Mabelene and Doreen were impressed.

With their encouragement, Tom sang a few more songs before Olivar left and returned with an instrument the young boy had never seen. It looked like a miniature guitar, but was played with a "funny looking stick," as Tom would write years later. Olivar tuned the fiddle and asked Tom if he could dance as well as he could sing. In no time Olivar was playing the fiddle as Doreen grabbed Tom and they began to dance around the kitchen. Mabelene clapped along as Olivar tapped his foot and the house filled with music. Tom led the family as they sang songs like "Buffalo Gal," "She'll Be Coming 'Round the Mountain When She Comes" and "Turkey in the Straw" repeatedly. It was his first kitchen party, and he later called it "the most wonderful time in my life."

Tom wrote in *Before the Fame*, "the greatest joy I got out of life as a child was singing the old-time country songs . . . if there was anything positive during my first few years on this planet, it had to be country and western music." His mother had been singing these songs to him for as long as he could remember. Terrence had a guitar and sang those same songs. He also heard them on the radio and gramophone. And he sang them himself with Olivar and family. Tom would continue to sing those "old-time country songs" for the rest of his life.

Although Tom thought he was only going to be with Olivar and Mabelene for the summer, he ended up staying through till Christmas. When Doreen returned to school in September, Tom was too young to be enrolled, but nonetheless followed her and made himself at home in her grade two classroom. The teacher didn't seem to mind and gave him a colouring book to help pass the time. She said he was welcome any time he wanted to attend. Tom went to school with Doreen so often that when it came time for the Christmas concert he was included in the show. Although he didn't have a large part, he was scheduled to be on stage with Doreen's grade two class. Doreen was supposed to recite "'Twas the Night Before Christmas," but blanked when faced with a huge crowd of expectant faces staring up at her. Tom left the other students, took

Doreen by the hand and started to recite the Christmas poem.

Doreen continued to stand there, stage struck, as four-year-old Tom recited the entire piece from memory. She began to mumble a few words as he said, "When what to my wondering eyes should appear," and by the end they were delivering the poem in unison. As they recited "and to all a good night," the audience was on their feet giving Tom his first standing ovation. Tom wrote, "Maybe I should have been an actor not a singer," although anyone who saw him perform later in life would argue that a fair amount of acting went into his musical performances.

As the concert neared its end Tom was shocked to spot his mother in the crowd. She and Terrence had come to surprise him, with plans to celebrate Christmas in McAdam. Not only was Tom thrilled to be reunited with his mother, but she had arrived in time to witness his first triumphant stage appearance! He was so excited to see her that when it came time for him to deliver the one line he was actually supposed to say, "Thank you and Merry Christmas, everybody," he blurted out, "Happy thank you. Hi there Isabel," before he jumped off the stage and raced back to his mother's arms.

The next couple of weeks brought presents, music, family time and more food than Tom had ever seen his life. But this abundance of good cheer was about to come to an end. Isabel was going to take Tom back to Saint John with her and Terrence after the holidays. Olivar wanted the boy to stay for the winter, but it was clear that Mabelene wasn't keen on the idea.

Terrence hadn't secured a better job in Truro, but he was now working as a longshoreman at the Saint John port. He had to get back to work, so he left ahead of Isabel and Tom. The plan was for him to find an apartment, get some food and be ready for their return. When they got back to Saint John there was an apartment, but nothing to eat. Terrence and Isabel fought as he tried to come up with various excuses for where the grocery money had gone. Isabel and Terrence were right where Tom had left them, as unhappy and destitute as ever.

For the next year or so, life continued apace. The little family would move, go without food and generally struggle to eke out an existence. They had money for firewood or food, but rarely both, so they had to decide whether they preferred being cold or hungry. One of the few highlights of life back in Saint John was when they moved into an apartment next to people who had an electric record player, the first Tom had seen. The neighbours played Tom's favourite kind of music, country and western. They would let him hang out in their apartment listening to songs from artists like Gene Autry and Wilf Carter.

After the magical Christmas with Olivar and his family in McAdam, the Christmas of 1941 was meagre. Isabel and Terrence were both unemployed, so there were no decorations or presents. Tom didn't even have a bedroom in their latest apartment, so he slept on the floor of a closet. He found a tree bough and some tinsel that someone had tossed aside and took it into his tiny "bedroom" where he prayed to Santa before falling asleep, hugging his little bit of evergreen. He awoke to find his prayers had not been answered. In describing the early 1940s and the devastating effect the Great Depression had on the people of the Maritimes, Tom wrote, "The middle class became the poor and the poor became the beggars, the thieves and the outcasts." Tom's family was firmly in this latter category.

In spring 1942 Isabel was pregnant with Terrence's baby, or at least Tom assumed it was Terrence's child. Broke and desperate, she stole a baby carriage. Even though Terrence painted the carriage in an attempt to disguise it, Isabel was caught, arrested and sentenced to a week in jail.

Terrence took no time in moving another woman into their apartment for the week. Tom wanted to be back in McAdam more than ever, so he decided to run away. He had travelled to Olivar's by train, so he figured he would get there eventually if he walked the tracks. Just six years old, he was into his second day of walking, without food, when he was picked up by the police twenty-five to

thirty miles from home. He was taken back to Terrence.

When Isabel was released from jail and Tom told her about the woman who had moved into their apartment, Isabel left Terrence. Years later, Tom recalled his mother standing on relatives' doorsteps where she would beg for any kind of help. She would often be told in no uncertain terms to go away and not come back, leaving in tears. Despite his hunger, it was his mother's pain that caused Tom the most distress.

They moved in with friends of Isabel's long enough for her to give birth to her third child, Nancy. Shortly after the birth, Isabel found the funds to move the three of them to Montreal in an attempt to start over. Tom was never sure how she got the money, writing in *Before the Fame*, "I don't even want to speculate how that may have happened," implying she may have done something illegal. He goes on to say that perhaps she stole Terrence's paycheque or got a loan from friends.

In the new city Isabel went to work every day, but Tom never knew exactly what she did. He was just six years old but his mother once again left him home alone for the day. This time he also had to take care of his baby sister. There wasn't much food to be had, so, as Tom recalled, they "slept, played or cried" until their mother returned. Tom remembered his mother being willing to do anything to provide for her small family. He recalled walking all over the big city to gather some sort of government assistance. Another time she had the children baptized in the Catholic faith then asked the priest for some money before she left.

As had been the case in Saint John, they moved constantly. Tom was now school aged, but he had such a hard time always being "the new kid" and getting beaten up every day that Isabel pulled him out. Before long she decided to head back east, and hitchhiked almost one thousand kilometres home with a seven-year-old and a one-year-old. Once again they relied on the kindness of strangers along the way, who not only gave them rides, but also food and a place to stay.

Arriving in Saint John, Isabel visited a few people and managed to get enough money for them to take the train to Truro, Nova Scotia, where Terrence had moved. They stayed with him for a short time before their relationship exploded for good and Isabel continued to Halifax with Tom and Nancy. In his autobiography, Tom wrote that they eventually stayed with a woman his mother knew who "had more than a dozen kids" and lived in a "rough and rundown ghetto-like area of Halifax."

While they were there, Tom caught diphtheria. It was the second time he almost died. By the time Isabel got him to the hospital he was unconscious and remained in a coma for nine days. When he woke up, his nurse yelled down the hall and in no time his room was packed with doctors and nurses, all celebrating the fact that he was out of the coma. Tom was so swept up in the festive nature of the moment that he started singing "The Star Spangled Banner." This was followed by that Hank Snow song he had sung for Olivar, "Blue Velvet Band." For Tom, music was always associated with the good times in his life, and this celebration deserved a song.

Although Tom liked school, as evidenced by the time he had spent in the grade two class at McAdam Elementary when he was just four, he didn't like getting beaten up. It was no easier finding playmates in Halifax than it had been in Saint John or Montreal. Kids would chase him from school and physically attack him just because he was the new kid in the neighbourhood. He had to come up with inventive ways to get home through back alleys so he could escape the bullies. The abuse became so bad that Isabel eventually took him out of school again.

In his autobiography, Tom was very honest about how much this bullying hurt him: "I wanted to fit in. I really did . . . but I was different enough back then that kids noticed and picked on me as an easy target." Tom goes on to say that these children probably didn't realize the lasting psychological damage they inflicted. Although it reinforced his sense of being an outsider, he felt in some ways this abuse helped to make him stronger. He wrote, "I

was a survivor. It was this rough introduction to the real world that made me tough." He seemed to take pride in having endured all the challenges that life could throw at him and coming out the other side tougher.

In spring 1944, when Tom was eight and his little sister was about a year and a half, Isabel decided she'd had enough of Halifax and they hit the road again. This time they headed to the Annapolis Valley in southern Nova Scotia. They passed through a small village that had a few houses and a store. They were all hungry and when Tom asked if they could go in to buy something, Isabel replied that she had no money. She eventually spotted a cabin away from the main road, broke the pane of glass on the door and let herself in. She discovered a wood stove and a pile of firewood. It was March in Nova Scotia, so in addition to being hungry the three of them were cold. Isabel soon had the fire going and they finally had some warmth. She told Tom that they would eat after dark. Sometime around midnight she left Tom alone with Nancy and disappeared for an hour or two. She returned with armloads of groceries and they all went to bed with full stomachs for a change.

They were awoken in the morning by a banging on the cabin door. It was a police officer who immediately apprehended Isabel. The children were taken to someone's house while she was formally charged with the various crimes she had committed to keep her children from going hungry. That night she was put in jail, joined by her two small children. Tom would spend the next month in jail with his mother and little sister. They slept on a mattress that was covered in lice and bed bugs. As he lay in bed at night, he could hear the scampering of mice.

Once out of jail, Isabel and her children made their way back to Saint John. She had tried her luck elsewhere, but was always drawn to home. Maybe they could make things work this time. Isabel didn't realize that an all-points bulletin had been issued for her arrest. It was unclear to Tom exactly why the Saint John police were looking for her, but someone at the YWCA where they'd tried

to get some food had recognized her and called the authorities.

Isabel became suspicious while she was waiting for the food, but before she could escape two police officers and a social worker were at the door and she was blocked in. She did not go easily. Neither did little Tom, who tried to escape the grasp of one of the police officers by going under tables and over furniture, tearing down curtains and knocking over lamps. The social worker managed to get hold of Nancy, but the other police officer was having a hard time capturing Isabel. Years later, Tom would say that his mother was like a "wildcat" that night. She "bit, scratched, kicked and screamed at the other policeman," but was eventually subdued. As Tom was taken outside he saw his mother and little sister being put in a squad car. And then they drove off.

After all that Tom had been through in the first eight years of his life, he was finally defeated. "That's when my world caved in," he wrote in his autobiography. Tom was taken to a children's aid shelter and locked in a detention room, where he spent the night in tears. He wrote many years later, "I just knew I was never going to see my mother again."

## Chapter Two
# The Orphan

There's an old mellow moon,
That shines there in June,
He can tell you of the good old country ways,
He'll tell you with a smile,
There's no place like P.E.Isle
— "My Home Cradled Out in the Waves"

Being taken from his mother was perhaps the defining moment in Tom's life. When he wrote about it more than fifty years later, the emotions were still raw and those final moments with his mother were burned into his memory. Despite the challenges of Tom's young life, when he was with his mother he felt loved. He knew that when his mother broke the law she did it to provide for him and his sister. Tom believed that those who hadn't lived in abject poverty would never be able to understand this.

While it is now generally acknowledged that separating a child from his or her parents can have lasting psychological damage, this was not understood in the 1940s. Having experienced it first-hand, however, Tom was fully aware of the harm it caused. He wrote in his autobiography, "This method of treating human beings is nothing short of barbaric." If the goal of taking Tom from his mother had been to create a better life for him, the system failed him miserably.

In the 1940s many Canadian orphanages were owned and oper-

ated by the church. The children's aid shelter where Tom was first taken was a Protestant organization. He was there for just two months, but it was long enough to suffer more misadventures. One day in the washroom he accidentally urinated on another boy who subsequently threw a milk bottle at Tom's head. The bottle hit him in the forehead causing extensive bleeding and a scar that would last a lifetime. The cut was so severe that Tom ended up spending time in the hospital.

Tom hoped that his mother might visit him in the hospital, but that was not to be. She probably had no idea Tom had been hurt and she may even have been in jail. Tom had been trying desperately to find out where his mother and sister had gone, but no one would give him any information.

Tom's mother had converted him to Catholicism in Montreal, so he was eventually moved to St. Patrick's, a Catholic orphanage in Silver Falls, New Brunswick — about eight kilometres outside of Saint John. The home was originally opened in 1880 as St. Patrick's Industrial School and Farm and, although it had changed its name, it was still a working farm. Eventually the orphanage would be home to both girls and boys, but during Tom's time there it was strictly male. There were about 150 boys aged one to twenty-one, and anyone older than four had to work. The boys were treated as free labour. They milked and fed the cows, gathered hay from the fields, gardened, made dairy products and cleaned both the barns and the orphanage itself.

By the mid-1920s every province in Canada had legislation that made school attendance compulsory for anyone under the age of fourteen. This removed most children from the workforce. The children at the orphanage attended a school on the premises, but they also had so many "chores" that it looks an awful lot like child labour from a twenty-first-century perspective.

Tom was transferred to St. Patrick's with two other boys who had been at the children's aid shelter. All three realized immediately that they were going to be put to work. They ran away the day

they arrived. Tom made it back to Saint John with his two friends and followed them to their house, as he had no idea where to find his mother. They arrived to find the boys' mother was not at home, but a man who answered their door told them to get back to the orphanage. Reluctantly, they returned to St. Patrick's where they were sent to bed without food. Tom would try to run away again, but later punishments were more severe. Tom claimed that he was tied to a bed by his arms and legs and had his back strapped for trying to escape.

Even though he was now eating regularly, he didn't care for the food and was often looking for something else. He and the other boys would steal milk from the orphanage or directly from a cow so they could make homemade butter to go on their dry bread. They would raid the garden for vegetables. The boys who were lucky enough to work in the kitchen would take bits of bread or cookies when the nuns weren't looking. Tom's first job was scrubbing the floors, so he had no access to the pantry, but he used his love of singing and telling stories to his advantage. He would get a bit of bread or some other ill-gotten good in return for a story or a song.

Tom was nicknamed Cowboy because of all the country and western songs he knew. He could also yodel like his hero, Wilf Carter. Tom would tell stories and the boys would gather round to hear tales both made up and real. Some stories were based on the plots of movies he'd seen, while others were inspired by his life. Tom had an almost endless supply of adventures to pull from. At just eight years old, he'd already been to jail, hitchhiked across much of Eastern Canada, almost died on a couple of occasions and helped his mother steal more than a meal or two. The stories based on his life were often embellished. He wrote in his autobiography, "I would exaggerate these hitchhiking stories and place my mother right in the centre where she was built into such a hero that she was beating up cops, taking great risks and overcoming insurmountable problems. Before long, the name 'Isabel' was like that of Wonder Woman."

The boys caught a glimpse of the famed Isabel when she unexpectedly appeared at the orphanage one day. Tom was outdoors playing with the other boys when one of them told him there was a woman hiding in the bushes, on the edge of the ballfield, who claimed to be his mother. Tom was careful to avoid the watchful eyes of the nuns as he made his way to the woods in the hopes of being reunited with his mother. Isabel was indeed waiting for him, but she did not rescue him as he had hoped. She explained that she had escaped from jail but she was going to have to leave him there and it may be a long time before she saw him again. Not knowing how long that might be, she told Tom that he would always be able to identify her by her missing thumb and she would know him because of a small birthmark on his neck. Isabel hugged Tom, gave him a bag filled with desserts and candies and disappeared back into the woods.

When Tom returned carrying the gift from his mother, the other boys swarmed him, tearing open the bag and spilling its contents. They helped themselves to Tom's bounty and he managed to get just a couple of treats before it was all gone.

There was constant fighting at the orphanage. Tom wrote that you "never knew when you might get a punch in the face." If someone wasn't starting a fight, they were egging others on, causing rifts between the boys and encouraging them to fight it out. Tom said that he must have been particularly unlucky, because he found himself in fights "every day, every day, every day." While Tom hated the constant fighting, he blamed the violence less on the boys and more on the nuns. He wrote in his autobiography, "It seems to me the reason there was so much violence between the boys was because that was the only reaction they learned from the nuns. If someone irritated you, just give him a good pounding."

Tom claimed that he suffered regular emotional and physical abuse from the nuns who ran the orphanage. Not getting your schoolwork done warranted a beating. Running away got you a whipping. If the boys wouldn't reveal which of them had done

something that deserved punishment, they would be lined up and all of them would be struck repeatedly. As Tom told Alden Nowlan, "they beat the hell out of me, and everybody else, with leather straps and bamboo canes, and whatever else they could lay their hands on, and if they couldn't find anything to hit you with they grabbed you by the hair and almost twisted your friggin' head off."[1]

When Tom arrived at the orphanage he was still wetting the bed. He was not alone in this affliction and all of the boys who did so were put together in a dorm called St. Vincent's. The boys had to sleep on top of rubber sheets with no blankets. The windows were left open, even in the winter months, so if a boy did urinate during the night he might wake to find himself frozen to the rubber sheet. They were only allowed blankets if they managed to go three nights in a row without wetting the bed. If they had an accident, they would get a minimum of five whacks across the hand with a stick or strap, often leaving their little hands bleeding.

As a sixty-year-old man writing his autobiography, Tom's hatred of the nuns is palpable. He never understood how the nuns could "preach and teach children the catechism and the gospels . . . all in the name of a loving Jesus, and at the same time pound the bodies and torture the minds of innocent babes."

In addition to the alleged abuse, there were other dangers inherent in living in an orphanage. If one child got a disease it was sure to spread. Tom wrote that during his time there he had "mumps, measles, whooping cough, chicken pox and a host of ringworm, hives and rashes, along with lice and other irritations."

No doubt one of the saddest stories during Tom's time at the home occurred at Christmas. The boys had heard that Santa would be making a visit to the orphanage and he would have a sled for every one of them. When Christmas morning came Tom had to do his chores before he could go down to meet Santa. At the time it was his job to make the beds. He didn't do it right the first time so one of the nuns insisted he remake all of them. By the time the beds were properly made and he got down to see Santa, there were

only a few boys left waiting to receive their Christmas present. Tom noticed immediately that he was the last of five boys and there were just four sleds. He hoped that perhaps there was another one hidden somewhere, but that was not to be. By the time he got to Santa, the jolly old man looked slightly uncomfortable, handed Tom an apple, an orange and a few nuts and said, "Well, Merry Christmas." Tom claimed he was the only child at the orphanage who didn't get a sled that Christmas. He spent the rest of the morning in bed, crying and wondering what he had done wrong to not get a present like everyone else.

Years later he wrote "An Orphan's Christmas," a song about that disappointing morning, with the lyrics, "And when my turn came to meet Santa Claus, I can still remember those words he said, 'And that's all the presents I have for this year, kids.' And I turned away hanging my head."

While there's no doubt Tom endured horrific treatment that haunted him for the rest of his life, there is reason to question the veracity of some of the stories in his autobiography. In one story, Tom claimed that a day or two before he left the orphanage, Arnold Marks, the younger brother of Tom's good friend Gerry, was killed in a haying accident. Tom wrote that while lifting hay into place in the barn a cable snapped and "it caught Arnold by the arm and ripped it off" and he died soon after from his injury. In fact, Arnold Marks's death certificate shows that he died two years after Tom left the orphanage, in August 1947. The boy did not have his arm ripped off but suffered a "severe laceration" to his right hand. While in hospital Arnold developed "post-operative bilateral pneumonia" and succumbed to the illness two days later.

The key facts of the story remain, however. A young child died at the orphanage from work-related injuries. But Tom's assertion that he was at the orphanage when the accident occurred, and his rather dramatic claim that the boy had his arm "ripped off," are perfect examples of the sort of embellishment that Tom was guilty of as a teller of tall tales. While that imagination would serve him

well, ultimately providing a healthy living for him in the years to come, it does make for an occasionally unreliable narrator.

Once or twice a month, the boys would get cleaned up and stand in line to be inspected by someone looking to adopt. If a boy was chosen, he would then go to a private room for an interview. Despite their desperate hope that a good family might rescue them from the orphanage, the boys became accustomed to not being chosen. Tom's greatest hope was that he might be adopted so he could run away and find his mother. He figured it would be easier to escape a private home than the orphanage and he was hoping that the punishment, were he caught, would be less severe.

Cora Aylward from Skinners Pond, Prince Edward Island, had been to the home a couple of times and had already adopted an infant named Marlene, who was just two years old when Cora returned in search of a boy. Something about Tom caught her attention and within a few weeks he was meeting with a children's aid worker, who arranged for him to live with Cora and her husband, Russell. It was 1945 and Tom was now nine years old, having lived at the orphanage for a year. Tom felt that he was being purposely sent far away from Saint John so that his mother would not be able to find him.

It is unclear if Tom was legally adopted by the Aylwards. Articles written through the years variously say that he was adopted and that the Aylwards were foster parents. Tom himself was unsure of the arrangement, writing in his autobiography, "I don't know what sort of deals were made between the orphanage and the families that took the children . . . in those days we thought we were being adopted, although there were different forms of adoption." As Tom never took their name, it seems unlikely that it was a traditional full adoption.

Regardless of the specifics, Tom, like the fictional Anne of Green Gables, was an orphan from New Brunswick moving to live with a family he didn't know on Prince Edward Island. And like Anne, Tom was plucky with a great imagination. There were some differ-

ences however. While Anne was able to melt Marilla's heart and become like a daughter to her, Tom had no such luck with Cora. He quickly discovered that she didn't really care for boys and she had no interest in having a son. She put up with Tom so they could have help on the farm. She obviously loved Marlene, but Tom felt she treated him and all boys in general like "barn animals." According to Tom, she was emotionally abusive and occasionally violent. In both cases, the men of the family, Matthew for Anne, and Russell for Tom, were initially the ones to offer a genuine welcome and a sense of affection.

Having spent most of his life in cities like Saint John, Montreal and Halifax, arriving in Skinners Pond was a bit of a culture shock for Tom. The community was comprised of just a few families whose main occupations were fishing and farming. The Aylwards' farm had no electricity and they still used an outhouse. They did, however, have the only telephone in the community, and if any neighbours needed to make a call they came to the Aylwards'.

Tom had his own bed, but no bedroom — he slept in the upstairs hallway. He ate regularly and was free from the abuse of the nuns, but he still cried himself to sleep most nights, missing his mother. As Tom later wrote he eventually learned that "All the beds, food, clothing and regimentation in the world can never again replace even the smallest piece of a broken heart."

Tom would go to school, then come home to work around the farm. When his chores were done he was not allowed to roam the house, but had to sit on a chair at the kitchen table and silently wait for supper while Marlene was free to go wherever she liked in the house.

Cora seemed to want Tom to fail and resented it whenever he did well. He would come home from school with a good grade and, rather than receiving the praise he had hoped for, Cora would push the report card back towards him and tell him to get his chores done. She appeared to like Tom better when he played dumb. He wrote in his autobiography that "The more idiotic I acted, the bet-

ter she liked me . . . I'd stutter and stammer and get such stupid looks on my face that she would smile in a way that told me she was pleased and now I was on the good side of her." It was as though Cora didn't want him to act above his station in life. She saw Tom as the bastard, orphan farmhand who had no right aspiring to anything higher.

Tom claimed that Cora sometimes hit him repeatedly and that he often didn't know what he had done until later. Tom eventually learned to wait until Russell was present and then ask why he had received a beating. This was his way of letting Russell know about the abuse. Cora wanted to exert control over Tom, who hated being told what to do. He wrote, "Because of my tough upbringing I also didn't like taking orders. I was opposed to all kinds of authority. I would buck it simply to buck it, especially if it came from anyone with an attitude that in any way resembled that of the nuns in the orphanage."

In the small communities of Canada's East Coast, "Who's your father?" is as common a question as "Where are you from?" Establishing a family connection is a quick way of placing a person within the social structure. Tom was still going by Tommy Messer while living with the Aylwards, but having a different last name made him stand out. One day he wrote the name "Tom Aylward" on a school textbook. When Cora saw it, she told him in no uncertain terms that he was to never do that again. She made a point of telling him that not only was he not an Aylward, but that he would never become one and he would not inherit the family farm. The thought of owning the farm had never entered Tom's mind, but a last name the same as the people he lived with would have given Tom a sense of belonging. He wrote, "All I ever dreamed of was to feel that I was wanted and to feel that I was part of something." The Aylwards were prepared to provide the basic necessities of life, but not the one thing he wanted most of all: love.

Unfortunately, Tom never felt that sense of belonging. He came to accept that he was a "bastard," with all the negative connotations that

word evoked. He would use the word to define himself for the rest of his life. When speaking with interviewer Alden Nowlan, he started the conversation about his childhood with, "I was a bastard child."[2]

Despite the physical and emotional abuse Tom suffered at the hands of Cora, Russell offered some respite. In Russell Tom found another kindly older man who took an interest in him and served as a father figure. Tom often complained to Russell about the way Cora treated him. Although Russell seemed to understand Tom's feelings and offered a sympathetic ear, he was powerless over Cora.

Tom worked hand in hand with Russell on the farm from the time he arrived in Skinners Pond. Although he was just nine years old when he moved in with the Aylwards, he worked extra hard to prove he was worthwhile. As Robert Everett-Green wrote, "No one at Skinners Pond expected anything good to come of the orphan from the mainland, and he responded by going at everything as hard as he could, trying to do it better than anyone."[3]

Tom wrote in *Before the Fame*, "Every time someone hinted that I was in any way inferior to the other kids, which was most of the time, I'd silently take an 'I'll show you' attitude and go out of my way to bust my ass to gain a more favourable status in that person's opinion. Ninety per cent of the time it didn't seem to work, and with Cora it was 100 per cent of the time. No matter what I did there was never even the slightest hint of praise from anyone."

Nonetheless, the orphanage had taught Tom that in order to survive you had to have "no fear, you had to prove yourself." He lived by this philosophy, whether it was working the farm or playing with other children. But it wasn't just about proving himself. Tom loved being the main attraction and was a bit of a show off. He saw himself as a modern-day Huckleberry Finn, walking around in the warmer months in just overalls, with no shirt or shoes. Where the other kids showed hesitation, Tom would swim across a river or walk across the roof of the barn. His hardscrabble life had made him fearless.

If he wasn't getting attention for his acts of daring, he would hold the other kids enthralled with his tall tales, and he readily admitted that he was prone to hyperbole. He wrote of that time, "I would tell the kids all kinds of stories, similar to the tales I told to get extra food at the orphanage. By the time I was telling them in Skinners Pond they were becoming more elaborate. I also knew I had a more gullible audience so the embellishments got a little bigger and bigger all the time." One has to wonder how many of Tom's autobiographical stories incorporated these "embellishments" without him even being aware of it.

It is surprising to watch or read Tom's few interviews about his childhood prior to the publication of his autobiography. Until then references to his childhood in Prince Edward Island made it seem idyllic. As he explained in the short documentary *This is Stomping* (sic) *Tom*, "the memories I have of my childhood on Prince Edward Island are... they're really something. It was a real simple, quiet type of life and everybody was genuine and honest and... good. Everything was nice."[4]

Oddly, in this same interview he says, "I got adopted out of the orphanage. I was around six or seven years old." Since he was actually nine when the Aylwards adopted him, and it must have been a significant event in his life, one has to wonder if he honestly didn't remember or if he was protecting his privacy by being vague.

To be fair, Tom's life with the Aylwards wasn't all misery. He did come to appreciate the simpler ways of life that his new home offered. Until he arrived on Prince Edward Island, Tom's experience had been that if you didn't have money you went hungry or had to steal or beg for food. In Skinners Pond in 1945, most people grew or raised the food they needed and what they didn't have was provided by a neighbour. The barter system was still in effect, so a fisherman might offer some fish to a farmer in exchange for some chicken or wood.

Everyone in the community would help one another, depending on who needed what done at what time of year. They were a

resourceful lot; they would make their own clothes and get the things they couldn't provide for themselves from the Simpson's or Eaton's catalogue only when they had a bit of extra money.

Every fall, after harvest, the Aylwards would order a battery for their radio, which would have to last them through the winter. They would tune in to country music programs and Tom would dream of one day having a career like those he heard over the airwaves. As Tom told CBC radio, "On the farm there was nothing much to think about except the simple life . . . the radio was a big source of entertainment for us. We used to listen to Hank Snow and Wilf Carter . . . and I always wanted to grow up and do what they did."[5]

Tom was no doubt also inspired by the live music he experienced in Skinners Pond. The community was populated by families of French and Irish heritage so there were lots of kitchen parties where people played the fiddle, sang and step danced. Russell's father, Bill, had been a bit of a musical legend in the area at one time, although by the time Tom knew him he had mostly given up playing music. Russell's brother, Charlie, was also well known on the island for his fiddle playing.

Tom asked Cora if he might learn to play an instrument and she laughed at him. She found the idea so preposterous that she would mock him and chuckle while telling visitors that Tom had musical ambitions. Not only was he discouraged from playing an instrument, but Cora wouldn't even let him sing in the house. He didn't fare much better at school. He wanted to sing in the Christmas concert, but the other children refused to perform if Tom sang. As he told an interviewer, "When I went to school in Skinners Pond they told me I couldn't sing and I had a tin ear. And every time that the kids were supposed to sing they didn't want me singing with them because I couldn't sing."[6]

This didn't silence Tom though. He would still sing and yodel while doing chores or anytime he had some distance between himself and Cora. In that same interview he said, "the cows sure liked it because I used to yodel going up through the fields, for the cows."

Tom had a great memory for lyrics and claimed that by the age of ten he could sing every word to hundreds of songs.

Tom wrote his first song at the age of eleven. "Reversing Falls Darling" told the story of a girl who was waiting for him in "Saint John, New Brunswick, a city by the sea." As he told Alden Nowlan, he began by writing poems. "I wanted to be a poet. I can still remember every word of every poem we learned in grade school. But after a little while I decided they'd sound prettier if I put a tune to them, so I started doing that too."[7]

Tom had been listening to traditional country and western music for his entire life and he knew the form well. In "Reversing Falls Darling," one can hear the Hank Williams influence in lines like "Listen here you old moon, I'm tellin' to you, I'm gettin' sad, so lonesome and blue." It also owed a debt to one of his mother's favourites, Wilf Carter. Tom acknowledged this in an interview saying, "[Carter] was the last of the Canadian cowboy western artists who actually wrote quite a few songs about Canada . . . I kind of took my idea from that."[8] Interestingly enough, Carter had left the Maritimes for Calgary, Alberta, and in Tom's song he imagines his narrator not in Prince Edward Island, but in that same province as he sings, "Goodbye Alberta, I'm going to roam, back to my darlin', back to my home."

Carter was Canada's first major country music star and he spent time travelling Canada and writing songs about the country of his birth, including "Maple Leaf Waltz," "My French Canadian Girl" and "Calgary Round-Up." Although Tom had heard plenty of songs about the United States from the American country stars who populated that era's most popular radio programs, he was drawn to Carter in part because he sang of the country Tom knew. In Tom's very first song, Canada's geography already had a prominent role as he placed the girl of his dreams in his hometown of Saint John, near the city's Reversing Falls.

Although it was the late 1940s, many of Tom's favourite songs and artists dated back to the 1920s and 1930s. He loved

old-time country music and would stay committed to that style for the rest of his life. In fact, Tom seemed to admire everything that might be considered "old-fashioned." He became so enamoured of the old ways that he experienced on Prince Edward Island that he actually said in the documentary *This is Stomping Tom*, "Sometimes I wonder whether or not electricity was a good thing."

In his autobiography, Tom wrote of the old days: "This was the era I often wished I had lived in, the time of home-grown, home-made entertainment, back when there was no TV, little radio, no videos and the only records owned by anyone had to be cranked up on a wind-up gramophone."

But it wasn't just the good old days that he appreciated. Tom felt that the older people he knew had a spark that the younger generation did not. He continued, "I found that most of the old folks all seemed to have the great fun-loving spirit that I would like to have seen among some more of the younger generation." He wrote about his peers that "they seemed to have lost their creative abilities, or at least their desire to be creative." He felt they should spend more time singing rather than making fun of others who sang. He thought they should learn to be the source of their own entertainment.

Despite appreciating the way of life on Prince Edward Island, Tom still missed his mother and thought of her every day. Sometimes he would go into the woods and cry for the mother he had lost. He started running away from Skinners Pond almost as soon as he arrived. While he left in the hopes of being reunited with his mother, he also wanted to escape Cora's abuse.

It became a pattern where Tom would run away and eventually be found by the Mounties, who would take him back home where he promptly got a "kick in the arse." While it was no doubt unpleasant, it didn't compare to the whippings he'd received from the nuns at the orphanage for the same transgression. He admitted in his autobiography that there was a part of him that

ran away in the hopes that he would be missed and that things might be different upon his return.

Unfortunately, this never came to pass.

On one occasion Tom and his cousin, Danny Aylward, lasted on the road for two days, eating nothing but blueberries, before they were caught by the Mounties and sent home. Another time he managed to stay away for six days. He built a lean-to for himself near the river and lived off smelts that he would catch and cook over a little fire he made. He finally grew tired of this meagre existence and made his way back home.

As Tom got older, he became more serious about getting free of the island. He told television host, Elwood Glover, "Back home on the potato farm if you don't wanna pick potatoes, and if you don't wanna fish or you don't wanna do anything like that well you're no good, see? But all I wanted to do was bang on a guitar and sing. So I had to leave home to get anywhere."[9]

Tom was thirteen years old when he went to live on a nearby farm for a few weeks to help with the harvest. After gathering his pay, he decided it was time to make a break for good. Tom met another farmhand named Bud Fitzgerald, who was a couple of years older, and the two decided to buy train tickets as far as Cape Tormentine, New Brunswick, so they could get on the ferry undetected by the Mounties.

The police had always caught Tom on foot in the past and he knew that they wouldn't expect him to be on a train. As the train drove on to the boat Tom spotted the police, who he was sure were looking for him. He stayed out of view and before he knew it the boat was taking him towards New Brunswick. Once in his home province, he planned to hitchhike to Saint John, find his mother and start his life over. Tom Connors was barely a teenager but his childhood had come to an end and he was ready to make a new life for himself.

## Chapter Three
# The Drifter

Rode the rails and thumbed the cars
Learned to play this old guitar
Hangin' round those Country Bars
Many Years Ago

— "Ode for the Road"

After three or four days of hitchhiking, sleeping outdoors and not eating, Tom and Bud finally arrived in Saint John. But once there they had no place to go. Tom wanted to find his mother, but had no idea where to even start looking and had no other family or friends he could turn to. On their first night in the city they slept in a graveyard.

Bud quickly decided he'd had enough and returned to Prince Edward Island. Tom felt he didn't have a home to return to and stayed alone in Saint John. Since he was still a minor, he knew that he had to be careful where he went for help. If he was discovered by the authorities he would be sent back to Skinners Pond or even worse, the orphanage. But he needed food and a place to sleep. His only option was to get a job.

Luckily Tom was tall and looked old for his age. He went to the dockyards, said that he was sixteen and was immediately hired to load skids. Before he started his second day of work he managed to get paid in cash for his first. After five days without food he was

finally going to get something to eat. That night he slept in an alleyway on cardboard boxes crafted into a makeshift bed.

Early on his third day of work he saw a suspicious-looking car, which he correctly guessed to be representatives of the children's aid society looking for him. Someone had reported him. Although he was still legally a child, Tom felt it was unfair that he should be controlled by the government. He thought, "I am not going to stand here and be taken prisoner again by these people — just because I don't have a mother. What kind of crime is that? It's not my fault. Why don't they leave me alone?" He tried to run, but was apprehended and taken into custody by the authorities.

Tom eventually told them his real name and story. After children's aid contacted the Aylwards, Tom was given a choice. He could return to Skinners Pond or they would put him up in a boarding house in Saint John, as long as he agreed to go to school until he was sixteen. They would provide him with clothes and books and even find him a part-time job, with some of his earnings going towards his expenses. Tom chose to stay in Saint John.

While the other residents at the boarding house were mostly older male labourers, there were a few boys there the same age as Tom. In fact, he knew a couple of the boys from the orphanage. While Tom was now free of Cora, and no longer had to work the farm, he still had to do chores at the boarding house and work a part-time job as an usher at the Capitol Theatre. He was also committed to at least three more years of school, and started attending Saint John Vocational School, later called Harbour View High.

Tom shared a room at the boarding house with one of the boys from the orphanage and a man named Gerry Cormier. Cormier often played an old beat up guitar. Tom's dream of learning to play an instrument finally came to fruition when Gerry taught him a few chords. Cormier eventually agreed to sell the guitar to Tom for two dollars, but Tom soon realized that the neck was so bowed and the frets so worn that he couldn't keep it in tune or get a good sound out of it.

Tom would often go out of his way to walk by Ben Goldstein's Music Centre in downtown Saint John and admire a guitar in the window that had a nineteen dollar price tag on it. The minimum wage was just fifty to seventy-five cents an hour. Tom was only working part time and some of his earnings had to go to the boarding house, but he arranged to put the guitar on layaway and did odd jobs, saving every penny he could until it was paid for. Tom bought a book and taught himself a number of chords. He practised day and night, even sleeping with the instrument. He not only played and sang the popular country and western tunes of the day, but he was writing his own songs as well. Not everyone was appreciative as Tom struggled to master the guitar — particularly the men who worked night shift and wanted to sleep during the day.

He told CBC radio: "I used to have a big bar inside my door at the boarding house because of all these fellas coming in and going to work, you know, they'd hammer on that door and they'd say, 'If we ever get a hold of you, we're gonna bash that thing right over your head.' I used to sit in there just shivering and shaking, hoping that bar'd hold."[1] While the men at the boarding house may not have appreciated Tom's musical efforts, he was about to meet someone who did.

Tom liked to hang out at an all-night greasy spoon called The Silver Rail. One night a teenager named Steve Foote approached the jukebox and Tom yelled out, "Play a good one, huh." As musicologist Steve Fruitman wrote of the meeting on his website, *Back to the Sugar Camp*, Foote "turned around and found himself staring at a long, tall, stringbean with an ear to ear grin." He asked, "And what's a good one?" to which Tom, the tall stringbean, replied, "Anything by Hank Snow."

They were just fourteen years old and although they were very different physically — Foote was as stocky as Tom was lean — they quickly realized they had a lot in common. They shared a love of country music and neither was interested in being a labourer. Both had dreams of seeing the world beyond Saint John. The two boys

sat in the diner, smoking cigarettes, drinking coffee and talking about music, surrounded by "sailors, longshoremen, loose women and winos," as Tom would say in his memoir, feeling much more worldly than they were. Tom wrote, "I don't know if it was because of some of the parallels I saw between us or just my need to at last confide in someone, but that night I decided to tell Steve everything about my life. I guess I felt I had finally found someone I could trust." Until he met Steve, Tom hadn't told anyone about his search for his mother. As he wrote in *Before the Fame*, "I didn't want to involve anyone in my story. It was too personal . . . And besides, though I didn't like to think of it very often, I had considered the possibility that Isabel might be dead."

With no picture to remind him of her, all Tom could remember was that Isabel had black hair and was missing a thumb. Tom would often spot a woman with black hair and abandon his friends to follow her up and down the streets of Saint John, hoping to get a view of her right thumb. As Tom started to doubt that he would ever find his mother, he decided to return to Skinners Pond and see if perhaps things might be different. He missed Russell and figured he could at least help out around the farm for the summer. Unfortunately, although Russell and a number of people in Skinners Pond were happy to see him, nothing had changed with Cora. She continued to be cold towards him and rebuffed any effort he made at engaging her.

By this time Tom had learned a few more chords on the guitar and had even written a song about the men who helped build the Skinners Pond Harbour. He made some money playing wedding receptions and was asked to fill in for the guitar player at a dance held at the one-room schoolhouse. He was to play his guitar, accompanied by fiddle. The fiddler, Andrew Jones, advised him, "When you're playing without electricity you'll have to bang your feet in order to be heard." And so the stompin' began.

Tom got himself into a bit of trouble when he attended a dance at the nearby Tignish Legion. A band from New Brunswick was

playing, but some of the crowd knew of Tom's musical abilities and encouraged him to get up and sing a song. After performing one song the crowd wanted more. Tom was prepared to offer another when the leader of the band told him to get off the stage. Tom tried to leave but the crowd kept shouting and applauding, demanding another. When Tom headed back to the stage the band leader gave him a shove, which Tom promptly responded to with a punch to the face. Before long the entire legion exploded into flying fists and furniture. When word got back to Cora she used it to belittle and berate him once again. He decided to leave Skinners Pond for good.

Russell was reluctant to see him leave. He offered to give Tom a drive out to the main highway so he could begin to hitchhike back to Saint John. In the truck on the way there, Tom sensed the older man's disappointment. Tom wrote that Russell said, "It's too bad. You could have stayed around, just when I needed you the most." Tom explained that he would have loved to stay and help, but no matter how he tried he couldn't get along with Cora. They both had tears in their eyes as Tom said, "I would like to be a son to you."

More than ever, Tom wanted to find his mother. Shortly after arriving back in Saint John, he was hanging out with some friends when a woman walked by with two little girls. Tom noticed her right away because she had black hair. When one of the girls dropped her ice cream the woman bent down to pick it up. Her outstretched right hand was missing half its thumb. Tom approached her and asked if she was Isabel Connors. In her typical tough-talking style she responded, "Yeah, what's it to you?" As he explained to CBC's Pierre Pascau, "So I said, 'Well, I think you're my mother,' and I opened my shirt collar up," showing her the birthmark on his neck.[2] They were both in shock. She knew Tom as an eight-year-old boy and here, looming over her, was a tall fourteen-year-old.

Isabel took him around to a few old haunts, visiting people he had known as a child. Later that same day, she told him she had to

leave for Montreal. Tom wrote, "Whether it was the truth or not, I don't know. It seemed like she didn't want me to know exactly what she was doing." Nonetheless, she gave him the phone number of a woman in that city who would know how to contact her if he went looking for her again. She told him that he was better off with children's aid, advised him to be a "good little boy" and said she had to catch a train. She was gone from his life again. Tom told Robert Everett-Green, "It was awful hard. She couldn't treat me as a son, and I couldn't treat her as a mother, because you've lost all that touch and contact and warmth that the average person would have with their mother. She was like just another person. There was something lost and you never knew what it was."[3]

Initially his mother had been taken from him by the authorities. This time she chose to leave him. He wrote in his autobiography, "I realized my hope of ever finding the mother I once knew was gone and without it I felt more alone than I ever had before."

He had severed ties with Skinners Pond and now his days of looking for the black-haired woman with the missing thumb were over as well. If he was to have any hope of finding a parental figure, maybe it was with the father he had never known. Tom knew his father had been a longshoreman, so he started asking around the docks if anyone knew the whereabouts of a Thomas Sullivan. He finally found someone who said that he thought the man Tom was looking for was a tailor and now went by the nickname Sally Sullivan. Tom tracked him down.

Sullivan was separated from his wife and living with a woman named Lil. He had two sons from his marriage. Oddly enough, one of them was called Tommy, while the other was Bobby. Sullivan clearly gave Tom no consideration when he decided to give his next son the same name. While initially excited to be reunited with his son and to catch up on all that had happened in his life, the relationship quickly fizzled. Sullivan's oldest son seemed jealous of Tom, so Tom eventually stopped visiting. Tom was fourteen years old and knew that he alone would be responsible for whatever kind

of life he might have from now on. There would be no parental figure to offer advice, guidance or love. But this also meant he had nothing to tie him down.

Just after his fifteenth birthday, Tom met a nineteen-year-old merchant seaman named Raymond Fleek who was desperate to buy a bottle of whiskey. Fleek sold Tom all the personal papers in his wallet for five dollars. Tom told no one at the boarding house of his plans, but the next morning he reported for duty on an Irving coal boat as Raymond Fleek. He had a grade nine education and would not be returning to school. According to a story in *Today's Senior*, the Irvings soon discovered they were paying two Raymond Fleeks. Nonetheless, the company decided to keep Tom on and he was eventually joined by Gerry Marks, his old friend from the orphanage. For much of the next year, Tom worked on various coal boats, including two operated by the Irvings — the Irvingwood and the Irvingdale. During his relatively short time working on the water Tom learned a lifelong respect for the sea and the people who make their living on it. He wrote in his autobiography, "You can't imagine how cruel it can be until you experience one of those North Atlantic storms . . . The people of the sea, both men and women, are among the bravest in the world."

Tom eventually committed himself to staying on land and exploring Canada. In the spring of 1952 many young men from the Maritimes were heading out west to seek their fortune. Tom asked Steve Foote if he'd like to hitchhike across the country with him. Steve wasn't interested, but Gerry Marks was. He had heard about the burgeoning oil fields of Alberta and thought maybe he and Tom could find good jobs out there. Tom had no interest in a traditional job. He would have been quite happy to be paid to sing and play his guitar, but otherwise he felt he'd already worked hard enough. At just sixteen, he'd worked at the orphanage and as a farmhand, he'd worked on the docks, as a movie theatre usher and on the coal boats.

Tom wanted to live the life of a hobo — a life that had been

glamourized in country music, since the Great Depression. Tom would not only bum rides, but also spend time hopping on and off freight trains. His mother had taught him to hitchhike, but he no doubt learned about "riding the rails" from country music. Hank Snow was well known for his covers of "Waiting for a Train" and "The Last Ride," both songs about hobos hopping on freight trains. Wilf Carter wrote "The Hobo's Song to the Mounties," which includes the lyrics, "We're just a jolly bunch of hobos. No money, not a job can we find. So, Mr. Redcoat, don't let us keep you waiting. We're just a-going little farther down the line."

Tom left Saint John with nothing but his guitar, some socks and a razor. As he and Gerry crossed the country, they knocked on doors looking for hospitality. Sometimes they'd get a cup of tea or just a chance to warm up. Some people would offer them a meal, while others would put them up for a night or two. Quite often, if they stayed the night, Tom would play guitar and entertain his hosts. On occasion friends and neighbours would be invited in for an all-night party. Tom and Gerry only made it as far as Ontario before they started bickering and agreed to split up. Gerry got a job on the border of Alberta and Saskatchewan while Tom continued to head west.

When Tom first saw the Rocky Mountains, he had an almost religious experience that would change his life. As he explained in an open interview, which was included with his CD release *Believe in Your Country*, when he first saw the mountains he thought, "I'm from Skinners Pond, PEI — just this small island in the Atlantic — and the magnificence, the grandeur, the bigness . . . it made me feel so small in comparison to my country." He continued to explain the profound impact the moment had on him: "even though I didn't have a penny in my pocket and I didn't own anything, it told me you know, 'I am yours. You haven't seen me before but I am here, [with] these open arms. Come and see me. You're a young fella, come and travel me and taste my waters,' and all this kinda stuff."

As his country spoke to him Tom replied, "By god, I'm gonna

see ya . . . I'm coming." It was such an emotional moment for him that he shed a tear as he stood there on the side of the road. Tom later wrote "Rocky Mountain Love," ostensibly a love song, but he may well have been talking to the mountains themselves when he sang, "From the Prairies to the mountains, you have lured me like a lamb, till my lonely heart is crying and I don't know where I am."

The idea that Canada spoke to him would last a lifetime. He told Steve Fruitman, "Canada has a voice of its own and it speaks to me and I hear it. Much like maybe some native in the woods or something, he hears the forest. And maybe other people don't, but I hear Canada. And all I'm doing when I write a song is saying what Canada is saying to me."[4]

Tom dreamed of being a country singer and he continued to pursue that dream as he crisscrossed the country. In the early 1950s, most radio stations had a studio on site for live performances. When Tom got to a town with a radio station he'd drop by and ask if he might sing. He would perform songs he had written, but more often than not he'd be told he should try to sound more "Nashville."

After going as far as Edmonton, Tom decided to head back to the East Coast, arriving in Saint John in June of 1952. Once there he met two young men, Art Coles and Sonny Taylor, who were on their way to Port Burwell, Ontario, to work on Sonny's sister's tobacco farm. Tom decided to join them. It turned out Sonny's sister could only hire two of them, so Tom went on to another tobacco farm in a place called Colten Corners, near Tillsonburg. It was hard work that would inspire one of Tom's most famous songs, simply called "Tillsonburg." The song includes the lyrics, "With a broken back from bendin' over there, I was wet right through to the underwear. And it was stuck to my skin like glue, from the nicotine tar in the morning dew." Tom's penchant for simple, catchy lyrics and strong imagery was already apparent. One season harvesting tobacco quickly convinced him this was not a job he'd want to return to. The song continues, "I might get 'taken' in a

lot o' deals, but I won't go workin' the tobacco fields of Tillsonburg, Tillsonburg. My back still aches when I hear that word."

Tom finished the season with enough money to purchase an old truck, get his driver's licence and head for Saint John with about eighty dollars to spare. He was so excited to show his new vehicle to his friends back home that he decided to drive through the night, making the trip in less than a day. Unfortunately, he fell asleep at the wheel and went off the road, destroying his new truck and his guitar. As Tom wrote in his autobiography, "I didn't normally want to work, but buying a guitar was an emergency." Once back in Saint John, he got a job in a machine shop and saved every cent he could until he was able to purchase a new guitar from a pawn shop for forty dollars. With his instrument in hand, Tom was ready to leave his regular job behind and hit the road again.

In *Before the Fame* Tom wrote that Steve and a couple of his friends were on their way to Montreal because "they had come into some quick money as a result of breaking into a store or something." Tom was very vague about who actually committed the crime, writing, "I don't know which one of them pulled the job, whether they all did, or some of them." He says that they were basically going to "hide out" in Montreal. Tom went along with them, but wrote that they all had a falling out once in the city and within a week he and Steve were off on their own, ready to hitchhike across the country.

Steve Fruitman, who became friends with both Steve and Tom later in life, tells a different version of this story. He said in an interview for this book that "Steve was into a life of petty crime . . . He got asked to join a group of kids that were going to go to Montreal and rob a bank. And Tom talked him out of it." He added, "Steve's told me this story too. He said, 'Oh, yeah, Connors saved my bacon that time.'" Fruitman said that Tom told the slightly altered version of the story in his autobiography because "he didn't want to paint Steve in a bad light." He added that Tom "was as honest as they come."

Supporting Fruitman's version of the Montreal story, Tom wrote, "I'll never forget the time Steve Foote said to me, 'You know, Tom, you made a man out of me. Had I stayed in the direction I was going, I would have been in jail for the rest of my life.'" This greatly affected Tom, who often doubted his own value. He wrote in his memoir, "Well, when somebody says that to you in later life, it somehow really makes it all worthwhile. It tells you that even a bum can be worth something."

Once Tom got Steve away from his criminally minded friends, he talked him into hitting the road. Steve had never hitchhiked before and it took some convincing on Tom's part. Foote said Tom made it sound like the paradise described in "Big Rock Candy Mountain," whose lyrics include, "In the Big Rock Candy Mountains, there's a land that's fair and bright, where the handouts grow on bushes and you sleep out every night." As they began their journey, Tom shared some "rules of the road" with Steve. One of the first things he explained was that they would be spending a few nights in jail.

Tom had learned that he could stay in a jail cell free of charge if he got to the police before they got to him. The trick was to find a policeman and ask for help before the officer could book him on a vagrancy charge. If Tom asked for help, the officer was obliged to provide shelter for the night. Tom figured this was to prevent destitute, homeless people from robbery or some other crime of desperation, leaving the officer partially responsible.

Steve and Tom decided to head towards Tillsonburg on the first leg of their cross-country tour. Steve figured they'd get jobs working in the tobacco fields, but Tom had no interest in returning to the tobacco fields or getting a real job of any kind. They eventually ran into one of the guys Tom had met in Port Burwell the year before. It would be a while before the tobacco harvest was to begin, but Tom's friend told them of a farmer in nearby Eden, Ontario, who was looking for some men to do a bit of work around the farm. At Steve's urging, Tom reluctantly agreed to take the job.

They spent a couple of days trying to remove old tree stumps from the farmland. When the farmer complained that they weren't working fast enough, Tom got upset and replied, "If you want more work to be done, as far as we're concerned you can do it yourself." Tom's dislike of being told what to do had gotten the best of him and they were fired on the spot. Steve, who wanted to work, was upset with Tom for causing them to lose their jobs. They decided to go their separate ways. Tom ended up bumming around for a bit, but they eventually reunited when he found Steve working at a gas station that had a restaurant. Tom played music at the restaurant for a few meals and then the two of them took off together again with the goal of making it to the West Coast. They may have had their share of arguments along the way, but as Steve wrote in the book, *Stompin' Tom, Story and Song*, "good times or bad; cold or comfortable; bone-tired or rested; two buddies, closer than brothers . . . made it through, side by side!"[5]

In Regina the two young men got a job on a construction site, but on their first day Tom punched a foreman who condescendingly gave him conflicting directions about what he was supposed to be doing. Tom and Steve both walked off the job, unfortunately, covered head to toe in mud. They took their day's pay and went to an army surplus store to get new clothes. They bought black cowboy hats and new cowboy boots. The boots and hat would remain part of Tom's image until the end of his life.

The two friends hit the road again, but eventually split up after a fight over Steve's mustache. Tom felt it made people less likely to offer them drives and pestered Steve about it until Steve had had enough and took off on his own. Tom made it to Vancouver where he begged on the streets for spare change so he could afford a bed and a meal at the Salvation Army. At this particular hostel, there were a number of men who had been checker and chess champions earlier in their lives. Tom would play both games with the old men for hours on end, learning from these masters. He spent his evenings going around to bars and restaurants where he

would make a bit of money performing.

He finally left Vancouver and headed east again. After getting a lift into Calgary, one of the men in the vehicle gave him a shopping bag that contained a couple of western shirts and a few odds and ends. The western shirt would become a staple of Tom's wardrobe. His look was complete.

Tom wasn't particular about where he slept. According to his autobiography, during those years of hitchhiking he slept in "cabins, boxcars, used cars, empty buses, jails, train stations and beside the road." For food he'd buy a loaf of bread, some mustard and bologna, and he'd eat sandwiches for a couple of days. As he told *Canadian Composer* magazine, "I just thumbed and bummed my way through Canada... I didn't care where I was going, you know — if there was no traffic coming down one side of the road, I'd just cross over and hitch a ride going the other way."[6]

Tom eventually found himself back in Ontario, where he got a drive with a man who was heading to Kirkland Lake. As Tom sang and played in the back seat, the driver told him he should go to Rouyn, Quebec. He said there were lots of bars there and Tom would have no trouble getting a paying gig. Tom headed for Rouyn on the Ontario/Quebec border. The first hotel Tom came to was called the Royal. Tom went to the bar and asked if they might be interested in hiring a musician. The owner, Mr. Perron, asked Tom to perform a few songs as an audition. There were less than fifty patrons in the two-hundred-seat room and they were primarily French speaking, but they responded well to Tom's music and he received hearty applause. He was hired immediately.

Tom would perform Monday through Saturday and receive five dollars a night as well as a room and tips, which might be another five to ten dollars a night. He had his first regular gig and a place to sleep. On his first night, Tom sang a Hank Snow song followed by one from Hank Williams. Both were warmly received, but it was once he sang Wilf Carter's "Take Me Back to Old Alberta," complete with a yodelling interlude, that the crowd really responded.

They started applauding partway through the song and were on their feet by the end of his set. Everyone wanted to meet this energetic young performer, and there was a beer waiting for him at every table. Between sets, Tom went out to talk to the audience. He was making fans one table at a time. Tom sang a number of yodelling songs and repeated "Take Me Back to Old Alberta" about ten times that first night. By the weekend the lounge was full, with everyone coming to hear "Le Cowboy de l'Alberta." Tom stayed at the hotel for a couple of months, but the gig eventually came to an end and Tom set out looking for another.

On his own, Tom was known as a "single." Very few bars wanted to hire singles, as most were interested in duos or full bands. He hooked up with another musician, Gene Groulx, to form a duo and spent the next few months touring small-town Quebec. Eventually, Gene decided to quit the music business, leaving Tom alone in a province where he didn't speak the language. It was late winter in 1954. Tom was eighteen, and he decided to head for Toronto and contemplated the idea of getting a real job. However, as he wrote in his autobiography, "when I thought of working at jobs other than music, I came to the conclusion that maybe jail was better."

Once in Toronto, Tom discovered that the city had no shortage of country musicians, but there were very few places for them to perform. For a short while Tom toyed with the idea of calling himself Hank Spur, no doubt inspired by Hank Snow, Hank Williams and his newly acquired western look, but ultimately decided against it. He managed to book a few jamborees and played at a country bar called the Famous Door for a couple of weekends. After having had some regular gigs in Quebec, Tom was back to being broke with no place to stay and little money for food. He decided to head for the East Coast. Along the way he got invited to house parties where his hosts would often take up a collection for him. One particularly successful night he made $51 and hit the road the next day feeling rich.

Tom eventually arrived in Saint John and searched for Steve Foote in the hopes that they could once again try to hitchhike to the West Coast, as Steve hadn't made it all the way to Vancouver the last time. He discovered that Steve was in Montreal and decided to go look for him. Tom found Steve, but they eventually went their separate ways without ever heading out west. Tom instead decided to track down his mother, whom he hadn't seen since their brief reunion in Saint John almost five years before. Tom eventually found her, and this time they took the opportunity to reconnect. The first night he was with her they drank beer and talked until four in the morning. This continued all weekend as he found out what had happened to his mother since he was taken from her at eight years old. After escaping from jail and visiting Tom at the orphanage, she'd left for Montreal as a way to avoid the authorities. She eventually made her way back to Saint John and had two little girls, whom Tom had met very briefly when he was fourteen. Isabel had been arrested again and had those two children taken from her as well. Upon her release she'd made her way to Montreal and vowed not to return to the East Coast. Tom doesn't mention whatever became of Nancy or these half-siblings in his autobiographies.

Tom ended up staying with his mother for the next few months. He wrote songs and got a few gigs performing at various restaurants and bars. He also got a regular gig playing on CHCH radio as part of their weekly jamboree. Tom even got to sing with his mother at a few house parties. He wrote in his autobiography, "my mother knew lots of old cowboy songs and everybody always got her singing them. Just give her a couple of beers and she sure could liven the place up." Although Tom and his mother had grown apart over the years, they still had some things in common. Tom got to spend his nineteenth birthday with her — his first with her since he was eight years old. She gave him a watch that he continued to wear long after it stopped working.

Although Tom enjoyed this reunion, he had to finally admit that he and his mother would never have the traditional relationship

that he longed for. He wrote in *Before the Fame* that "the ties that normally bind a mother and son, which had been forcibly severed so long ago, must now, sadly, remain forever broken. The long years of separation and grief had taught us both to live and think independently. And now we were two different people from two different worlds."

Tom got restless in Montreal and by April of 1955 he found himself back in Saint John. He had managed to save a little money from his gigs in Montreal and rented a cheap room. He was asked to play at a party in the rooming house, but when a drunk man staggered into his guitar and knocked it to the ground Tom ended up in a fistfight. More importantly, his guitar now had a hole in it, which affected the sound. Once again, Tom needed a new guitar, so he was willing to settle down and take a traditional job.

Tom got work on a tugboat that was dredging Saint John Harbour. He also managed to get Steve Foote hired. After about three weeks, Tom finally had enough money to purchase a new guitar. This one cost him close to sixty dollars. He took it aboard the tug and entertained everyone whenever he wasn't working. Before long he was being called Tugboat Tommy, and briefly considered adopting the name professionally. After a few weeks, the two friends quit and took off hitchhiking around the Maritimes, eventually finding themselves in Cape Tormentine, New Brunswick, where the ferry left for Prince Edward Island. Steve had heard lots about the island from Tom and felt he knew it in part because of Tom's song about PEI, "My Home Cradled Out in the Waves." Steve suggested they take the ferry over and Tom agreed, but only if they didn't go to Skinners Pond.

Steve was immediately taken with the island. Tom wrote in his autobiography, "Steve had to admit he had not yet seen anything in Canada to compare with the exquisite beauty of a landscape with so many quaint settings." After hitchhiking around the island for a few days, Tom started to wonder about the Aylwards and all the

people he knew in Skinners Pond. He wondered if by any chance Cora's heart had softened. He knew that she was always on her best behaviour when other people were around, so he reasoned that maybe if he went there with Steve she would be kinder to him. He wrote years later, "I stood a little distance away from Steve so he couldn't see the tears in my eyes as I tried to deal with the surge of gnawing hunger that only comes from a deep need for a place to call home and a sense of belonging to someone who cares." Tom, at nineteen years old, still wanted the love and safety of a family and a place to call home. He decided to visit Skinners Pond.

Having realized he would never have a traditional relationship with his birth mother, he was willing to give Cora another chance. Russell and his parents were excited to see Tom. The men shook his hand while Russell's mother held him in a big embrace. Tom approached Cora at the far end of the room. She held out her hand. Tom shook it. He and Steve stayed for a few days, helping Russell around the farm, but they soon had more than they could take of Cora. As they left, Tom vowed he would never return. At the very least, he now had someone who had witnessed the way Cora treated him. He and Steve spent hours walking the highways of Canada, discussing what could possibly make Cora behave the way she did.

Steve and Tom had decided to hitchhike down through the United States, but by the time they arrived in Saint John Steve had changed his mind and decided to stay home for a while. So Tom took off on his own, travelling around the eastern United States and Canada before eventually ending up in Toronto. He spent the rest of 1955 and the beginning of 1956 doing odd jobs in the city. He continued to write songs and tried to get them recorded to no avail. He did manage to get one of his songs, "Gone with the Wind (I'll Be)," put on a reel-to-reel tape. It was a simple recording of just Tom and his guitar, but a number of people told him that it sounded like a Hank Snow song and Tom hoped he might be able to get the song to his hero. He also made a few dollars from per-

forming at jamborees, but his musical career was not progressing at all as he had hoped it might.

As the snow melted and the weather became more hospitable, Tom was ready to get back on the road. Just as he was making plans to leave the city, his guitar was stolen. The thief left the case, but Tom's main source of income was gone. He took a full-time job as a short-order cook at a place called Lombardo's Grill. He had been working there for a few weeks when he was shocked to see Steve Foote walk in the door with another old friend of Tom's from Saint John, "Lucky" Jim Frost.

Steve and Jim were headed for Mexico and were as surprised as Tom at this chance reunion. When Tom heard their plans, he decided to go with them. Mostly he wanted to get to Nashville and track down Hank Snow, the Nova Scotia native who had become one of country music's biggest stars. Tom didn't have a guitar but he had saved a hundred dollars, so he decided he'd buy one when he got to the United States as they were cheaper there. He packed his guitar case with his clothes and used it as a suitcase until he could once again fill it with an instrument.

The three men made it to the car bridge at the Canadian/American border in Fort Erie, Ontario, but US Customs would not allow them to enter on foot. They decided to wait until after dark, climb a fence and make their way over a rail bridge that crossed the Niagara River. As Tom told the *Atlantic Advocate*, "I remember we sneaked under the rafters, under the railroad bridge, and were standing over this water with trains going over, waiting for the watchmen to change shift so we can sneak past on the lower rafter."[7] They got to the other side, went through some woods and in the morning walked into Buffalo, New York. They eventually made their way to Nashville, the home of American country music.

In Nashville they ended up in a furniture store that had caught their eye because it had some belt buckles displayed in the front window. Once inside, Tom noticed an old guitar case on a shelf high up in the store. He asked if there was a guitar in it, but was

told there couldn't be. When the sales clerk got it down there was indeed a Gibson Southern Jumbo guitar inside. Before the building was a furniture store it had been a pawn shop and the guitar had apparently been abandoned many years before.

Tom was drawn to the instrument and knew it was very valuable. The three men now had less than ninety dollars left between them, but realized the guitar would be an investment. It was worth well over a hundred dollars, but Tom haggled with the sales clerk until he got the price down to eighty dollars. Tom threw away some of his clothes to make room for his new instrument in his guitar case. He bought some guitar strings and was soon playing "one of the finest flat-top guitars that any of us had ever heard."

The purchase of the guitar had left them with less than ten dollars between the three of them. However, it meant that Tom could try to earn some money. As he wrote in his autobiography, "armed with a new guitar, we now had the potential to pick up another couple of dollars here and there, or at the very least I could sing for our supper once in a while."

Tom also thought he might be able to make money as a songwriter. His years on the road had proven to be great inspiration. He told CBC radio, "I roamed the country and I gained a lot of experience . . . I rode the freight trains from coast to coast about a dozen times. And I hitchhiked all over the place and I met people from small towns, cities. I met white collar people. I met bums. I talked to them all. I just garnered a great deal of experience and it's coming in handy now for writing."[8]

By this point Tom had written hundreds of songs. He just needed someone to record some of them. That's why he wanted to find Hank Snow. Tom had an old songbook that included pictures of Snow's home in nearby Madison, Tennessee, on an estate called the Rainbow Ranch. The three friends went looking for it. Tom was hoping Hank might give him his big break. Just two years earlier, Snow had been instrumental in the career of a young Elvis Presley. In 1954, Hank convinced the *Grand Ole Opry*, where

he was a regular, to feature Elvis. Presley, along with artists like Jerry Lee Lewis, Carl Perkins, Roy Orbison and Johnny Cash were adding rhythm and blues to country music to create a new sound called rockabilly, which would become known as classic rock and roll. This sound was perfected at Sun Records in Memphis, Tennessee, where they all recorded. While the rest of North America was discovering this new style of music, and even Hank Snow saw the shift, Tom, at just twenty years old, was firmly entrenched in the old-style country music of the 1920s, '30s and '40s.

When Tom and his friends got to the Rainbow Ranch it looked as if no one was home, so they sat by the side of the road and waited. When a limo finally pulled into the driveway, Tom saw his hero get out of the car. According to Tom's version of the story in his autobiography, Hank Snow spotted Tom and his friends and, pointing at them, said to one of his musicians, "Get rid of that riff-raff over there." The musician, bass player James "Sleepy" McDaniel, approached the three young men. He was apologetic for his boss's behaviour, saying Hank wasn't in a very good mood. When McDaniel heard that Tom had hitchhiked from Canada in the hopes of having Hank listen to one of his songs, McDaniel offered to take it to his boss. Tom handed over the reel-to-reel tape of his song, "Gone With the Wind (I'll Be)," which he had written when he was just fifteen.

Tom, Steve and Jim went to a restaurant in Nashville to wait for McDaniel. He showed up a short time later, paid for their lunch and offered Tom around $75 to purchase the song. Tom was hoping that Snow would record the song and Tom would collect royalties, which offered the potential for a much greater financial reward. He refused to sell the song. He wrote, "I might be broke now, but I'd rather starve before selling a song outright to Hank Snow or anyone else."

The men found the people of the United States not nearly as kind to drifters as people in Canada had been. It was hard to find someone who would offer them a meal, so they often ended up

stealing raw vegetables from gardens as they made their way across the country. They had no money and no real prospects, but they decided to leave Nashville behind them.

Jim was a pool shark — his "Lucky" nickname referenced his pretending to be lucky when he conned someone in a game of pool. Steve could do magic tricks and earned a bit of change busking on the streets. Tom contributed to the group's financial well being with his guitar. No doubt inspired by Tom, Steve had recently started to write music. So the three men, a singer, a pool shark and a magician, continued their trek towards Mexico, earning what little money they could and relying on the kindness of strangers when it could be found.

Things went relatively well until they found themselves all in love with the same girl in Carthage, Texas. Tensions got so bad that they split up and each went their separate way.

Tom met up with another drifter who sang and played guitar. Together they managed to book a few nights in various bars and seemed to hit it off until they were arrested because Tom's new friend had been caught stealing stereo equipment. Although Tom claimed not to be part of the heist, he had no identification papers and was detained by the authorities. It turned out the police were looking for a draft dodger by the name of Tom Connors and decided to hold Tom until they could confirm that he was indeed Canadian and not the man they were looking for.

He was held in Brownsville, Texas, near the Mexican border in a detention centre that primarily held Mexican citizens trying to enter the United States illegally. The prison guards took Tom's guitar from him, and because of the language difference between him and most of the other detainees he couldn't communicate with anyone. He thought music might be his best chance at getting along with his fellow inmates. He asked repeatedly for his guitar but the guards refused. Tom eventually went on a hunger strike and started acting like he was mentally unstable, walking in circles around the prison yard, staring at the guards and tearing apart

cockroaches only to watch ants eat them alive. The other inmates became scared of him and the guards grew so concerned that they finally gave him his guitar in the hopes that he might act more "normal."

Once Tom had his guitar, the mood at the camp changed dramatically and he was suddenly very popular. He wrote that when he played music, "the Mexicans were delighted. They all began to dance around . . . For the next week or so we were all singing and having parties every night and the camp finally became a very bearable place to live. Even the guards' attitudes changed and they'd let us stay up and party an extra hour each night, just so they too could enjoy the happy times and the music." Music made life bearable, no matter how difficult the circumstances. Even a detention centre could become fun if Tom was able to sing and play his guitar. All he wanted to do with his life was bring joy to others through his music.

After about a month Tom was flown back to Toronto. He spent the next year and a bit in the Toronto area doing a number of odd jobs and trying to find work as a performer. He eventually reconnected with Lucky Jim, whom he hadn't seen since they went their separate ways in Texas almost a year before. The two of them got a room together and made some money, with Jim playing pool and Tom playing his guitar at parties.

The summer of 1958 saw Tom on the road again, hitchhiking and spending time in cottage country in Ontario. He would often get invited to people's homes by the lake where he would play music in the evenings, have a bed to sleep in and the chance to do some fishing and boating during the day. By this point, Tom claimed he had written over five hundred songs. He had also memorized thousands of other people's songs. With his guitar in hand he was well prepared to entertain any party all night long.

Tom's lengthy autobiography is incredibly detailed. He seems to mention almost every ride he got in over a decade of hitchhiking. He names every small town he passed by or stayed in for even a few

hours. He talks about everyone he ever played music with. However, when he gets to 1958 he gets light on the details. In interviews given in later life, he talked about his ten to twelve years of hitchhiking, but he never mentioned the years that he was off the road. In his autobiography he simply wrote, "For the next two and a half years, from the fall of 1958 to the spring of 1961, the life of Tom Connors the drifter had become very tumultuous. For one thing there was a girl who wanted me to settle down. But try as I might, I didn't do a very good job of making myself over."

In the introduction to his autobiography Tom made a point of saying that he would talk about almost everything in his life except his romantic relationships. It seems odd that someone who wrote a two-volume autobiography, going into exhausting detail about the minutiae of his life, would choose to leave out his love life. If one wants to understand more about Tom's ideas on love, however, there are hints in his songs. If his music can be seen through an autobiographical lens, he seems to think of a relationship as something that will tie him down and hold him back from achieving his goals in life. In "Ode for the Road," he sings, "Whenever love came snoopin' around, it wasn't long until I was found, far away in another town." He goes through three women in the first verse of his song, "Movin' On to Rouyn," with the lyrics, "The day I left Kirkland, My girl's head was circlin', I left her with only one shoe on. My baby in Larder, she may take it harder, 'Cause I've got a new one in Rouyn." In that same song he sums up his feelings about love in general with the line, "Now love is a stranger, To some it's a danger, To me, It ain't nothin' to stew on." It's somewhat surprising that someone who so desperately wanted to be loved seems to have run away from romantic love when it was offered.

In his autobiography, Tom wrote that he spent much of this time away from the road asking himself how he could be good to anyone if he wasn't true to himself. As he questioned his purpose in life he kept coming back to music. He felt that "the reason I was given the talent to sing and write songs was because somewhere,

somehow, sometime, it was all going to mean something to someone." He wrote in *Before the Fame*, "I figured the only worth I had was to make others happy, and the only time I seemed to be able to impart happiness to others was when I was singing. Therefore the only time I had worth was when I was singing. Without worth and without singing I might as well be dead. So from now on I was just going to live to sing and sing to live or die as I lived, unwanted."

In the spring of 1961, Tom was done trying to have a "normal life" and he returned to the road, heading for Vancouver. Once there, he managed to get a few months' work at the Flamingo Restaurant and had the opportunity to sing on TV. He performed a song he had written called, "My Little Eskimo," but the television appearance didn't lead to any more offers. Tom decided to head back to the East Coast.

As he hitchhiked back and forth across the country, Tom often found himself spending time in libraries — as much to get in from the cold as it was in search of knowledge, but he had a voracious appetite for learning. His life circumstances may not have afforded him the opportunity of a good education, but he was intelligent. He had a good memory, a curious nature and could be a deep thinker. Long after he left school, Tom continued to educate himself about subjects he was interested in. He was particularly drawn to matters of a spiritual or philosophical bent and was interested in learning about world religions.

When Tom finally made it back to Saint John in October of 1961 he went to see his old friend, Steve Foote. As they talked, Steve suddenly got up and left the room. Tom wasn't sure where Steve had gone, but while he was out of the room Tom retrieved some of the books he had been reading so he could share his newfound interests with his friend. Tom was shocked when Steve walked back into the room with a pile of books that he wanted to share with Tom. It turned out that over the past few months they had both, independently, discovered an interest in the paranormal. Although Tom's image as a down-to-earth everyman who

sang about blue-collar workers belied this interest in the supernatural, he wrote in his autobiography that he and Steve were both interested in "yoga, psychic phenomena, reincarnation, the occult, flying saucers, mysticism, astrology, comparative religion" and more. Not only had they both discovered an interest in these topics, but almost half of the books they owned were the same.

Tom and Steve spent a couple of months talking about their newfound interests and ultimately decided to go in search of a guru in Northern India with the idea that they might become Tibetan monks. With no money to get to India, they decided their best chance might be to catch a "tramp ship" from Halifax Harbour that was heading to the Far East. They were willing to work on the ship to cover the cost of their voyage. When they arrived in Halifax, they discovered that they couldn't make the journey to India without a passport. Since that would take a couple of weeks, and involved more bureaucracy than either felt like dealing with, they decided to abandon their plan of becoming monks and just keep hitchhiking.

They travelled around the Maritimes and even went to Prince Edward Island (without going near Skinners Pond). It was approaching Christmas, and Steve had family in Saint John, so they made their way back there. Tom tried to convince Steve to accompany him on the road after the holidays. Steve told Tom he thought he might like to work on the docks until the weather warmed up and perhaps then he would join his friend. He promised to think about it and give Tom a definitive answer in the new year.

On January 2, 1962, Tom went to see Steve to get a final answer. Steve had decided to stay put. Tom surprised Steve by giving him his guitar. He told Steve that the guitar was now his to do with what he wanted. Steve knew how much Tom loved that guitar and couldn't believe Tom was going to start hitchhiking without an instrument. Tom simply said he wanted to have a long "chat with God" and he wouldn't need the guitar for that. Steve was worried about his friend, but Tom offered no more.

Tom knew that he and his mother would never have the relationship he so longed for. He no longer felt anything drawing him to Skinners Pond. He was even doubting that his friendship with Steve had amounted to anything. The last attachment he had was his guitar and he gave that away. Despite the fact that Tom had decided his only worth was as a singer, he couldn't understand why he couldn't succeed at a career. He wrote in his autobiography, "it didn't seem to matter where I travelled or how willing I was to sing and play for people, I just never met anyone who was in a position to help me achieve my goals, nor did I meet anyone who had the wherewithal and the financial capability to help me, who had ever been in the least bit interested in doing so." He began to seriously question whether God meant for him to be a singer. Perhaps the guitar was standing in the way of him discovering his true purpose.

As he stood atop Fort Howe watching people move about in the city below, he hoped he would see Steve rush into the street looking for him. He was hoping his friend would change his mind and come with him, returning his guitar. Maybe that would be a sign. But it was not meant to be. He headed for the highway. Tom wrote in *Before the Fame* that he spent the next few days hitchhiking west through cold and snow. By the time he arrived in Rivière-du-Loup, Quebec, he had spent days thinking about his purpose in life and whether it mattered at all that he was alive.

He sat on a snowbank on a deserted stretch of highway and lit a cigarette. He asked God for a sign. He was looking for something that would tell him where he was supposed to go or what he was meant to do. When there was no answer, he felt that God, too, had abandoned him. Although he had long felt alone and unwanted, he maintained that God at least loved and wanted him. When he felt that God had also failed him, he dug a hole in the snowbank and crawled inside. He waited for a snowplough to come by and bury him alive, or thought perhaps he would simply lie there till he froze to death.

Chapter Four
# The Troubadour

T-I-M-M-I-N-S,
That's the town I love the best.

— "Carolyne"

After lying in the snowbank for a while, Tom grew impatient and considered simply pulling the snow down on himself and ending his life.

When he left Saint John, he had told Steve that he was planning to have a chat with God. As it turned out, he began a philosophical conversation with himself. He explained in his autobiography that he eventually reasoned that since God had created him he had no right to deem himself worthless. That would be God's decision. If God had let him continue to live, it must be because he felt Tom's life had value, and if God felt this way it didn't matter what Tom himself or other men felt. He crawled out of the snowbank, wiped himself off and started hitchhiking towards Montreal. Tom wrote in *Before the Fame*, "For the next three days, on my way to Montreal, I was resolved to walk the daily path that God set out before me, without feeling ashamed anymore."

This shame that Tom referred to can be explained in psychological terms. Dr. Claudia Black wrote in *Psychology Today* that

"living with repeated abandonment experiences creates toxic shame. Shame arises from the painful message implied in abandonment: 'You are not important. You are not of value.' This is the pain from which people need to heal."[1]

Tom tried to share his new philosophy with others, but quickly discovered that people didn't want to hear about someone else's enlightenment. He said the response he got was basically, "We don't mind listening to your songs, but when it comes to your ideas, you can keep them to yourself." This may explain why most Stompin' Tom fans would be surprised to learn that Tom was well read in world religions and philosophy. He felt that people weren't really interested in these ideas and they certainly didn't fit with the notion of the simple country singer writing songs about working class people.

Tom spent about a month and a half on the streets of Montreal before he started to miss his guitar. He wanted to start writing songs again. He thought that maybe this desire was a sign that God wanted him to get his guitar back and pursue the path of a country singer. He decided that he would go back to Saint John, and if Steve still had the guitar and gave it to him freely that would be the sign he needed that he was meant to pursue a life in music. He was barely in Steve's door when his friend handed him the guitar, without Tom even asking for it. Steve explained that he had had a dream about a week before — right around the time Tom decided to go back for the guitar — that Tom was coming to get it.

Tom explained to Valerie Pringle how he committed to pursuing a career as a country singer, saying, "If you have it in your heart to do something, you decide, 'Well, I better do that. I can't do anything else.' I didn't have the education to, you know, get a better job, type of thing."[2]

In the late spring of 1962 Tom decided that he would have the best chance of getting a country music career going in Toronto, so he set out for Ontario. Tom spent most of 1962 approaching every record company and music publisher he could find. No one

was interested in Tom or his songs. He went to bars in and around Toronto, hoping to get a week or even a night's work. His luck was even worse than it had been before. Over the next year he booked just a week each in two different bars. He found himself going back and forth between despair and trying to remember the enlightenment he had achieved lying in a snowbank pondering death.

Tom took the odd job when he had to, mostly if he was in desperate need of food or clothing. He carried a needle and thread with him to repair his one pair of pants, adding patches as required. When he had a little money he would purchase his old reliable bread, bologna and mustard. He would find a little stream where he could have a sandwich, maybe even a bath and sit under a tree, contemplating life or writing a song. His songs were sometimes about his own experiences, but more often than not they were inspired by the stories others told him on his travels. As Tom told Volkmar Richter, "I might be walking down the street and see a street cleaner or a street car driver or a truck driver or something and maybe stop and have a conversation with them . . . You'd be surprised at some of the stories they have to tell. Then I digest it all . . . and as soon as I get in the mood I write two or three songs. Sometimes in a day."[3]

In the early 1960s stringent liquor laws meant that bars had very limited hours. Those who wanted to drink late into the night or on a Sunday went to "bootlegging joints." Tom found work at a number of these, often in people's homes. He would provide entertainment in return for some beer and a place to sleep. Occasionally a meal would be part of the agreement and he might even be lucky enough to earn some tips. He sang and played for countless late night parties and spent a fair amount of time sleeping on musty mattresses in damp basements, sometimes becoming a regular at one of these bootleggers' for a few weeks or more.

Steve Foote had also ended up in Toronto and Tom stayed with him for a couple of months in the spring of 1964. Steve was becoming quite good at writing his own songs and the two

friends often talked about music and dreamed of having careers as country singers. After a few months of couch-hopping, Tom found himself working on a friend's brother's tobacco farm in Port Elgin, Ontario. He was there in May, so he didn't have to harvest the tobacco again, but he did odd jobs, painting, seeding, weeding and whatever else needed doing around the farm. In the evenings, when he wasn't working, he could be found singing and playing at parties at the homes of nearby friends and neighbours.

In August, before the harvest, Tom hit the road again, but was unsure where to go. Toronto had not provided the career opportunities that he had been hoping for. He wasn't sure whether he should head to Quebec where he had had some success securing gigs in the past or maybe try out west again. He happened to catch a ride with a musician who was heading to Kirkland Lake. He told Tom that the nearby Larder Lake Hotel was looking for entertainment. Tom got dropped off there. The owner agreed to try him out for the night and give him five dollars. The response was good enough that he was hired for $25 per week and given a room at the hotel. It was his first booking of longer than a week since playing the Flamingo in Vancouver three years before. After five or six weeks, Tom asked for a five dollar per week raise. When the owner refused, Tom quit. He knew that he was bringing people into the bar every night and he thought $30 per week was a bargain.

Tom was willing to go wherever the next ride took him. He got a lift with a man going to Timmins, a mining town in Northern Ontario, and decided that would be his next stop. It was mid-October 1964 and Tom's hitchhiking days were about to come to an end. What happened that night has become legendary among Tom's fans and a big part of the legend of Stompin' Tom. The exact details vary based on who is telling the story or when Tom shared it.

He told TV host Elwood Glover, "The guy that gave me the lift into Timmins had given me a buck. And so I don't know, I got a hamburger and a cup of tea or some damn thing with it . . . and I

had about thirty-five cents left and I went in the [Maple Leaf] hotel to get a beer and that's where it all started."[4] This is also the version he tells in *This is Stomping Tom*. In *Before the Fame*, however, Tom says that upon arriving in Timmins he went to a bar called Leone's and asked if they were looking for a singer. He performed a couple of songs with the band, but they were not terribly supportive and he was turned away. He then went into the Maple Leaf so he could get a beer and directions to the local jail.

Gaet Lepine, a bartender at the Maple Leaf Hotel, told CBC radio that Tom came in asking for directions to the Salvation Army after having been thrown out of another bar. Lepine said, "They threw him out. They thought he was a bum and they threw him in the street."[5] Tom seemed to verify this version of the story in an interview with Peter Gzowski: "I got tossed out of a couple of joints before I hit the Maple Leaf. Nobody knows about that, but that's a fact."[6]

Gaet Lepine, speaking on the radio almost fifty years after the fact, seemed to have a fairly clear memory of that night and his description of it sounds like something straight out of a movie. He set the picture: "It's a cold night, half rain, half snow, and this stranger walks in with a guitar. Lanky looking." He went on to say that Tom chose the bar because of its name. Gaet told CBC that Tom said, "The only thing that drew me in here is this hotel is called The Maple Leaf." Gaet explained, "And the Maple Leaf flashing kinda did something to him. It's very strange, you know. He walked in because of that Maple Leaf." Tom's love of Canada may well have guided him to the bar that would change his life.

Regardless of how exactly Tom ended up at the Maple Leaf, what is generally agreed upon is that he asked for a beer and discovered he was five cents short. Gaet threw in the nickel and gave Tom the beer. He offered him another drink if he would take out his guitar and sing a song or two. Gaet told the radio interviewer that Tom pulled out "an old beat up guitar and there was a shirt around the neck. That was his spare shirt. He had a shaving kit and that was

all he had to his name. And a pair of socks in there. That was it."

Tom sang "Pick Me Up on Your Way Down." He told Gaet he had memorized over two thousand songs. Gaet asked Tom to sing Hank Snow's hit, "I've Been Everywhere," knowing it was a challenging song to sing. Tom not only knew the song and sang it well, but impressed Gaet by changing the lyrics to include names of Canadian towns. Gaet gave Tom another beer and told him to wait while he went to speak with the owner, Pete Kotze.

Gaet said to Kotze, "I got a character in there. Just blew into town. He's singing songs and his voice is pretty gravelly, but there's something about him." Tom had been waiting years for someone to recognize that he had something special to offer. Gaet recognized it.

Tom said that when he entered the Maple Leaf, he "was downtrodden, bedraggled, tired, unshaven. I looked pretty bad. Pretty thin. Cheeks bowed in. Pretty desperate looking character."[7] Gaet explained to Kotze that Tom was hungry and in bad shape, but he thought that if they fed him and gave him a place to sleep he would perform even better. Kotze agreed to meet him.

After a brief audition, it was agreed that Tom could have a room for a couple of nights and they would try him out for the weekend. He would only be singing for tips, but at least he'd have a place to sleep and they would give him a meal a day. As Tom explained in *This is Stomping Tom*, "[it] wasn't much to begin with, but it was eating and I got a room. And the bed looked awful good because I'd slept outside the night before and it was kinda chilly in an old broken down car in a junkyard."

Although it was just Thursday night, Kotze said that if anyone came into the bar Tom was welcome to try out a few songs. They moved a table so Tom would have a place to stand. There was no stage or sound system. It was just Tom standing in the corner with his guitar. A few people came in and Tom asked if they'd like to hear a song. They requested some Hank Williams, among others, and they were impressed enough that they stayed till closing.

The next night, being a Friday, was his real tryout. There were a few more people around and Tom stood next to the ladies' washroom, singing their requests. He got a few tips and the patrons again stayed until closing. Gaet told Tom that was unusual, as most people had a beer or two and moved on. His future at the Maple Leaf was looking promising.

On Saturday night a lot of those Friday night customers returned and brought friends with them. The mostly deserted bar that Tom had walked into on Thursday night was almost half full by Saturday. Tom was hired for the next week. He would get $35 per week as well as his room, a daily meal and tips. Tom performed from 8 p.m. to 1 a.m. six nights a week with a ten-minute break every hour. That first week went so well that it was agreed Tom would stay on in an open-ended contract. If either he or Kotze decided to end the agreement, they would give the other two weeks' notice. After a few weeks, when it looked like Tom would be staying for a while, Kotze built a little stage and invested in a sound system. Before long the bar was packed on the weekends and three quarters full during the week. Tom was gaining a following and he had a place to call home.

Tom also made a lifelong friend in Gaet, who was a country music fan and a singer/songwriter himself. Occasionally, after the Maple Leaf closed for the night, the two friends would go to a bootlegging joint and play music till morning. Tom would order a case of twenty-four beer for himself and they would stay until it was gone. Other times they would just hang out in Tom's room, chatting. Gaet told CBC, "Every night I was in his room. We'd talk til the sun would come up in the morning . . . sometimes we'd cry. Sometimes we'd laugh . . . He told me everything. He really opened up to me."

The story of how Tom got his start at the Maple Leaf Hotel may be legendary, but what many people might not know is how hard he worked to take advantage of that opportunity. Once he had a place to play his music, he went to work promoting himself and

making friends and fans of the patrons, one person at a time. He may have had a ten-minute break every hour, but he used that time for his "public relations," as he called it. He told Elwood Glover, "Well I make it a point too, to go down and talk to all the people, table by table. Every chance, every second I get. When I go in there my job starts as soon as I walk in the door and it's done when I leave. There's no such thing as a break in between because I talk to everybody."[8]

Yvon Lapierre was one of those patrons from the Maple Leaf Hotel who ended up becoming a friend of Tom's. In an interview with the *Timmins Daily Press*, Lapierre said, "He was a kind-hearted man, and always happy, always a smile. The people he met, you could tell he was happy to meet them, and the people felt the same way towards him because he was so friendly. He really liked to laugh."

Tom was soon drawing in people from all walks of life — everyone from labourers to the mayor were becoming fans. There seemed to be a thirst for country music. As Tom told *Canadian Composer* magazine, "When I started to play at the Maple Leaf in Timmins, none of the other bars had country music. They had go-go girls and rock and roll and God knows what else. Nobody was playing country up there til I started — and that's why people came to hear me, not because I was so all-fired good."[9]

One of the people who became a fan was Nick Harris from the local radio station, CKGB. He invited Tom to come into the station to record a couple of songs that he would later play on air. Tom's broadcast was so well received that he was invited to do the same three nights a week, and then six. He went from doing a five-minute spot to fifteen minutes to twenty-five. He wasn't paid for these spots, but it was great promotion for his live performances. The DJ would introduce Tom's segment with, "From the Skyway Room at the Maple Leaf Hotel." Tom would also promote the hotel during his shows.

Tom met some reporters from the *Timmins Daily Press*, includ-

ing John Farrington. These writers featured Tom in the paper, helping to build his fan base even further. They were also a useful source of information, keeping Tom abreast of what was going on in the town. He used this in his writing. In February of 1965, a fire began in Timmins' McIntyre Mine. One miner died and nearly a thousand were out of work as the gas from the fire permeated the nearby Hollinger Mine as well. After a month, the fire was finally extinguished. Tom's reporter friends gave him regular updates on the blaze and he used the information to write a song about the incident called "Fire in the Mine." Tom added this song to his repertoire at the Maple Leaf along with "Carolyne," a love song he had written that opened with the line "T-I-M-M-I-N-S, that's gonna be my new address."

Tom knew that writing a song about a town was a quick way to endear himself to the locals. While playing in a town called Ansonville for a few weeks, he wrote a song called "May, the Millwright's Daughter" that included the lyrics, "In a little town called Ansonville, not very far from the paper mill." He acknowledged that by doing so "it immediately assured us of a contract renewal." But there was another purpose to writing songs about the places he visited. Tom had grown frustrated with hearing songs about people and places he couldn't relate to. He wanted to hear about the people and places he knew. Since those songs didn't seem to exist, Tom took it upon himself to write them. As he told *The Globe and Mail*, "That's what songwriting is about for me: You write songs about what's going on in your country. I want to hear truck-drivin' songs, songs about fishermen, about factory workers, about mine disasters, about cowboys, about places in Canada that people can identify with, and about the Canadian way of life."[10]

He told music reporter Rudy Blair:

> *Wilf Carter, in the early days, he used to sing songs about the Strawberry Roan, which was a Canadian horse and he sang about the blue Canadian rockies*

*and he sang about the disaster in . . . The Moose River Gold Mine down in Nova Scotia and the capture of Albert Johnson, the mad trapper. He sang songs about Canada. My mother used to know a lot of those songs and she'd sing them and I'd pick them up. Then when I got older and realized, 'Hey, with no Wilf Carter, nobody's singing anything about Canada.' So, I kinda picked it up from there. I seen a drought that nobody was writing about Canada or singing about it. Or very damn few. So I thought, 'Hey, there's a niche. I think I'll do my best to fit in there.'*[11]

Tom soon had dozens of songs about Canada and regularly performed them along with the hits of the day and the classic country songs that people often requested.

Although he still didn't have a record deal and hadn't achieved the kind of success he dreamed of, something happened one night at the Maple Leaf that reassured him he was on the right path. A group of school teachers who had just returned from an exchange trip to Germany came in. Between sets Tom sat to have a drink with them. He learned that when they were overseas they had gone to a number of house parties where the Germans sang songs from Germany and then encouraged the Canadian teachers to perform some Canadian songs. The teachers were stumped. They realized the only Canadian song they could think of was "O Canada."

They were surprised to wander into the Maple Leaf and hear Tom singing song after song about Canada. Tom told Peter Gzowski that the teachers said, "And now, we're back from Germany, after spending a year over there, and now we come here, and of all places, we just came to have a nice quiet conversation and we're sitting in the Maple Leaf Hotel listening to the only guy that we've ever heard in our lives, standing live on a stage and singing songs galore about this country."[12] Tom continued, "And when they said words like that to me, just in a small little hotel in a town called

Timmins, that stuck with me and it made me know that I was on the right track. So the world has to hear about Canada. And Canadians have to hear about Canada."

Unable to land a recording contract, Tom decided to produce some singles on his own. With the help of CKGB he put two songs, "Carolyne" and "Movin' On to Rouyn," on a reel-to-reel tape and sent them off to Quality Records in Toronto, where he paid to have a hundred singles pressed. When the recordings arrived from Toronto, Tom wrote, "I was just like a little kid at Christmas. I don't usually get excited, but on that day I was all fingers and thumbs trying to get the wrappings off." Tom ran out and bought a cheap record player so he could listen to himself.

He sold the records at his shows between sets, and almost half were gone on the first night. By the end of the week all hundred had been sold and he ordered three hundred more. He had only made about $25 from the first batch, but he saw the recordings as a promotional tool. The people who left his shows with a record would no doubt play it for others who then might come to see him perform live.

Once Tom had more records, he visited every business in Timmins that had a jukebox and asked them to put his record in the machine. He also convinced a few local businesses to sell them for him. During his radio programs he would promote his singles and encourage people to order them by mail, paying one dollar for the single and twenty-five cents for postage. He also gave away a few on air and continued to sell them at his live shows. Tom was not only the singer/songwriter, but now he was his own producer and he basically ran his own label, handling production, sales and promotions. He claimed that he sold twenty times more records than the Beatles in Timmins in 1965. He recorded eight or nine more singles at CKGB and a couple at other radio stations in Northern Ontario. As of 2018, those singles are collectors' items and sell for upwards of $350.

Since Tom performed alone, and had no drums or bass to keep

time, he had always created his own rhythm by tapping his left heel while he played guitar and sang. One evening a couple of older ladies, sitting near the front of the stage, asked him to stop his banging as he was making it difficult for them to carry on a conversation. Although by now the tapping was a habit and it was hard for him to play without it, he held back as much as he could. However, in no time he was unconsciously tapping his foot again. The women threatened to complain to the owner, claiming he was a friend of theirs. Tom once again tried to keep his foot still, but when the next fast number came up others in the bar were yelling for him to start banging his foot. He tried to find a happy medium but soon the women were off to complain to Mr. Kotze, who asked to see Tom when his set was done. Kotze asked Tom to stop tapping his foot, but Tom explained that it was part of how he performed and if those women were more important to the bar than Tom he would have to quit. Kotze told him to do what he had to do.

As Tom started his next set, the women looked quite satisfied with themselves and confident in Kotze's assurance that Tom would stop banging his foot. Tom wrote in *Before the Fame* that he strapped on his guitar, gave them a big smile and "came down with the goddamnedest banging they ever heard in their lives. There was dust and sawdust flying everywhere, and chips of plywood the size of quarters landing in people's drinks halfway across the room." Soon people were coming up to the stage and filling matchboxes with sawdust and chips from the plywood stage to save as souvenirs of Tom's performance. As the crowd cheered, the ladies exited in a hurry. Tom stomped his foot harder than ever and later called that evening "the night the stompin' really began."

In mid-December of 1965, Tom's old friend Lucky Jim Frost happened into the Maple Leaf Hotel. After Tom's show the two friends stayed up late drinking and reminiscing. Very early in the morning there was a knock on Tom's hotel room door. It was the hotel's cleaning service. Tom asked the woman to come back a lit-

tle closer to noon. She informed him that he would have to leave so she could clean the room for its next guests. That's how Tom found out that he had been fired from the Maple Leaf. He was in shock. He was drawing big crowds and had been given no indication that there were any problems. Not only did the firing come completely out of the blue, but Tom and Mr. Kotze had an agreement that if either of them wanted to end their arrangement they would give the other two weeks' notice. Tom went in search of Kotze, but the owner refused to talk to him. Tom found Mrs. Kotze in the kitchen, and according to his autobiography, she simply said, "You're done, you're finished — that's it. Goodbye."

Tom went to the Ministry of Labour to see what could be done, since he had been promised two weeks' notice. He eventually got one week's pay, which after fourteen months was up to $130, as well as retroactive vacation pay covering the entire length of his engagement.

Although Tom acknowledged that the Maple Leaf had been good for his career he was also aware that he had been very good for the Maple Leaf. During his time there the bar had undergone a number of renovations and, according to Tom, its real estate value had tripled. He wrote in his autobiography that with him as their sole entertainer the "Maple Leaf had gone from a little-known bar for rubby-dubs to the foremost country music night club of the North." He never did get an explanation for his dismissal beyond the fact that Kotze had hired a new band. Tom discovered that the band was being paid four times what he had received. Years later, the Maple Leaf would be the site of some of Shania Twain's earliest gigs and when a centre to commemorate her career was created in Timmins it included a re-creation of the hotel.

After all the success of the past year, Tom grew despondent. Having been fired from the Maple Leaf he needed to find a place to live. He rented a two-bedroom apartment with his girlfriend of the time in a suburb of Timmins, ironically called Mountjoy. Christmas had never been a particularly happy time of the year for

Tom and this one would be no different. Years later he released a holiday album that included the song, "Down on Christmas," expressing how hard it was to get excited about Christmas after a very challenging year. It would seem that Christmas 1965 was the inspiration for this song.

While some of the song is clearly fictionalized, as he sings about his wife leaving him, there are other elements that appear to be autobiographical, including references to a doctor limiting his eating and drinking habits. Tom sings, "I can't eat nothin' fried. Had a slice of meat that was cut so thin, it only had one side," and "I hit the floor like an apple core when Doc took me off the beer." Earlier that year, Tom had been having pains in his stomach and, after a particularly bad attack, finally went to see a doctor. Having lived on his own since the age of thirteen, Tom had developed some bad habits. He had started smoking and drinking at an early age and his years of living hand to mouth had left him with irregular eating and sleeping patterns. He often ate just one meal a day and rarely slept for more than a few hours at a time. He was diagnosed with severe ulcers and put on a diet of egg whites, toast and milk while he awaited surgery. Tom adhered to the diet for a few days, but felt himself growing weaker on what he called a "starvation diet." He also hated the idea that he couldn't drink. He had grown accustomed to visiting tables between sets and having a beer with the Maple Leaf's patrons. He acknowledged in his autobiography that he was concerned about looking stupid when people offered to buy him a drink and he ordered milk.

Tom happened upon an article in the Timmins newspaper about a doctor from India who claimed to have had great success in treating ulcers simply by eliminating salt from the patient's diet. The writer of the piece clearly viewed non-Western medicine as based more on superstition than science, but Tom was interested in the Indian doctor's ideas. He started eating whatever he wanted but avoiding salt. The ulcers never flared up again and he cancelled

his surgery. From that point on, Tom was suspicious of doctors and Western medicine.

As the holiday season of 1965 came to an end, Tom had to decide what his next move would be. He could either start traveling the country again or continue building on the reputation he now had in Northern Ontario. People had been travelling to the Maple Leaf to see him, so he knew that the radio had given him significant exposure throughout the province. He decided to stay in the area.

Because of their acrimonious split, Tom was reluctant to credit Kotze with giving him his big break, but he continued to hold a warm spot in his heart for the Maple Leaf Hotel and Timmins for the rest of his life. Former bandmate Duncan Fremlin posted an audio clip on his SoundCloud page of Tom in concert in Timmins decades after his firing from the Maple Leaf. Tom says to the crowd, "I started out hitchhiking all over the country, from east to west and everywhere. A town in Northern Ontario took me in and said, 'I'll give you a chance. No matter where you've been, I'll give you a chance.' And that town was Timmins, Ontario. Thank you Timmins."

Because he had been earning money for the past year, he had a few more belongings than when he used to hitchhike. He had two guitars, a few changes of clothes and boxes of records. If he was going to travel around looking for work, he'd need a vehicle. He had about $1,500 in savings and spent some of it on a car, with most of the rest going towards a little sound system and some posters that he could use to promote his appearances. By the time he was done, he had $100 and decided to leave his girlfriend and apartment behind. He wrote in his autobiography, "the girl and the housekeeping had to come to an end." He hit the road looking for his next gig.

As another sign that Tom was serious about his career, he joined the Musicians' Union. This enabled him to have a number of blank contracts to take on the road with him. After the way he had been treated at the Maple Leaf, Tom knew he needed something in writing to protect his rights. Occasionally he would play for a night or

two before getting a signed contract. After a couple of bar owners refused to pay him, he learned to never perform without a completed contract in hand.

Over the next year Tom had gigs in bars all over Ontario. Occasionally he was there for just a night or two, but he managed to secure a few weeks at a time in a number of locations. Serving as his own manager and promoter, he also started asking for a return contract before moving on to the next town. Most places were happy to oblige, particularly if he had written a song about that community. Generally his return engagements would build on his last appearance, with patrons returning and bringing friends to see him. Tom was gaining a following not just as the guy who sang songs about Canada, but also as the guy who banged his foot. Although it was a regular part of his performance, he lost a couple of jobs after his foot tapping wore holes in various carpets and stages. While the bar owners weren't terribly enthusiastic about his stomping, the patrons loved it. Some people couldn't remember his name but they would ask their local bar to "bring back that guy who stomps his foot."

In an interview on CIUT radio, reporter John Farrington said that Tom was initially upset that people were coming to see him stomp rather than to hear him sing and play. Tom didn't want to be known as a novelty act. However, Farrington said, "He eventually embraced it. He knew it was his gravy train." Tom started carrying a couple of pieces of three-quarter inch plywood with him so he could bang his foot without damaging the stages. These bits of plywood became known as his "stompin' boards" and they were soon an integral part of his act.

As he told Peter Gzowski, "let's say the boot and the board got them in the door. Because that made people talk. They said, 'You should come see this guy ripping boards apart. And the sawdust flies everywhere and it's into your drink and it's on your clothes and it's all over the place and you can go up and get a matchbox full of sawdust just to prove to people that this happened' and

all that sort of thing. But the second time they came to see me, it wasn't to see me bang my boot into the board. It was to hear what I was singing."[13]

The next eighteen months were a particularly productive time in terms of songwriting. Since he had branched beyond Timmins, Tom was meeting new people, hearing their stories and learning about the communities where he played. If he was in an area for any length of time those stories became songs that drew people in to see him. While in Sault Ste. Marie he wrote one of his most popular songs, "Algoma Central 69," which opens with the line, "She's on a bar hopping spree, back in Sault Ste. Marie." The song tells the story of a man who ends a relationship but then rethinks his actions and gets on the Algoma Central 69 train that takes him back to the woman he left behind. On a return engagement to that city he sang the song to packed houses every night. He wrote in his autobiography, "This convinced me all the more that writing songs about every town where they would have me long enough to gather the proper information was paying off. It was good for me and it was good for them, and everybody had something to talk about."

When Tom secured a three-week gig at the Towne House in Sudbury the crowds were fairly small during his first week, but started to build in week two. During his third week there he wrote "Sudbury Saturday Night," which would become one of his best known songs. Unfortunately, he wrote it a little too late to build the audience. When he returned two months later, he got much bigger crowds, drawn by stories of a stage he had destroyed with his stomping in nearby Chelmsford. They may have shown up to see the stomping, but they were won over by "Sudbury Saturday Night" in which Tom sings, "Oh, the girls are out to bingo and the boys are gettin' stinko, We think no more of INCO on a Sudbury Saturday Night," referencing the mining company that was one of the city's biggest employers. Tom was still making a little extra income selling the singles he had recorded in Timmins and people in Sudbury were disappointed that they couldn't yet buy their song.

Heinz had opened their first Canadian plant in Leamington, Ontario, in 1909. When Tom played there in the mid-1960s, the town was known as the "Tomato Capital of Canada" because of the Heinz processing factory. Tom used this knowledge to write "The Ketchup Song" about the town. The song tells the story of a PEI potato and a Leamington tomato who fall in love. It's a silly little song with the lyrics, "Big size French Fries; how they love tomatoes! So dress 'em up with Heinz ketchup, Ketchup loves potatoes." Though it may be a slightly goofy novelty song, it showcased Tom's sense of humour and was a huge hit with the crowd in Leamington. In his autobiography he described the reaction of the crowd at the town's Seacliffe Hotel the first time he played it. He wrote, "I walked up on the stage. I didn't say a word, but immediately started singing the song. All heads turned and looked at the stage. Not one person took a sip of beer until the song was over. I had to sing it half a dozen more times that night, and the same thing for the rest of the two weeks."

In the days before recorded music folk singers would often go to a house party and sing a song a number of times in one night so everyone could learn it. Whether knowingly or not, Tom was employing this method at his shows. He may not have always had a recording of a particular song, but his tunes were catchy and easy to learn so by the time he left a community people knew his songs about them. Always trying to think of ways to promote himself and his music, Tom even pitched "The Ketchup Song" to the folks at the Heinz factory. Although there was some interest, they eventually passed.

Tom played Wawa, Ontario, a short time later and got another promotional idea when he walked into a local grocery store and spotted a six-foot-tall inflatable Heinz ketchup bottle that was being put on display. He convinced the owner of the grocery store to sell the bottle to him, hired someone to fly a plane over downtown and drop it on Main Street where it bounced down the road before landing on a roof. Soon everyone in Wawa was talking

about ketchup and his new song proved very popular. Tom denied having anything to do with the bouncing bottle.

Luckily for Tom, writing came quickly and easily to him, so it wasn't a challenge to write songs about every town he visited. He claimed the quickest song he ever wrote was "Maritime Waltz." Granted the song was just one verse and one chorus, with no bridge, and it contains just four chords, but he wrote it in twelve minutes. On the promotional CD for Tom's 1992 album, *Believe in Your Country*, he explained, "when I write songs . . . the lyric comes first. So the whole song is built around the story and the lyrics." It was important to him that his lyrics be straightforward and easy to comprehend. As he told *Canadian Composer* magazine, "I started in to writing about the people I knew, and stories I heard on the road. They seemed to make good songs, and when I'd sing them people could understand what they were about."[14] Tom pointed out on the promo CD, "I'm not going to write a song where it says 'I love you,' but really you have to get the deeper message in the song where it says 'I don't love you.' You know, my lyrics are very clear, to the point, and whatever I'm saying is what I mean. There's no double talk to the lyrics."

There has been criticism of the simplicity of Tom's musical arrangements, which often employ just three or four chords, and not much complexity. Tom was aware of that and again said it was intentional. On the *Believe in Your Country* CD he said,

> *The music is not the important thing about Stompin' Tom. It's the lyrics . . . if it really comes down to it I think I could do the same thing with just my guitar. So I wouldn't need a band at all. But I think I gotta go halfway. So instead of just me and my guitar singing the songs there's a band there to show that there's music behind it, but not going too far and making a big production.*

While his lyrics and arrangements may have been simple, and many of the songs used humour to tell their story, there was also a more serious side to what Tom was doing. He knew that he was documenting both Canadian life as he and his fans lived it and important events that might otherwise have faded away over time. Country music journalist, Steve Pritchard wrote, "a lot of the music that he sang, and the songs that he wrote, were legitimate folk songs, they were about events . . . the more serious ones he does were about events that nobody has captured in a song like he has."[15]

When Tom played Kapuskasing, he started hearing about a dispute that had happened in nearby Reesor Siding in 1963 between striking pulp and paper workers and the local farmers who supplied pulpwood to the mill. The confrontation resulted in eleven union members being shot, with three of them dying. The incident became an important milestone in Canadian labour history and, as Tom described it, "the bloodiest labour dispute" of its time. Tom thought it was an important enough event that he wanted to memorialize it in song. As he explained on the *Believe in Your Country* CD, "I write for the need, I guess. Where I see there's a need that gets me in the mood. That is the inspiration. If I see something that needs to be written about, something of interest that hasn't been written about before . . . The need to have a Canadian song written for that occasion is enough to prompt me."

The more Tom enquired about this particular incident, however, the more he realized that the community thought it was best not to revisit the tragedy. Tom continued to research the story, and when it came time to write his song, he tried to tell the tale without taking sides. Tom had a three week gig at the Radio Hotel in Kapuskasing. On the Monday of his final week, he signed a new contract for an additional three weeks and he mentioned to the owner that he was working on a new song about the area that he planned to premiere on Saturday night. The owner had no idea what the song was about, so was undeterred.

Tom wrote the song on Tuesday. He told people about this new

tune and word spread quickly. According to his autobiography, by Thursday he was getting notes while performing that read, "Sing of Reesor and die," and "Sing your new song at your peril." Before anyone had even heard the song he was being shunned everywhere he went in town. This only made Tom more determined than ever to sing it. He didn't want to be cowed by intimidation. It had become a matter of free speech for him. He told Elwood Glover,

> I think it was five or six guys got me in the washroom before I was to go on stage to sing this song on a Saturday night. And they pushed me around quite a bit and they told me, 'If you sing that song, Buddy, that's it. You've had it.' So I went out anyway and I got up on the stage and I said, 'A lot of people don't wanna hear this song even though they haven't even heard it yet. And you're saying that it's no good and all this and that, but I don't care what happens to me from here on through. I'm singing it.' [16]

By the time he got to the last line of the first verse, "Twenty farmers met that night, To guard their pulp from a Union strike, Unaware this night would see the Reesor Crossing Tragedy," the bar was half empty. By the time he was done, there were just two tables of people left in the room. The owner immediately told him he was fired. Tom explained that he had a three-week contract and he intended to fulfill his end of the bargain, but if the owner wanted to give him his three weeks' pay he would leave. The owner didn't pay him and Tom went on stage to perform each of his sets to the now almost empty bar. He sat with the few people who were left and explained what had happened with his boss. They took it upon themselves to start a petition to save Tom's job. At the end of the night, Tom decided to leave for Timmins, where he was still recording his radio program every Sunday. He returned on Monday, just in time for his show.

As Tom entered the bar he was shocked to find it was packed. A group of men grabbed him and put him on their shoulders, carrying him to the stage. People were cheering, requesting the Reesor song. The waiters placed trays of beer for Tom all across the front of the stage. Those few people who had stayed on Saturday had taken their petition to enough people and convinced them that the song wasn't so bad that everyone had started to reconsider their actions. As Tom sang the last line, "It reminds us in the North, not to bring our tempers forth, so there may never elsewhere be, a Reesor Crossing Tragedy," his plea for peace was met with cheers. He was asked to repeat the song five more times. Afterwards someone went to the stage and expressed their regret on behalf of the community that Tom had been treated so poorly. They acknowledged that they had been avoiding their past and it was time to accept their history and move on. They credited Tom with helping them do that and told him he would always be welcome in Kapuskasing.

Although he was having success as a one-man operation, he was looking for someone else to help with his career. He was hoping to find an agent who could book him into bars and handle contracts, or a record label that would sign him and take care of the recording of his music. He found it hard to find an agent, in part because agents worked on a percentage basis and bars were willing to pay more for a full band than they were for a single performer. Most agents preferred to represent bands and earn more money. Tom knew that he could pack a bar as well as any band and felt his fee should be comparable. He also felt that he had something different to offer venues. Most bands were all playing the same songs, whereas Tom could offer original material. Although he knew over two thousand country classics, his performances focussed much more heavily on his own material. He did eventually find an agent, but he still sought bookings on his own as well.

At an agent's office, Tom met John Irvine from Rebel Records. Irvine agreed to audition Tom and ultimately asked him to record a full length album for Rebel. Unfortunately, Irvine had no money

to pay for the recording session so Tom ended up footing the bill, with the idea that he would someday be paid back. Tom recorded sixteen tracks, accompanied by guitar, for an LP that would be called *The Northlands' Own*. All the songs on the album were written by Tom and the entire recording was done in three hours. It opens with "World Goes Round," a number he had written to commemorate Expo '67, which was being held in Montreal that year as part of Canada's Centennial celebrations. The album also contained a number of songs that had proven popular in live performance including "Movin' On to Rouyn," "Algoma Central 69," "Sudbury Saturday Night" and "Carolyne."

Although he was still going by Tom Connors, this first album had all the hallmarks of a Stompin' Tom release. The LP was identifiably Canadian, but more regional than many of his future recordings, as twelve of the sixteen tracks made reference to Ontario cities and towns. Other parts of the country were referenced with "Maritime Waltz," Tom's song about PEI, "My Home Cradled Out in the Waves" and one about Canada's national rail line, "Flyin' CPR."

Tom had wanted to bring in his board and stomp along while recording, but according to his memoir he was told that "that noise" would sound "ridiculous." As it was, the engineer snickered at Tom for the entire recording session. Indeed, Tom alone with his guitar must have sounded rather sparse. His songs, with their simple lyrics, repetitive rhyme schemes and three chord arrangements, no doubt struck the engineer as raw and unsophisticated, even for country music. In 1967, some of the country acts at the top of the charts were Loretta Lynn, George Jones and Merle Haggard. All sang a traditional style of country music, but their recordings had a much more polished sound than Tom's.

After performing on CKGB in Timmins for a year and a half, Tom decided to give up the show in order to travel further throughout Ontario. In late June of 1967 he was booked into the King George Hotel in Peterborough, Ontario. He had played there

for the first time a couple of months before and gained quite a following, in part because of a love song he had written called "The Peterborough Postman." The song had proven so popular that some local artists had started to perform it at the Saturday afternoon jamborees that were held at the King George. Tom was quite flattered, as it was the first time his music had been covered.

One afternoon Tom and Boyd MacDonald, a bartender at the King George, were talking about the fact that Tom thought "Tom Connors" was a boring name and that he might want a stage name. Tom's heroes, Hank Snow and Wilf Carter, were known respectively as The Singing Ranger and Montana Slim. Tom probably thought a nickname was a prerequisite for a successful career as a country singer. He had already toyed with Tugboat Tommy and Hank Spur, but neither stuck. Boyd had taken to calling Tom "Stomper," but Tom never considered adopting it as his stage name.

According to Tom's memoir, on Saturday, July 1, 1967, Canada's hundredth birthday, as he headed towards the stage Boyd took the microphone and said, "Ladies and gentlemen, it is my distinct pleasure to introduce to you a man who is not only more Canadian than the maple leaf, and more devastating to a piece of plywood than a hungry beaver, but he's even stomped down more streets in this country than a Peterborough Postman. Ladies and gentlemen, make way for the one and only Stompin' Tom Connors."

Tom claimed it was the first time he had been called Stompin' Tom, and the crowd cheered as Boyd urged them on, having them chant "Stompin' Tom." Tom said he was initially embarrassed and "felt a little stupid," but it was clear they approved of the moniker. He said to them, "Well, I was looking for a new name anyway. And if that's the one you all want, then that's the name I'll stick with. I guess I'll just have to get used to it. So my first official words as Stompin' Tom are, 'Thank you, Peterborough.'"

Tom wrote in *Before the Fame* that "The applause, the laughter, the friendliness pervaded the whole room for the rest of the night"

and the King George set a record in liquor sales that evening. He said that from that moment on he would be known professionally as Stompin' Tom. Tom claimed that he threw out all of his posters and had new ones printed. He left Peterborough feeling like a new man, and as soon as he could get to Toronto he registered "Stompin' Tom" as his official business name. He wrote, "Stompin' Tom was now the Entertainer; and Tom Connors was to be just Mr. Private Citizen from now on."

## Chapter Five
# The Entertainer

There's songs to be sung and stories to tell,
Here at the hustlin', down at the bustlin',
Here at the Horseshoe Hotel

— "Horseshoe Hotel Song"

If a writer were to invent the ultimate Canadian troubadour they couldn't do much better than to give him his big break at the Maple Leaf Hotel and then have him christened on Canada's hundredth birthday. All indications are that a writer did invent part of the story — that writer being Tom Connors.

That July night in 1967 when Tom got his stage name has become part of the accepted folklore of "Stompin' Tom," but Boyd MacDonald's full introduction and the date when it happened were never shared until Tom wrote *Before the Fame* in 1995. Although Tom would eventually write, "We are all born again on Canada Day," in his song "Canada Day, Up Canada Way," it's unlikely that Stompin' Tom was actually "born" that day.

In a 1970 interview, Tom told a quite different story of that night, saying, "I think the fellow there forgot my last name — anyway, one night the waiter gets on the microphone to introduce me, and shouts, 'well, lads, here he is — Stompin' Tom!'"[1] There was no indication that it happened on Canada Day, the introduction is

not nearly as flowery and he doesn't even mention Boyd's name. There is also no mention of the fact that Tom was looking for a new stage name. Rather, Boyd, who Tom claimed was a friend, just forgot Tom's name.

In a 1973 radio interview, Tom called Boyd by name, but again there was no mention that it was on Canada Day and the introduction was very brief. Tom said, "I came in one night, and this waiter, Boyd MacDonald was his name, and he came in. He says, 'Here he is folks, once again, Stompin' Tom.' From that second on, I knew forever, I guess, that's what my name was gonna be as long as I picked up a guitar and sang."[2]

In William Echard's essay, "Forceful Nuance and Stompin' Tom," he writes, "The exact origin of the name 'Stompin' Tom' is not clear, but a few themes emerge in various tellings of the story. Connors was in the habit of stomping his foot as he performed . . . It is usually agreed that it was in Peterborough, sometime around 1967, that this practice led to the name "Stompin' Tom" (some say the fateful words were spoken by a waiter, some say the MC, some say two old ladies in the front row)."[3]

Although the essay appeared in 2002, Echard says much of Tom's history as related in the article was based on research he did for his Master of Arts thesis in Musicology, which was completed in 1995. So before 1995, the year when *Before the Fame* appeared, the origins of "Stompin' Tom" were unclear. Echard says his research was based on "newsprint articles, radio archive materials, biographical and PR mailings from A-C-T records, personal interviews with fans and local broadcasters, and correspondence with Connors."

Tom's assertion that from July 1, 1967, on he was known professionally as Stompin' Tom is simply not true. His second album, *On Tragedy Trail*, was released in 1968 and he was credited as Tom Connors. A CBC radio interview with him from early 1969 when he was playing in a Toronto bar identifies him simply as Tom Connors. Tom appears to have gotten the name

in Peterborough sometime around 1967, but it was probably not on Canada Day, and based on contemporaneous interviews and articles, as well as record releases, he probably didn't adopt the name fully until 1969.

***

While 1967 was a significant year for Tom, it was also a big year in the history of Canada. The Centennial marked not just Canada's hundredth anniversary as a country, but it also saw a change in the way Canadians saw themselves and the way the country was perceived on the international stage. Tom had literally been singing Canada's praises for at least a decade by 1967, but it's important to put his patriotism in context. Until Canada's Centennial year the country was still struggling to find its identity and had displayed little to none of the patriotism for which its neighbours to the south were famous. Canada saw itself as part of the British empire politically, while geographically it lived in the shadow of flag-waving Americans. In an article titled "In 1967, Change in Canada Could No Longer be Stopped," Doug Saunders wrote "Anniversaries are ... usually symbolic moments of reflection, but Canada's hundredth was a very real bid to create an almost entirely new country, and, to a large extent, it succeeded."[4]

Until 1947 Canadians were British subjects, so Canadian citizenship was just twenty years old in 1967. The Canadian flag was even newer, having been introduced in 1965, replacing the Canadian Red Ensign, which incorporated the United Kingdom's Union Jack. "O Canada" was slowly replacing "God Save the Queen" as the country's national anthem, although that wouldn't be made official until 1980. As Tom Hawthorn, author of *The Year Canadians Lost Their Minds and Found Their Country*, told *Canadian Geographic*, "There was so little of Canada seen in the rest of the world, there was a sense that Canada didn't matter and we weren't

important." He went on to explain, "Up until then, Canada had lived in the shadow of Britain and the U.S. — and sometimes we still struggle with that — but I think Canadians realized at the end of '67 that we have something special and unique here."[5]

Expo '67 would turn out to be the most successful World's Fair up to that point and it showed the international community, but probably more importantly Canada, that it was a relevant player on the world stage. Canada was ready to be celebrated. Tom was aware of the importance of Expo to Canada, as he marked the event with the opening track, "The World Goes Round," on his first album. He sang, "All the world will say, Tap your feet to the birthday beat, For Expo's underway."

Steve Fruitman, who is a folklorist as well as a musicologist, made the point in an interview for this book that "Tom never claimed to be the first guy to sing Canadian songs." Fruitman said, "There were all kinds of songs like that. There were all kinds of performers doing them. He wasn't the first. He was the first that really made it big doing that . . . He was the guy who said, 'Wake up! We can sing these songs and we should be singing these songs about our country and about who we are.'" Tom's love of Canada and his promotion of its people and stories predated the birth of the country's patriotism, but his cultural presence no doubt played a role in helping to promote that feeling in the years ahead.

Tom was beginning to gain a following in Northern Ontario, with people sometimes driving two hundred miles to see him after taking in a performance in their own hometown. While at the Hotel Collingwood in Dorchester, Tom wrote "Around the Bay and Back Again," in which he named almost every town in the Georgian Bay area. The song, which tells the story of a man asking a "ferry man" to help him find his girlfriend, mentions Manitoulin, Tobermory, Owen Sound, Meaford and Collingwood as well as another half dozen or so locations. The song proved very popular in many of those communities.

In late July of 1967, Tom's album, *The Northlands' Own*, was

ready for release. The cover featured Tom standing in front of a gnarly tree stump, with a guitar strapped over his shoulder and his "stompin' foot" resting on a guitar case. The back of the album has "Tom Connors" and "Songs of Canada" printed in large letters above an essay that asks, "Are you a Canadian????" It goes on, "If so I would like to introduce you to another Canadian. His name is Tom Connors, and this being Centennial Year in Canada we thought it would be appropriate at this time to release this first of a series of albums on Tom's Canadian Songs." The essay states that Tom has written over 350 songs and that more than "three-quarters of them are about real live Canadian people he has met in his various travels throughout Canada." The piece ends with the promise that "this fellow Tom Connors will take you on his own Canadian trip without you having to leave your record player." The photograph on the back features a serious-looking Tom, holding a guitar, staring intently into the camera. With his greased-back dark hair, strong jawline and chiseled features he looks more like a movie star than the rumpled drifter he had been just a few years before or the "down-home" country entertainer he was to become.

While Tom was at Rebel Records picking up the twelve free copies of his LPs he signed over a new batch of songs, which the company did nothing to promote, so they went unrecorded. Tom was disappointed to discover that Rebel provided no real distribution, so his new album was placed in just one store. In 1967 many of the small communities where Tom played didn't have record stores, so the only way to get recordings of many artists was at their shows. Tom bought a couple hundred copies of *The Northlands' Own* to sell at his performances, but he didn't even get a substantial discount on those and he was never paid back the recording costs. On top of all that, being with a label hadn't helped to get him on the radio. Signing with this particular label had not afforded him much opportunity that he hadn't already been able to generate on his own. The LP did make him look a little more professional and successful in his fans' eyes, however. Despite his misgivings, he

made plans to record a second album for the company.

Tom went to visit his friends Donnie and Winnie Wortman in Port Elgin, Ontario, in part to show them his new album. While there, Donnie mentioned that he was reading a book about Canada's infamous Black Donnellys. The Donnellys were Irish immigrants who had settled in Ontario and found themselves in a number of feuds and land disputes that continued for more than thirty years. The family members were accused variously of arson, theft, assault, trespassing and even murder. It was often difficult to prove their guilt, so a group of vigilantes decided to take justice into their own hands, killing five members of the family and burning their farm to the ground in February of 1880. Despite the fact that the members of the vigilante group were well known, no one was ever convicted of the murders. Donnie asked if Tom was familiar with the story, thinking that it might make for a good song. Tom had indeed already read a couple of books about the Donnellys, but decided to do some more research. He and Donnie drove the hundred miles to Lucan, Ontario, where the family had lived.

When they arrived they went for a beer and explained that they were there to research the Donnellys. Not only did no one want to help them, but they refused to even serve them. As with "Reesor Crossing Tragedy," Tom was discovering a community that had no interest in revisiting its past. In Reesor Crossing, however, the wounds were still fresh as the events had unfolded just a few years before. In Lucan the Donnelly massacre had happened more than eighty-five years previously. The community was less concerned with the feelings of any current residents than they were with the idea that the Donnellys still had some sort of hold over the area. They refused to talk to Tom out of superstition.

Tom and Donnie set out on their own to find the location of the old homestead. They ran into a man from another town who told them where the farm had been and pointed out the church where the family was buried. After checking out the foundation of the former Donnelly farm, they decided to visit the gravesite,

which was surrounded by a barbed wire fence. They broke into the graveyard only to be chased away by a passing police officer. Tom didn't learn much about the family during his visit to Lucan, but he did continue researching the family's story and eventually wrote two songs about them. The first, "The Black Donnellys Massacre," was about the massacre itself, while "Jenny Donnelly" told the story of the family's only daughter, who escaped death because she was already married and no longer living at home on that fateful night.

Tom and his friend Reg Chapman attended the Old Time Fiddle Contest in Shelburne, Ontario, that spring. The annual event saw people camping out, with live music being played all over the grounds, not just on the official stages. With some beer and his guitar in hand, Tom set out to make some music. They stopped and shared drinks and songs with a number of people. A man named Elwood Hill happened to hear Tom sing and asked him if he'd like to be in the Hank Snow show, which Hill was producing at Rockhill Park in August. Tom didn't take the man seriously and assumed he was just trying to impress people by pretending to be an important music promoter. Nonetheless, Tom gave him Reg's phone number and said he'd be happy to be in the show.

Tom still thought it was some kind of a setup when he got a call a short time later at Reg's asking him to be at Rockhill on the afternoon of August 19 and enquiring about how he'd like to be credited in the promotional materials. Tom figured Hill was just trying to guarantee an audience and Tom would arrive to discover that he wasn't really going to be on stage. It wasn't until a press clipping arrived in the mail with an advertisement for the show that Tom believed it was a real gig. He was thrilled to see the promotion, which included a list of performers. The star, of course, was Hank Snow, but at the bottom of the list was "special guest star, Stompin' Tom Connors." Seeing his name in print with Hank Snow's was such a significant event for Tom that he chose to end the first volume of his autobiography with that moment. After all

the years of struggle, he finally felt he was going to make it as a country music entertainer.

Tom's first meeting with Snow back in Nashville hadn't gone well, but this time he'd be sharing a stage with the country music superstar. He wrote in the second volume of his autobiography, *The Connors Tone*, "To say I was nervous about the prospects of playing on the same stage as Hank Snow would be an understatement." In the dressing room before the show Tom was thrilled to see his musical hero enter, fully decked out in a rhinestone suit. Tom cautiously approached the superstar: "I turned slightly and took a step towards him, saying, 'Hi, Mr. Snow, I've always been a great fan of yours . . .' he gave me a loud disheartening 'Harrumph,' pushed me slightly, and walked over to where his rhythm guitar player was standing." Snow then proceeded to complain that his guitar hadn't been tuned properly. That was the end of their interaction.

The evening that Tom had been so excited about proved to be a bitter disappointment. He wrote in his autobiography that as he lay in bed that night thinking about what had transpired, "the only resolve I made before going to sleep was that 'if the only chance I ever get to make it in the music business has to come by way of thinking as much of myself as Hank Snow appears to think of himself, then I and the music business have nothing in common, and the powers that be who think otherwise can take their 'opportunity of a big break' and shove it.'"

Alden Nowlan wrote about Tom's feelings towards Snow: "Connors doesn't like to talk about his impressions of Snow then or in subsequent encounters. 'Put down that you asked me what I thought about Hank Snow as a man and I answered, 'No comment' . . . But, look I was crazy about the guy when I was a kid and I still think he's one of the best singers around. Let's leave it at that.'"[6]

Tom continued performing in bars throughout Ontario for the rest of 1967. In November, he went to visit his old friend Bud Roberts, a singer/songwriter who had performed on the same bill with Tom in the past. Roberts had just gotten a record deal, but

didn't have enough of his own songs to fill an LP. He asked Tom if he might write a song for him. Bud had been a trucker previous to becoming a performer and thought Tom might be able to write a trucking song for him. Tom agreed to give it some thought and see what he could come up with.

Richard Flohil wrote of Tom's writing process: "Tom Connors can do amazing (and grammar-shattering) things to make his songs rhyme . . . He writes them (usually late at night, with an open beer at hand, when it is quiet) the way he does because that is the only way he knows how. Tom Connors cannot write about something he has not seen, or experienced, or researched."[7] Tom knew about trucking from having hitched rides with truckers, but he was having trouble coming up with a song for Bud. While playing in Peterborough he finally had a breakthrough and wrote the song that would become arguably his biggest hit.

Tom explained to Pierre Pascau how "Bud the Spud" came about:

> *It was written kind of quickly . . . I wanted to write a song about the Prince Edward Island potatoes and a friend of mine . . . wanted me to write him a truck driving song. And the two songs were coming into my mind at the same time. And I was trying to write one and I couldn't get it written. And I'd try to write the other one and I couldn't. So, what actually happened, I put the two of them together and I got the potatoes on the back of the truck and I was away with a song called, 'Bud the Spud.'*[8]

After his gig in Peterborough, Tom stopped by and played the song for Bud. Roberts didn't seem particularly impressed, but Tom put it on tape and left it with him in the hopes that his friend would include it on his album. It was agreed that if he did Tom would receive credit and royalties and maintain ownership of the song.

In the spring of 1968, Tom blew the engine out of his old station wagon. He replaced the motor but knew the car didn't have much life left. He bought a brand new white pickup truck. Tom had a friend of Steve Foote's build a box for the back of the truck that was basically a small camper with a fold-down bed and table. The box was fairly tall, as it had to be 6'4" inside to accommodate Tom's 6'2" frame (while wearing his cowboy hat). Once the cabin was on the truck Tom thought the whole thing looked like a boot and that became the vehicle's name, the Boot. It saved him money, giving him a place to sleep and eat between gigs, and he had somewhere to store his equipment and records. It became his home away from home. Tom painted the box bright red, adding a guitar to each side and the words, "Stompin' Tom Connors — Star of TV, Radio, Stage and Rebel Records." He had Steve Foote paint a workboot on each of the truck's cab doors. The lettering and the guitar on the box were painted black and blue, so the vehicle attracted a fair amount of attention wherever Tom went. When he was performing he would park the truck in front of the bar or hotel, using it as a sort of mobile billboard.

Tom recorded a second album for Rebel Records called *On Tragedy Trail*. He again signed over the rights to all the songs on the LP as well as a few new songs he had written, including "Bud the Spud." This album, too, had a heavy emphasis on Ontario stories, with "Reesor Crossing Tragedy," "Fire in the Mine" and "Black Donnellys Massacre." Considering that Tom had gained a following in part because of his lively stage presence and penchant for telling jokes, this LP had a heavy emphasis on sad songs. In addition to the songs about historical events, the album contained a number of old style hurtin' country songs. The first track, "Tragedy Trail," a sad love song, included the lyrics "You taught me to cry, Now teach me to die." There has rarely been a more depressing song written than "Little Boy's Prayer," about a man who overhears a small boy praying in church for his mother, who was beaten to death by the boy's father. The boy prays that his father, who is now

in jail, won't also die, before leaving the church and getting hit by a passing car and dying. "Around the Bay and Back Again" is the only track that could be considered a lively bar number, but even that is about a man who is looking for his missing girlfriend, so it's not a happy song.

The cover of the album features a picture of Tom walking through the gates of an iron fence, guitar on his shoulder. He is wearing the black Stetson, looking like the "Stompin' Tom" fans would come to know, though he is still credited as Tom Connors.

By the fall of 1968, Tom heard that Bud Roberts had released his debut album and hadn't included "Bud the Spud." Tom figured his friend must not be interested in the song, so he started performing it himself and got a good response. Performing it one night in Sudbury led to an interesting opportunity. According to Terry O'Reilly of CBC's *Under the Influence*, Carl Dewar, who had just opened a tire store with his business partner, Vic Duhamel, was on his way to a hockey game at the Sudbury arena when he noticed a sign in the window of the Towne House Tavern: "Tom Stomps at 9." Carl wasn't sure exactly what it meant, but during the first intermission he and some friends slipped into the bar for a quick beer as the arena wasn't licensed.

Tom was on stage, singing "Bud the Spud" to a nearly empty bar. Carl liked the song immediately and asked Tom if he might write a jingle for his tire business. Tom agreed and dropped by the store the next day. He pulled up in the Boot and went inside to talk to Carl and Vic about what they were looking for and to learn a bit more about their business. Carl told Tom he'd like a song similar to the catchy ones he'd heard the night before. Tom said he'd see what he could come up with. He went outside and sat in his truck for just half an hour, then returned and played the song he'd written for them. The jingle, which had three verses, opened with the lines, "When your tires are old and worn and you know they should look newer, Just drive down to the Tire Town and see Duhamel and Dewar." Carl and Vic loved it and used it as their jingle for the next

fifteen years. Tom wasn't paid in cash, but instead drove away with a new set of snow tires.

In November 1968, Tom was asked to be a last-minute replacement for a show in Coburg, Ontario. Tom was one of a number of artists performing that night and he arrived shortly before going on stage, so he didn't know who else was in the lineup. One of the songs he performed was "Bud the Spud." He walked off stage to discover an angry Bud Roberts, who was also scheduled to perform. According to *The Connors Tone*, Bud said, "Well, you're some kind of a nice guy aren't you? What kind of a dirty trick was that supposed to be?" Tom had no idea what he was talking about, but Bud went on, "I thought you wrote 'Bud the Spud' for me."

Tom explained that he had given Bud permission to record the song, but he never gave him ownership of it. He added that, since Bud hadn't used it on his album, he assumed he didn't want it. Bud said that he was saving it for his second album, but by then it was too late. The two men were upset with each other, and Tom took his song back. It would be the title track of Tom's next album.

Although Tom had been touring extensively for the past few years, and he tried whenever possible to get signed contracts for return engagements before leaving a bar, he didn't have much work lined up for the end of 1968. The contracts he did have wouldn't start until after the new year. It was looking like Tom was going to have another rough Christmas.

He was well known in the bar circuit in Northern Ontario and he had released almost a dozen singles independently, as well as two albums with Rebel Records, but he wasn't making any inroads in Toronto and he still couldn't get radio to play his music. He was told it was too "regional," because it mentioned Canadian place names and that it didn't have that Nashville sound. While Tom's production values were sparse, the crowds he drew in bars from Timmins to Sudbury and Peterborough led him to believe that people liked his music. They just had to hear it.

When Tom complained to his friends Reg and Muriel Chap-

man that he couldn't catch a break in Toronto, they suggested that maybe he should clean up his image. They talked a reluctant Tom into wearing a suit to an audition at a Toronto bar. It did not go well. Tom said he looked like the "ambassador of France" as he hopped out of the Boot with his guitar and went into the Edison Hotel, which featured country music. When he started stompin' his board and yodelling, dressed in a suit and bowler hat, the crowd laughed uproariously. After twenty minutes the owner said, "Get the f--- away from me. You stink, stink, stink." Tom dumped the suit and never looked back. Perhaps the cowboy boots, western shirts and hat weren't impressive as a performer's "costume," but they were authentic and Tom decided that moving forward he would just be himself.

For months Tom had been pestering Jack Starr, the owner of the Horseshoe Tavern, about performing there. By this time the Horseshoe was twenty years old and had become a legendary country music venue in Toronto. It proved particularly popular with misplaced Atlantic Canadians, often featuring East Coast musicians. On the weekends it hosted some of Nashville's biggest stars, including Loretta Lynn, Waylon Jennings, Conway Twitty and Charley Pride. As Tom wrote in *The Connors Tone*, "This was our equivalent of the *Grand Ole Opry* in Nashville. This was the place where the country music fan felt the same as a hockey fan would feel on entering the Montreal forum. This was where you could see the pictures of all those stars you had heard singing on the radio since you were a kid. And they all played on this very same stage."

Mickey Andrews, Gerry Hall and Randy MacDonald were East Coast musicians who made up the house band at the Horseshoe. They called themselves "The Good, The Bad and The Ugly," inspired by the Clint Eastwood movie of the same name. Hall, who played lead guitar, was from Newfoundland, while Mickey Andrews, who played steel guitar, and Randy MacDonald, who played bass, were both from Cape Breton. Andrews had seen Tom at the Matador Club after hours and recommended him to Jack Starr. Mickey said,

in an interview for this book, that Jack told him, "This guy's been calling me for a long time, six months, seven, maybe even more than that... It's funny, but I plan on giving him a shot."

Tom was thrilled when Starr told him he was going to try him out. Tom was scheduled to start on a Monday at 9 p.m. He arrived at 4 p.m. and sat there for five hours, staring at the stage, finding it hard to believe that he would be performing at the 'Shoe, as it was often called. As Tom started playing with the band that night, they initially had a hard time establishing their tempo. The band tried to follow Tom's foot, but it took them a while to realize that he was hitting his stomping board on the offbeat, rather than the downbeat, as most percussionists would do. Once they had that sorted, the four of them were in sync and had a great week.

For Tom this was one of the easiest gigs he'd had in years. As a single he was used to performing for four or five hours with just the occasional ten minute break. At the Horseshoe he performed with the band for half an hour, then the band performed for half an hour and then they all took a half hour break. Tom took full advantage of his time off stage. He spent that hour meeting everyone in the audience, having a beer with as many of them as he could and selling his records. At the end of the night, Tom was at the door saying goodnight to everyone by name. Before the week was over, Starr had signed Tom for a return engagement of three weeks in February.

As 1969 started Tom found himself touring Northern Ontario fulfilling some commitments he had made the previous year. When he got back to the Horseshoe in February, it was a turning point in his career. For the rest of his life he would have a gig whenever he wanted one.

It was customary for the Horseshoe's performers to appear on a local television program called *The Bill Bessie Show*. One day, after a live appearance on the broadcast, Tom got a phone call while he was still at the studio. The woman on the other end of the phone asked if he was Tommy Messer from Skinners Pond. When he answered that he was, she said that she was his stepsister, Marlene,

and that she'd been looking for him for years. Tom had not been in touch with any of the Aylwards since he last visited PEI fourteen years before.

Tom went to visit Marlene and her husband and two small children the next day. They caught up on all that had happened in the intervening years and shared stories about their childhood. Marlene was surprised to hear Tom's stories about Cora, because her memories of the woman were very different. Tom wasn't particularly surprised, as Cora had always treated Marlene differently and seemed to genuinely love the girl as a daughter.

By the time Tom became a regular at the Horseshoe he had played countless hotels and bars and learned how to work a crowd. He told Peter Gzowski:

> There's more to singing than just singing. You have to be an entertainer. When I was out there, I know for a fact, that people in every room that I ever played they became friends instantly. When I seen two tables sitting together and they weren't talking to one another I would introduce them, right off the stage, one to the other and say, 'Hey grab that guy by the hand, because he's a fisherman from Newfoundland and you're a lumberjack from Northern Ontario. Why don't you get to know each other?' And I'd sing a song for each of them. And next thing you know, Stompin' Tom was the go between and I'd say, 'Well, I'll be down to have a brew with you after there' or something. So I'd go down and we'd all talk and the next thing you know they put the two tables together and from that time on they're friends.[9]

Tom created a friendly, down-home, party atmosphere at his shows. He often commented that he was fully aware that he wasn't the most talented of performers, but he used that to his advantage

as well. He could easily be the guy who stops by your bonfire to sing a song or the friend who brings his guitar when he drops by the house on a Saturday night. Dick MacDonald wrote in the *Atlantic Advocate* that "Stompin' Tom Connors has a raunchy voice, a gravelly voice. And he certainly isn't the country's best guitarist, to say the least. But he touches the spirit. And that's probably more important than anything else."

By the time Tom left the Horseshoe at the end of his three-week gig in February, he had been invited to come back for a five-week stint in May. In the interim, he continued performing in bars and hotels around Ontario. While he was getting big crowds and a favourable response for his live shows, he still couldn't get many radio stations to play his music. A few stations in Northern Ontario had started to play "Sudbury Saturday Night," although it had been banned in Sudbury itself, because the local radio station didn't want to offend INCO.

Tom returned to the Horseshoe in May, and by the end of his third week he was selling out all 300 to 350 seats. Until then the bar had only been packed on the weekends when the big Nashville stars came to town. Starr offered to double Tom's salary if he'd stay for another five weeks. Tom cleared his schedule and accepted the gig. According to the book *The Legendary Horseshoe Tavern*, written in 2017, "This stretch of ten straight weeks for a single featured performer and twenty-five consecutive nights in a row became the official record of endurance that still stands today."[10] Tom's performances at the Horseshoe became legendary in Canadian music. He had been saying forever that Canadians wanted and needed to hear their own stories. He was finally being proven right. Even Willie Nelson, who was booked into the 'Shoe and happened to catch Tom on stage one night, recognized that he was a special kind of performer. A story in *The Legendary Horseshoe Tavern* quotes Nelson as saying, "That guy's got something goin' for him. He's gonna turn out to be somebody."

## Chapter Six
# The Star

Well I had my hopes of being a "Star,"
But not for selfish greed,
I wanted my country to take the credit,
For me if I succeed.

— "Ripped Off Winkle"

Tom took full advantage of his time at the Horseshoe to hone his performance. Not only did it give him the opportunity to provide a fuller sound, as he was now backed by a band, but he also had the opportunity to work on his shtick, settling on jokes and stories between songs that he would use for decades.

Mickey Andrews said in an interview for this book,

> *He'd come across 'off the cuff.' It felt spontaneous. But after you got to know him, [you realized] that was the way he worked. He was very smart like that. He knew how to promote himself on the stage. He knew what he was about. He knew exactly who he was. He was a very bright guy. Like, when he came in, he sang some of their old songs. Like some of the people, his heroes. And he sang some of his songs, like 'Bud the Spud' and a few of the songs about the little towns he'd been in*

> *. . . and then eventually he was singing mostly all his own stuff.*

Music promoter and writer, Richard Flohil noted that Tom's years of playing rough bars had helped him to sharpen his skills as a performer. He wrote that under those conditions, "You have to know how to hold a crowd's attention at the same time the bouncers are throwing out a drunk, and you have to entertain people who are not used to the disciplines and manners of the concert hall."[1]

By now Tom was electrifying to watch on stage. He stood there on one foot, with the other keeping the beat, slamming down onto his little sheet of plywood, harder and louder as the songs got faster. He acted out every song, adopting accents, hooting and hollering, throwing in made up words and sounds. When he sang Jimmie Rodgers's "Muleskinner Blues," he'd twist his face and cross his eyes, all the while yodelling and quacking like a duck. And in between songs he'd banter with the audience and tell off-colour jokes. Tom told television host Carmen Kilburn, "I've never been scared to make a fool of myself . . . I like to see my audience . . . I like to see the faces. And once I play into that and they play into us guys, all of a sudden there's a rapport goes on. And when that happens . . . the level just rises a little more and a little more as the show goes on. Oh, we have a hell of a time. It's fun."[2]

Tom knew that part of his appeal was the stomping and he came to embrace that. He started each show by walking out with his plywood in hand and plunking it down in front of the mic before he tore into his first number. At the end of each performance he would pick up the board, blow off the sawdust and wave it over his head as a farewell while exiting the stage. Tom explained that the response of the crowds at the Horseshoe gave him the freedom to just be himself. He wrote, "While most other Canadian acts up till then were trying to imitate their American counterparts, even to the point of copying their accents, I came on stage with a new kind

of confidence. I came on stage as 'Stompin' Tom from Skinners Pond.' Like it or lump it."

Not only did Tom not imitate American country artists, but Mickey Andrews believes that a number of those American artists took inspiration from Tom. He said,

> I think that Tom was, indirectly, not knowing this himself... partly responsible for the country outlaw movement in the States. When Willie and Waylon played the Horseshoe early on — like they were there in the '60s, late '60s and '70s, while I was in the house band — they were clean cut. They wore suits and ties. They had a college like, police style, short haircuts kinda thing. Very tidy. Like nudie suits you would call them. Names on their guitar straps and all that. Now, Tom, to give you a picture of him. He was just the opposite of all the people that played there. Like he would wear an old black cowboy hat, sort of faded jeans. He had a cowboyish kinda shirt, and a black vest and old, well worn cowboy boots. He'd be like Clint Eastwood in the early, Fistful of Dollars kinda movies... Tom looked like a cowboy. Like one of the bad guys from a B western or something. The black hat. You could almost imagine he wore a gun belt on his hip or something... He was tall and lanky. Just the way he stood, he had a drifter look to him.

Andrews firmly believes Tom had an influence on these other artists. If one looks at pictures of those musicians before the early 1970s, when they would have seen Tom at the Horseshoe, they did have a much more clean-cut style, and it soon changed.

In addition to performing at the Horseshoe, Tom was still touring Ontario, and he had started to employ "mysterious advertising" for his shows. He would put a large question mark on a poster and

then in progressively smaller print he would write something along the lines of "Guess who's going to be playing at (a certain bar) on a (certain date)." He signed the bottom of the poster with a signature too small to be legible. He would put the posters on telephone poles late at night and then the next day sit in his truck and watch people read the signs. The curious would often call the named bar to find out who was playing. The increased calls to the lounge made the owners think Tom had a huge number of fans.

Tom was not above playing tricks on bar owners in order to get a gig. Lyle Dillabough, an Ottawa Valley writer and singer/songwriter, tells a story about the first time Tom arrived at the Mississippi Hotel in Carleton Place, Ontario, looking for work. The owner, Lorraine Lemay, agreed to let him audition to an almost empty bar. Lyle, who heard the story from Lemay, said in an interview, "He came in carrying a guitar and a bit of a board. And there were four guys . . . all sitting there in the afternoon, drinking beer. And he bribed them. He said, 'Mrs. LeMay's going to let me audition and I'm going to get you some beer and I want you guys to hoot and holler.' And they did. And he got the job."

Tom may have played the simple, down-home, heavy drinking partier on stage, but in reality he was a good businessman who was very smart about publicity and promotions. At the Horseshoe he started putting books of matches on every table. He couldn't afford to have them printed, so he had a stamp made and paid his friends' children a few dollars to stamp the matchbooks with a picture of the guitar from the side of the Boot and the words, "Hometown Songs by Stompin' Tom." He claimed that he handed out close to 10,000 books of matches.

One night at the Horseshoe, Mickey introduced Tom to Jury Krytiuk, a young man who was the head of Canadian Music Sales' small record label, Dominion Records. Krytiuk had come to the bar that night to see The Good, The Bad and The Ugly, because he was interested in making an album with them. Mickey, however, had seen how many records Tom was selling and said to Jury, "This

guy here really sells a lot of records. He'd sell more than we would." After watching him perform, Jury approached Tom and asked him what label he was signed to and if he was happy with them. Tom explained that he was with Rebel Records, but it wasn't going well. He still hadn't been reimbursed for his studio time, he had received no royalties, the company had no real distribution and they weren't helping to get him on radio. In fact, Tom was so unhappy with the arrangement that when he wrote his autobiography he didn't even mention the company's name. He refers to his contact at the label, John Irvine, only as "Mr. Irvin." Whether this was a mistake or a deliberate attempt to make sure the man got no credit in Tom's eventual success is unclear.

Jury told Tom that he was the head of Dominion Records, but he had already spent his entire budget without having any success. He had not produced a record that sold more than 125 copies. In a 1978 interview, Krytiuk said that when he met Tom they were in similarly bad situations, but Jury thought perhaps they could have a little more success together. He said, "So we were crying into each other's beer. From my point of view, I told him that if he signed with the company I was with at least if there was a penny, he'd get it; it was an honest company."[3]

The next day Tom met with Jury and his boss, Sinclair Lowe, who offered Tom a contract if he could get out of his agreement with Rebel Records. Tom wrote to Rebel, stating that they had not lived up to their end of the deal and asking to be released from his contract. He also said that he wanted to buy back the rights to all of his songs and get the masters from his two albums. Tom received a reply from someone he had never heard of, saying that he had purchased Tom's music and it would cost $3,000 to get it back. It was expensive, but Tom just wanted to be rid of the company and once again own his music. He couldn't afford the full amount, but he paid half and Dominion Records gave him the other half as an advance. Tom would retain ownership of his songs for the rest of his life.

It's interesting to note that the songs are all credited to T. C.

Connors even though Tom's legal name was Charles Thomas Connors. It's doubtful he legally changed his name and more likely that since he went by "Tom," he chose to use that initial first in his song credits.

In August of 1969, Tom was in the studio to record his first LP for Dominion Records. The recording was done at the RCA Victor Studios in Toronto and the title track was "Bud the Spud." According to Krytiuk, because he had already spent his entire production budget, Tom agreed to once again pay the upfront costs of the recording. Krytiuk told *Canadian Composer* magazine, "I didn't have any money left to record him, but he said he'd got $500 saved up, and that could buy six hours of studio time and four hours of mixing, and he could get the house band from The Horseshoe."[4]

*Bud the Spud and other Favourites* was recorded in a day, like each of Tom's first two albums. However, having The Good, The Bad and The Ugly record with Tom, gave him a fuller sound. This time he insisted on using his stomping board as well. When he walked in with his piece of plywood and was asked what he was doing, he replied, "That's my 'drum' and I intend to stomp my foot on it . . . I've been talked out of using the boot and the board on my first two albums, and there's no way I'll be talked out of it this time." Mickey Andrews remembers how important the stomping was to Tom on the recording. He said, "His main concern was 'get the board right.' The sound of his foot pounding the board." Tom knew people came to see him stomp, he was going to make sure they got to hear it on his recordings too!

Mickey added, "I was a drummer so I overdubbed a little drums . . . and I played dobro and steel guitar. I would add Johnny Cash tick tock, clinkety clink. You know how you hear that backup sound? That was deliberate and he liked that." He continued, "Within three hours we did that album. Everything was done live. We were all in the same little room. And we went song to song to song." The recording went quickly in part because the four of them had played these songs together at the Horseshoe for about thirteen

weeks at this point in time. Not only were there more instruments on these recordings, but Tom also used sound effects for the first time. "Bud the Spud" opens with the sound of a transport truck racing by and later includes a police siren and a honking horn. Moving forward, sound effects would become a fairly common feature of Tom's recordings. The album, which included fourteen tracks, was mixed the next day.

Tom included "Reversing Falls Darling" on the album, the first song he ever wrote. He told Alden Nowlan that he used the song because, "I guess I figured I owed that to the little guy,"[5] referring to his eleven-year-old self. The album also included "The Ketchup Song," a new recording of "Sudbury Saturday Night," which had appeared on his first album, and "Gone with the Wind (I'll Be)," the song he had hand delivered to Hank Snow years before. Another song, "Luke's Guitar (Twang, Twang)" would prove to be one of the album's most popular numbers. The song, which had originally been recorded as one of Tom's CKBG singles in Timmins, opens with Tom's growl, sounding a bit like a pirate's, as he spits out the nonsense lyrics, "Twang twang a diddle dang, A diddle dang a twang a twang." The song tells the story of a man who hocks everything he owns to satisfy his wife's desire for new clothes. The one thing he refuses to sell is his guitar, ultimately choosing it over his wife, with the line, "If she don't come back, I won't be sore, 'cause I don't give a hoot about her no more."

Within a few weeks the album was released as both an LP and an eight-track tape. For the first time, Tom was credited as "Stompin' Tom Connors." The first single from the album was "Bud the Spud," with another of the album's tracks, "The Old Atlantic Shore," on the B side. The song was sent to every country music station in the country, but a couple of weeks later there was no indication that any of them had added it to their playlist. Eventually Jury told Tom that a Halifax radio station had started to play it. In *The Connors Tone*, Tom berates himself for not remembering the name of the DJ who was the first to support what would become his signature

song. Tom was still so grateful to this man, more than twenty-five years later, that he wrote in the book, "Maybe if he reads this he'll jot me a note?"

A couple of other East Coast stations, including CFCY in Charlottetown, PEI, began to play the song. According to Tom's memoir, it was being played not because the programmers were supportive, but because their listeners were calling and requesting the song. No doubt as a result of the popularity of "Bud the Spud" in Tom's home province, he was offered a two-week gig at the Prince Edward Lounge in Charlottetown. Marlene had been telling Tom that he should try to visit Russell and Cora, so he thought if he went to the Island perhaps he could reach out to them.

Tom drove the Boot east for his first contract in the Maritimes. When he arrived at the bar he thought the owner, Johnny Reid, looked familiar. A few days later he realized that the two had met years before when Tom and Steve Foote were hitchhiking on the island. The two young men had spent a night in the Charlottetown jail. That evening a man was brought in on bootlegging charges. He made a huge commotion, shouting at the officers that they had made a terrible mistake and that he would be suing the police department, the city and anyone else he could think of. That man was Johnny Reid. As they recalled that night, Johnny remembered Tom as well, and Johnny told Tom that he did indeed sue the city and that's where he got the money to buy the Prince Edward Lounge.

Tom attracted good-sized crowds in Charlottetown and the bar was almost full on the weekends. When people found out Tom had grown up in Skinners Pond, he received the warmest welcome the island had ever given him. It was as if the prodigal son had returned. "Bud the Spud" proved very popular at his shows and he sold a lot of records. At the end of this two-week gig, he decided to go to Skinners Pond to visit the Aylwards for the first time since he had been there with Steve Foote, fourteen years before. When he arrived, unannounced, Russell answered the door and was thrilled

to see him. Cora even hugged him and said, "Welcome home," before offering him something to eat. He gave them a couple of copies of his latest LP and sang a few songs before suggesting he should get going. They insisted that he stay for the night and told him that he was welcome for a few days.

Cora didn't seem terribly interested in Tom's life, but she wasn't as cruel as she had been in the past. Tom and Russell stayed up, drinking homemade beer, and catching up on all the local gossip. Tom suggested, as Marlene had, that Russell and Cora come to Toronto for the winter where it was milder and might offer them a change of pace.

Tom was asked to perform at a fundraiser for the Parish Hall in nearby Tignish. The show sold out and the crowd went so crazy for "Bud the Spud" that Tom performed it almost half a dozen times that night. He wrote in his memoir, "I thought they were going to tear the place down. And they almost did before the song was over. I don't know how anybody heard the song I was singing; they were making so much noise, I couldn't even hear myself." He sold close to a hundred records that night and donated his share of the door receipts back to the hall. It was a nice homecoming, and after a few days he was on the road back to Ontario.

In addition to releasing the *Bud the Spud* LP, Tom's contract with Dominion Records included the re-release of his first two albums. Tom was furious to discover that Rebel Records had somehow "lost" the masters. Steve Fruitman related the story as told to him by Connors: "He recorded those two albums twice," Fruitman said in an interview. "When they gave over the artwork and the publishing rights, they conveniently 'lost' the master tapes." Referring to John Irvine, Fruitman says, "He was trying to give Stompin' Tom a hard time." He continued, "I like the Rebel Records ones better because Tom was more sincere in his delivery on the first two albums. Because he was pissed off when he had to re-record them. He was just, you know, 'The hell with it. I have to do this.'"

Although the Rebel Records versions of the LPs are long out of

print, a few tracks have been posted online. The differences in the recordings are subtle, but certainly noticeable to a true Tom fan. Tom's second recordings of these songs are generally faster and most of the tracks are shorter. Only "Maritime Waltz" and "The Northern Gentleman" run a bit longer on the second recording. The other fourteen tracks are all anywhere from ten to thirty-four seconds shorter. It does seem as though Tom just wanted to get the recording done as quickly as possible. It's interesting to note Tom's growth as a performer in those two years. One of the most noticeable differences between the two recordings is on "Sudbury Saturday Night." By the time he returns to the song he has started to exaggerate his accent and incorporates more of a "let's party" attitude. It is no doubt this latter version of the song that most Canadians are familiar with, whereas the original Rebel version is much more subdued. The artwork for the two releases are the same, except that the Dominion recordings list his name as Stompin' Tom Connors.

In early December of 1969, Tom was back at the Horseshoe. Russell and Cora had come to Toronto to spend the winter with Marlene, and the whole family came to see Tom perform. The Aylwards were a little overwhelmed being in Canada's "Grand Ole Opry" and witnessing the crowd's reaction to Tom, but he thought they seemed proud of him. He had waited a long time to get that reaction, particularly from Cora.

Tom wrote in *The Connors Tone*, "As an entertainer, if you played on the stage of the Horseshoe Tavern you were already a star. You may not have been an international superstar, but you had already reached that first plateau. And all you needed now was that first big hit record." He went on to say that a performer of course, needed the right song, but even more importantly, "Ninety-nine percent of all recording artists must have media exposure, especially on radio, before their song can be considered a big hit." Tom had mastered live performance, but he wanted a hit record. "Bud the Spud" had been released in the summer, but it still

wasn't getting any airplay in Ontario. He would drop by the country music radio stations, with his LP in hand, and talk to the DJs. He would usually hear that they didn't have the album despite the fact that Dominion had sent a copy to every station in the country.

According to a story at Library and Archives Canada, radio programmers in the 1960s "felt that a Canadian record could automatically be trashed without listening to it, because it was, by definition, inferior to the American product. Good English-Canadian artists, it was assumed, would follow the traditional route, pioneered by Guy Lombardo, Paul Anka and countless others, and find success in the United States, before they would receive recognition at home."[6]

Because Jack Starr bought advertising on CFGM, one of Toronto's large country radio stations, they would often play songs by artists who were scheduled to perform at the Horseshoe, particularly the big American artists who played there on the weekends. When Tom complained to Jack that he couldn't get his music on the radio, Jack asked CFGM to play Tom. They did, but according to Tom it was only in the middle of the night.

Tom may not have been getting airplay in Toronto but he did get some unusual publicity in December of 1969. As Tom tells the story in his autobiography, he was surprised on his first night back at the 'Shoe when a patron mentioned that he saw Tom's name going up on a billboard. The next night one of the guys from the band said they, too, had seen a billboard with Tom's name on it, just down the road from the Horseshoe. Between sets Tom and his band members went to check it out and were surprised to see a large sign that read, "Stamp Out Stompin' Tom." Tom said that he jumped out of the car and stood there in shock. He wrote in his memoir, "'Who in the hell put that there?' I asked. 'And what in the hell is it all supposed to mean, anyway? Did Jack Starr put it up? And if so, why would he want me stamped out?'" Tom wrote that one of the guys from the band said, "Well, one thing about it, Tom, it can't do you any harm. All publicity, they say, is good pub-

licity." Tom talked to Starr who said he was not responsible for the billboards, which eventually popped up all over the city.

People began to speculate that Tom's old record company was behind the signs. Or perhaps Idaho or New Brunswick potato farmers had done it because they weren't impressed with Tom's claim in "Bud the Spud" that "the best doggone potatoes that's ever been growed" were from Prince Edward Island. One of the crazier suggestions was that the Beatles, who had recently played Toronto, didn't like Tom's music.

The billboards generated so much publicity that Tom was contacted by *Canadian Panorama* magazine. After assuring them that he hadn't put up the billboards they took a picture of him in front of one of them and ran a story in their magazine. The company responsible for creating the billboards would only say that a man had come into their office and paid in cash, with the receipt made out to the same and that he never gave his name. The billboards stayed up for about six weeks. Less than three weeks after the billboards first started appearing, Tom hit the country music charts for the first time. On December 20, 1969, "Bud the Spud," entered RPM's country singles chart at number 48. It would stay on the charts for a couple of months, peaking at number 26 in February of 1970. It was Tom's first top forty hit.

As he told Alden Nowlan in 1972,

> *One thing that attracted a lot of attention to me in Toronto was there was somebody put up these billboards all over town, saying 'Stomp out Stompin' Tom.' The funny thing is I don't know to this day who it was that put those billboards up. I don't know if he liked me or hated me: damn few people are neutral about me when they hear me sing! I do know it wasn't me, not on the $200 a week I was getting paid then.*[7]

In *The Connors Tone*, published in 2000, Tom includes the picture of himself in front of one of the billboards, which ran in *Canadian Panorama*. He wrote under the picture, "We still haven't found out who did it."

The person behind the billboards was finally revealed when *The Legendary Horseshoe Tavern* was published in 2017. Mickey Andrews claimed it was Tom himself. He said, "One of the biggest things Tom did [and] he didn't even tell us, is he spent all his money on these big billboards around Toronto that would say Help Stamp Out Stompin' Tom. You didn't know how to take it . . . it created a big thing about him because they wouldn't play him on the radio."[8] In an interview for this book Mickey recounted the night he first saw the billboards: "I said, 'Tom, what the heck's going on there?' It sounded negative at first. But then I realized and he gave me this sly look." But as Andrews said, "He just smiled and took it all in, he made people talk about it. That's why I thought he was brilliant." Tom eventually admitted that he had put up the billboards. Andrews said, "When he finally did tell us . . . he put up about twenty which cost him $750 each. He told me he put his last cent into it 'cuz that's the way he promoted himself."

If Tom did create the billboards, it's interesting that he used the opportunity to attack himself. He could just as easily have printed, "We Want Stompin' Tom on the Radio," or something supportive. Instead, he created a controversy and made himself out to be the victim. Tom never backed down from a fight, and it would appear that on occasion he invented his own rival. For the rest of his career, he always had to have an adversary. The billboards are mentioned in a short biography of Stompin' Tom that appears in the book *Maritime Music Greats*. The author says that Tom didn't know whether the person responsible for the signs, "was genuinely trying to snuff out his popularity or slyly trying to create more sympathy for him." As it turns out, Tom was "slyly" creating more sympathy for himself.

In January of 1970, Tom was back in the studio to record a five-album box set, featuring sixty of the country classics he had been singing since he was a child. The album, called *Stompin' Tom Connors Sings 60 Old Time Favourites*, included songs like "Big Rock Candy Mountain," "Muleskinner Blues," "Wabash Cannonball" and the song he sang for Olivar so many years before that led to his first kitchen party, "Blue Velvet Band."

In early 1970, Tom had one of his few forays into the United States. Jury Krytiuk had arranged for him to appear on WWVA, the famed country music station from Wheeling, West Virginia, whose broadcasts could be heard through much of the United States and eastern Canada. Tom appeared on the show and his performance was well received. He claimed that the live audience was eventually clapping along and tapping their feet, and during "Muleskinner Blues" they were "falling in the aisles from laughing so hard." He received a standing ovation and had to come back to bow twice more. Unfortunately, it didn't lead to any kind of real breakthrough in the American market or an invitation to return.

The morning after the performance, Tom, Jury and Tom's friend, Reg, who had accompanied them on the trip, went for breakfast. When it came time to pay, Tom had to use a Canadian nickel or break a twenty dollar bill. When Tom gave the cashier his money, including the Canadian currency, the man at the counter tossed the nickel back at Tom, asking if he'd gotten it from a box of Cracker Jacks. Tom explained that it was real money. He said that he was visiting from Canada, and that five cents in Canada was actually worth more than five American cents, given the current exchange rates. The man made Tom break the twenty so he could pay his full bill with American cash, saying, "You can't buy food to run a restaurant with phony nickels." Tom was so furious that he walked back to the table where he had left an American five dollar bill as a tip. As the waitress cleared the table he grabbed the money from her hand and said, "Excuse me, I'm from Canada. And if you want to know what this is all about, ask that son-of-a-bitch up

there behind the cash." He then threw his Canadian nickel on the table and left.

In early 1970 Tom was back in the studio to record *Stompin' Tom Connors Meets Big Joe Mufferaw*, his second album for Dominion Records. The LP got its name from what would prove to be one of Tom's biggest hits, "Big Joe Mufferaw." Although Tom usually wrote his songs quite fast, this particular track took a few months to compose and caused Tom some legal troubles. The previous summer, one night after a show at the Mississippi Hotel in Carleton Place, Ontario, Tom said he went to a house party at a farm. There was lots of music and people were telling stories. There was an older man sitting in the corner who caught Tom's eye. He was clearly enjoying the evening, but after a lot of the stories the old man would say, "That's a mufferaw." Tom had no idea what the old man meant and as the evening wound down he approached him to ask exactly what a "mufferaw" was.

The old man explained that his grandfather had worked with a lumberjack and legendary strongman named Joseph Montferrand who lived in the area in the early to mid-1800s. Stories spread of Montferrand's legendary strength, claiming that he could easily kick the roof off a tavern, that he could cut a ten-inch tree with one swing of his axe and that he had single-handedly fought off forty Irish lumberjacks. The anglicized version of Montferrand's last name was Mufferaw, and because so many exaggerated stories were told about Joe his last name became synonymous with tall tales.

As the old man recounted some of the stories about the famed lumberjack, Tom commented that it sounded a lot like the legendary American figure, Paul Bunyan. He thought perhaps Joe was based on Paul. The man pointed out that it was the other way around. According to Tom's memoir, the old man said that in French Joe had sometimes been called Bon Jean, which became anglicized to Bunyan. A story about Joe's giant bullfrog became Paul's blue ox. While stories about Joe had been in circulation since

the mid-1800s, Paul Bunyan first became popular when he was written about by William B. Laughead in 1916. Tom was intrigued and did some further research at the Ottawa Library. He then wrote the first verse of the song at the Mississippi Hotel.

He worked on the song for the next few months. In early 1970, Tom met a man named Bernie Bedore, who had written about Joe Mufferaw for a number of years. Tom accepted a small chapbook from the man, which included some of the Mufferaw tales. Tom wrote in *The Connors Tone*, "One of the stories in the pamphlet which I found especially interesting was the one where Joe Mufferaw had to swim both ways in a lake one day to catch a bass that was cross eyed. I didn't know whether this was a Badore [sic] creation or just one of the ongoing oral traditions he may have picked up somewhere." Tom included a line about this story in his song, with the lyrics, "He jumped in the Calabogie Lake real fast, And he swam both ways to catch a cross-eyed bass."

Bedore sued Tom for plagiarism, asking for some form of compensation. After Tom's lawyer sent a letter back disputing the claim the suit was dropped, but the issue remained contentious. As late as 2000, Stompin' Tom's company was fighting the Bedore family over the trademark for "Big Joe Mufferaw." Bedore's family maintains the rights.

Tom wrote a few other songs specifically for his Mufferaw album, including "Sable Island" and "Roll on Saskatchewan." He also wrote "The Coal Boat Song," inspired by his time working on the coal boats when he was fifteen. The song tells the story of a man working the boats who falls in love with a woman who at first rejects him because he's a "dirty old man," referencing the coal dust that covered him. With his penchant for acting, Tom becomes the narrator, singing the song in the voice of a "dirty old man" with a strong Cape Breton accent. The album included his second song about the Donnellys, "Jenny Donnelly," and a new recording of "Algoma Central 69." Like *Bud the Spud*, this LP included songs that represent many different regions of the country.

The album gave Tom his first number one single when "Big Joe Mufferaw" hit the top of the charts on May 23, 1970. Oddly, when Tom heard the news he wasn't excited — he was doubtful. He wrote in *The Connors Tone*, "I thought this was rather odd, however, because with all the driving around I was doing, I hadn't heard it on the radio anywhere . . . I put it down to the possibility that maybe they were playing it out west."

In the late spring of 1970, Tom was back in the Maritimes, touring with the American performer Doc Williams, followed by a few dates on his own. He played to large crowds at the Prince Edward Lounge for two weeks and performed at Holland College. He was invited to appear on a CBC television program taped in Halifax called *Countrytime*, but had to fly there in order to fit in his previous commitments. Tom's first song on that program was "Bud the Spud," and after enthusiastic applause from the Halifax audience the host joked, "Well, I don't know if I'd rather keep him in plywood or keep him in boots. One way or the other I think it'd be pretty expensive."

Tom then sang "Big Joe Mufferaw" and followed it up with the Hank Snow classic, "I've Been Everywhere." He performed the first bit of the song as Snow did, telling a trucker all the American places he's been. Tom then inserted new lyrics, saying that the trucker turned to him and said, "Listen, Buddy, I'm a Canadian truck driver and I want to hear a little of the North Country for a change." Tom then listed a number of locations in Ontario and Quebec before making it to the Maritimes and singing "Moncton, Chatham, Saint John, Campbellton" and another twenty or so East Coast communities. The audience burst into applause as Tom made the song Canadian. As Rick Salutin wrote in the *Toronto Star*, "Stompin' Tom took Hank Snow's 'I've Been Everywhere' and replaced U.S. names with Canadian ones. Snow was born in the Maritimes, like Connors, but he went south and glorified 'their' map. Stompin' Tom brought it home and kept it here."

When Tom got back to Charlottetown he was greeted at the

airport by a number of politicians. Dan MacDonald, the minister of agriculture, presented Tom with a "Gold Spud" to thank him for increasing the sales of PEI potatoes with "Bud the Spud." Tom was whisked away and sat atop a large pile of potatoes on the back of a truck for a parade through the city. Johnny Reid had helped to arrange the event and Jury Krytiuk had flown in to be there, driving the Boot in the parade behind the potato truck. Tom was now a big star on Prince Edward Island.

Tom's return to Prince Edward Island was a success until he went to CFCY, the Charlottetown radio station. It was agreed that Tom would do a late-night interview after one of his shows. He arrived at the station after 1 a.m., and when the DJ grabbed *Bud the Spud* from the station's library so he could play a few songs he discovered that someone had scratched all the songs except "Bud." According to Tom's memoir there was a note attached that read "The only selection suitable for play on this album is 'Bud the Spud.'" Tom said this was not atypical; despite the popularity of his live shows, he still couldn't get played on the major radio stations. He said that the two most common reasons given were that his music didn't fit a station's format and that it didn't have the same production values as a Nashville recording.

It would become one of the defining characteristics of the legend of Stompin' Tom that he achieved his success without radio play. However, the facts don't support this. Or certainly not the RPM charts. According to a history of the charts on the *Library and Archives Canada* website, the charts were "compiled from sales figures, radio and television play, and discussions with record companies and retailers." These were the charts that music programmers used to determine their playlists.

From the time Tom entered the charts with "Bud the Spud" in December 1969 until May 1974, there was rarely a week when he didn't have at least one song on the top fifty country singles chart. In 1970 alone he had two number one hits with "Big Joe Mufferaw" and "The Ketchup Song." The latter entered the country singles

chart on June 6, 1970, the same week that Anne Murray's crossover smash hit, "Snowbird," debuted on that chart. "Snowbird" was not only successful in Canada, but was also a top ten hit in the United States, appearing on Billboard's pop, country and adult contemporary charts. Yet "The Ketchup Song" premiered on Canada's country charts one position above "Snowbird," and made it to the top of that chart a full month before Murray's track. It is difficult to reconcile these charts with Tom's claim that he got no airplay from the very start of his career. If the RPM charts are to be believed, Tom was getting considerable radio exposure and had a number of hit singles in the early 1970s.

In early August, Tom was invited back to Charlottetown to play for two nights at the Kennedy Coliseum as part of Country Days. It would be his biggest audience yet. Tom entered through the crowd of 5,000 and everyone was on their feet. He wrote in *The Connors Tone*, "The standing ovation was indescribable and the din was deafening." Tom waited for the crowd to settle down so he could sing. As they took their seats he launched into "Bud the Spud" and they were back on their feet. They stayed there until he was halfway through the next song. After his second night, Sue Watts, another performer on the bill, said that, "If Tom had shit on the stage everyone would have fought for the chance to clean it up." Tom was overwhelmed by the response.

Tom's output during 1970 was remarkable and must have set some sort of record for a recording artist. In that year alone he recorded eight LPs. He started with the five-record set of country favourites, followed by *Big Joe Mufferaw*, and then a holiday recording and a live album.

*Merry Christmas Everybody* featured primarily original material, with "An Orphan's Christmas," about the year at the orphanage when he was the only child not to receive a sled, and "Down on Christmas," which seemed to take some of its inspiration from his depressing Christmas of 1965 when he was inexplicably fired from the Maple Leaf Hotel. The title track was a jaunty, toe tapping,

typical Stompin' Tom song, wishing everyone a Merry Christmas and a Happy New Year. His only nods to more traditional holiday fare were a sped up, country version of "Gloria (Angels We Heard on High)" and "Our Father," which was the Lord's Prayer sung to a country arrangement with slightly altered text.

In a relatively short time, Tom's performances at the Horseshoe Tavern had become legendary and his record company hoped to reproduce that experience on vinyl. His eighth full-length recording of 1970 was *Stompin' Tom Connors Live at the Horseshoe*, recorded on Friday, October 30. Unfortunately, the recording did not capture the essence of a Stompin' Tom performance — or certainly not as Tom had hoped. Of the album's twelve tracks, only half of them are Stompin' Tom songs, including "Big Joe Mufferaw," "Bud the Spud" and the lesser known songs, "Come Where We're At" and "Bus Tour to Nashville."

In *The Connors Tone*, Tom wrote that the audience was put off by the lights, cables and executive types roaming around the Horseshoe as they arrived. He started recording at 9 p.m., while the crowd was still sober, and he never achieved the party atmosphere he usually created until later that night when the recording was done and the technicians had cleared out. Tom's disappointment with the whole evening is apparent in his voice when he offers a very genuine apology to the crowd just before the last track on the LP:

> *I'm sorry, you know, to put you folks through a lot of this. See, I have to explain something here. A lot of you folks came in tonight, and you've asked me for a lot of requests and things. And I wanted to do all the requests that you asked me for. Really, I did. But tonight, the company is here and they want to do a live album and so I have to do what I'm told and the whole shebang . . . Anyhow, sorry about that. But I am gonna do this here song again because I've gotten this request about a hundred and fifty thousand*

> times tonight and I don't care whether they like it on
> the album or they don't like it on the album, but it's
> going on again and again, whether they like it or not.
> It's called "Bud the Spud."

When the album was mixed it was necessary to add audience reaction at some points, because the crowd was inaudible. Tom thought this took away from the "genuineness" of the live album and felt the recording didn't really capture the feel of his live show. Although the release would go on to be very successful, Tom was not happy with it, writing in his memoir, "I certainly expressed my disappointment about the whole project and promised myself it would never happen again."

Canadian Music Sales also published seventeen of Tom's songs that year in a book called *Stompin' Tom Connors Song Folio #1*. Tom was thrilled to see his songs in print and wrote in his autobiography that, "Even though I knew them all off by heart, I must have read them twenty times. I just couldn't get over having my own song folio."

Tom was beginning to get a fair amount of media coverage. That fall, he appeared on a national CBC TV program called *Luncheon Date with Elwood Glover*. Rather than the loud, animated jokester he played on stage, Tom comes across in this interview with Glover as quiet, thoughtful and very humble. This is the Tom that his friends described, as opposed to the performer, Stompin' Tom. When Glover mentions that Tom is the most popular performer at the Horseshoe Tavern, "even compared to the Nashville group," Tom looks embarrassed and replies with a sheepish grin, "I wouldn't want to say that." Glover responds, "I'm not embarrassing you about this, but I have heard this. That when Stompin' Tom is booked in there, you can't get in the place . . . It's the answer to what I call 'sincerity, naturalness and down to earth projection of personality.' This is why you're so popular. You have never changed from the days when

you used to tramp around and as they say, 'ride the rods' up and down the country."

The November 1970 edition of *Canadian Composer* magazine featured a lengthy profile of Tom, opening with, "Stompin' Tom Connors is tall, lean and has that weather-beaten look of a man who spends a great deal of his time outdoors. Instinctively, you guess that he would rather drink beer than Scotch; that he has seen more places and more times — good and bad — than most of the rest of us; that he could, if he had to, catch a rabbit, skin it and cook it."[9]

The piece says that Tom is something of an oddity because he is "a man without a family or a permanent home." Tom was still staying with friends when he wasn't on the road. It goes on to tell Tom's story, but much of it does not correspond with what he would later write in his autobiography. For instance, the story claims that when Tom ran away from home at thirteen he went to Halifax rather than Saint John. This appears twice, so it's unlikely it's a typo, and there is even a quote from Tom: "I had some disagreements with my folks and I left for Halifax." It also says that Tom hitchhiked for seven years, where most other accounts say he started at sixteen, in 1952, and that he was on the road until his 1964 gig at the Maple Leaf, a full dozen years later.

It's possible that Tom gave some misinformation as a way of maintaining a sense of privacy. He wrote in the introduction to *Before the Fame*, "The mystery that surrounds me is something that has built up over the years . . . And, to be honest, I have sometimes enjoyed playing along."

## Chapter Seven
# The Businessman

The singer is the voice of the people,
And his song is the soul of our land.

— "The Singer"

Although Tom was happier with Dominion Records than he had been with Rebel Records, he never really enjoyed working for other people. He had long had a problem with authority, and after years of managing his own career it was no doubt difficult being told what to do by a record label. One can hear the resentment in his voice on *Live at the Horseshoe* when he explains he can't do more requests because "the company is here and they want to do a live album and so I have to do what I'm told."

As he wrote in *The Connors Tone*, "I had to be with a company that would not only listen to my input, but would also act upon it. And where was such a company to be found? Absolutely nowhere. Unless, of course, I started my own." While Tom was contemplating this, Jury Krytiuk was complaining that he was making just $100 per week at Dominion Records and there was little room for advancement. Tom knew that with a busy performing and recording career he couldn't also run a record label. Jury had worked in various capacities within the music industry and understood

it well. He was also very driven. Tom figured he would make the perfect partner.

Tom agreed to pay the initial expenses to set up their record company, but Jury would run it on a day-to-day basis. Tom wanted to be behind the scenes, with Jury as the face of the company. This enabled him to have final say at the company without anyone knowing it was him making the decisions. Tom maintained 51 per cent ownership while Jury got the other 49 per cent. In honour of Tom's truck and his well-heeled foot, the new label was called Boot Records. The logo was the work boot that Steve Foote had drawn on the cab doors of Tom's truck.

Jury would act as Tom's "manager," though Tom would continue to manage his own career. If someone approached Jury with an offer, he would relay it to Tom. The two would discuss it and Jury would go back to close the deal. This would not only give Tom an agent who could ask for more on his behalf, but also allowed Tom more time to contemplate any offer.

It was savvy reasoning that kept Tom from letting people know he owned the company. He admitted in his autobiography: "I could continue to preserve my image as the 'down-to-earth country boy' that I knew was necessary to maintain the affinity it took so long to establish between Stompin' Tom and his fans. It seemed to me that if word got out across the country that Stompin' Tom was really a 'bigwig owner' of a record company, and not just a simple artist recording for the label, he would soon find himself alienated from the common people he was singing about." It's interesting that Tom almost always referred to Stompin' Tom in the third person. There is no doubt that he saw the character he created for the stage as quite apart from himself. When he appeared on the Elwood Glover show in 1970, Glover said, as Tom entered wearing his cowboy hat and holding a cigarette, "You came fully regaled. I'm glad you did. That hat is part of the costume isn't it?" Tom didn't respond, but seemed to nod in agreement.

Mickey Andrews admits it took him some time to realize how smart Tom actually was, in part because of the character he played. "He projected a humble thing about him," Andrews said in an interview. "Like his clothing, the way he dressed, what vehicle [he drove] . . . He had a hillbilly image to him, but he was smart. He was generally the smartest guy in the room. People didn't know that until they got to know him."

It bothered Tom when people would tell him how lucky he was to have Jury managing him. He wrote in *The Connors Tone*, "This type of comment would often hurt my pride a little . . . and this was all due to the fact that they gave Jury the credit for everything I had accomplished." Tom wrote, "while Jury knew a great deal about record companies and song publishing, he knew very little about artist management and nothing at all about instruments or the actual writing, composing and playing of music." That is not exactly true. Jury was a composer and had a number of instrumental numbers recorded by Boot Records artists. "Maritime Farewell," which he co-wrote with Mark Altman and John Spence, was recorded by more than thirty different artists including George Hamilton IV.

While Tom may have been reluctant to share credit with Jury, others felt that Tom learned a lot from him and they both benefited greatly from the partnership. "Jury taught him the music business from the inside," Mickey Andrews said in an interview.

> *Jury was only young but he was a very bright guy. He took the business part more seriously. I thought it really broadened Tom's horizons. He learned about publishing and booking. And there was money to be made in different areas . . . different ways to market his image that Jury thought would be good . . . (he wanted to make Tom's) name synonymous with Canadian. Mr. Canada.*

And indeed, after two years of playing at the Horseshoe and working with Jury, Tom had become Mr. Canada. As Andrews said:

> *When he left the Horseshoe he was the full Stompin' Tom guy wrapped in the flag. He knew that if he pushed that Canadiana thing . . . that was his bread and butter. And the more he pushed those songs that was his royalties.*

On January 1, 1971, Tom and Jury opened the office of Boot Records. They rented a four-room apartment on Bathurst Street in Toronto. One room became the office, another was their kitchen and they moved in, each taking one of the other two rooms as a bedroom. Tom was almost thirty-five years old, and for the first time in his adult life he had a permanent address. They agreed that Boot would be a strictly Canadian label. Tom wanted to provide opportunities for Canadian artists to be signed to a label at home, in the hopes that it might be easier for upcoming acts than it had been for him. Because Tom was the label's best-known artist they were initially thought of as a country music label, but they had no such rules about genre.

The first three artists signed to Boot Records were Tom, Humphrey and the Dumptrucks and Tom's old friend Steve Foote, who was now using the stage name Stevedore Steve and had recorded an album for Dominion Records.

The year that Tom and Jury started Boot Records was also the year that the Canadian Radio-television and Telecommunications Commission (CRTC) implemented new rules regarding the amount of Canadian content (CanCon) that radio stations would have to broadcast. Despite Tom having had a few hit singles, it had been very difficult before 1971 to get mainstream Canadian radio to play homegrown artists. As Bob Mersereau, music journalist and author of both *The Top 100 Canadian Singles* and *The Top 100*

*Canadian Albums*, said in an interview, "There was no money in it for them to be playing Canadians. The excitement of the '60s was the Beatles and those big acts and they wanted to be right on top of that. There was a belief that Canadians didn't match up."

Mersereau went on to say that occasionally there would be a Canadian artist that might have a regional hit, but it was a challenge to make that hit national. "The Ugly Ducklings famously had a big number one hit in Toronto," he said. "But trying to get that Toronto hit played in the Maritimes was difficult . . . there was no national system in place. There was no national anything. There were very few recording studios . . . There was no infrastructure. Touring was very difficult because of Canadian weather and the length of the country and all those things."

It was easier for radio to play a star than to make a star and as Mersereau pointed out, "Most of the record companies were the big multinationals, that had only limited success with Canadian artists. And they were making tons and tons of money off . . . the pop music explosion of the '60s . . . They were pretty big entertainment companies run out of New York and Los Angeles and they were putting their development money into potential stars for the rest of the world, not Canada."

Boot Records would try to change this by developing and promoting Canadian artists, but they needed the support of radio. The new CanCon regulations seemed to offer some hope. After a series of public hearings, it was determined that starting in 1971 all Canadian radio stations would have to play at least 25 per cent Canadian performers and/or creators. That number was increased to 30 per cent by the 1980s.

Many broadcasters tried to fight the ruling, and Tom wrote in his autobiography that one radio chain threatened Boot Records, sending them a letter implying that if Boot Records continued to support the CanCon regulations their music would never be played on any of the chain's stations. Tom and Jury refused to back down and continued to support the new CRTC regulations.

Tom wrote, "History would show that we never dropped our support, and also that these radio stations lived up to their threat. And with a vengeance."

Tom was one of the lucky few who managed to get airplay. He was near the top of the charts as 1971 began. "Luke's Guitar" peaked on the RPM Country Singles charts at number two on January 9. He sat in the top ten with such American country artists as Lynn Anderson, George Jones and Johnny Cash. It was Tom's third top two hit in less than a year.

Mersereau said, "He was pretty strong with country radio . . . especially in rural Canada. When he says he didn't have great support at radio he's talking about major cities. He wouldn't have heard himself at home much . . . but back in the day he had a solid string of country hits. That was definitely the way most people were introduced to him."

Tom started 1971 with another month-long stint at the Horseshoe. One fan who got to know Tom at the 'Shoe that year was Steve Fruitman, a grade thirteen student at Thornlea Collegiate. Fruitman had been a fan of Tom's since discovering his music in 1965. More than fifty years later, Steve remembered the first sounds he ever heard from Stompin' Tom as a friend put "Luke's Guitar" on the record player. As Tom sang out, "Twang, twang . . ." Fruitman said, "I just got goosebumps hearing that." Steve was hooked. His friend, on the other hand, "thought it was a joke." The young men represented two schools of thought that persisted throughout Tom's career. There are those who hold that Tom's music was important, while others, as Steve said, "just see the clown."

Fruitman had a radio show on campus at Thornlea Collegiate in Toronto and went to see Tom in hopes of securing an interview. He talked to Tom after a performance one night, and Tom agreed to meet with the young man the next day. Fruitman was thrilled to interview this performer whose career he had followed for the past six years. "He just treated me like a professional," Steve said. "As if I was any interviewer from any radio station . . .

He was very friendly and a little bit cautious of what he would say ... He always was very cautious about what he would tell people."

Steve eventually became a musicologist and a DJ. His website, *Back to the Sugar Camp*, features interviews with countless artists and is an invaluable source of lesser-known Canadian music. He and Tom became lifelong friends, and Steve interviewed Tom a number of times over the next forty odd years, even conducting the last interview Tom ever gave.

The typical crowd at the Horseshoe was made up of expatriate Maritimers and diehard country music fans. While they certainly made up part of Tom's audience, he also attracted a new crowd. Mickey Andrews said, "His audience was the university/college guys who would never come to the Horseshoe. The Toronto Maple Leafs. Like Dave Keon and all these ... the old Maple Leafs. They hung out there. The police, the detectives, they hung out there. He had a different crowd." And Tom made it a point to get to know all of them. While he had a glass of water on stage, he drank alcohol when he went into the audience. Andrews says, "Every table in that place had beer on the table for him ... He went to every table in the Horseshoe ... you could see him with the hat and the way he was dressed and everybody was gathering, running for autographs."

In February of 1971 Tom won his first Juno award as Best Country Male Artist. The other nominees in his category were Gary Buck, Dick Damron, Tommy Hunter and Hank Smith. The Juno awards began as a readers' poll in *RPM* magazine in 1964, with the idea that awards might bring additional exposure to Canadian musicians. Until 1969, the winners' names were simply published in the magazine with no ceremony and no physical award being presented. An actual trophy, the Gold Leaf Award, was handed out for the first time at St. Lawrence Hall in Toronto in February 1970. The next year, the awards were called the Junos in honour of Pierre Juneau, the first chairperson of the CRTC — the man who was in part responsible for the new CanCon regulations. He received a

special award at those first official Juno Awards in 1971 as "Canadian Music Industry Man of the Year."

*The Globe and Mail* described the crowd for that night's awards show as "a large audience of long haired musicians, medium hairy public relations men and balding vice presidents of recording companies." It was not exactly Tom's crowd. He and Jury arrived at the awards in a taxi, while many of the other nominees showed up in limousines. Jury wore a suit and Tom wore his "normal stage gear — black hat, boots, vest, etc." Tom claimed in *The Connors Tone* that he was incredibly surprised when his name was announced as the winner on the night of the awards. However, he would have known he had won the award before he arrived as the winners were announced in advance of the ceremony until 1974.[1]

Tom also expressed bewilderment that he could win the award when he had received no airplay, writing in his autobiography, "The big question that seemed to be floating around was 'How did this guy rate getting a Juno when we've never even heard him on the radio?' And to tell you the truth, I was wondering the same thing." From the outside it looked like Tom was being embraced by the music industry. He was regularly on the Country Singles charts, his albums were selling well and he now had a Juno. Yet he was unable to trust or embrace this acceptance.

While Tom had very mixed feelings about the music industry, he never failed to appreciate his fans and seems to have been most at home with them. He once said:

> *When they come up to me and ask me for an autograph or show me a record that they bought or a picture they took, what enters my mind at the time is that I feel humble . . . I know that if I had a chance to sit down and talk to that person, each and every one of them, directly, to say to them, 'It's you that makes me who I am. It's nothing that I've done. It is you. So, it is me that should look up to*

*you, rather than you looking up to me.' It's about the only way I can really explain it.*[2]

One of Tom's biggest fans was Edwin Heistad, who bought the *Bud the Spud* album in Saskatchewan in the early 1970s when he was just thirteen. Heistad went to see Tom in concert whenever he toured nearby, and would always stay afterward for a chat and to get a picture and an autograph. Heistad was struck by how down-to-earth Tom was, saying, "Something about him just grabbed me. I just liked what he was doing. Something just told me this man is genuine." He often wrote to Tom, and he got a reply just about every time. Unlike many artists, who might have an assistant respond or just sign a picture, Tom would answer every piece of mail himself, typing page-long, single-spaced letters. It meant the world to Heistad, who said, "It seemed to me it got personal and very genuine. That really hit me when he wrote back those letters." Tom had a way of making every fan feel special.

Duncan Fremlin, who toured with Tom later in his career, said in an interview for this book, "His career was driven by the affection that he felt towards the people that put him there. He was a humble man with a grade nine education who pinched himself every day that he was able to achieve the notoriety and the national fame that he was able to achieve. He owed it all to the fans." Tom pointed out that those fans stayed with him throughout his life, writing, "Loyalty runs both ways."

Tom had finished up all his longer bar gigs, and started doing only one-nighters in 1971. He was earning as much in a night as he had once made in a week, so he was able to cover a lot more of the country. Tom knew that he could handle any room alone onstage with his guitar. As Mickey Andrews said, "He could have done these shows by himself. He didn't actually need the band. He was that powerful of a performer." But beginning in 1971, Tom decided that he'd like to have a band to help fill out his sound while playing bigger venues. Because he was planning to be on the road more, he

also thought he might like the company.

Tom asked The Good, the Bad and the Ugly to join him on tour. They opted to remain at the Horseshoe as the house band, but Mickey introduced Tom to Billy Lewis, who played lead guitar. Gary Empey, a bass player, answered an ad Tom posted and after having him play with Billy, and discovering that both men liked beer, they were hired for the tour. After a few shows in Ontario, Tom and his two new band members set off for a series of one-night shows in the Maritimes, as well as a two-week stint at Johnny Reid's Prince Edward Lounge in Charlottetown. Even after he started playing primarily one-night gigs Tom would make an exception for the Horseshoe and his friend Johnny Reid, still playing at both of these locations for weeks at a time.

Since it was no longer just Tom and his guitar, he needed more than the Boot while on tour. He filled the truck with records and instruments, then rented a U-Haul trailer, which carried sound equipment and was pulled behind another car. Tom toured through much of the 1970s in this sort of a convoy, with two or three vehicles travelling together. They used CB radios and/or walkie talkies to stay in contact with one another. Tom insisted that they stay together and that he always be in the lead.

Back in the Maritimes, a new waitress at Johnny Reid's caught Tom's eye. He first spotted her as she was coming downstairs towards him. He wrote in *The Connors Tone*, "As I looked up and saw the great shape of this good-looking, well endowed beauty, my attention was particularly drawn to the exceptional size of her now bouncing boobs." Tom stared at her ample chest and asked, "Where did you get those, at Eaton's or Simpson's?" Tom wrote that he might have gotten hit, except that her hands were full. Unfazed, she responded, "That's for me to know and you to find out, Cowboy." While this exchange comes across as demeaning now, Tom was clearly from a generation that found this acceptable enough that he recounted the story in his autobiography. That waitress, Lena Welsh, became the love of Tom's life and eventually his wife.

Mickey Andrews, who had spent a lot of time in bars with Tom before he met Lena said of Tom, "He wasn't a womanizer . . . He was sort of laid back. They'd have to come to him." Tom made an exception for Lena, and asked her out right away. It took some convincing, but they eventually spent a few afternoons together and hit it off. He even took her to Skinners Pond to meet the Aylwards.

At the end of his East Coast tour Tom headed back to Toronto, but he and Lena agreed to keep in touch. She later came to Toronto to visit her sister and by June she had decided to move there so she and Tom could continue their relationship.

In the spring of 1971, Tom recorded another five-album box set of country standards called *Stompin' Tom Sings 60 More Old Time Favourites*. Eventually a single compilation album was created from each of his box sets. The first one was called *Pistol Packin' Mama*, while the compilation from this second set was called *Bringing Them Back*. These albums were also released in 1971. Tom now had a dozen LPs of old-time country songs.

That spring Tom also recorded an album of original material called *My Stompin' Grounds*. This new LP would prove to be one of Tom's most popular. It included five songs that hit the top forty on the Country Singles Charts. "The Snowmobile Song," a tune he had written for the Muskoka winter carnival, hit number forty, while "Name the Capital," a song he wrote in part to help teach children the capital cities of Canada's ten provinces, went to number thirty-four.

The album's title track tells the story of Tom's hitchhiking days and includes a shout-out to the people who fed and housed him during those years: "Wherever you find a heart that's kind, You're in a part of my Stompin' Grounds." It went to number thirty-one on the charts. The album also included "Tillsonburg," which became one of Tom's signature songs, although it peaked at just number twelve on the charts. The most successful song on the album, "The Bridge Came Tumbling Down," went all the way to number two. It told the true story of a bridge collapse that happened in Vancouver

in 1958, killing eighteen men who were working on the structure and a diver, who died during the rescue efforts.

Jury booked a tour of England and Ireland for Tom that started in June of 1971. In Ireland, Tom noticed that at least two thirds of the music on the radio was by Irish artists. Many hit songs from around the world were covered by Irish artists, and these versions got as much airplay as the originals. This helped to create a star system of homegrown talent — something that Canada had been unable to do. Tom wrote in *The Connors Tone*, "Is it any wonder, then, that the three million people of Ireland (and most other countries, including the United States and Great Britain) don't seem to have a problem identifying with who they are and where their roots are? And it shouldn't come as any surprise that Canadians do."

Tom was certainly not alone in this thinking. The late 1960s and early 1970s saw the birth of a new kind of homegrown art in Canadian literature, theatre and music. The country's artists were beginning to tell their own stories, rather than focussing on American and British imports. Margaret Atwood wrote in her 1972 book, *Survival*, that "a country needs to hear its own voices, if it is to become or to remain an aware society and a functioning democracy." She was referring to Canadian literature, but it applies to other art forms as well.

Tom wrote in his autobiography, "most of our Canadian children, getting up in the morning and going to school, are humming and whistling the lyrics and melodies of songs that not only don't remind them of who they are as Canadians, but continually bombard their minds with the notion that their opportunities in life are far greater in a foreign country, where people are proud enough to sing about themselves, than they are in a land they perceive as being dull."

Tom was well-received overseas, but the trip did not lead to him having a continuing presence in Europe. Back home, Tom continued to tour the Maritimes and Ontario and played at the famed Mariposa Folk Festival for the first time. He was beginning to

prove that songs with American place names were not inherently better than songs with Canadian place names.

One of the people who was introduced to Tom at Mariposa was Carol Dennett, an American college student who was visiting Canada. More than forty-five years later, she remembered the impression Tom made on her: "We watched Tom for quite a while as he was stompin' up a storm and I'd never seen anything like that! I loved that there were songs about Canada . . . Everyone was so friendly. After a few weeks we went to PEI. I had to see the island after hearing Tom. I remember I had no idea where PEI was. I thought it was near BC. I never went back to live in the States again."

In September of 1971, Tom recorded another album of all original material, *Love and Laughter*. This album contained the typical humorous songs, but it also had more love songs than usual. Five tracks dealt with romantic relationships, including "Movin' In (From Montreal by Train)" and "Rubberhead" — a fairly lighthearted song about a breakup, where the couple ends up hurling childish insults at one another like, "Goodbye Rubberhead, so long Boob, Go and blow your inner tube." Arguably, the best-known love song from this album is "Little Wawa," the story of two geese and their undying love, written in Wawa, Ontario, years before.

Three tracks from *Love and Laughter* cracked the top forty Country Singles charts. "Fire in the Mine," went to number twenty-four, while he had another number one hit with the song, "Moon-Man Newfie." "The Bug Song" not only went to number nine on the country charts, but was also Tom's only song to ever hit the MOR (Middle of the Road) or Adult Contemporary charts, peaking at eighteen. Following the tradition of having his name in the title and promoting one of the more popular songs on any album, the title of *Love and Laughter* was changed to *Stompin' Tom and the Moon Man Newfie* for subsequent reissues.

A review of the album in *Canadian Composer* magazine said, "Connors sings them all in his deep, easy voice — a voice which

reminds some of Johnny Cash. He is obviously at home with his material and he sings it as easily as he writes it."[3] The reviewer goes on to say that while, "Tom's records are getting better every time; there are still moments though, when the listener wishes that everyone involved had spent just a little more time on the project at every stage in its development." Tom wrote and recorded fast. Part of his appeal was the spontaneous nature of his performance and he aimed to capture that when he recorded, with everyone in the room together, playing all their parts at the same time. The reviewer made an important observation, writing that the album "gives the listener not the vaguest idea of Connors' charisma as a performer. In person, he remains a superb artist — but the record to let you know what all the shouting is all about hasn't been made yet."

Seeing Tom perform was a big part of his appeal. From his first stage appearance at the Christmas concert when he was four, Tom knew he could easily have been an actor. When he sang, he was playing a character who acted out all of his songs, using voices and accents and making faces. That magic was lost on record. Much like an actor who is successful in theatre, but can't make the transition to film, Tom had to be seen to be truly appreciated. His albums sold well, but just hearing Tom would never be the same as seeing him perform live.

Tom had recorded his first LP in 1967. Just four years later, by the end of 1971, he had twenty albums on the market. His twenty-first was also released that year, a greatest hits collection called *The Best of Stompin' Tom*.

Back in Toronto, Tom got a fair amount of publicity when he appeared on the cover of *Last Post* magazine, which featured his first real in-depth interview, written by Mark Starowicz. The story recapped most of Tom's life, and was described as "The life and times of Canada's most remarkable singer — a cantankerous nationalist, bard of the byways, heir of Wilf Carter, lost love of the Algoma Central and the man who gave Canada

'Bud the Spud.'"[4] More than in any interview before or since, Tom declared himself a populist. He described the country from Newfoundland to British Columbia, discussing who could take a joke and who couldn't. It's clear that these latter types were not his favourite people and he summarized by saying, "I think it's got a lot do to with rural people. They're closer to the stock."

Tom went on to defend the working man, saying:

> *Let's face it, the majority of the country is always the poorer class. These are the voters that are told how to vote, and where to put their vote, these are the guys that are brainwashed into thinking this is what you should have, and they go along with it. But you can only tell them so long this is what you should do and this is what you shouldn't do.*
>
> *But then some jackass like Stompin' Tom comes along and throws a monkey wrench into the whole machinery. I come along and say look that's not the way it is. The way it is is the way you want it. Your kind of thing. We're talking about you. OK, You tell this kind of jokes, you do this, you do that, and that's the way you like it, that's the way you're going to get it.*
>
> *We ain't going by what somebody from a university or college or government — what they say, take it with a grain of salt. But in the meantime we've got some songs here and we're going to sing them the way you like them.*

Tom felt the constant need to prove himself. He had been playing in bars, high school gyms and community halls for years, but he wanted to show the music industry that he could also play a concert hall. He set his eyes on Toronto's famed Massey Hall, which had about 2,700 seats. Working with music promoter Richard

Flohil, he announced a concert in that venue for February 4, 1972. Tom wrote in *The Connors Tone* that people in the business were saying, "Stompin' Tom must be crazy. He might be able to pack some places way out in small-town Canada, or maybe even a few booze halls like the Horseshoe Tavern, but he's out of his mind if he thinks he can draw people into such a prestigious landmark as the world famous Massey Hall, especially with his kind of cornball show." It's unclear how many people were actually saying this, and how much of this was imagined by Tom as a result of his own insecurities, stemming from a childhood where he never felt that he was good enough.

Tom ended up selling about 2,400 tickets. He noted that, "the illustrious reputation of the great Massey Hall would never be quite the same again. I guess there are those who would say the old shrine was desecrated." Tom wrote, "It was like some kind of a revolution had taken place. The little man got to dine at the big man's table, and even got to choose his own style of entertainment . . . Massey Hall was still standing, Stompin' Tom had proven he could play in the big leagues, and the pride of the common man was slightly elevated because of it all."

In an interview almost five decades later, Flohil clearly remembered that night. He said, "I remember after the show, Tom sitting on the edge of the stage and I swear he signed as many autographs as there were people in the audience. It was hugely successful." A review by Jack Batten, entitled "Stompin' Tom leaves 'Em Cheerin' and Hollerin' at Massey," appeared in *The Globe and Mail* the next day, and somewhat begrudgingly acknowledged that the show was a success:

> *Everybody that showed up had a shouting good time, Stompin' Tom put on a terrific show (longer on laughs and hollering than on anything you might call art) . . . what Connors showed himself to be, in his first-ever Toronto concert (as opposed*

> to gigs at the Horseshoe) is a Canadian nationalist
> ... His songs deal almost exclusively with the lives
> and times and struggles and jokes of lower-middle-
> class Canadians — they make up his constituency
> and also his audience. He isn't a marvellous singer
> — his voice is a Johnny Cash like rumble — and his
> songs don't add up to poetry, and his jokes, leaning
> largely to the bathroom variety, tend to be corny.
> But the message is clear — Canada first — and his
> audience is devoted.[5]

After Massey Hall, Tom was back touring the Maritimes. New Brunswick based writer Alden Nowlan interviewed Tom in Halifax on February 23, 1972, and then attended his show that night. The article appeared in the *Atlantic Advocate* and was reprinted in *Maclean's* magazine later that year. When Nowlan arrived at Tom's hotel, he found a room littered with Moosehead and Molson bottles as well as leftover room service. They talked for hours while drinking room temperature beer, which was Tom's preference.

Nowlan seems to have approached Tom with some doubts about his sincerity, but was quickly won over. He wrote that he thought Tom's hat, which stayed on throughout the interview, looked "ludicrous and a bit phony,"[6] until he realized that it was "talismanic, like a poor man's only prized possession." He also acknowledged that Tom's stated ambition to "Sing Canada to the world," might have seemed phony coming from someone else. However, Nowlan wrote that "having spent the afternoon with him, I was convinced the man was so damn honest he deserved some special kind of divine protection."

When Nowlan expressed his surprise at Tom quoting the Koran, Tom replied, "Yeah, I've read it. The Koran, and the Buddhist scriptures, and the Hindu scriptures, and a lot of psychology and stuff. In libraries mostly, when I was on the road." Tom told Now-

lan that his time with the nuns in the orphanage made him feel that everything from spitting to scratching oneself was a sin, but these books had taught him it was not a sin to be happy, and he embraced that notion. Always aware of his image, Tom said to Nowlan, "But probably I shouldn't be saying this. Some of Stompin' Tom's fans might be kind of put off by the idea of him readin' the Koran." One has to wonder if Tom thought back to those days as a child, when Cora liked him best if he pretended to be dumb. He seemed to feel that his fans preferred him that way as well.

As Nowlan prepared to leave at the end of the interview, Tom said, "I think sometimes that one of these days I'll just say to hell with all this, doing shows and making records, to hell with all this money, and I'll hit the road again, hitchhiking. Maybe I'll call up my buddy, Steve, and ask him to go with me. Right across Canada, and back. Yeah, one of these days I just may do that."

When Nowlan arrived at the show that night there were roughly three thousand people crowded into a high school auditorium. He painted a vivid picture of Tom's audience, writing that most of them were "members of the working class, inhabitants of that other and all but invisible Canada whose separate culture so seldom impinges on the national consciousness that often its very existence is denied." Tom knew that what he did was important, and Nowlan recognized that. Tom was giving voice to the voiceless. Nowlan wrote that once Tom appeared on stage the audience yelled out to him as though he was an old friend who just happened to be performing. People variously shouted, "Hiyuh Tommy!", "God love you, Tommy boy!" and "Tommy, you damn thing!" This was not uncommon at Tom's shows. Tom treated his audience as though they were his guests at a kitchen party and they acted like he was family.

Tom shared his feelings about Nashville, saying, "Some folks ask me why I don't sing some of them nice Nashville songs. I tell them I'll be happy to sing some of them nice Nashville songs as soon as them fellers in Nashville start singing' some of my songs about

my country." The crowd, of course, cheered at Tom's unabashed patriotism. This would become a standard bit in his shows.

Alden wasn't the only well-known New Brunswicker who became friends with Tom. Premier Richard Hatfield was also a fan who Tom got to know quite well. Tom shared his recollections of Hatfield in the book, *Remembering Richard*, writing:

> *Dick was an avid country music fan and attended most of my shows we played in his area. During 1971 and 1972, before my wife Lena and I were married, we often got together with Dick and his friend Libby. We were quite the foursome: Stompin' Tom and the premier of New Brunswick, struttin' our girls down the streets of Fredericton, saying hello and cracking jokes with everyone we met 'til the wee hours of the morning. After closing the bars and restaurants, we'd hop into that mighty fine Bricklin and, after a nightcap at the motel, we'd bid goodnight to a couple of swell friends, promising to do the same thing again sometime.*[7]

Tom wrote in *The Connors Tone* that while touring the Maritimes Jury called to tell him that *My Stompin' Grounds* had gone "gold." Canada did not yet have an official body that certified and presented gold records. The idea of gold records began in the United States in 1937 as a way for record companies to publicize their significant record sales. The companies would issue the records to their artists, which generally represented sales of 1,000,000 units. In 1958, the Recording Industry Association of America started officially awarding gold records to any single or album that achieved retail sales of $1,000,000.

When Tom started recording there was no equivalent Canadian organization, but record companies would often present gold records to a disc that had $100,000 in retail sales. Music Canada

did not establish its official Gold Platinum Awards Program until 1975, and gold record status initially represented sales of 50,000 units. When Jury informed Tom that *My Stompin' Grounds* had achieved gold record status, he meant that it had achieved $100,000 in sales.

This was an impressive achievement in Canada, particularly for a country artist. In February of 1972, *RPM* magazine wrote, "His *My Stompin' Grounds* album has now chalked up sales in excess of $100,000 at retail level — the first Canadian country artist to ever accomplish this feat."[8] Tom was so proud of this accomplishment that he took great offense when *Maclean's* magazine, a number of years later, credited another country artist with being the first to have a gold record. He had Jury write to the magazine and make them print a retraction, and then complained about how long it took them to correct their mistake in his autobiography. As humble as Tom was, he could be very sensitive when his accomplishments were overlooked. The *RPM* article noted that "Boot (Records) was so excited by this first, they put together a Gold Disc Award for Tom." Seeing as Tom owned Boot Records, he basically gave himself the gold record, but that didn't diminish the remarkable sales he had achieved in just seven months.

By the end of the year, Tom had four gold records. *Bud the Spud* went two times gold that year and *Live at the Horseshoe* went gold in December. In an interview with *Canadian Composer* magazine, Jury Krytiuk said that Tom "was selling at the level of a rock artist." Tom also received his second consecutive Juno Award as Best Male Country Artist. Because he was on tour, his sister Marlene accepted on his behalf.

Early in 1972, Tom recorded a jingle for Prince Edward Island tourism. The ad was called "Dial an Island," and almost anyone on Canada's East Coast who listened to radio or watched television in the 1970s or early 1980s still remembers the phone number to call "If you'd like to feel just right, Laugh and have some fun." The number of course was, "Eight, double zero, five, six, five, seven,

four, two, one." The ad proved so popular that it ran for a decade and was re-recorded by Tom in 2004 for a new campaign.

Boot Records had grown so much that by early 1972 they left the apartment and rented a house. A third partner, Mark Altman, joined the label and they created their own publishing company, Morning Music. Although the company was growing, Tom was by far the biggest artist at the label. Stevedore Steve Foote had a hit with "Lester the Lobster," but beyond that they didn't have any other Juno-winning artists or hit records. Tom sunk his own royalties back into the company to keep it going.

That spring while playing the Horseshoe, Tom was approached by Ed Moodie, a film student at York University, asking if he could produce a documentary about Tom as his thesis. Tom agreed and Ed created a seventeen-and-a-half-minute-long documentary called *This is Stomping Tom*, which helped him earn his film degree. Tom was filmed giving one of his legendary, energetic performances at the Horseshoe. When he sang "Muleskinner Blues," his eyes crossed, his face twisted and he adopted an exaggerated accent. The lighting highlighted his crooked teeth and he looked like a man possessed.

In an interview segment that looks as though it was filmed backstage, Tom appears with a group of people, including Lena and Steve Foote. The contrast between the thoughtful subdued Tom of the interview and the almost-crazed performer is quite remarkable. He and Steve talk about their history together and their feelings about Canadian music. Steve says, "We've come a long way. As a matter of fact we've covered quite a bit of ground since we were down east together, you know?" Tom adds, "When we were hitchhiking along the road we often talked about why there isn't more songs being sang about Canada, the Canadian people and what the Canadian way of life is like. And we talked it over that if we ever had a break or a chance to ever sing to the people and that, we'd write our (songs about) Canada." Tom continues, saying that he thinks, "it just takes just a little bit more guts, and a little bit more stamina and stay power to stay here in Canada," but he thinks it

can be done if people stick with it.

That spring Tom was asked to submit a song to be considered as the theme for a new CBC TV show called *Marketplace*. He was approached about writing the song on a Friday and by Saturday he had written "The Consumer," which was ultimately chosen to represent the new TV show.

Tom had another shot at breaking into the American market when Jury booked him to play a few shows with Hank Snow in Maine and Massachusetts. After these American dates, Tom and Hank were to join Wilf Carter for a short tour through Ontario and Quebec. Carter and Snow were legends of country music not only in Canada, but also the United States. Tom wrote in *The Connors Tone* that he thought doing a show with Hank in Boston in particular "would be a good stepping stone for me to tour further into the States with my Canadian songs." Unfortunately, Snow cancelled at the last minute and Boston was not interested in Tom alone. He ended up playing a few smaller communities before joining his childhood idol, Wilf Carter, back in Canada. They had one show together before they were joined by Hank Snow.

Unlike Snow, Carter was down to earth and friendly, going so far as to say he'd be happy to sit backstage on a stool and wait for showtime when there wasn't enough room for all of them in the dressing rooms. Tom wrote, "within two minutes of talking to the man, I came to realize that this was the real genuine article. With his big friendly smile, he immediately won the hearts of everyone he spoke with." Tom was thrilled that he was getting to share the stage with the man who had inspired him since childhood. He wrote in *The Connors Tone*, "behind the curtain, as I watched him perform for the first time, I shed a bit of a tear, and told myself, 'This is the kind of man I want to emulate.'"

Hank Snow joined them a couple of days later and was as aloof as he had always been, barely acknowledging Tom or his bandmates. The Good, the Bad and the Ugly joined Tom for this tour and Mickey Andrews agreed, saying, "Hank Snow, he sorta didn't

give us the time of day. We met on the first part of the tour, like we got introduced, and he was very standoffish." Andrews pointed out that a lot of the audience came to see Wilf Carter and Hank Snow, who had both been major country stars for over thirty years. He said, "Hank Snow had the power of the radio and the Grand Ole Opry and all that stuff," while many people were seeing Tom for the first time. Andrews said, "Tom sorta stole that thing. He had the same effect on that audience as he did at the Horseshoe... Tom was like the entertainer. Whereas Hank Snow stood there and sung his songs."

That fall, Tom went to visit Lena's family. Everyone who lived on Entry Island was thrilled to have this big star in their midst. Lena's dad told Tom about the inhabitants of the island and their way of life. Tom took notes and eventually wrote a song about it called "Where Would I Be?" inspired by what he'd heard. Tom would often ask people questions about their lives and take notes with the thought that he might later write a song about it.

After visiting Lena's family, they went on to Skinners Pond. Tom decided that he would buy some of the Aylwards' land to help them financially. He had the house sectioned off so they would continue to own that and could live in it, but he bought the rest of the property. He wrote in his memoir that he paid them three times what it was worth and included a new car in the deal. When Tom had the land surveyed, he discovered that the Skinners Pond schoolhouse was on their property. As it turned out the government had decided to close the school that year anyway so Tom took possession of the building, which had fallen into disrepair. He renovated it in time for Prince Edward Island's Centennial, which was celebrated the following year.

Tom was a regular on a number of television programs during this period, including *The Tommy Banks Show*, *The Juliette Show*, *Don Messer's Jubilee*, *Here Comes the Sun* and *The Irish Rovers*, as well as programs hosted by Pierre Burton and Ian Tyson. Tom's fanbase was not only loyal, but also incredibly protective of him.

When he appeared on *The Tommy Hunter Show*, one woman wrote to the CBC, complaining, "Hopefully I was the only one to watch tonight's program. I endured the whole disaster with my head hung in despair and embarrassment. He didn't get named Stompin' Tom Connors for sitting on stools. How could you dare to sit Stompin' Tom on a high-chair in front of that outrageous set and expect him to sing as he loves to sing?"

That summer, Tom recorded *Stompin' Tom and the Hockey Song*. The album included "The Consumer," as well as "Where Would I Be?" Another song on the LP, "Singin' Away My Blues," could have been Tom's theme song. With the lyrics, "I'm recuperatin' fast from a dark and dismal past. Well, well, my heartaches are all gone. I feel a song comin' on, I feel like singin' away my blues," it seemed to perfectly capture Tom's relationship to music and how it had helped him through many rough patches in his life.

"The Hockey Song," would arguably become Tom's best known song, rivalling "Bud the Spud," but it was not a hit upon its release. It took twenty years for the song to start to gain in popularity. While Tom's previous four albums of original material generated multiple hit singles, this LP had just one song make the charts and it didn't do terribly well. "The Consumer" went to just fifty-nine on the Country Singles charts. Tom would not have another song break the top twenty for the rest of his career.

In November of 1972, the contract for Tom's first three albums with Dominion Records expired and all three were re-released by Boot Records. Because of a typo, which no doubt occurred when someone misheard the title, *The Northlands' Own* was released as *Northlands Zone*. According to Steve Fruitman, "Tom was livid when that happened."

In December 1972, Tom was back at the Horseshoe as the tavern celebrated its twenty-fifth anniversary. One night during the celebrations Jack Starr took to the stage to make a speech in front of the gathered media. He spoke about the history of the tavern and then, to Tom's surprise, Jack said, "of all the great entertainers that

ever played on this stage, the one that jingled my till the most, the one who broke all previous attendance records and set new ones, the guy who came from nowhere and surprised all of us, and the guy we love because he sings all those songs that make us proud to be Canadian is none other than this young man standing right here: Stompin' Tom Connors." He then presented Tom with a gold record for *Live at the Horseshoe.*

When Tom and Lena got to the car, she noted that Tom had received four gold records that year and asked what he planned to do with all of them. He replied that he might melt them down and make a wedding ring. Two months later they got engaged, with their wedding planned for November of 1973.

Tom and Lena spent the Christmas of 1972 in Skinners Pond and on New Year's Eve, which would kick off PEI's year of Centennial Celebrations, Tom was presented with a scroll from Premier Alex Campbell declaring Tom a special goodwill ambassador for the province.

Prince Edward Island held a competition searching for a song that would become the official anthem for their celebratory year. Tom submitted a number called "Prince Edward Island, Happy Birthday." Not only was his song not chosen, but he never heard back from anyone after sending in the track. He was somewhat offended by this, writing in *The Connors Tone*, "They must have thought it was a real dud to not even bother to send back a thank-you note for the submission."

When Tom was a guest on the CBC radio program *Cross Country Checkup* with Pierre Pascau, people called in from across Canada to talk to him and it was clear they thought of him as family. At one point in the interview Tom mentioned the Aylwards and added, "I'd like to say hi to Russ and Mom if you're listening." It's interesting to hear Tom call Cora mom, as he doesn't do that once in his two volumes of autobiography and he referred to his own mother as Isabel.

In early 1973, Tom won his third consecutive Juno Award for

Best Male Country Artist. The award was presented by Toronto Mayor David Crombie, who was a fan of Tom's and had become a good friend. According to Tom's autobiography, Crombie presented the award saying in part, "People have said that Stompin' Tom's music is not culture. But I say that it's real." With Toronto's mayor endorsing him on national television, Tom felt that he had finally achieved one of his life's goals that night. He explained that his objective had been "to try and prove that a simple and friendless orphan kid with nothing can come from nowhere, and be accepted and respected as an equal individual among all people of all ranks living anywhere."

There is a photo of Tom from that night where he holds a drink in one hand and a cigarette in the other, looking on as Anne Murray and Gordon Lightfoot appear deep in conversation. In this photo of the three iconic Canadian artists, Tom still clearly looks like the outsider, a loner standing just apart from the "cool kids," listening in. The Junos were broadcast on radio for the first time that year as part of a CBC program called *The Entertainers*, and Lightfoot and Murray had won Male and Female Artist of the Year. A recorded candid conversation between the two aired as part of the program. They were deep in discussion about the value of the relatively new CanCon regulations and, while Murray sounds unsure, Lightfoot clearly didn't support them. Tom would definitely be the outsider in that conversation.

Later that year, Tom was asked to take part in a short film called *Catch the Sun*, which was to be filmed in IMAX and shown at the Cinesphere in Ontario Place. Tom recalled that the camera that filmed him was larger than any he had ever seen. He wrote in his memoir that it was so big the cinematographer literally used a ladder to climb inside it. IMAX was born from a philosophy similar to Stompin' Tom's approach to music. Tom felt that there was no need to compete with American music when the Americans could do it quite well on their own. He wanted to create identifiably Canadian music. The filmmakers behind the creation of IMAX felt the

same about film. The United States had a monopoly on full-length narrative film, but Canada had made a name for itself as a creator of world-class documentaries and short films, so they would focus on that.

Graeme Ferguson and Roman Kroitor created two very successful short documentary films for Expo '67 that used multiple large screens and soundscapes, which were more about stimulating the senses than telling a traditional story. They decided to take this a step further with IMAX, creating similar films, but on the largest screen surface anyone had seen up to that point. The creation of Ontario Place, which was announced in 1969, was to include a large dome-shaped building that eventually became the Cinesphere, offering a six-storey-high screen. *Catch the Sun* was the second film created for this remarkable new theatre. Tom performed the song "Algoma Central 69" and it became the soundtrack for much of the documentary, which offered scenes from life in Ontario, including a roller coaster ride and a speed boat racing down the Rideau Canal.

Tom described seeing the move in *The Connors Tone*: "The movie began with sound only. And was it a sound! It nearly terrified everybody. It was so loud it seemed to be coming at you from everywhere. And what was it? It was the heavy, stomp, stomp, STOMPING of my left cowboy boot on a huge piece of plywood which everyone could now see covering the whole wall. Even the splinters and wood chips coming off the board were the size of logs that seemed to be flying towards everyone."

That wasn't the only film Tom was involved in that year. He was offered a contract for three feature-length films. The second and third would be dependent on the success of the first, but the deal made major headlines and even warranted a column in *Billboard* magazine's April 7, 1973, edition. The other two films were never made, but *Across this Land with Stompin' Tom* was filmed at the Horseshoe Tavern in May of 1973 and released later that year. Journalist Peter Goddard once said, "If you ever had to put one

thing in a time capsule to explain the Horseshoe, Stompin' Tom would be the one thing I would put in." In a sense, this film is that time capsule. The movie captures the spirit and energy of that time and the legendary country tavern beautifully.

Tom performs many of his best known hits, including "Bud the Spud," "The Hockey Song," "Sudbury Saturday Night" and "Luke's Guitar." He also sings a number of covers, including his scatological version of "Green Green Grass of Home." Watching Tom perform, it's clear he's already made friends with the audience, acknowledging different groups of people in the crowd and where they're from. He is charming, funny and full of confidence, and it's clear the audience loves him. The performances are intercut with animation, silent film stock footage and even Tom acting out his song, "Movin' In (From Montreal by Train)," where he gets off a train, kisses some women and leaves a row of them looking somewhat dejected as he walks away.

A number of other Boot Records artists perform in the film, including Kent Brockwell, Bobby Lalonde, Sharon Lowness, Chris Scott and Joey Tardif. When the other artists perform, Tom sits at a table with the audience, smoking and having a beer. The entire performance resembles a kitchen party more than a well-planned concert. When he first goes to sit in the audience there is no chair for him, so people pass one over their heads from the back of the room to much applause. This is one of the first films that famed Canadian movie director David Cronenberg ever worked on. He was a young University of Toronto student who got to be an assistant production manager on the movie.

Taking advantage of Tom's cowboy look, the poster for the film looked like the promotion for an old John Wayne movie. The film closes with Tom as a solitary figure, walking down a long dirt road with a guitar slung over his back. The scene is underscored by Freddy Dixon singing his song, "Ballad of Stompin' Tom," which recounts many of the better known details of Tom's life. Dixon,

who would go on to become a member of the Ottawa Valley Country Music Hall of Fame, was another Boot Records artist and Tom had included Dixon's song, "Last Fatal Duel," on his *Hockey Song* album a couple of years before.

The author of *Maritime Music Greats* wrote that during the early 1970s Tom "became something of a media darling, his face and his distinctive voice ('full of gravel and beer' as broadcaster Peter Gzowski once called it) becoming as instantly recognizable as that of Prime Minister Pierre Elliott Trudeau. Even people who didn't follow country music could hardly avoid Tom Connors . . . His fans, far from being country and western rednecks, included homesick Maritimers, cultural nationalists and just plain folks."[10] As the promotion for his movie stated, in Canada Tom was the "Undisputed King of Country Music."

*St. Patrick's Orphanage in Silver Falls, NB, where Tom was sent at eight years old.*
Photo courtesy of the Provincial Archives of New Brunswick

*The Aylward house in Skinners Pond, where Tom lived from the ages of nine to 13.*
Photo by Charlie Rhindress

*Skinners Pond School, which Tom attended as a boy from the ages of nine through 13.*
Photo by Charlie Rhindress

*The interior of the Skinners Pond schoolhouse.*
Photo courtesy of Mary Ann Keddy

*Tom's truck, famously called "The Boot," parked at the Skinners Pond Schoolhouse. Young Wendy Callaghan was visiting the site with her family.*
Photo courtesy of Ed McCabe

*Tom in a Bricklin — Canada's first sports car — owned by former New Brunswick premier Richard Hatfield.*
Photo courtesy of the Provincial Archives of New Brunswick

*NB Premier Richard Hatfield, Tom and writer Alden Nowlan in the early 1970s.*
Photo courtesy of the Provincial Archives of New Brunswick

*Tom accepting a 1973 Juno Award as Best Country Male Artist.*
Photo provided by Bruce Cole. Copyright © Bruce Cole, 1973

*Anne Murray, Gordon Lightfoot and Stompin' Tom at the 1973 Juno Awards.*
Photo provided by Bruce Cole. Copyright © Bruce Cole, 1973

*Tom being interviewed at the CFGM radio station on August 31, 1973.*
Photo provided by Bruce Cole. Copyright © Bruce Cole, 1973

*Tom performing on stage in 1973.*
Photo provided by Bruce Cole. Copyright © Bruce Cole, 1973

*Tom and Lena's first dance at their wedding on November 2, 1973, at the Holiday Inn in Toronto.*
Photo provided by Bruce Cole. Copyright © Bruce Cole, 1973

*Tom playing guitar at the summer home of his friends, Reg and Muriel Chapman, in Anagance, NB, July, 1982.*
  Photo courtesy of Paul Saulnier

*Tom signing a stompin' board as his son, Tom Jr., looks on in 1982.*
  Photo courtesy of Paul Saulnier

*Tom in front of his camper with Paul Saulnier (l) and Reg and Muriel Chapman's son, Wayne (r), in 1982.*

Photo by Muriel Chapman, courtesy of Paul Saulnier

*Freda and Anthony Keefe's teapot, which inspired Tom's song, "Skinners Pond Teapot."*

Photo courtesy of Pauline Arsenault

*Stompin' Tom Road in Skinner's Pond, PEI, which was named in Tom's honour in 1999.*
Photo by Charlie Rhindress

*Tom receiving his honorary degree from the University of Toronto in 2000.*
Photo courtesy of the University of Toronto Archives and photographers Stephen Frost and Lisa Salulensky

*Tom featured on a Canada Post stamp in 2009.*

*Photo used by permission of Canada Post*

*Tom backstage before his last performance on PEI with old friends, Freda Keefe and her granddaughter, Pauline Arsenault (nee Keefe), July 25, 2009.*

*Photo courtesy of Pauline Arsenault*

*Tom with band member Al Widmeyer and wooden statue of Joseph Montferrand, aka Big Joe Mufferaw in Mattawa, Ontario in the late 2000s.*
Photo courtesy of Al Widmeyer

*Tom with the Stanley Cup and band member, Al Widmeyer, in the late 2000s.*
Photo courtesy of Al Widmeyer

*Tom enjoying his 75th birthday celebrations.* Photo courtesy of Duncan Fremlin

*Tom celebrating his 75th Birthday with Deane Cameron, former President and CEO of EMI Music.*
Photo courtesy of Duncan Fremlin

*Tom's tombstone in the Erin Union Cemetery, Erin, Ontario.*
*Photo courtesy of Phil Gravelle*

*Closeup of the poem on Tom's tombstone. Photo courtesy of Phil Gravelle*

The body has returned to sod,
The spirit has returned to God.
So on this spot, no need for grief,
Here only lies a fallen leaf.
Until new blossoms form in time,
The tree is where I now reside.
But with this poem,
as you can see,
They haven't heard
the last of me.

*Mural celebrating Tom in his hometown of Saint John, New Brunswick. Photo by Charlie Rhindress*

Stompin' Tom Connors
(1936 - 2013)
Musician & Canadian Icon

*Stompin' Tom Connors commemorative bronze unveiled in Sudbury, Ontario, November, 2015. Sculpture by Tyler Fauvelle.*

Photo supplied by Tyler Fauvelle

*Lineup waiting to get in to the Stompin' Tom Centre in Skinners Pond on opening day, July 1, 2017.*

Photo by Charlie Rhindress

## Chapter Eight
# The Rebel

The music of strangers they play in our homes,
And tell us that we don't have songs of our own.
— "(We Have) No Canadian Dream"

Despite Tom's incredible success, he found himself at the centre of a number of controversies and very public battles over the next few years. He had never been one to back down from a fight and he carried that attitude into the music industry, some would say to his own detriment. As early as 1971 Tom was called "cantankerous" in the press. This attitude of defiance would come to define the myth of Stompin' Tom as much as his music and fierce nationalism. Part of his image was that he did things his way and he would not be abused or disrespected by anyone.

The first big controversy of Tom's career was a fight with the Canadian National Exhibition (CNE). Tom had been asked to perform at the CNE and provide backup for a major American country star on the grandstand. Because it would be a much larger stage than Tom normally played, he would have to rent extra sound and lighting equipment and hire more backing musicians. Tom was asked to do all of this for a fee of $3,500. With the extra expense he figured he would just break even, but it was worth it

to get exposure on one of Canada's most coveted stages. He wrote in *The Connors Tone*, "to play there even once would show all my critics everywhere that I had been equal to the task of overcoming the last great hurdle. It would show them once and for all that I had really made it to the big leagues."

He was thrilled to find out that the big name country artist was Charley Pride. However, before Tom's deal with the CNE was finalized, someone with access to Pride's contract managed to sneak a copy to Jury Krytiuk. Tom was furious to discover that Pride would perform just six songs, not have the added expense of lighting and equipment, and be paid $35,000, as well as a percentage of the gate and his travel expenses. At first he thought it was a joke. But when Jury assured him it wasn't, and said that in three months of negotiations he hadn't been able to get Tom's fee higher than $3,500, Tom decided he didn't want to do the show.

Tom acknowledged that Pride was a big star, but he couldn't fathom how an American star, playing Canada's National Exhibition, could be worth ten times as much as a Canadian star. Tom had won three Junos, while Pride had just one Grammy Award. He couldn't understand why an organization that was supposed to be a national exhibition for Canada didn't focus more on Canadian talent. He thought they should have at least 60 per cent Canadian artists on the grandstand and that those artists should be paid a fee commensurate to what their American counterparts were receiving. Tom instructed Jury to reject the offer and "go and tell them bastards to shove it right up their royal American arseholes." The CNE subsequently offered to pay Tom $3,500 to play on a smaller stage in mid-August, where he wouldn't have the expense of additional equipment. He saw the offer as an insult and turned that down as well.

The controversy played out in the media for the next year and a half. No mention was made of the fact that Tom's problem with the CNE was that they had offered Charley Pride ten times as much money as they had offered him. From the public's perspective, the "feud" was completely about the 60 per cent minimum that Tom

had set as a condition. He never did play the CNE and he claimed that because of the negative publicity he was never invited to play any other major exhibition in the country.

In May of 1973 Tom was in the studio again recording, *To It and At It*, another album of original material. This new recording had a much fuller sound, as Tom employed members of the Toronto Symphony Orchestra in addition to his bandmates. The LP contained Tom's usual mix of humorous and historical songs, including the title track as well as "Prince Edward Island, Happy Birthday," and a tribute to Don Messer. "Pizza Pie Love" is a funny love song that features Tom employing a bad Italian accent, and another song is sung in praise of "Cornflakes." It's unlikely there are many songwriters whose catalogue includes songs about potatoes, ketchup, snowmobiles, cornflakes and other inanimate objects. Tom could find inspiration almost anywhere.

"Marten Hartwell Story" was inspired by contemporaneous newspaper accounts of a bush pilot whose plane had crashed in Northern Canada after setting out in bad weather in hopes of getting medical attention for a pregnant woman and a boy suffering from appendicitis. That song was the highest charting single on the album, going to number thirty on the Country Singles chart.

Although the album did not have any top ten hits, "To It and At It" reached number forty-two and "Don Messer Story" went to number forty. The LP would be awarded a Juno for Best Country Album, the only one of Tom's recordings to receive that honour.

In May, Tom set out on another tour of the Maritimes and Ontario. While in Saint John, New Brunswick, he met up with his father, Thomas Sullivan, who had fallen on hard times. Oddly enough, Tom's father and mother had reunited and gotten married in 1965, thirty years after she first became pregnant. The reconciliation did not last long — they were separated by the time Tom met his father again in 1973. Tom invited his father to Toronto and offered to give him a job through Boot Records. Sullivan accepted the offer, but after a few months Tom was forced to fire him when

Sullivan's drinking became a problem. He caused a commotion more than once while selling Tom's merchandise at his shows, and disappeared while on tour, along with the truck containing all of their sound equipment, almost causing the cancellation of a show.

In late June, Tom was headed to Prince Edward Island with his road manager, Wayne Hughes, and two bandmates, Gary Empey and Billy Lewis, to take part in the province's Centennial celebrations. They were flying to the island, but their plane was diverted to Moncton because of heavy fog. They had to get to Charlottetown that night in order to fulfil some of their commitments, so they rented a car. Near Point de Bute, New Brunswick, a horse came out of the fog and they hit it. The windshield smashed and the car veered to the opposite side of the road. Hughes, who was driving, jumped out and started running in a panic as Tom reached over to push down the brake and stop the car. He managed to get the car to the shoulder, safe from oncoming traffic.

Dave and Linda Strathearn, who were boarding the horse for a friend, were home with their twelve-year-old son, Kevin, when they heard the screeching tires and collision. According to Kevin, "The horse was still alive but it was hit hard enough that it wasn't going to survive. It had to be put down." Dave took the men back to the house and once in the kitchen realized who was standing there. Kevin said in an interview forty-five years later that despite the unfortunate circumstances of their meeting, "I remember Dad being really excited about it because he liked his music and back then Stompin' Tom was the man, right?"

Kevin recalls Tom asking if there might be someplace he could remove his pants, saying "I got glass down the front of my pants, cutting my balls." Kevin's older brother, Larry, who was fifteen at the time, arrived home a few minutes later to find a man in their darkened driveway shaking glass out of his pants. He remembers it being one of the band members, rather than Tom, but either way it's clear the glass from the windshield had covered the men and they had narrowly avoided serious injury. Larry recalls that the

men were "pretty adamant they had to get to the island. At that time it would have been the ferry. They had to catch the boat so they took the car and went." They apparently drove to the island in a car that no longer had a windshield.

Tom confirms this in *The Connors Tone*, writing that they had to race in order to catch the last ferry of the night. In the days before the Confederation Bridge was built, if they had missed the boat they would have had to wait until morning to get to the island. Tom wrote that he felt so bad about the incident that he compensated the family for the horse before getting back on the road.

On June 29, Tom opened the newly refurbished schoolhouse in Skinners Pond. He had put a foundation under the building and restored the interior. Tom wrote in his autobiography that "Even the blackboard and all the original double-seat desks were restored. The old pot-bellied stove was all shined up and stood in the middle of the floor complete with poker, shovel and coal scuttle." A small fee was charged for admission, which went towards a scholarship for the Skinners Pond high school graduate with the highest average who planned to continue their studies.

A cairn was erected outside of the school, which told the history of the building and of Tom's wish to preserve it "as an historical landmark for his friends, the people of Skinners Pond, as a part of their contribution towards the Prince Edward Island centennial year celebrations." As a final touch Tom parked the Boot, the truck that had taken him across the country, next to the building and left it there.

On June 30, Tom was the headliner at a concert in Victoria Park in Charlottetown that was attended by an estimated crowd of 11,000 people. Queen Elizabeth and Prince Philip also spent Canada Day on Prince Edward Island as part of the Centennial celebrations. Tom got to meet them, and in a rare move, took off his hat for the occasion. They congratulated Tom on his work and for having written so many songs about Canada.

Premier Alex Campbell was there, and Prince Philip asked him if he had seen the film *Catch the Sun*. Before going to the island the

royal couple had been in Toronto and saw a screening of Tom's IMAX film at the Cinesphere. According to *The Connors Tone*, the prince told Tom and Campbell "how astounded they were to hear and see such a large boot come stomping down on that giant piece of plywood." The prince stretched out his arms as he described "the size of those big woodchips that made us both duck down as they came flying toward us." Tom had indeed come a long way when the Queen of England was sitting in a darkened theatre ducking from the flying wood chips caused by his famed stomping.

That summer Tom toured Newfoundland for the first time. Unfortunately the person who booked Tom's concerts had set the ticket price at $3.50, which was relatively expensive for 1973. This resulted in smaller crowds than he would have liked. Tom was so upset that the working class people for whom he sang couldn't afford to see him that as he left each town he took out an ad, which ran in the local paper the next day:

> *An Apology From Stompin' Tom Connors. To the people of St. John's and surrounding areas. I wish to apologize for the high price of admission to my show. The price was solely determined by the agent who brought me into Newfoundland. I was totally unaware of the high price until I arrived in the province. I assure you that in the future when I return to play this area the admission price will be much more reasonable. Please accept my humble apologies. Sincerely, Stompin' Tom Connors.*

True to his word, the next time he played in Newfoundland the tickets were just $2.50 and anyone fourteen or under got in for a dollar.

In Halifax Tom joined Sam Sniderman for the opening of a new Sam the Record Man store. While there Tom was presented with his fifth gold record, this time for *Stompin' Tom Meets Big*

*Joe Mufferaw.* Lena was touring with Tom and dealing with merchandise sales during the shows. While in PEI, they made some wedding plans by asking Johnny Reid to be their best man and Lena's sister, Pauline, to be the maid of honour.

One night while playing at Johnny's Prince Edward Lounge, Tom was surprised to see his old friend Premier Richard Hatfield making his way through the crowd. Hatfield approached the stage and asked Tom for his stomping board. Tom had no idea why Hatfield wanted it, but he complied and started stomping on a new piece of plywood. A short while later Hatfield returned with the board in hand, with the signatures of all ten premiers who were in the city for a conference.

Boot Records continued to grow and in August 1973 they had to buy a bigger building, which became the company's headquarters. That same month Jury approached Tom with a novel idea. He had spoken to a producer from the Elwood Glover show who suggested that Tom and Lena could get married live on television. Tom rejected the idea, fearing it might be tacky. However, after further discussion with Lena, they realized it might allow Tom's many friends and fans from across the country to be part of their special day.

A few years before, Tiny Tim had famously married Miss Vicki on *The Tonight Show*. Tom had heard that the entire thing was "quite a farce" and he would only consider getting married on television if he could be guaranteed the ceremony would be respectful and not a joke. Jury assured him that would be the case and plans were made for the couple to wed live on air on November 2, 1973. They would be the first Canadian couple married on national television.

Tom's friend Steve Fruitman said that people accused Tom of copying Tiny Tim: "People were comparing it to that. And with Tiny Tim it was a stunt. People were convinced it was a . . . copycat type of thing. Getting married on TV. Tom got a lot of negative press over it. Because Canadians are crass when they do stuff that Americans do." But Fruitman believes Tom's heart was in the right place. "I truly believe his explanation. He wanted his fans to

enjoy it, because if it wasn't for his fans he would have had nothing. Absolutely nothing." The people of Canada really had become Tom's family, so it made perfect sense to invite all of them to his wedding, if only over the airwaves.

The wedding took place at Toronto's Four Seasons Hotel in a room that seated about 140 people. Both of Tom's mothers were in attendance. The Aylwards had travelled from Prince Edward Island, while his birth mother, who lived in Montreal, was making her first visit to Toronto. Some of the well-known guests at the wedding included Richard Hatfield, Sam Sniderman and Toronto's Mayor Crombie. Gaet Lepine, the bartender who had given Tom his big break at the Maple Leaf Hotel in Timmins years before, was on hand to sing a song he had written.

On the morning of the wedding, Tom had a beer and some toast for breakfast. When he got dressed he put on his Stompin' Tom attire rather than a traditional tux. Just the week before, Tom had written a song for the occasion called "We're Trading Hearts." It included the lyrics, "We're trading hearts today, Knowing the world's O.K., Walking the same highway, Never to part." The song was performed at the ceremony by the Sonny Caulfield Trio.

After the ceremony, Glover interviewed Tom and Lena before the program ended and the guests had lunch and wedding cake. There were toasts and someone read congratulatory telegrams from around the world, including messages from Johnny Cash and Wilf Carter. Knowing that Tom was a fan of Moosehead beer, the company sent him a full truckload as a gift. He received 200 two-fours of beer.

Most of the guests went to the premiere of *Across this Land with Stompin' Tom*, which happened to open on their wedding day. Tom and Lena were leaving early the next morning on their honeymoon, and would not have another chance to see it. Once the movie was over, they went to another reception where about three hundred guests were waiting to celebrate with them. The next morning they set off on a honeymoon that included a cruise and a great deal of

travel by car through the United States and Mexico. After touring and recording almost non-stop for the past ten years, Tom had more than earned his extended two-month vacation with his new wife.

Shortly after arriving home in January of 1974, Tom received an offer from the CBC to host his own musical TV series. The half-hour show would feature Tom crossing the country, visiting communities that had inspired some of his songs. The show would be a mix of location sequences and studio performances from Tom and his musical guests. The CBC wanted twenty-six episodes, but Tom only wanted to do thirteen out of fear that being in people's living rooms too much would cut into record sales. They compromised and Tom signed on for twenty-one episodes.

CBC wanted Tom to feature American talent on his show. According to his memoir, Tom responded with, "Our Canadian talent is every bit as good as the American, and it's high time we gave them the national exposure they need and deserve. So if I can't have the guests I want on this series, there won't be any series." The series went ahead with all Canadian talent. Some of the people featured on the show included Al Oster, Gaet Lepine, Stevedore Steve, Buddy Roberts and Dick Nolan. None of them were household names or went on to great fame, but they were given exposure that they would not have otherwise had.

Tom recorded another album of mostly original material in 1974. *Stompin' Tom Meets Muk Tuk Annie* was the first of Tom's self-penned albums whose title came from a song he hadn't written. "Ballad of Muk Tuk Annie" was a humorous song written by Bob Ruzicka that sounded a lot like a Stompin' Tom song. The LP also included "We're Trading Hearts" and "Streaker's Dream," the only song from the album to hit the charts, peaking at number thirty-four.

In March of 1974, Tom won two Junos, bringing his total to five. He received his fourth consecutive Best Male Country Artist award and he picked up the trophy for *To It and At It* as the Best Country Album of the year.

Much of 1974 was spent planning and filming the twenty-one episodes of his TV show. When he wasn't working on the show, he continued to tour and play the Horseshoe. *Stompin' Tom's Canada* premiered on Thursday, September 26 at 9 p.m. The show aired in that time slot until March 13, 1975. A review published in *The Globe and Mail* the day after the first episode had the headline, "Nothing Fancy, but Connors' Show Seems Sure Winner." The review began, "Stompin' Tom Connors is a musical nationalist, and a fervent one, and these are nationalistic times. He is also a cunning performer, and one with the common touch. Given all that, there seems no way that his CBC-TV series can fail."[1] Tom was the only performer on that first episode, and the reviewer wrote, "Connors was so confident that he didn't bother to bring in even one guest artist to vary the bill. He droned everything out in his nasal bass voice with clarity and simplicity. No fancy singing, no fancy staging."

The program aired for just one season, but that had been Tom's plan all along. He was annoyed when the press announced that the show had been cancelled. Tom told the *Acton Free Press*, "It wasn't cancelled, the contract was up."[2] In that same article, Tom mentioned the negative view that he thought others had of him, saying, "I'm known to be the fool of Canadian businessman. I'm fighting a losing battle . . . but I'm happy and contented inside — at least I did my bit." He does not however, appear to be particularly happy or content in interviews from this period.

Tom and Lena spent Christmas of 1974 at Skinners Pond and invited their friends Steve and Gini Foote to join them. They stayed into January so they could work on the property. In late January 1975, Tom presented the inaugural scholarship from the Skinners Pond schoolhouse. The first recipient was Pauline Keefe, the granddaughter of Freda and Anthony Keefe, who owned Skinners Pond's only car when Tom arrived there in 1944. The couple and their two boys had picked Tom up at the train station in Tignish and driven him to his new home.

Pauline, whose married name is Arsenault, was awarded five hundred dollars, which she said in an interview "was a lot of money back then." She remembers that her future husband, Robert, took her to Charlottetown to meet Tom and receive her scholarship early one Sunday morning. She said, "He was playing at JR's [Johnny Reid's bar in Charlottetown], I believe, because . . . I went down to get the scholarship on Sunday morning at JR's lounge. That's where we met." A photographer was on hand to mark the occasion and Arsenault adds, "There was an official picture that was in papers all across Canada." She has a copy of the photograph signed by Tom that still hangs in her living room.

In March of 1975, Tom won his fifth consecutive Juno award as Best Male Country Vocalist. He was also nominated as Best Male Vocalist and Best Folksinger, but he did not win in either category. He continued to tour and record, releasing *The North Atlantic Squadron*, another album of mostly original music. Tom got a little more political on this album, including the song "Unity," which speaks of the importance of Canada remaining united and contains the lyrics, "But I still remember well, The voice that said to write, And sing of what shall be, There's a promised land for those who stand in Canada's unity." As with his last release, this LP had just one song make the country music charts. "Jack of Many Trades" peaked at number twenty-four.

That year, Boot Records released a songbook called *Stompin' Tom: Story & Song*, which featured 125 of Tom's songs. The accompanying text was written by Stevedore Steve and recounted their hitchhiking days. Steve also provided illustrations throughout the book. A review that appeared in *Books in Canada* was not kind to the publication, with the reviewer writing that the book "looks and feels as if it were produced in the U.S.S.R. by one of the printers who specialize in producing cheap English-language editions of Lenin's works. It has a dreadful introduction by Stompin' Tom Connors' best friend Steve Foote and even crummier drawings by the same man."[3]

Tom had thus far been celebrated in the media for bringing a new energy and sense of nationalism to country music, but by the mid-1970s a backlash had begun. Many felt that his music was too simplistic and that his "shtick" was growing tired. A review from 1975 appeared in *The Globe and Mail* with the headline, "Connors Curries Favor Shamelessly."[4] The reviewer, Blaik Kirby, wrote that "Stompin' Tom Connors knows his audience by now — all the people who feel they're the abused, hard slugging common herd. And he caters to them so shamelessly that he is rapidly becoming a caricature."

He wrote that Tom was "grovelling shamelessly for applause, cheers and whistles when he didn't have to. The crowd — about 2800 on a damp, chilly night, which means wide acceptance — would have been with him anyway." He even criticized Tom's use of Canadian place names as "a dated, hackneyed and devalued stage trick. Anyone can do it, and lots do, but few so shamelessly." Kirby concluded, "He does not need to stoop to some of the tricks of which he seems so fond, to win acceptance. They devalue him, make him a caricature and a clown. He should drop them before they wreck him."

It was exactly this shtick that led to Tom's own frustration with his career. As the years went on Tom grew irritated with the media and music industry, who didn't see that he was more than Stompin' Tom. In some ways, Tom had created his own monster. As Kurt Vonnegut once said, "We are what we pretend to be, so we must be careful about what we pretend to be."

Ironically, as Tom was becoming irritated by the music industry his personal life was the best it had ever been. In June of 1975, he and Lena bought their first home in Ballinafad, Ontario, just outside of Georgetown. The purchase warranted a mention in the *Georgetown Herald*. In a column of community news from Ballinafad, amidst reports of local church sermons, weddings and deaths, was the following observation: "The community of Ballinafad is getting to be quite a place for notable people to make their home.

The latest one being Stompin' Tom Conner [sic] of T.V. fame. The Connor's have purchased the former Harris property on the outskirts of the village."[5] Unfortunately, Tom was so busy touring that they weren't able to fully unpack and settle into their new home until later that fall. On their wedding anniversary, in November, Lena announced that she was pregnant with their first child.

Touring wasn't the only thing keeping Tom busy. As of 1975, Boot had fourteen employees and over one hundred artists signed to the label. They had branched out into merchandising, at one point even operating a printing press and a silk screening business. Tom started work on another major project in 1975 as well; he wanted to use the Skinners Pond schoolhouse as the centrepiece of a tourist attraction. He hoped to start with a golf course and trailer park and perhaps create a Stompin' Tom museum and licensed dining room. He offered Willard and Marlene the opportunity to work with him on the project. They would develop the attraction and Tom would pay Willard a salary until the operation could sustain itself. From then on they would own it fifty-fifty. Tom and Willard signed an agreement to develop "Double C Resorts" — for Connors and Clohossey, Willard's last name. In January of 1976 Willard and Marlene moved their family to PEI to begin work.

When the Juno nominations were announced in early 1976, Tom was once again nominated for Best Male Country Vocalist and Folksinger of the Year but he did not win either award. It was the first time since 1971 that he had not won Best Male Country Vocalist. To add insult to injury, he lost to Murray McLauchlan, who was not a traditional country artist. As Blaik Kirby wrote in *The Globe and Mail* after the awards, McLauchlan was "about 80 per cent folkie and 10 per cent uptown country."[6]

Until he lost, Tom didn't seem to have a problem with the Juno awards. However, he wrote in *The Connors Tone*, "I certainly didn't want to be classed with artists who have previously and adamantly stated to the press that they were definitely not country artists yet allowed their names to stand as nominees in the country category,

thereby depriving the true country artists the opportunity of being nominated in their own natural slot. (Some artists will do anything for a Juno Award.)"

Tom was not alone in feeling that the wrong artists were winning country music Junos. Kirby wrote that, of the three big country winners that night, McLauchlan, Anne Murray for Female Country Artist and the Mercey Brothers for Country Group, only the Merceys were really country artists. He added that the award might make Anne Murray "scowl if not swear." He went on to say, "She's trying to shake the country image in favour of the richer rewards of rock."[7] While Anne didn't initially see herself as a country artist, in an interview for this book she admitted, "I was in such shock when they put me on the country charts, but after a while I just went, 'Well, great. Somebody's listening.'" She continued, "It's sometimes in the ear of the listener . . . some people hear it and if they want to call it country, they can call it country. I don't care."

Murray just wanted people to hear her music. "You want to get played," she said, "on as many different formats and as many different radio stations as you can. And who cares who's listening? They're all people. I was too busy working and I was out performing for the folks and as long as they liked what I was doing I didn't care where they played me." Likewise, she wasn't concerned whether she was nominated for awards in pop or country categories.

In March of 1976, Tom recorded another album of original material, called *The Unpopular Stompin' Tom*. Tom wrote in *The Connors Tone* that "The Title was merely to reflect the reaction I was receiving throughout the industry at the time for my stand against the policies of radio, the CNE, the Junos and others, whom I thought were not giving Canadians a fair shake." In early 1976, however, his only well-known public feud was with the CNE. Whatever the case, the title was prescient in that, other than his holiday release and *Live at the Horseshoe*, this was his first album that did not place any songs on the Country Singles charts. The past few years had seen Tom getting less and less radio airplay.

None of the songs on the LP became particularly well known or part of Tom's standard repertoire.

On June 14, 1976, Tom and Lena's son, Tom Jr., was born, but Tom was back on the road by August. For the first time in years Lena did not go with him, but stayed home with their new baby. Tom crossed the country twice that year, playing over a hundred shows, finishing the tour in Vegreville, Alberta, on December 16. When he finally returned home he discovered that his six-month-old son was uncomfortable around a father he had not yet gotten to know. Tom decided to take 1977 off so that he could spend more time with his new family.

Tom wanted time with his family, but he was also growing increasingly frustrated with the music industry. In January of 1977 Jennifer Barr interviewed him for the *Acton Free Press*. She wrote, "Stompin' Tom Connors has fought hard for recognition of Canadian talent. Now he feels he's losing the battle."[8]

In the article Tom complained about the CNE, Canadian artists who move to the United States, his own media coverage and radio not playing enough homegrown artists. It's worth noting that as a record company owner Tom had a vested interest in radio supporting Canadian artists. Barr wrote, "He claims that he might go bankrupt if Canadian artists don't start getting more media attention . . . Connors has been sinking everything above modest living expenses back into the company." She quotes Tom as saying, "If I'd saved my money I could be very well off now." Tom comes across in the article as bitter and defeated.

When the Juno nominations were announced in 1977, Murray McLauchlan was again among the nominees for Best Male Country Artist and he won for the second year in a row.

In early 1977, Tom wrote a song called "Ripped Off Winkle," which expressed his frustration with the state of Canadian music. He recounts how he dreamed of being a singer but the message he got was "If you want to be a 'Big Country Star' you go to Nashville, Tennessee." He goes on to say that he wanted to be a star not out

of greed, but "I wanted my country to take the credit for me if I succeed."

Although Tom continued writing for much of 1977, he did not perform that year. He spent time with his family, worked on the property in Skinners Pond and wrote songs for his next album, *At the Gumboot Cloggeroo*. The album contained "Ripped Off Winkle" and "The Singer," a song in which he laments those who leave Canada in search of success elsewhere, with the lyrics, "The Singer is the Voice of the People, And his song is the soul of our land. So Singer, please stay, and don't go away." While this album had no charted singles "Gumboot Cloggeroo" did prove popular in live performance and appeared on subsequent releases. A review in *Canadian Composer* noted that Tom played "lead and rhythm guitar, fiddle and banjo." He had come a long way from the days when he just played guitar and stomped his foot. The review goes on to say that "Connors, with his gruff voice, and the simple settings he gives his material, remains a singer-songwriter who touches his audience in a direct person-to-person way that is rare in Canadian country music."[9]

Tom wrote in *The Connors Tone* that when he saw the list of nominees for the 1978 Junos, he thought that "It was becoming a bigger farce than ever." He asked that his name be removed from the list of nominees. He initially said that he was withdrawing because he wanted to give others an opportunity to be nominated. Tom wrote in his autobiography, "Some artists already had over twenty Junos and were still being nominated in several categories in the hopes of winning more." He felt that "three successive Junos in the same category" proved that an artist was successful and twenty or thirty served no real purpose. He suggested that after three awards an artist should be inducted into a Juno Club of Excellence and step aside so that others might reap the benefits that a high-profile national award might offer. Over time, instead of one musician having thirty awards there would be ten artists with three awards each, bringing recognition to more artists.

Despite this being his public explanation, what seemed to bother Tom the most was the inclusion of Ronnie Prophet in the Best Male Country Artist category. Unlike McLauchlan, Prophet was definitely a country singer, but Tom was upset that Prophet had lived much of his life in the United States. Not only did Prophet win, but the award was presented by Charley Pride.

According to Tom, stories started appearing in the press saying that there were other reasons he had withdrawn his name. One claimed that his record sales would show he hadn't earned the nomination, while another suggested that his withdrawal was simply a publicity stunt like his battle with the CNE and his televised wedding. Tom wrote that he thought, "All right! Enough is enough. If it's a goddamn publicity stunt they're looking for then I'll give them one."

Two days after the awards were presented, Tom asked Jury to arrange for a press conference at Boot Records without explaining why. He also asked Jury to have a taxi ready to make a delivery and to cancel all of Tom's bookings for the next year. Once the media was gathered in the foyer of the record company, Tom entered, removed his six Juno Awards from a box and lined them up on a desk. He explained that he was sending his awards back to protest the awarding of Junos to artists who no longer lived in Canada. In news footage of the press conference, he says, "The thing is that they are taking opportunities away from the people who choose to be proud to live in this country and to do their work here."

Tom had written a statement to accompany the awards. It read:

> *To the Canadian Academy of Recording Arts and Sciences*
>
> *Gentlemen:*
>
> *I am returning herewith the six Juno Awards that I once felt honoured to receive but which I am no*

*longer proud to have in my possession. As far as I'm concerned you can give them to the border jumpers who didn't receive an award this year and maybe you can have them presented by Charley Pride.*

*I feel that the Junos should be for people who are living in Canada, whose main base of business operations is in Canada, who are working toward the recognition of Canadian Talent in this country, and are trying to further the export of such talent from this country to the world, with a view to proudly showing off what we can contribute to the world market.*

*Until the Academy appears to comply more closely with the aspirations of this kind, I will no longer stand for any nominations nor will I accept any award given.*

*Yours very truly,
Stompin' Tom Connors*

According to an article in *The Globe and Mail* the next day, Tom also "noted that no other entertainers had come forth to support him in his campaign on behalf of Canadian talent."[10] Tom said, "I feel I have valid points and yet I'm frustrated by this complacency. Does this mean that Canadian entertainers are not concerned with their opportunities for further advancement within their own country or that they don't even have an interest in their own Canadian music industry? If it is too much to ask others for their support in this matter then I consider that my contribution to the Canadian music industry thus far has been pointless."

He told the assembled media that he vowed to "make myself unavailable for a period of one year from today for any jobs this publicity might entitle me to." With that, Tom left the room, planning to take a year off from the music business.

# Chapter Nine
# The Recluse

I'm long gone to the Yukon,
Those northern lights I want to see,
I'm long, long, gone to the Yukon, boys,
'Cause the Yukon is callin' for me.

— "Long Gone to the Yukon"

Tom's press conference received coverage on national television news and in newspapers across the country. He wrote in *The Connors Tone*, that the coverage was mixed, saying "I was being called everything from a hero to a lunatic." The controversy continued for close to a month, but Tom stopped giving interviews after a week, writing that "The questions were becoming the same and so were my answers, so I just let them go with what they had and left it at that."

An article in *RPM* magazine reported that Tom had sent them a Telex two days before the awards to outline his problems with the Juno Awards. The story pointed out that wanting to give other artists a chance to win the award, "was not the key reason for his withdrawal. Rather, it was his total disagreement with the qualifications set by CARAS for possible nominees that prompted his action." CARAS was the Canadian Academy of Recording Arts and Sciences, the organization that oversaw the Juno Awards. Tom was quoted as saying, "In my own field of music, I have

seen people nominated in the country category after having told the press that they were pop, not country, artists. Then when they won and the time came for them to collect their award, they cheerfully went up to accept, forgetting the stand they had previously taken with regard to the country field."

He told the magazine that he was also upset that the Junos included artists who had left Canada to pursue their careers elsewhere. He felt that there should be an International Juno for those Canadians who no longer lived in Canada. The basic disagreement between Tom and CARAS was that Tom saw the awards as a promotional tool for Canadian artists, whereas CARAS wanted to celebrate Canadian artists no matter where they lived.

Tom went so far as to call those who pursued careers outside of Canada "turncoat Canadians." He eventually wrote a song called "Believe in Your Country," in which he angrily sang with nationalist fervor, "If you don't believe your country should come before yourself, you can better serve your country by living someplace else." Even those close to him thought he had perhaps gone too far with that song. Duncan Fremlin wrote in his book, *My Good Times with Stompin' Tom*, about the first time he heard the song: "Holy crap, I thought. That's rather draconian. No room for speculation there. That was Tom."[2]

Despite Tom's feelings about "Turncoat Canadians," his boyhood idols Wilf Carter and Hank Snow had moved to the United States and achieved their greatest fame there. Carter had gone so far as to adopt the very American stage name, Montana Slim. By the late 1960s and early 1970s, however, some Canadian artists were managing to achieve American success while staying at home.

Anne Murray pointed out that she and Gordon Lightfoot were breaking the mould by staying in Canada. She said, "Gordon and I were the first. Paul Anka went and Joni Mitchell and Neil Young. All of those people went." Like Tom, Anne had no intention of leaving. She said, "I endured great pressure to move. However, I had already reluctantly left the Maritimes to go to Toronto

because I had to, for my work. I was not going to move out of Canada! It was home and I wasn't leaving it." Yet she understood why others did. In reference to Mitchell she said, "Joni did, but maybe she had to. Because things were different. She was before my time even. There was a hotbed of great writers and singers and everything in L.A. and she went there. She wanted to be part of that. And I get that."

Although Tom often complained about artists leaving Canada, in an open letter to *Country: Canada's Country Music Magazine*, he explained that what bothered him the most was when those artists Americanized their music. He wrote, "Our songwriters must write songs that are identifiably Canadian, with Canadian styles and themes about Canadian life . . . Our songs have to be Canadian and our singers have to be damn well proud to sing them no matter where in the world they find themselves with an audience." He pointed out that "When the Americans bring their talent to this country, they sing songs about America with American pride. They make no bones about who they are and make no excuses for what they are."

While Murray didn't share Tom's feeling that artists who left Canada were being disloyal to their country, she did concede that when it came to the Junos, "Maybe he was right." She pointed out that it was a young organization, saying, "These people were trying to find themselves at that time." Murray, who never courted controversy, boycotted the awards ceremony herself for many years. She said, "I wouldn't go to the Juno Awards. I was there for the first couple I think. But in 1975 I stopped going because there was an audience, they were all drunk, and it was televised. It was dinner and they drank through all of that. And I performed and I don't think that one person in the audience was paying any attention to me." She continued, "And so I just went, 'You know what? Until they put on a proper television show I'm not going to be part of it.'" She explained that it was important because she didn't feel the artists were being properly served. She said,

"I really felt that the show was beneath all of us. The production values were below all of us. And they finally got it together and then I came back."

Although Tom took a year off from performing to prove that returning his Junos was not just a publicity stunt, his reputation ultimately grew as a result of his protest. Dave Bidini wrote in *Nerve* magazine that "These statements lingered in the press and made Tom an even bigger name."[3] Mickey Andrews acknowledged that while Tom's concerns were no doubt genuine, he would also have been aware of the promotional value in returning the awards. He said, "He gave back the awards. Naturally that's going to get in the papers and all that stuff. That's smart. Those awards are home sitting in your bedroom or on the wall. Who cares about an award? But if you give them back, everybody knows how Canadian you are. I actually think that's his smartness."

Although it was Tom's discontent with the Juno Awards that got all the attention, he was actually upset with the entire music industry when he walked away in 1978. He was still feuding with the CNE and he felt that radio, despite the new CanCon rules, was not doing its part to build a following for Canadian artists. He had grown tired of the fight and despite imploring artists in "The Singer" to "Please stay and don't go away," he walked away from the industry. He had already taken 1977 off from touring. Now he had another year with no performance or recording commitments.

Tom's entrepreneurial spirit, however, wouldn't let him sit around and rest on his laurels. Tom was an avid reader of history books and he became interested not only in the dates when certain events occurred, but also the day of the week when they happened. He couldn't find a perpetual calendar that would give him this information, so he decided to create one himself. He started working on a calendar in late 1977 and finished it in the spring of 1978. He filed a patent for his creation, which he called Everdate, and started making plans to have a business card-sized calendar mass produced.

Tom also took this time away from music to start writing his autobiography. He tried to recall every moment of his life, and after three months he had 130 single-spaced, typed pages that only covered up to the age of four. He calculated that at the rate he was going it would take 1,300 pages to get to his present age. He became overwhelmed and decided to set the book aside so he could go to Skinners Pond for the summer and help Willard and Marlene develop Double C Resorts.

The school had been operating as a tourist attraction since 1973 and they sold a variety of Stompin' Tom merchandise, including records, tapes, bumper stickers, pictures and some miniature Stompin' Boards, which Tom had created with Lena. Each one had a heel print and Tom's signature. Marlene also ran a canteen on the property, doing most of the cooking herself. The school provided summer employment for two local students each summer.

Tom was disappointed, however, to arrive at Skinners Pond and realize that vandals had attacked the school over the winter. People had been shooting at the building and Tom counted sixty-seven bullet holes on the outside walls. Windows had been shattered and some of the contents inside had been destroyed. Even the Boot, which was parked outside the school, was not spared, as someone had stolen parts off the old truck. Tom wanted to do something to stop the vandalism, but was at a loss. He felt that in such a small community someone had to know who was trashing his property, yet no one was willing to come forward. He finally concluded that all he could do was work on his expansion and hope that things got better.

As Tom's year away from the music industry came to a close, he realized nothing had changed. When the Juno nominations were announced in early 1979, Tom saw that Ronnie Prophet was nominated again. He wrote in *The Connors Tone*, "There's nothing wrong with awards, in and of themselves. But when they have to be yet another source of unfairness to Canadian artists, in an industry that already reeks of unfairness, it's time for those with even an

ounce of integrity to separate themselves from those who can't see anything wrong with its perpetuation." Tom decided he would not return to music. He wrote in his autobiography, "For the next ten years I would be trapped between a rock and a hard place." He knew, based on the thousands of letters he received, that his fans still wanted to see him, but he sincerely felt that "to record and entertain would be tantamount to becoming a part of the music industry once again, at least in the eyes of the public, and therefore caving in and turning a blind eye to its injustices."

In a 1987 interview, Jury Krytiuk explained why Tom had decided to walk away from his career. He acknowledged that Tom "was frustrated with the attitude of the press, radio stations and record stores toward Canadian entertainers," but he also added that Tom "felt he had accomplished all he could do within the industry."[4] It's important to note that Tom had been talking about walking away from his career long before he started feuding with the industry. In 1970 he told *Canadian Composer* magazine that he might take the following year off, and he said something similar to Alden Nowlan in 1972.

Tom had spent his earliest years searching for someone to love him and longing for the family that was denied him as a child. He now had a nice home, a wife and a young son. In an interview for this book Steve Fruitman said, "A big part of why Tom stopped in '77 was because of that. It was the first time he had had a family. He doesn't talk about it. He gives the impression that he just quit in protest, gave his Junos back, walked away from it all in disgust. Nothing could be further from the truth."

Fruitman goes on to point out the difference between Tom, the performer, and Tom, the man. "That was the 'Stompin' Tom' side of things," he continued, "it wasn't the 'Tom Connors' side of things. The Tom Connors side of things was, since he'd been married to Lena . . . she toured with him. Then when she got pregnant with Tommy, I guess they wanted to start planning a normal life. And that's when he bought the place in Georgetown. This is where

they lived to raise Tommy. He was just enjoying his life and his family. But I think it was because of the way he was raised. It was something that he always craved and always cherished, to his very last breath. Having family was so important. That's really why. He wouldn't tell his fans that." Fruitman added that it better fit the image of Stompin' Tom to say he had walked away in protest.

Tom returned to Skinners Pond to work on the property in the summer of 1979. Willard and Marlene had bought a farm and were no longer living at Skinners Pond, so the vandalism had gotten even worse. This time the vandals had gone beyond the school and the Boot, driving Tom's backhoe and lawnmower into the pond.

Tom was not generating any income as a recording artist and the Skinners Pond development was costing him more than he'd expected. Despite his "retirement," Boot Records had continued to be active and now represented over one hundred artists and bands. The list of Canadian talent who were signed to Boot Records over the years is quite remarkable. Some of Canada's best known musicians released albums through the label, including Rita MacNeil, Stan Rogers, Ryan's Fancy and polka king Walter Ostanek.

Boot Records had also branched out from the country and folk artists it originally supported. Surprisingly, the company was Canada's first classical music label, producing Liona Boyd's debut album, *The Guitar*, in 1974. Boyd told the *Toronto Sun* that Tom "basically launched my career ... as I understood it, he wasn't really a fan of classical music but he had heard Canada had no classical label, which was absolutely true. So bless him, he went and decided he'd be the first one. And he signed myself and The Canadian Brass ... So he was a bit of a pioneer with classical music."[5] Boot was also the first Canadian record label to bring Jamaican reggae to Canada.

In addition to the record label, Tom was also part owner in two music publishing companies that represented artists signed to Boot Records, as well as other composers around the world. Those two companies, Crown Vetch Music and Morning Music, continued to be a profitable part of the Boot Records business. Tom had never

taken his royalty payments from Boot Records, but used them to the keep the company afloat. He had reached a point where he needed to get paid by Boot. The company was forced to reduce its overall recordings and not sign any new artists for a bit.

In early 1980, Tom's perpetual calendar was finally available for sale. He took out ads in local newspapers and the *National Enquirer*. Under the headline, "Stompin' Tom's 3000 Year Calendar," was the copy, "Just a glance at this amazing new invention, printed in plastic on a business sized card, will tell you the day of the week any date falls on from the time of Christ until 3100 A.D." Tom included the calendar in the second volume of his autobiography and also had it reprinted in his music book, *250 Songs by Stompin' Tom*. Tom also included in that book a list of "Handy Rhymes and Memory Aids," he had developed which dealt with mathematics and physics and covered everything from the area of a triangle to the volume of a cylinder.

In a 2018 interview, Duncan Fremlin remembered a story Tom had told him about playing memory games to pass the time while working at a rather tedious job. Fremlin said, "He told me one time he had a job . . . in a factory or something. He had very little to do and boredom would drive him crazy. So they had a wall with little drawers, many, many drawers. On the face of each drawer there was a number or something so you could find nuts and bolts or whatever was in those drawers. And he spent an hour memorizing that quadrant so that if somebody said, 'What's in the fourth drawer down, third one over?' he'd be able to tell them exactly what it was." Fremlin went on, impressed by Tom's commitment to improving his memory, "He did that just to entertain himself. Just to . . . occupy his brain."

In the spring of 1980, Tom decided to buy a small van and travel Northern Canada with Lena and Tom Jr. In his autobiography, Tom wrote that he told Lena they were going on a trip and "then maybe I can get my mind off business problems, Skinners Pond hoodlums, radio stations and everybody else who is too blind to

see what a great country we could have if they'd only stop taking advantage of the other people they believe to be more stupid than they are."

Tom loved exploring Canada and he, Lena and Tom Jr. spent almost three months travelling more than 11,000 miles from Ontario to the Yukon, Alaska and Western British Columbia, then back home again. In *The Connors Tone* his thoughts on his home country verge on purple prose. He wrote:

> *What is wrong with our government? Why haven't they seen fit to make sure that every child who was ever born on Canadian soil could and would be the first ones to know that they have been blessed by Almighty God with the Crown Jewel that sits on top of this planet as an eternal beacon, forever flashing its hope throughout a world that has extinguished its own light by not teaching its children to acknowledge and enjoy the light they have while it's still shining?*

This trip inspired the song, "Long Gone to the Yukon," which he wrote and recorded many years later as the title track of one of his last albums. In the song Tom imagines himself as a gold prospector enjoying the beauty of Canada's north with the lines, "I can see a little cabin by the mountains; I'll soon be there to share the gold with you; 'Cause I want to live a life like Robert Service, Old Sam McGee and Dangerous Dan McGrew."

In the fall of 1980, Russell and Cora came to Toronto to spend the winter with Tom and Lena. They were getting older and with Willard and Marlene living elsewhere on the island they had no one to take care of them. When they returned in the spring, they discovered that not only had the schoolhouse been vandalized again, but this time the culprits had also attacked the family home. Tom decided to abandon the schoolhouse and his plans for Double C Resorts. He had invested approximately

$150,000 in the enterprise, but felt he had little choice but to give up. With this project behind him, and Jury running the day to day operations of Boot Records, Tom spent the next few years as most retired people do. He found new hobbies and had quality time with family and friends. He grew a mustache and when he travelled around, wearing a ballcap rather than his usual cowboy hat, he was almost unrecognizable. Like many men going through a midlife crisis, he also bought a motorcycle.

Tom now had time to pursue his love of games and started a 45 Card Club that had chapters throughout Ontario. They awarded trophies and he produced a newsletter that shared scores from the various groups. He had hopes that the organization might become national, but it all fell apart when some members didn't follow the rules of the constitution that Tom had created. Tom had a pool table at home and was also known for his love of darts and croquet. He was incredibly competitive and highly skilled, with many former bandmates claiming he was almost impossible to beat at chess and checkers in particular.

Tom even went so far as to invent a board game called Codamania. Despite sounding like it might be a game about fishing for cod, it was about breaking codes. He received positive feedback from the few friends who played the game and he took out a patent on his creation, but never had it manufactured.

Tom's love of code breaking may have come from a strange incident he experienced while sitting, pondering life one day. He said that during his time away from music he spent a fair amount of time alone contemplating the eternal questions of "Who and what am I, why am I here, and what exactly is my true connection to this whole universe?" Tom wrote that years before, he was hitchhiking near Thunder Bay and had been sitting, with his mind completely blank, when a "series of vocal sounds and numbers just popped into my head." He didn't understand what they meant, but felt they were important and tucked them away to be considered later.

During his retirement, while reading ancient religious scriptures

as well as books about philosophy and mythology, the sounds and numbers came back to him. He wrote, "As I slowly began to sound out passages that previously made no sense whatever, and applied the numbers at the same time, it was almost as if the angels were talking to me, revealing for the first time exactly what these scriptures and other ancient writings were trying to say."

He claimed that this new way of reading these texts worked across many different languages and that in using this code, with the Christian Bible in particular, it was "revealing things that would astound scholars who have been studying it for thousands of years." He wrote that hidden in the Bible was everything from the value of pi to the distance around the earth. Tom made a point of saying that he was fully aware of how outlandish this idea seemed, but he stood by it.

Although Tom was no longer working on Double C Resorts, he still made regular visits to Prince Edward Island and when he was there he visited family and old friends. He always made a point of going to see Freda and Anthony Keefe. In the summer of 1984 the Keefes were celebrating their fiftieth wedding anniversary at the legion in Tignish. Tom attended the party and even performed a couple of songs on stage near the end of the evening.

After the party Tom went back to the Keefes'. More than thirty years later, the Keefes' granddaughter, Pauline Arsenault, remembered that night fondly. She said in an interview, "he came back to my grandparents' house and we partied 'til 6 in the morning. He said, 'I'll play 'til there's no beer left,' so my husband and my brother-in-law went to all the bootleggers around. What a party that was! Oh my god!"

One of the gifts that the Keefes received that evening was a teapot that had quite the story behind it. It had been given to them as a wedding present in 1934. When they were invited to the wedding of their friend Georgie Handrahan, they couldn't afford a gift and gave the new couple the teapot they had just received. Freda told Georgie the story many years later and on the Keefes' fiftieth anni-

versary, Georgie gave the teapot back along with a note saying that the pot had travelled a bit, but it always missed them and wanted to get home to Skinners Pond.

Tom heard the story and, using the note as inspiration, wrote a song called "Skinners Pond Teapot." He recorded the song on an album called *Fiddle and Song* a few years later. Despite retiring from the music business, Tom never stopped gathering stories and finding inspiration in the people and places around him.

That year marked the passing of both his birth father, Thomas Sullivan, and his adopted father, Russell Aylward. This loss, along with his time away from music, seems to have given Tom a push to step into his own role as a father, and not just to Tom Jr. Before the second volume of Tom's autobiography was published in 2000, the public perception was that Tom Jr. was his first and only child. A typical story about Tom from *Atlantic Advocate* in November of 1976 stated "He's also a daddy now. Wife Lena gave birth to a bouncing baby boy in Guelph in June," referring to Tom Jr., who was in fact Tom's fourth child. There appears to be no mention of his other three children in interviews prior to 2000 and they weren't referred to in any profiles of Tom.

Despite the fact that Tom's two volumes of autobiography seem to mention almost everyone he ever worked with or met, he did not mention these children until he was almost 1,000 pages into his 1,165 page life story. It is jarring to suddenly have him mention his other offspring when there has been no acknowledgement of them previous to this point in his story.

Tom dedicates less than a page to his three older children, and his family is reluctant to provide any details. What can be pieced together from *The Connors Tone*, interviews, online posts and news articles is that in addition to Tom Jr., he had a son named Taw, and two daughters named Karma and Carol.

Tom wrote in *The Connors Tone*, "We also had occasions, during this hiatus period, to have a reunion with a daughter of mine who was now married with a couple of children of her own."

Since he calls it a "reunion," one would assume that he knew this daughter, Carol, earlier in her life. He adds that her children made him an "unexpected grandfather," so he clearly did not know she was a mother and must not have been in touch with her for a number of years.

As stated previously, Tom basically skips over the period of his life from late 1958 to early 1961 in his autobiography, saying only that his life had "become very tumultuous" and that "there was a girl who wanted me to settle down. But try as I might, I didn't do a very good job of making myself over." It's quite possible that the girl who wanted him to settle down was Carol's mother.

In *The Connors Tone* Tom wrote that, in 1991, "While playing in St. Catherines, after the autograph session that night, I met my daughter Karma, whom I hadn't seen in almost thirty years." This means that he had last seen her sometime shortly after 1961. So it's also possible it was Karma's mother with whom he tried to settle down between 1958 and 1961.

Of Tom's three older children, Taw is the only one who has gone on to have a public profile. Since Tom's death, Taw has launched a career as a singer, performing his father's songs as well as some of his own. He is known professionally as The Canadian Stompper. Taw wrote, in a since deleted website dedicated to his musical career, "I was born in Timmins Ontario and my father is Stompin' Tom Connors, and my mother is Florence Lachapelle. My parents separated by mutual agreement, due to their different paths when I was a young child back in Timmins Ontario." Tom, of course, spent about a year and a half in Timmins after launching his career at the Maple Leaf Tavern in October of 1964. It seems likely that Taw was born during this time.

Beyond Lena, Tom mentions almost no romantic relationships in his autobiographies. However, he wrote in *Before the Fame* that after he was fired from the Maple Leaf he rented a "two-room apartment in a suburb of Timmins," adding, "It was here that my girlfriend at the time moved in with me for a while and

proved to be a great help in keeping all the doom and gloom off my mind."

If, as Taw wrote, Tom and his mother were together for a time in Timmins it seems likely that Lachapelle was the girlfriend who moved in with him. As mentioned earlier, Tom wrote that he eventually decided to hit the road and pursue his career so "the girl and the housekeeping had to come to an end." Taw wrote on his website, "My father left Timmins to travel from town to town to sing and play songs about his country, our history, and all of our Canadian People." The two descriptions of Tom leaving Timmins seem similar, so it's likely that Taw was born between 1964 and 1966 and Tom lived with his mother for a short while.

Lena also had a child who did not grow up with them. Tom wrote in *The Connors Tone* that in June of 1997 Lena was reunited with a daughter she had put up for adoption a few years before she met Tom. She had called the baby Eva, but the adoptive parents had changed the girl's name to Trudy.

Tom's fans and the media were not alone in being unaware of Tom's other children. Even people who knew him well were surprised to discover he had four children. Pauline Arsenault, who grew up in Skinners Pond and knew Tom her entire life, hadn't read *The Connors Tone* so she was surprised to discover that Tom had other children when they appeared at his funeral. In an interview in 2018 she said in reference to Taw, "I'm not sure where he came from . . . I didn't know anything about those children until the funeral."

Tom spent pages of his autobiography talking about how difficult it was to be taken from his mother, the time spent in search of his parents in the hopes of having a relationship with either of them and how he was always looking for someone who could give him the unconditional love of a parent. He often referenced himself disparagingly as a "bastard." Knowing all of this, it is surprising that he fathered three illegitimate children and was not present in their lives.

Tom did reference his shortcomings in regards to family in his first book, *Before the Fame*. He explained that the "feeling of being a part of and belonging to someone was torn from my heart on so many occasions by appointed guardians with no sensitivity and little understanding, that I still have great difficulty sometimes relaying these qualities to my own family even to this very day." Tom may not have been present when they were young, but from his retirement onward he seems to have used his time to reacquaint himself with all of his children and to make them part of his life.

By the time Tom turned fifty in 1986, he hadn't toured in ten years and he hadn't put out an album in nine. His "disappearance" only added to the legend of Stompin' Tom. In a 1987 *Country Music* column Susan Beyer wrote, "Since I began writing this column almost two years ago, the question I am asked most frequently is: 'Whatever happened to Stompin' Tom?'"[6] It was not an uncommon question in Canada, and many theories abounded.

In the book *Maritime Music Greats* the author writes, "Some said he was living on the Magdalen Islands, another source believed he had returned to P.E.I., while still another claimed he owned property in Ballinafad, Ontario."[7] The last theory was of course correct.

Dave Bidini was a twenty-one-year-old music journalist and one of the founders of the Canadian band the Rheostatics when he discovered Stompin' Tom's music while attending Trinity College in Dublin, Ireland, in the summer of 1985. A friend had made him a mix tape of Canadian music to take with him that had songs from The Band and Gordon Lightfoot on one side and two Stompin' Tom albums on the other.

Ironically, Bidini had purchased Tom's album *My Stompin' Grounds* earlier that year but when he listened to it with his friends it was purely for comedic value. As he wrote in his book, *On A Cold Road*,

> *I experienced no sense of cultural enlightenment while listening to it, nor did I feel anything close to*

> the epiphany that would later hit me like a ham shot from a cannon. In fact, I found the sound of Tom grinding his boot heel into his wooden plank was sometimes too much to bear, and when I read on the back of the album that the percussion parts were actually credited to 'Tom's foot,' I almost split a gut.[8]

While in Ireland, Bidini discovered, as Tom had years before, that the Irish loved their own music. In the book, *Have Not Been the Same: The CanRock Renaissance 1985–1995*, Bidini is quoted as saying, "I learned that the people in Ireland loved Irish music. And not only did they love it, but they would tell anyone who would listen that it was the best fucking music in the world."[9]

Their sense of national pride inspired Bidini, so when people asked about Canada he played Stompin' Tom for them. As he told CBC, "I didn't really know how to articulate where I came from or who I was. So instead I just ended up playing them Stompin' Tom songs."[10]

In *On a Cold Road*, Bidini wrote, "Tom's voice drew me back across the ocean and the songs about bobcats and Wilf Carter that I'd once been embarrassed to listen to anchored my identity in a culture where nationhood was everything. They taught me who I was and where I came from."[11] This is exactly what Tom had been preaching for years. He felt that young people needed to hear their own stories and songs if they were to ever understand themselves or their country.

Bidini had been considering giving up music and focussing exclusively on writing. Tom's music convinced him otherwise. He told the CBC, "I came back from Ireland a sort of a new person, a reinvented person, I suppose."[12] Bidini returned home determined to track down Tom. He said, "I really just wanted to talk to Tom and thank him for, you know, writing the way he did write and for making the records he did. And having a big impact on my life at the time."

Bidini had a bit of a challenge in finding Tom. He wrote, "Everywhere I turn, someone has a story about Tom. So far, I've been told: Stompin' Tom committed suicide and is buried in a Skinners Pond graveyard; Stompin' Tom is living on a trailer park in Burlington where he performs only for his friends; and Stompin' Tom is living up North as a hermit: He hates talking to people."[13]

It's important to put Tom's career at this time into perspective. John Doyle wrote in a 2013 article entitled, "How Stompin' Tom Made Me a True Canadian":

> *It was the mid-1980s. The first thing to know is that few people cared much about Stompin' Tom then. He'd retired. He was not recording or performing. If his name came up at all, it was in the context of nostalgia for a time in the 1970s when he was popular, his songs celebrated. Some people remembered that Tom had been angry at the Juno Awards, packed up his trophies and returned them, and then disappeared, in bitterness they presumed. Some people thought he had died.*

Bidini knew Tom was very much alive, and he was intent on finding him. He visited Boot Records a number of times, hoping that he might cross paths with his musical hero. On one of his visits the secretary was in the process of sending out invitations for Tom's surprise fiftieth birthday party. She held up an invitation addressed to Richard Hatfield so Bidini could see the location of the party. On February 16, Dave and a couple of his friends set off from Toronto, on snow covered roads, heading for a community hall in Ballinafad, Ontario, armed with a petition signed by 150 people that stated, "Please Come Back Tom. Canada Needs You."

They walked up the steps to the hall, approached a woman and asked if Tom was there. When they explained that they had something they wanted to give to him she went inside to get Tom.

A moment later, Bidini was looking at his hero in the flesh. Tom stood in the doorway, dressed entirely in black, exhaling cigarette smoke and wearing his black cowboy hat that made him look even taller than he was.

The young man wished him a happy birthday and handed him the petition. Bidini wrote in *On a Cold Road* that he rambled something like, "The youth of Canada need you to come back. Our country's in trouble, save it. The Tory scourge. My band loves Canada, hockey, the National Dream, besides we think you're really, really great"[15] to Tom's laughter.

Tom wrote in *The Connors Tone*, "As I went outside with the intention of telling him to get lost, I found that he was very cordial and down to earth, so I told him to come in and have a couple of beers, as long as he left his camera in the car." It must have been a surreal experience for Bidini to find himself sitting in a rural community hall observing the legend in his natural habitat, surrounded by family and friends.

Bidini noted that Tom smoked from a cigarette holder. Tom had been using the holder for some time, believing that it reduced the harm from his one hundred cigarettes a day habit. As his friend Steve Fruitman said, "He used to use a cigarette holder and he thought it was not causing him any problems." He continued, "He had a cigarette holder with a filter thing inside it. He'd take them out and they'd be black. I saw him changing them a few times. I think every day he had to change them because he smoked like four packs a day."

Although Tom hadn't given an interview in years, he took the time to talk to Bidini. He wrote in *The Connors Tone*, "Once I saw they had taken a seat and weren't bothering anybody, I went over and sat down and gave the guy an interview. He asked a lot of the kinds of questions that told me he was not just trying to get a story, but was also somewhat of a fan."

Bidini asked Tom, "Do you know that people are still listening to your records? Do you know how many friends I have who love

your music?" Tom explained his frustration with the music industry and his reasons for leaving. He said, "Canadians got to get up on their own two feet and shout about what's right . . . They don't need me, but they need people to do the things that I did." He added, "I did my part — it was just a small part — then I got fed up. The interviews I gave all mentioned the board I used, and things like that. They didn't want to talk about my songs. They thought I was a joke. I hated lookin' at 'em. They'd talk to me one minute and laugh the next."

Bidini later said, "There was a lot of bitterness. A lot of crust has formed on the old cowboy."[16] But Bidini thought the petition from young people like himself helped to soften Tom a bit. He added, "I think he became aware at that point of the extent of his reach and the resonance of his music across a new generation." In Tom's autobiography he doesn't bestow a great amount of significance on this meeting with Bidini, but most accounts of Tom's career acknowledge that the young writer and his resultant article were a big part of Tom's eventual return to music. Within a few months Tom was planning a new recording.

Artists had never stopped sending Tom demos of their music and looking for career advice. Tom was quite impressed with some of the music he was receiving, and in the fall of 1986 he came up with a plan to get some of these artists on record, hoping to help them gain some exposure. He decided to release an album called *Stompin' Tom is Back to ACT* (Assist Canadian Talent). This new recording would include two songs each from six unknown artists, Kent Brockwell, Bruce Caves, Wayne Chapman, Cliff Evans, Art Hawes and Donna Lambert, as well as four songs from Tom, in the hopes that they would draw attention to the LP. The musicians all agreed that should any of them find success, they would do the same as Tom had done and before releasing a solo recording they would release a compilation album featuring six other artists.

In the past Tom had heard from radio stations that they didn't play his songs because they didn't have the albums. Tom devised

a plan to make sure that excuse could not be used. The liner notes for the LP included a letter from Tom asking the purchaser to listen to the recording and pick one or two songs that they particularly liked. They were then to call and request the song from their local radio station. If the station claimed to not have the album the purchaser would take the album to the station, have them sign a coupon and stamp it with the station name so there would be proof that the album had been delivered. The coupon could then be mailed to Tom and the owner of the LP would get a new copy in the mail along with a certificate signed by Tom saying that they had helped Assist Canadian Talent.

Tom expected even more from the album purchaser however. They were then to request the songs and if the station still wouldn't play them they were to complain to the Canadian Radio-television and Telecommunications Commission (CRTC), who managed CanCon regulations, and eventually go so far as to boycott the station and its advertisers.

Another reason Tom chose to stage a bit of a comeback when he did was that there had recently been a challenge to the CanCon rules that specified radio stations must play 30 per cent Canadian content. In 1984, a number of country broadcasters told the CRTC that there wasn't enough quality Canadian music for them to fulfil their quota. They wanted the minimum to be reduced to 20 per cent. They noted that they could meet the original quota with traditional country music, but styles had changed and there was not enough urban or contemporary country music available.

Country music had indeed changed significantly in the few years that Tom had been away. With the release of the movie *Urban Cowboy* in 1980, country music was suddenly popular with the urban crowd, but the soundtrack for that movie was indicative of the kind of music that people considered country. It included artists like Bob Seger, Jimmy Buffett, Bonnie Raitt and Canada's own Anne Murray, none of whom were traditional country music artists.

Hank Snow had his last hit record in 1974. Tom had not had a hit in more than a decade. Everything had changed by the mid-1980s, but Tom refused to give up on traditional country music. He wasn't going to come back on the scene and provide broadcasters with more urban country music to help them meet their CanCon quotas, but he was going to fight any reduction in that 30 per cent. Tom told the *Halifax Chronicle-Herald* in 1975, "If it weren't for the CRTC ruling on Canadian content, then the stations would have continued to play 90% American music . . . I believe the ruling greatly helped a lot of careers to take hold."[17] Tom wasn't even convinced that 30 per cent was enough, adding, "I suggest for at least five years that Canadian content be pushed to 60% of air time."

According to an article in the *Ottawa Citizen*, Tom's *ACT* album was in reaction to the CanCon fight. Susan Beyer wrote, "Connors, absent from active recording and performing for 10 years, has returned, spurred by the current proposal before the Canadian Radio-television Telecommunications Commission to cut Canadian content requirements."[18]

The album was released in December. Before it hit the market, interest in Tom was suddenly renewed when Dave Bidini's article about him appeared in Toronto's *Nerve* magazine. The article portrayed Tom as the mysterious, rebel hero of Canadian music who had dropped out of the industry and disappeared. Bidini helped create the legend of Stompin' Tom, painting the picture of a mythical character. He wrote that Tom so fervently believed that Canadians could do anything they tried that "he strapped his guitar on his back, rode the rails from East to West, and touched every corner of the nation until he became this country's biggest star. That's right — the biggest. Then he quit."[19]

Bidini then told the story of his search for Tom and the night he found him. He recounted saying farewell to his musical hero, writing, "The singer is alive: He's a tough guy, and he'll call a spade a spade. The legend turns and swaggers, back to the party of com-

mon folk, where he is not the star attraction — but merely the man who plays the guitar. Tom looks every bit the rebel. His strong, weathered face implies that he's too proud to ever be taken for a martyr, especially in his own country."

When the *ACT* album was released, the media latched onto this image of rebel Tom, angry at the world. A short column appeared in the press reading, "He's back and madder than before. No, it's not another Godzilla movie, it's Stompin' Tom Connors, who has had it again with the Canadian record business and has come back to try and wake up industry dunderheads to the wealth of Canuck talent dying on the vine due to lack of support." The piece goes on to say it's unclear exactly how Tom plans to do this, but if you buy the album you will find out.

Unfortunately, the response to the album was not great. Susan Beyer's review in the *Ottawa Citizen* was typical. She wrote, "The people on this album are not the rising stars of the Canadian nation. They are a collection of homefolk singing from their hearts. If commitment was all it took to make a great record this would be one. But it's not."[20] She goes on to say that "the vocals range from only adequate to very good." She does, however, note that Tom's star quality is intact.

Beyer wrote, "Included inside the album are two lengthy pieces of writing about why Stompin' Tom quit the business for 10 years and what the intentions in creating this album were. Connors needs a good editor. There is nothing in the four album-jacket size pages that he doesn't say more effectively in his songs, '(We Have) No Canadian Dream' and 'The Singers of Canada.'" Those were two of the four songs that Tom contributed to the album.

"(We Have) No Canadian Dream" included the lyrics, "The music of strangers they play in our homes, And tell us that we don't have songs of our own; They give us no choices and make it quite clear, They'll play what they want us to hear." He goes on to complain about Canadian radio, writing, "boy, is it grand, When you want to hear music from some other land." Tom points out

how successful Americans are at celebrating their stories, creating "The American Dream," while Canadians have no such thing.

Bob Mersereau said in a 2018 interview, "When he came back, I was working in country radio at that point. I remember there was no interest whatsoever in his new music, plus the fact that he was trying to introduce these other artists as well. Unfortunately the kind of talent he chose was definitely old school country. And hokey too. And there was no radio support for that. I think that his bitterness toward radio was fueled by that as well. His comeback was less than enthusiastically [embraced]."

The album was released by Boot Records which, along with the publishing companies, Crown Vetch Music and Morning Music, was owned variously by Tom, Jury Krytiuk and Mark Altman. Tom was mostly hands off and the day to day operations were handled by Krytiuk and Altman. In March of 1987, Tom received a package in the mail from Altman. Inside were various documents, including lawsuits against Boot Records that showed Jury had been keeping a number of important matters from Tom, and the company was in trouble. Boot Records and Crown Vetch both owed large sums of money. The company was spending in a way that wasn't sustainable, and some artists had not been paid.

Tom immediately went to Boot Records and confronted Jury. The exact details of the dispute with Krytiuk reman unclear, but he, Tom and Altman divided up their businesses that day. Jury was given full ownership of Boot Records, but had to move out of the building, which Tom owned. Tom got full ownership of Crown Vetch Music, including its debts. Altman and Tom shared ownership of Morning Music, with Tom having a controlling 60 per cent. He eventually sold his share of Morning Music to Altman, but he maintained Crown Vetch. For all intents and purposes it was the end of Boot Records. Krytiuk, who declined to be interviewed for this book, eventually left the business and ended up working as a travel agent.

This unexpected shakeup left Tom and his new album with no

record label. Having been an independent artist for most of his career, he felt he had no choice but to start a new label, and A-C-T Records was born. Cliff Evans, who was an artist on the compilation album and a neighbour of Tom's, had shown a keen interest in the production side of the *ACT* album so they struck a deal to run the new company together. Evans became Tom's de facto manager, responding to calls from the media and fans.

Tom still needed a distributor for the album and he was sure that no one would take just one album. He figured he stood a better chance if he were to offer a distributor not only the *ACT* LP, but all of his previous recordings and an official Stompin' Tom comeback album featuring all new material. Tom still had no intention of returning to touring. If he recorded a new album it would be an enticement to a distributor, in the hopes that he could do more *ACT* recordings featuring upcoming country musicians.

Tom and Cliff spent much of 1987 preparing the *ACT* album and Tom's older recordings for re-release. They eventually found a distributor in a company called Holborne. Tom started writing songs for a new album — his first in more than ten years. He returned to the studio in June of 1988 to record *Fiddle and Song*, his fifteenth album of original music. It was his first full length recording since *Gumboot Cloggeroo*, which was released in 1977.

*Fiddle and Song* included "Skinners Pond Teapot," as well as "Lady, k.d. lang," a tribute to the Canadian singer. In *The Connors Tone*, Tom wrote that he was impressed by lang when he saw her accept a Juno Award: "She was the flamboyant girl from Alberta with the great voice who jumped on the stage in a wedding dress to accept her award. And as I thought she was a welcome change from all the years of Juno humdrum, I decided to write a song about her." He was also flattered that while accepting her first Juno she had acknowledged Tom as being one of her inspirations.

The album also included "Canada Day, Up Canada Way," a song celebrating all things Canadian, and "I Am the Wind," which Tom said was his most personal song ever. It was inspired by that

time in early 1962 when he lay in a snowbank contemplating life, ready to accept whatever God or fate had in store for him. Unlike most of Tom's songs, it is not a narrative, but relies heavily on metaphor. It includes the lyrics, "I am the wind, I am the wind, Where I go is where I've been. I'm here today, and gone again, On my way; I am the wind."

The only print interview that Tom gave in support of the album was with Henry McGuirk of *Country Music News*. During the interview McGuirk told Tom that a friend of his had been working on a project with Capitol Records-EMI of Canada and heard that Deane Cameron, the company president, was trying to track down Tom. Apparently, Cameron had read Dave Bidini's *Nerve* article and decided that if Tom returned to music, Cameron wanted him on his label.

While this new album generated some attention in the media, most stories tended to focus on Tom's disappearance from the music industry and what he had been up to in the intervening years. A typical article appeared in the *Vancouver Sun*. It opened with, "There are many great mysteries in life. How do they get the caramel in the Caramilk bar? Who built the great pyramids of Egypt? And what in the world happened to Stompin' Tom Connors, Canada's premier country and western singer?"[21]

Another piece in the *Montreal Gazette* said that Tom "lives as a virtual recluse with his wife and 12-year-old son, Tommy, near a village in southwestern Ontario" and that his fans hoped he might "change his mind about remaining a hermit."[22] A photo accompanying the article had the caption, "Cult figure Connors has released first album in 12 years." The article also mentioned that Peter Gzowski, host of CBC Radio's *Morningside* had been making regular appeals for Tom to come out of retirement and quoted him as saying, "You can't get his songs out of your head. He's definitely an original, and he's ours." Other celebrities, including k.d. lang and Murray McLauchlan, joined Gzowski in his pleas.

Even actor Dan Aykroyd put out a call for Tom to return to

music. Aykroyd told the *Toronto Star*, "My interest in Stompin' Tom goes back to the old 505 days when we were all artists and actors in our garret there on Queen St. Maybe if I brought the Blues Brothers up to Toronto for a concert, I could have Stompin' Tom and [David Wilcox] open for us. I've never met Stompin' Tom. I've never talked to him. The last time I saw him was at the Horseshoe when it still was a country 'n' western bar."[23]

When *Fiddle and Song* was released, Gzowski began contacting Cliff Evans every second day, trying to get an interview with the reclusive country star. Tom finally relented, but with three conditions: the interview would be pre-recorded, with Tom having editing rights; it would take place at Evans's home; and that location would not be shared with anyone. Gzowski agreed and on December 28, 1988, Tom had his first radio interview in more than a decade.

Peter and Tom spoke in the kitchen while the technicians recorded from the living room. When the interview ended, the two men chatted briefly, then Tom asked if he could listen to the recording and make any necessary edits or clarify his responses. According to *The Connors Tone*, Gzowski replied, "I thought you wanted to edit the tape question by question, as we talked. And if you found something wrong with one of your answers we could have immediately redone the part." He assumed since Tom hadn't stopped he was satisfied with the results. Tom headed to the living room to get the tape only to discover the technician was already gone.

Tom told Gzowski, "Thanks one hell of a lot, Peter. And now that I know that your idea of editing rights is a hell of a lot different than mine, there's not too much I can do about it but trust your judgment when you air this thing. But I want you to know I don't like the way I've again been manipulated." When Tom heard the hour-long interview the next day, he thought it was the worst he'd ever given. He felt the piece should have been cut in half. Tom wrote that because he thought he had editing rights, he wasn't as

concise or thoughtful as he should have been. He felt that Gzowski had taken advantage of him and was more concerned with getting the scoop of talking to the reclusive Stompin' Tom than he was in creating a compelling interview.

Despite Tom's displeasure, listening to it thirty years later Tom appears serious and thoughtful, while Gzowski sounds both genuinely interested and like a true fan. Unlike many interviewers, Gzowski understood that there was much more to Tom Connors than Stompin' Tom. He pointedly asked, "Are you sorry about that part of you that was almost a caricature? You know, the thing that as you said, 'Got them in the door,'" referring to the stomping.

Tom responded, "No, no not really," but Gzowski pressed, asking, "Did it ever cover up what you were really saying? Do you sometimes wish you hadn't done that?" Tom finally admitted that yes, it did get in the way of what he was trying to do, but not with the fans. Tom said it was the media that had trouble seeing beyond the gimmick. He responded, "The media. Yes, the media didn't see the serious side of Stompin' Tom . . . They wanted more of, as I say, the boots and the boards and the hats and the shows and this kind of thing. Rather than knowing who I was and what it was I was trying to do."

In February of 1989, Henry McGuirk talked to Tom again and told him that that Deane Cameron was still asking about him and wanted to sign him to Capitol-EMI. Tom agreed to have a meeting. When they met, Tom was encouraged to discover that Cameron was not a typical record company executive. Tom was impressed that he had worked his way up through the company, starting out loading trucks.

Cameron said that Capitol-EMI would like Tom to make a comeback and that they were prepared to re-release all of his old albums. Tom told him that it would be hard for them to make their money back since radio would not play his music. Cameron countered that the music industry had changed in the ten years

that Tom had been away and that radio was more willing to play Canadian music now. He also pointed out that Capitol Records had more clout with broadcasters than the much smaller Boot Records would have had.

In *Have Not Been the Same*, Dave Bidini said that Cameron showed Tom the article that Bidini had written for *Nerve* magazine. Apparently it was the first time Tom had seen it and he was incredibly moved. Tom took Cameron's business card and agreed to consider the offer.

A short while later Cliff Evans told Tom that he was no longer interested in running their A-C-T record label. Faced with finding a new partner or running the company himself, Tom decided to take Deane Cameron up on his offer. In June of 1989 he signed with the label.

That same month he agreed to take part in k.d. lang's first television special, *k.d. lang's Buffalo Cafe*, which was filmed in Red Deer, Alberta. According to a story published in the *Edmonton Journal*, lang said she "had to talk long and hard to get Tom to come back."[24] She had to convince him that he would be returning, "for the joy of ordinary folk who want to hear him . . . and not the recording industry."

Tom had just signed with Capitol-EMI and was quite sure he wouldn't be getting any radio airplay. He thought the TV special might at least give him some exposure and help the company sell some records. He filmed the show in June of 1989. When it aired later that year the first thing the audience saw was that famous left heel stepping out of a train and onto the platform. Tom is shown from behind, but the silhouette of a tall thin man, wearing a cowboy hat and carrying a guitar was immediately recognizable as Stompin' Tom.

The camera cuts to a very excited k.d. lang who shouts, "Ladies and Gentlemen, a Canadian folk hero has just arrived into town. Please give a warm welcome to STOMPIN' TOM CONNORS!" She hoots and hollers as an emotional looking Tom enters to

thunderous applause and a standing ovation. Even the band is on their feet.

k.d. comes out to give Tom a hug before he thanks the audience and says, "I have a little surprise for k.d." He then launches into "Lady k.d. lang." lang is seen dancing along to the song in the wings. At the end of the number she returns to the stage for a bit of banter before telling Tom that she has a surprise for him and starts singing his song, "Cross Canada (CA-NA-DA)." Tom joins in and k.d. stomps along with him. It's an electric performance as these two iconic Canadian performers feed off one another's energy, clearly enjoying performing together. At the end of the song, as the audience applauds wildly, Tom takes a sip of beer, looking happy to be in front of an audience again. Stompin' Tom was back.

## Chapter Ten
# The Legend

The voice that said to write
And sing of what shall be,
There's a promised land for those who stand,
In Canada's unity

— "Unity"

When Tom signed with Capitol-EMI, they agreed to reissue his fifteen albums of original material, including *Fiddle and Song*. Although that recording had been released the previous December by Tom's A-C-T Records, it had not sold well. Tom blamed it on poor distribution, which may well have been the case, but it was hard to promote the album without a tour or radio airplay. It also didn't help that Tom was still refusing media interviews. Capitol-EMI gave the recording a second chance by re-issuing it the next summer and promoting it through the release of two singles, "I Am the Wind" and "Canada Day, Up Canada Way," which was released in time for Canada Day and made it to number twenty-nine on the Country Singles chart.

During Tom's retirement, music videos had come into vogue. As part of his new contract Tom filmed a video to accompany the release of his song, "I Am the Wind." The video is classic Tom, showing him walking along highways, through fields, between boxcars and down city streets, dressed entirely in black, guitar

in hand. There are also shots of working class people doing their jobs and chatting with him. The video shows countless Canadian landscapes and includes shots of Tom looking contemplative while writing the lyrics for the song on a tiny notepad. There is also a close-up of him playing guitar that shows the words "A Proud Canadian," imprinted on the neck of the instrument. "I Am the Wind" was Tom's favourite of all the songs he had written and the video summed up the character of Stompin' Tom.

Tom was still reluctant to fully commit to the idea of a "comeback." As part of his new contract he had agreed to the video and a new album. But there were no immediate plans for Tom to return to touring. In a story headlined, "Stompin' Tom Connors Making a Careful Comeback," from August of 1989, Tom finally admitted, "It's not a total comeback at the moment. But I figure it's almost useless to take that stand any more."[1] He went on to say that he felt his time away had accomplished little as he didn't see any big changes in the industry. As a boy Tom had run away from the Aylwards in the hopes that they would miss him and things would be better when he returned. That never happened. Leaving the industry to return and see little change must have felt similar. He told the reporter, "I feel I haven't accomplished a lot. It's unfortunate I haven't." Tom went on to say that he was waiting to see how *Fiddle and Song* sold before he committed to a tour.

He also suggested that he wasn't quite the recluse the media had made him out to be. He told the reporter, "I wouldn't talk to the media, so I guess I was reclusive as far as they're concerned," but he added, "As far as the average guy, like the neighbors down the road, they had access to me any damn time at all. There was never any desire to hide myself from the Canadian public." Indeed, throughout his retirement Tom continued to keep in touch with his fans. He tried to answer each letter personally and he never stopped performing, albeit for much smaller crowds, made up of close friends and family.

In 1985 Tom and Lena held their first annual "Camp & Jam."

They invited friends and colleagues to spend the weekend camping on their property. According to the invitation, Tom and Lena offered, among other things, a free corn boil, fresh water, toilet facilities, an emergency phone, a paddle boat on their pond and "one helluvah good time." Tom would jam with the other campers and no doubt sing some of his signature songs during these weekend parties.

Steve Fruitman had been a fan of Tom's for more than twenty years when he started a folk-oriented radio show from the University of Toronto's campus/community station, CIUT-FM, in 1988. While still a high school student in 1971 he had interviewed Tom at the Horseshoe Tavern. He was now determined that he would get a new interview from the retired Tom. Early in 1989 Steve and his friend Charlie Angus, a fellow Stompin' Tom fan, did an hour-long show about Tom and his music. Steve wrote to A-C-T Records telling the legendary singer about the upcoming tribute show. Steve was shocked when he discovered that shortly after he left the radio station Tom had called to congratulate him and Charlie on a great show.

A couple of months later, Fruitman was doing a show about Tom's old friend Stevedore Steve Foote and again reached out to A-C-T records to see if Tom might provide a short statement to be read on air. Fruitman was thrilled to get word that Tom would do a brief interview by phone, live to air, but it had to be kept to five minutes. No doubt it made a difference to Tom that the interviewer wasn't just a DJ, but also a fan. When it came time to do the show Tom stayed on the phone for twenty minutes. Recalling the interview, almost thirty years later, Fruitman imitates Tom saying, "Well if you just got a little moment there, Steve, I'd like to tell you another little story if I can."

Despite continuing to avoid the media, Tom also got involved in saving the landmark Mississippi Hotel in Carleton Place, Ontario, where he had performed years before and where he started writing "Big Joe Mufferaw." The formerly grand, one

hundred and seventeen-year-old hotel had become a strip club and was now known for biker gangs and drugs. It had fallen into disrepair and its owner, Brian Carter, had recently closed the doors. Unable to find anyone to buy and renovate the hotel, he was preparing to demolish it and sell the property to an oil company so they could build a gas station.

The townspeople, remembering the hotel's glory days, banded together to try to save it. One of those people was Lyle Dillabough. He had written a number of articles for the *Carleton Place Canadian* in the hopes of garnering publicity that might bring the old hotel to the attention of a potential buyer. The group was becoming more desperate and Lyle suggested reaching out to Stompin' Tom to see if his voice might help them gain the needed publicity.

As Lyle tells the story, "You know he was a recluse then because he was mad about the Juno awards and that. He had just put out his first album in years, but he wasn't doing interviews." Undeterred, Dillabough figured he had nothing to lose and wrote to Tom at his record company. He continued, "Well lo and behold a month later ... I go out to my mailbox and there's this letter. And I open it up and he had a statement that he prepared and he wrote a letter to me and he had a picture that he wrote on the back, to me. I was just flabbergasted."

Lyle immediately wrote another story for the *Carleton Place Canadian* incorporating Tom's statement. Tom had written about what the area and the hotel had meant to him and then added, rather poetically, "If such a grand old lady as the Mississippi deserves no more thanks and gratitude than a smash in the face with a wrecking ball, then maybe the cold north winds of modern change are sending a chill through the valley's heart." Lyle said, "The whole country was calling me, asking, 'How did you get Stompin' Tom to talk to you?'" The story began to get national coverage.

Just days before the hotel was to be demolished, Lyle and a group of local musicians hosted a musical evening called Mis-

sissippi Night. Now that it was a big story, television cameras were on hand to cover the event. When the owner arrived he was interviewed and asked if he would allow the demolition permit to be executed. On the spot, in front of the TV cameras, he said that he would withdraw the permit the next morning, and he did.

As Dillabough puts it, "The building didn't go down that day. So, Stompin' Tom saved it." A short while later, a woman who had caught wind of the story agreed to purchase the hotel. Thirty years later, the heritage building is still standing and in 2017 it was completely renovated and opened as The Grand Hotel, a luxury wedding and event venue.

Tom asked Lyle to send him any publicity that was generated about the hotel and the two men carried on a correspondence for years afterwards. Despite his self-imposed semi-retirement, it's clear that Tom was not hiding from his fans.

As Tom said on the promo CD that accompanied *Believe in Your Country,*

> When I feel that I'm wanted, or what I'm doing, my talent is wanted, well then I'll work like hell towards fulfilling the expectations from others. When I was told that, "Tom, you better come back. Your fans want you," and this kinda thing, I had to believe that. You know, that had to sink in. And when enough people told me that . . . then I said, "Well, I have my certain doubts about the industry and doubts about you know, radio'". . . but I thought . . . "the fans maybe don't deserve this. If they really want some more songs from Stompin' Tom I shouldn't maybe really let them pay for some gripe or something or inadequacy or inconsistency that I may see throughout the industry." So, I don't know. I've more or less come back for the fans.

Tom's official comeback party was planned for October 19, 1989, at the Matador Club in Toronto. He got Ronnie Richard and Gary Empey, who had been part of his backup band years before, to play with him. It was his first extended live public performance in thirteen years. Gaet Lepine was there, along with Deane Cameron and a number of people from Capitol-EMI. Tom was surrounded by friends and family as well as new fans like Dave Bidini, who performed that night with his band, The Rheostatics.

The Rheostatics were just one young band that had started to play Tom's music. Steve Fruitman tells of a folk rock band from Australia called Weddings Parties Anything who were in Canada for an extended stay in the late 1980s. They discovered Tom's music and incorporated it into their shows. Fruitman remembers, "they played at a club in Kensington Market. It was a speakeasy that's closed down now. They were playing 'Bud the Spud' and 'Sudbury Saturday Night.' And it was all rock 'n' roll kids. There was nobody there who could be identified as an old Stompin' Tom fan. They were just going nuts." According to an article in *Mariposa Notes*, the band left Canada saying that Stompin' Tom was "the epitome of what Canada's all about."[2]

Steve's friend Charlie Angus also played a number of Tom's songs with his band, Grievous Angels. Angus told the *Sudbury Star*, "I remember the first time I played the Townehouse with the Grievous Angels and we did 'Sudbury Saturday Night' and it was like watching the movie unfold in front of us and we were just the soundtrack. It was haywire. People were dancing on tables and there was beer being spilled and fights breaking out and it was just a chaotic, wonderful night. I felt, I'm part of the soundtrack of Canada."[3]

In *The Connors Tone* Tom wrote that he noticed among the younger musicians "a more pro-Canadian attitude than those of the previous decade." He went on to say that he "took this as a very positive sign of the times." He told *The Globe and Mail*, "What I see out there is something I've been wanting to see for so long.

Even though the industry hasn't changed that much, the young people are making the changes. Hopefully, I was instrumental in it a little bit . . . I can see a little more identifiably Canadian music coming out of the younger people and I think that's healthy for the country."

Another young person at Tom's comeback party was the owner of a talent management agency from Peterborough, Ontario, named Brian Edwards. He had written to Tom a couple of times saying that he was a fan and that if Tom ever returned to touring he would love to manage him. Tom told him he was unsure about a tour, but he'd keep him in mind.

Tom notes in *The Connors Tone* that while his party was well attended, one group was "conspicuous by the fact that not one of their representatives was there." This group, of course, was radio. Tom went on to say that radio completely ignored "I Am the Wind" when it was released as a single. While the song didn't become a big hit, it did crack the top forty on the Country Music Singles charts in November of that year.

If Tom had received little airplay in the few years before his retirement, he would receive even less in the second half of his career. Tom took it as a personal affront. In *The Connors Tone* he wrote, "the message to Capitol Records and everyone else was clear. They're just not going to play Stompin' Tom no matter what songs he sings or what company puts it out." He went on to say that it was "blatant discrimination."

While Tom believed that he had been blacklisted from radio because of his outspoken criticism of the industry, there were other more obvious reasons that he didn't get airplay. To begin with, he was not the only traditional country artist not getting airplay in the 1990s.

According to a post on the website savingcountrymusic.com, Johnny Cash, George Jones and Willie Nelson all fought the same battle late in their careers. In the 1990s, Cash had a resurgence with his series of *American Recordings* albums, which were produced by

the legendary Rick Rubin. Although the series was critically successful, with the second volume winning the Grammy award for Best Country Album, Cash still wasn't being played on the radio.

The blog post said that Rubin was not used to "being snubbed by radio, but when he took on his first country artist, he learned country was a different animal. Rubin called country radio a 'trendy scene,' and decided to fire a shot right at Music Row."

Rubin used a photo of Johnny Cash at San Quentin prison in 1969, offering his middle finger to the camera, to create a full page ad in *Billboard* magazine that read, "American Recordings and Johnny Cash would like to acknowledge the Nashville music establishment and country radio for your support." That photo, which was relatively obscure before Rubin used it, has since become iconic.

George Jones liked the ad so much that when he was promoting his song "Wild Irish Rose" he created a campaign that showed him surrounded by basketballs, footballs and baseballs with the caption, "If radio had any, they'd play this record." Jones said, "All of us older artists feel that way. Radio gives us one of the biggest insults there is when they don't play our music. If no one is going to stick up for us, we'll have to do it ourselves."

The other problem with Tom's music was pointed out in the book *Have Not Been the Same*, which stated that Tom's recordings were "lo-fi and primitive, and his voice descends from Hank Williams' nasal twang. These traits, combined with a blunt earnestness that isn't necessarily an asset in the music industry, distance Connors from the country establishment."[5] Tom recorded fast without much production, going for a raw sound that attempted to capture the feel of his live performances. Mark LaForme, who backed Tom on tour and in the studio on his 1999 album, *Move Along With Stompin' Tom*, told the *Cambridge Reporter* that Tom liked to do "things quickly and his way."[6] He went on, "We recorded the whole thing in a week. We did one initial rehearsal where Tom played us the songs, but he pretty much had it arranged in his mind before he got into the studio."

Duncan Fremlin, whose band Whiskey Jack backed up Tom on his 1993 album *Dr. Stompin' Tom . . . Eh*, wrote in his book that the "final take was rarely perfect and that suited Tom just fine."[7] When Fremlin was recording some banjo parts for Tom's album, *Believe in Your Country*, he overheard Tom say in the control room, "The fans don't want it too fancy."

William Echard also noted the imperfections in Tom's recordings, writing that "Connors has a propensity to sing ahead of the beat, slightly under pitch, and scoop up to the note. The instruments are often not perfectly in tune with themselves or each other."[8] While some critics felt that Tom and his musicians lacked in musical ability, Echard argued that the resultant sound was intentional. He pointed out that Tom didn't want a "Nashville sound," and that his "music has a different political and social purpose, and the openness and raggedness of the texture is an integral part of its effect." Echard believed that Tom aimed to appear less as a performer and more like a friend at a kitchen party. He suggested that one of Tom's greatest musical achievements was that he struck a balance between being "credible both as a professional musician and as just one of the crowd."

This way of recording may indeed have been intentional and served Tom well with his fans, but it did not endear him to radio. As Richard Flohil said in *Have Not Been the Same*, "a Stompin' Tom song sticks out of a music mix like a chainsaw on a manicured lawn."[9]

If Tom wasn't going to get airplay, he and Capitol Records had to figure out other ways of getting his music to the public. Capitol released *A Proud Canadian*, a compilation album of Tom's greatest hits, and partnered with Atlantis Direct Marketing to produce a ninety-second television commercial that declared Tom, "A legend in Country and Western music." This two LP set contained twenty hits and the commercial featured clips from Tom's "I Am the Wind" video, with a narrator declaring that "Stompin Tom's music reflects the true Canadian way of life and the people who

share in it." It went on to say that this was "a great album by a great Canadian!"

The recording would give Tom his first official gold record from Music Canada in October of 1990, when it hit sales of 50,000 units. It would eventually go platinum, meaning it had sold at least 100,000 copies. While Tom may not have been played on the radio, his record sales in the second half of his career would be the best of his life.

In April 1990, Tom recorded his sixteenth album of original material, *More of the Stompin' Tom Phenomenon*. He included "(We Have) No Canadian Dream," which had been released on his A-C-T album, as well as a tribute to Rita MacNeil. Like him, MacNeil was from Canada's East Coast and had made her career almost exclusively in Canada, including local references in her music. Boot Records had released Rita's first album, *Born a Woman*, in 1975. Tom also included "Margo's Cargo," which became one of his signature songs. It was inspired when a Toronto manufacturer sent Tom a clock made of cow manure. The song tells of a Newfoundland couple who upon getting a "Cowsy Dungsy clock" load up their cow and drive him cross country to Toronto hoping to sell a load of cow dung to the clock company. Tom eventually made a video to accompany the song.

Tom knew that the best way to get his music to the people was to take it to them himself. He started planning a cross-Canada comeback tour. He initially approached a couple of large agencies, but they wanted him to do fifteen cities at most. Tom wanted to go everywhere in Canada. He wanted to drive coast to coast, stopping in about eighty different communities, both big and small. The agencies thought he was crazy and had no interest in booking such a tour.

Tom remembered Brian Edwards, the promoter who had attended his comeback party. The two met and Tom laid out his plans. This was a bigger undertaking than anything Edwards had ever attempted, and although he was initially apprehensive, he was

intrigued. He decided to take on the project and plans were soon in place for Tom's comeback tour.

As promotion for the *Proud Canadian* album and Tom's upcoming tour, Capitol Records commissioned artist Bill Wrigley to create a large mural of Tom in downtown Toronto. A cartoon version of Tom is seen, wearing his trademark cowboy hat, guitar across his chest, with his foot coming down in a stomp. Stretched out behind him is a distorted map of Canada incorporating images and place names that he had immortalized in song. Measuring sixty by thirty feet, the image helped build on Tom's legendary status, which the record company was aiming to establish. Wrigley's website described the mural as giving "an almost super-heroic view of this uniquely talented and charming entertainer." The artwork stayed there, looming over Dundas Street, until the building was torn down in 2000.

When it came time to put a touring band together Tom reached out to Mickey Andrews of The Good, The Bad and The Ugly, who had worked with him at the Horseshoe starting in 1969. Andrews was the only member of the band still in the music business. Gerry Hall had died in a drowning accident, while Randy MacDonald had given up his musical career and was married with a day job. Mickey suggested Tom use the three-piece band he was now part of, which included Ray Keating and Mary MacIntyre.

Tom Gallant, a singer/songwriter living in Nova Scotia, was an acquaintance of Tom's. Gallant had written a tribute to Connors called "Hero." Gallant recorded the song with a young East Coast musician named J.P. Cormier, who played all the instruments and provided backing vocals.

"Hero" referenced Tom's retirement with the line, "All at once your voice fell silent, you grew weary of the fight." It then went on to say that everyone hoped Tom would continue to make music: "Here's a song that's from the country to the man from Skinners Pond, And the wish that you'll keep stompin'. You're the hero, Stompin' Tom." Gallant sent the song to Tom and Connors was

so impressed that he hired Gallant and Cormier for the tour. Tom now had five musicians to perform the opening set and provide backup for the tour.

Despite his return, Tom was still frustrated with Canadian radio and the media. A story in *Maclean's* magazine said that Tom agreed to tour with two conditions. There would be "no radio stations as concert presenters and no interviews with the media."[10] He did make a few exceptions, speaking to Mitch Potter of the *Toronto Star* and Nigel Jenkins, who was writing for *Maclean's*. In Summerside, PEI, Tom even allowed the CBC to record a bit of a performance.

Tom chose to begin the tour in Owen Sound, Ontario, on May 3, 1990. His return, after an almost fourteen-year absence, began in a high school gymnasium that seated about seven hundred people. Tom had intentionally chosen a smaller venue so he could try out the show and get over any jitters. He was incredibly nervous that first night back, writing in *The Connors Tone*, "I was nearly shittin' me drawers." He had no reason to worry. As he walked out on stage, plywood held high and a giant Canadian flag unfurling behind him, the packed audience leapt to their feet, welcoming him back.

Tom generally started all of his shows with "Bud the Spud." He had a staple of about twenty songs that he performed in every venue, but he was also careful to add songs relevant to the location he was playing. This night in Owen Sound he started with "Around the Bay and Back Again," his song that lists a number of communities from the surrounding area.

Jenkins, who attended that Owen Sound performance, wrote in *Maclean's* that "the crowd clearly adored his distinctive style — the nasal voice, comic facial expressions and trademark boot-pounding, from which he got his nickname."[11] He added "Connors's energy and spirit made it seem that he had never abandoned the concert stage." Tom got another standing ovation at the end of his two-hour show and then went out to meet his fans and sign autographs for close to an hour.

He may have been away from the concert stage for well over a decade, but not much had changed about his performance. He took requests from the audience and would often perform the same song more than once if that's what he felt the audience wanted. Until the end of his career he would use most of the same shtick and song introductions that can be heard on *Across This Land With Stompin' Tom* from 1973.

Although political correctness had taken hold during Tom's time away from the stage, he didn't let it change his patter. A review of Tom's performance on the Halifax stop of the tour stated, "Connors apologized for his slightly raspy voice by saying, 'I worked in the northern Quebec woods — that's how I got this frog in my throat.' Nobody dares tell such jokes anymore, but for the crowd there that night, Connors could do no wrong. His blue-collar humor was even liberating. He was preaching to his constituency."[12]

Duncan Fremlin was on the 1990 tour, but not as a musician. He served as road manager, a role he had played with his own band, Whiskey Jack. Years later Fremlin would create a touring show based on his personal relationship with Tom called Whiskey Jack Presents Stories & Songs of Stompin' Tom. In the program for that show he wrote, "I like to say I attended the 'Stompin' Tom Connors How To Entertain College' on the 1990 tour."[13] Fremlin wrote of how the sold out crowds gave Tom standing ovations every night, "delirious with joy that he had returned after 13 years." He continued, "Over the course of every evening, he would tease, cajole and invite the crowd to engage with him, sing with him, stomp their feet with him and laugh boisterously at his off-the-wall jokes. Some nights it felt like they were on stage with him. I had never seen anything like it. I watched. I listened. I learned. He was the master." Fremlin also noted in an online interview, "people at every stop would come up to him after the show and say 'Tom, remember that time in '62 when you came over to my house after the show and we drank beer all night?'"[14]

It made perfect sense that this tour was called the Unity Tour. Throughout Tom's career he had wanted to show Canadians that although the country was huge, their differences were not. His songs feature people from different parts of the country coming together. In "The Ketchup Song" it's an Ontario tomato and a PEI potato who become a couple. In "To It and At It" he sings of "A girl from old Spud Island, old potato lips; she married a Newfoundlander, and they lived on fish and chips."

Even his albums were an attempt to unite the country. In an interview with *The Globe and Mail* he said, "On every album I've put out, I've put diverse Canadian songs on it. They're not provincial albums, my albums are national albums. There'll be a song about Saskatchewan and Vancouver and Nova Scotia on there. I guess you could say that Stompin' Tom connects the nation through his albums and if I've accomplished that I'm proud."[15] Ruth Lloyd wrote that Tom's songs had "helped to weave the very fabric of this country together. Canadians in British Columbia, I believe, can feel a kinship with PEI after hearing 'Bud The Spud,' and we can all appreciate the blue-collar charm envisioned by 'Sudbury Saturday Night.'"[16]

Tom returned to the stage at a time when the very future of Canada was in doubt. As Mitch Potter wrote, "the irony of the comeback is sweeter still, coming as it does at a time when the fabric of national unity dangles in threadbare patches of disaffection."[17]

In 1981, when the Canadian Constitution was revised, Quebec refused to approve it. In the hopes of bringing Canada's only French province into the constitutional fold, Prime Minister Brian Mulroney and Canada's premiers developed the Meech Lake Accord. Among other things, it would recognize Quebec as a "distinct society" within Canada. At the last minute the agreement fell apart and talk of Quebec separating from the rest of the country began in earnest. In 1988, the Quebec government passed Bill 178, which stated that French was the only language allowed on out-

door signs, commercial advertising or within shopping malls or the public transit system. This angered many Anglophones in Quebec and many English-speaking Canadians started to feel that enough had been done to accommodate the province. It was amidst these tensions that Tom set out on his cross-country tour, which the media was referring to as his "national tour for unity." Tom had a genuine affection for Quebec and did not want to see it separate from Canada.

It was at the Sudbury, Ontario, stop of the tour, appropriately on a Saturday night, where Mitch Potter interviewed Tom and saw first-hand both how wary Tom was of the press and how serious he was about promoting a unified Canada. Potter wrote, "He shakes hands firmly, levels a steely, hawkish gaze and grumbles, 'I'd like to say it's a pleasure to meet you, but I won't know that until I read what you write.'"[18] The two men met again later backstage and Tom apologized, saying "I got a little carried away back there and I'm sorry, but you've got to understand I'm sincere about what I'm doing, and for years the media has treated it like some kind of joke." Tom told Potter, "If you turn this into some joke, honest to God, it will break my heart. I can't wait another 10 years to make another comeback, there's no time."

Tom went on to describe his frustration with the state of the country, saying, "There's something serious goin' on here, the country keeps going down the goddamn tubes. I'm older . . . but I'm also a little madder, a little harder than I used to be." He continued, "English Canada feels that, for about 10 years, it has done its best to bend to Quebec. So it's really the sign thing. Why can't they, for the love of God and love of country, turn around and say, 'Look, we will guarantee English people in Quebec can be able to go out their door and read a sign they can understand.'"

Tom's only set piece on the tour was a giant Canadian flag draped across the back of the stage to which he had attached a fleur-de-lis as acknowledgement of Quebec. He ended every performance with his song, "Unity," whose chorus was "Unity for you

is unity for me; Unity for all means all for Unity. Together we shall rise, forever to recall, that the Maple Tree is Unity and our flag will never fall." Potter referred to the song as "an almost hymnal salute to Canada, which underscores the sense of country [Tom] hopes to bring to the 1990s." Every night from the stage Tom boasted that his show was 100 per cent Canadian.

The only time that Tom allowed cameras to film any of the 1990 concerts was in Summerside, PEI, when the CBC produced a story about the tour. Tom can be heard saying from the stage, "In case you thought you were coming to see a concert tonight, you were wrong. You came to a party!" Although Tom had moved from bars to gymnasiums, arenas and concert halls he still tried to create a party atmosphere at his shows. He asked that the house lights be left on in the venues where he performed. He told Rudy Blair, "I like looking into the eyes of the people that I'm relating to. There's a lot of rapport that goes on between me and my audience. I'm not one for spotlights in my eyes. I don't want spotlights. I want to see everyone in the audience. We become one, the band, myself and the audience."[19]

Mickey Andrews witnessed Tom becoming one with the audience, feeding off their energy on a nightly basis. He said that before a show Tom liked to keep to himself. "Tom would be in his dressing room, just very quiet," he said. "He liked to be quiet before a show. He was thinking about what he was going to do when he went out there. What jokes he was going to tell. Even though he told a lot of the same stuff he wanted that hour to himself." Tom said that he'd often be nervous in the dressing room, waiting to be called to the stage. He added, "Once I'm out there in front of the mic. Bang, no problem." Andrews agreed, "he'd walk on the stage and throw the board down . . . do 'Bud the Spud' and he was off, he became Stompin' Tom."

On the promo CD for *Believe in Your Country*, Tom said that something magical happened once he hit the stage. He said it was hard to explain but that there was "something that goes through

the air... there's some kind of an electricity or a rapport or something. And once that connects... once I get the first couple of lines out, and I feel something happening, then all hell breaks loose and we have a hell of a time." Tom added that people often thought he was drunk on stage. He admitted that he'd sometimes "have a beer or two, you know, to loosen up before a show." But he added that he often performed without it. He said, "There's something else that makes me drunk. It's the electricity in the crowd. It's a kind of a high."

Duncan Fremlin said, "I can't even think of another performer who would stand on stage and encourage hooting and hollering from the stage. He'd actually converse with the fans who were hollering out songs and whatnot. He never got angry with that... He felt like they were all on the same level. A show with Tom was like a show in his kitchen. And the people in the audience were his guests at his house." When it was suggested to Mickey Andrews that Tom's shows were like a kitchen party, he readily agreed, saying, "That's a good term, 'kitchen party' is right. He created his own Stompin' Tom party, whether the venue was big or small. Anywhere."

Tom had had very little happiness in his young life. Music was the one exception. Some of the best times of his childhood were the nights he sang along with Olivar, showing off the country songs he knew; or later in Skinners Pond, at kitchen parties with neighbourhood fiddlers. For the rest of his life, whether in someone's car as they gave him a lift across the country, in someone's kitchen who gave him a place to stay for the night or in front of a large paying crowd of fans, Tom tried to re-create those magical, spontaneous, music-filled moments from his childhood.

Tim Hus posted a series of "Letters from the Road" on his website, documenting his time touring with Connors. He wrote, "Tom doesn't use a set list so we just try to listen to his stories and try to anticipate what song he is going to sing next and then do our best to back him up."[20] Sometimes the band could tell from the intro-

duction, other times the opening chords, and sometimes they'd have to wait for him to start singing to know for sure.

Duncan Fremlin told Bill King on his CIUT FM radio show, "Tom didn't know how to work with a band. We had to work to him . . . So when he started playing we had to watch his hand and listen to find out first of all, what key he's playing in, what song he's playing, and where the tempo is . . . So, I can't say Tom actually played with the band. He had a band with him," and whether he was playing as part of the band or not, he "always loved to have a band there."

Just as Tom wasn't too worried about his recordings being perfect, it never seemed to bother him if he made a mistake on stage. In *Across This Land with Stompin Tom*, which was recorded in 1973, after singing "Squid Jiggin' Ground," Tom said, "I might not have got all the verses in the right place, but I sang the whole song . . . anyway, you do your best. It's all you can do." More than thirty years later in a concert film from 2005 he starts a song in the wrong key before turning to the audience and saying, "These things happen you know, this ain't no Milli Vanilli show," referencing the infamous German duo who were disgraced when it turned out they never sang any of their songs and lip synced in performance. Tom regularly used this line in the second half of his career.

In a video posted on YouTube, singer-songwriter, Dave Gunning talks about the first time he met Stompin' Tom. Gunning was preparing to join Tom on the road as part of his 2002 tour and mentioned that he was nervous because he'd never played stand-up bass before. Tom replied, "What are you talking about? Why don't you relax and grab another beer. You don't have to worry about making mistakes on my show. I'll be making more than you!" Tom even referenced making mistakes in one of his most famous songs, "Sudbury Saturday Night," with the lyrics, "The songs that we'll be singing, they might be wrong but they'll be ringing."

Unlike many big stars who only have meet-and-greets with people who buy VIP tickets, Tom made himself available to every-

one. He stayed after every show to meet the fans, take pictures and sign autographs. This could sometimes take up to two hours. This enabled Tom to connect directly with his fans, but it was also a profitable part of the tour. Mickey Andrews said that Tom was a great businessman and selling merchandise was an important part of the tour. He pointed out that "There were no middle men. If a t-shirt was sold, he got all the money." Having toured with Tom for years, Andrews added, "Any product he sold, he sold a lot of. Like they wouldn't come in and buy one CD, they would buy almost every CD he had. The average person was spending between $100 and $200 on that stuff. T-shirts and everything."

Tom finished the biggest tour of his life with two sold-out shows at Toronto's Massey Hall. A review of one of those performances noted that in addition to Tom's regular fans there was a new group that had just discovered him. The reviewer wrote somewhat disparagingly of this younger crowd, saying that they think "the epitome of cool is to get drunk, holler like the Grand Champeen of the Kent County Hawg Hollering' Competition, and run up and down the aisles all night long in just-purchased 'I Stomped Along With Stompin' Tom' t-shirts."[21] At one point someone in the crowd yelled "Stompin' Tom for Prime Minister." While this seems to have bothered the reviewer, it had become a regular part of the tour and Tom enjoyed the youthful enthusiasm.

Tom wrote in *The Connors Tone* that as much as 60 per cent of his audience was now made up of young people. Brian Edwards confirmed this saying that the majority of Tom's fans were nineteen to twenty-five years old. He also pointed out that Tom's songs were "on the playlists of university stations across the country."[22] When a reporter told Tom that he was getting as much airplay on the University of Calgary's alternative radio station as groups like Urge Overkill and The Trash Can Sinatras, Tom said, "That makes my heart feel real good. I'm glad to hear that."[23] Tom explained his appeal, saying, "I think they [students] get a feeling of, well, you know, all young people have a feel of the rebel in them and I guess

maybe my music portrays that to a certain extent. You know, the sort of I-do-it-my-way kind of thing." Tom told another reporter, "A lot of university and younger kids treated me as underground, playing me on campus radio. Everyone thought I was dead. On tour people would say 'I had to see you in the real flesh and blood.'"[24]

David McClelland had moved to Canada from England in his late twenties and discovered Stompin' Tom when he was managing CHMA, the campus radio station at Mount Allison University in Sackville, New Brunswick. He saw Tom perform at the University's Convocation Hall and almost thirty years later he said, "When he started stompin' on that board I actually welled up and became quite emotional. It was such an iconic Canadian moment." He added, "And then meeting him afterwards and having my (never worn) t-shirt signed! It was a marvellous night."

Stephen MacIntyre was a young engineering student at Queen's University in Kingston, Ontario when he really became aware of Tom's music, which was popular at Clark Hall Pub, a bar run by the engineering society. MacIntyre came to appreciate Tom's songs, which he felt were "definitely simple but approachable, and there was a sort of earnestness to the songs and the music that appealed to me." Having become a fan, he decided to go see Tom when his tour stopped in Kitchener, Ontario at Lulu's, a converted K-mart which promoted itself as the "world's longest bar" with the capacity for three thousand patrons.

MacIntyre was struck by two things. He remembered there being a commotion in the audience as a young man climbed on his friend's shoulders and started shouting to Tom. Tom said into the mic, "Quiet, quiet, I want to hear what this guy has to say." As the crowd settled down, the man yelled, "The Ketchup Song!" Without missing a beat, Tom drawled, "Alllll right," and started playing the song. He added, "I don't think I've ever seen a performer more charismatic on stage. He commanded every ounce of attention in that building. It was this huge space and every set of eyes, every set of ears was laser focussed on him up on stage. And I don't think

I've ever seen that with any other musician. Every second that he was on stage he controlled this massive space."

A young couple who was interviewed by CBC TV in Summerside, after Tom's show, were asked why they wanted to see him. The young woman replied, "They play his videos on Much Music and we watch that all the time." Clearly the videos for "I Am the Wind" and "Margo's Cargo" were introducing Tom to a younger generation who liked to watch their music. The young man responded simply, "He's just . . . he's a legend to Canada!"

Tom would not undertake a tour of this magnitude again, but he had been reintroduced to people from coast to coast and been discovered by a new generation. He was established not just as Canada's most popular country singer, but as a legend. His time away had only helped to build the mystique around Stompin' Tom and he had returned a Canadian icon.

## Chapter Eleven
# The Icon

But if you don't believe your country,
Should come before yourself,
You can better serve your country,
By living somewhere else.

— "Believe in Your Country"

Tom's return to the music industry coincided with the birth of the East Coast Music Awards. Conceived by Halifax-based music promoter Rob Cohn, and originally called the Maritime Music Awards, just seven awards were handed out at the first ceremony at Halifax's Flamingo Cafe and Lounge in 1989. Eventually the organization would change its name and the celebration would expand into a five-day event where almost forty awards were handed out at a gala ceremony, which was occasionally broadcast on national television.

Tom had refused to accept any nominations or awards from the Junos or the Canadian Country Music Association, and was likewise initially reluctant to be involved with the ECMAs. He was bothered by the fact that the executive of the organization included people from the radio industry. As he wrote in *The Connors Tone*, "another organization was going to let radio determine what was good music in this country and what was not." He also claimed that he was not particularly fond of awards in general, writing that

"an artist who is liked by the people receives his rewards from the people."

Nonetheless, Tom felt that the organizers of this fledgling organization had the best of intentions and he wanted to be supportive, so he allowed his name to stand. Although he didn't win any of the awards he was nominated for Male Recording of the Year, Video of the Year ("I Am the Wind") and Song of the Year ("Lady, k.d. lang") in 1990.

Early in 1991 Tom discovered that he was nominated again. Cohn told Tom that he was up for four awards and that in all likelihood he would win at least one or two of them. He asked if Tom would agree to attend the show, hoping that his presence would garner some television coverage. Tom had no plans to attend but remained non-committal, hoping that the television cameras might show up anyway and provide exposure for the other artists. He ended up winning two awards that night: Country Recording of the Year and Entertainer of the Year.

According to the East Coast Music Association mission statement, one of their primary functions is to "advocate for our members to ensure they can sustain music careers while based in Canada's Atlantic region." Although Tom was from the East Coast, he had not lived in the region for well over twenty years. It's ironic that he didn't think of himself as a "border jumper," on a regional level when he allowed his name to stand for awards that were meant to help East Coast artists make a living on the East Coast. Tom understood that his association brought attention and legitimacy to these awards, but did not afford the Junos the same consideration. Artists who had left Canada and gone on to have success in the United States and/or internationally would have certainly helped the Junos' television ratings and media exposure. No doubt that was a consideration in including these artists as part of their annual ceremonies.

Tom planned another tour for 1991. Although this one was considerably smaller, with stops in just fifteen to twenty commun-

ities primarily in Ontario, it was just as political. A review in the *Toronto Sun* said, "underneath his aw-shucks country bumpkin veneer, there was an astute politician with a finger on the pulse of the national malaise."[1] The reviewer went on to say, "For Stompin' Tom, it seemed, the road to unity can be paved with something as simple as a song, a joke and a good, long laugh at ourselves. For the more than 2,000 fans in attendance that observation, however simplistic, seemed a logical recipe."

Early in 1992 Tom recorded another album, *Believe in Your Country*. He wrote in his autobiography, "On January 28 I recorded my 17th album of all original material," suggesting that the entire fourteen-song CD was recorded in a day. The album contained the title track; a song for his wife, "Lena Kathleen"; and "Johnny Maple," a song that Tom said personified French/English relations in Canada. On the promo CD that accompanied *Believe in Your Country* Tom explained that the two characters in the song, Johnny Maple and Fleur De Lis, represented English Canada and Quebec respectively. Tom said, "they're in love with each other and there's nobody, the Laurentian Mountains or the Seas or the oceans, or nothing, [that] is going to separate them." The song opens with the line, "Have you heard in Quebec City, There's a law they would decree, to separate Johnny Maple from his lovely Fleur De Lis?"

Tom explained why he chose to write about Quebec separation as a love song, saying, "People will understand a marriage breakup a lot easier than they'll understand a piece of land saying we're going to move over here." He went on, "The sophisticates are gonna laugh. They're gonna say, 'What foolishness is this?'" Tom was fully aware that some people dismissed his songs as simplistic, jingoism containing crude rhymes and a lack of artistry. Those detractors were present throughout his career. A 1975 review referenced Tom's song, "Blue Nose," saying that it, "like all his songs, was full of the most basic sentiments . . . totally lacking in subtlety,"[2] while an article in the *Toronto Star* referred to the songs

on his album *Ode for the Road* as "a collection of childlike, primitive folk-art ditties."[3]

Tom argued that what others saw as simplistic or childlike was intentional on his part. In *Country Gold*, a 1992 documentary about Canadian country music, Tom said, "I've often been accused that my lyrics are not sophisticated, and they're crude and this and that. Well, they're meant to be that way . . . because it's in the vernacular of the people whom I'm singing about. If I'm singing about miners, then I have miners' phrases incorporated into the song. If I'm singing about tobacco workers, it's the same thing. Wherever I'm at — if I'm writing a song about Newfoundlanders I'm going to try to sound as Newfie as I damn well can."

Tom's assertion that writing ungrammatically, and with a heavy emphasis on colloquialism, was intentional is supported by his casual use of the word "vernacular" as well as the vocabulary used in much of his prose writings.

Despite Tom's conviction that his songs would be ridiculed by "the sophisticates," a number of respected critics and literary figures recognized his artistry. Canadian writer and journalist Rick Salutin argued that Tom deserved a place "in the ranks of Canada's poets."[4] He wrote that

> *The first lines of "Sudbury Saturday Night" ("The girls are out to bingo/The boys are getting stinko/ We think no more of Inco") are immortal. The relations between the girls — and calling them girls — the rhymes and off-rhymes, bingo jibing with Inco, which is the gamble of a working life in a resource-dependent economy (still), and stinko, with its contempt for the company and the job you're tied to yet take great pride in, along with the utopian hints of Saturday night in the bar, where he's probably singing.*

Writer, Peter Stockland took it a step further, arguing that Tom should not only be considered a poet, but that he should have been made Canada's poet laureate. Stockland stated that two things set Tom's writing apart. The first was his power of observation, and secondly, he acknowledged Tom's fearlessness in being inventive with language. Stockland clarified, adding, "yes, the language of the Walmart crowd, if you will, but with a deliberately wall-eyed sense of humour and risk infusing every rhyme."[5] He analyzed the song "Gumboot Cloggeroo," quoting its descriptive lyrics: "Well there's Boots Bernard and the rough Richards, And the girls from way down Tracadie. How many Blue Nosers and Herring Chokers, We just don't know exac-ally."

Stockland wrote, "Short-story writer and poet Raymond Carver himself would have been envious of the compressive power in naming a character 'Boots' Bernard, and matching that with the scene setting immediacy of having the 'rough Richards' on hand as well . . . But it is Stompin Tom's sheer courage to rhyme the place name 'Tracadie' with the street-rooted expressiveness of 'exac-ally' that makes all the self-styled convention-breaking poets of the 20th Century look like pantywaists by comparison."

When Stockland wrote an article for the *Calgary Herald* arguing that "the 'Connorian oeuvre' should be properly recognized as authentic folk poetry, and recognized as far more meaningful to Canadians than any dot or dash Margaret Atwood ever put to paper,"[6] Tom saw the article and sent him a letter of thanks, saying, "Most people just like to laugh at old Stompin' Tom but you took me seriously and I appreciate that. I thank you very much."

Mickey Andrews, who witnessed first-hand the power of Tom's songs, said, "His songs, even though they seemed like little cartoonish things, they totally got right to the point of what [those situations] were like. A guy working in a tobacco field: 'My back still aches when I hear that word.' It got right to the point." As Peter Gzowski once said, Tom's lyrics had "no fat on them."[7]

The debate about the quality of Tom's songwriting may have

continued, but his fans weren't concerned. They knew what they liked, and their support, even without radio airplay, made *Believe in Your Country* Tom's first album to hit the Country Album chart, peaking at number nine. His only previous album to chart was *My Stompin' Grounds*, which went to number seventy-one on the top one hundred Album chart in 1971.

At the age of fifty-six, Tom got an unexpected career boost from the unlikeliest of places. A song that was twenty years old was about to become ubiquitous at hockey rinks across North America. The title track of *Stompin' Tom and the Hockey Song* did not get a lot of attention when it first appeared in 1972. The song was never released as a single, but it was played occasionally at minor hockey league games.

Randy Burgess worked as the game day producer for the Ottawa Senators during their first season in the NHL in 1992. Someone brought a Stompin' Tom CD into the office and Burgess happened to hear "The Hockey Song." He later said, "It wasn't really considered cool, or even popular, but I listened to the song and thought, 'This has some possibilities.'"[8] Burgess played the track at the game during a commercial break and it was an immediate hit with the audience. He said, "Everybody in the crowd clapped along with it as if they had been born and raised listening to the song."

The Toronto Maple Leaf's head coach, Pat Burns, heard the track when his team played against the Senators and decided he wanted it played at Leafs games as well. In no time it was being played at every Leafs game and by teams throughout the NHL. Connors claimed in his autobiography that before long "a lot of European countries were playing it as well." Although it had never been a big concern of his, Tom finally had a song that was popular outside of Canada.

When Tom attended a game between the LA Kings and the Toronto Maple Leafs in May of 1993, he was spotted in the audience and invited on camera to be interviewed by Ron MacLean as part of a *Hockey Night in Canada* broadcast. Asked what his

inspiration for the song was, Tom replied, "When I was a little kid and there was six teams and all that, I mean, hockey is Canada. It's the number one sport. With everything that I write about, I write songs about everything in Canada, should I miss hockey?"[9]

Mark David Norman pointed out that Tom wrote the song at a time when professional hockey was undergoing massive change. Just five years before, the NHL had expanded from its original six teams to twelve, and by 1972 there were fourteen. Only three of those teams were Canadian. Norman wrote that "The myth that hockey was 'Canada's game' and that the NHL was a protector of this national interest, [was] a myth that had been slowly eroding for decades."[10] "The Hockey Song" was in part Tom's attempt to reclaim the game as Canada's.

Despite the success of "The Hockey Song," not everyone was a fan. After hearing it at a January 1993 Senators game, *Ottawa Sun* columnist Earl McRae wrote an article apologizing to his American counterparts for the song and the behaviour of the Senators' fans. He wrote that he was embarrassed to have American "media sophisticates" subjected to the "horrendous caterwauling of that Canadian rube, Stompin' Tom Connors."[11]

Tom was furious when he saw the article and wrote about it at length in his autobiography, saying that McRae apparently viewed himself as "the judge of all human pedigree as well as of the kind of music people should listen to." He also referred to McRae as "another American kowtow-er." When Tom played Carleton Place in the Ottawa Valley later that summer he started the second half of his show by walking out and showing the audience that he had taped a picture of McRae to his stompin' board. As he wrote in *The Connors Tone*, "the audience went ballistic. And even more so when I threw it on the floor and proceeded to kick the livin' shit out of it."

"The Hockey Song," which became Canada's answer to "Take Me Out to the Ballgame," would continue to play a significant role in Tom's career for the rest of his life and beyond. According to Duncan Fremlin, Tom told him that the royalties for the song had

paid for the extension on Tom's house. In 1993 EMI included the song on a twenty-song greatest hits compilation album, *KIC\* Along With Stompin' Tom (\*Keep it Canadian)*. Tom was on the cover, in hockey gear, sitting in a penalty box, sneering like he's ready for a fight. Instead of a helmet he, of course, wears his cowboy hat. The album went to number twenty-six on the Country Album chart.

Dave Bidini used the phrase, "The Best Game You Can Name," as the title of his 2005 book about hockey, while the song also earned a spot in Bob Mersereau's book, *The Top 100 Canadian Singles*, placing eighty-sixth overall. Mersereau wrote that "Every Canadian knows and loves it," while admitting that, "Musically, it's as outdated as possible, a simple country-flavoured singalong, with a tune that's better suited to a summer camp than to modern airplay." He ends by saying that the song is "a combination of three great pillars of Canadian society: hockey, songwriting and Stompin' Tom."[12] In 1995 the song would be adapted as a children's book called *Hockey Night Tonight*, with illustrations by Brenda Jones. Artist Gary Clement provided illustrations for another children's book, *The Hockey Song*, inspired by the number in 2016.

Tom's first children's book had been published in 1992 when Doubleday released *My Stompin' Grounds and Four Other Songs*, featuring the lyrics to five of Tom's songs, accompanied by cartoon-like illustrations by Kurt Swinghammer. In addition to the title song, the book contained the lyrics for "Canada Day, Up Canada Way," "Cross Canada (CA-NA-DA)," "The Hockey Song" and "Unity." Two years later Tom's song, "Bud the Spud," was turned into a children's book with Brenda Jones providing the illustrations.

It had always been important to Tom that children understand his songs. In talking about his song, "Johnny Maple," Tom said, "If you can't get to the kids you can't get to anyone." In his song, "The Singer," he wrote, "You may pile up your gold but the pride of your soul, is the small bit of hope you bestow, on the children who come this way tomorrow, in search of the right way to go."

Tom often received letters from teachers thanking him for his songs, which they used as teaching devices. He was happy that his songs were being used in geography and social studies classes across the country, but he mostly wanted Canada's young people to sing the stories of their own country. In an interview with *Maclean's* magazine Tom said of radio, "If they would just play more Canadian music — and it doesn't have to be my music — our young people would wake up with a tune in their minds about Montreal or Vancouver or some Canadian that has done some great deed." [13]

In 1993 Tom was once again invited to the East Coast Music Awards. He had been nominated for Country Recording of the Year, but the association also wanted to present him with the Helen Creighton Lifetime Achievement Award. As a sign of how much Tom truly cared about other Canadian musicians, he agreed to accept the award, but only if he could give it back and have a new award created to honour the people in the industry who worked for years without any significant recognition or financial reward. Five Stompin' Tom Awards are now given out annually; one to an individual or group from each of Prince Edward Island, New Brunswick, Mainland Nova Scotia, Cape Breton and Newfoundland & Labrador.

In the spring of 1993, Tom was thrilled to be given an honorary degree by St. Thomas University in Fredericton, New Brunswick. He wore his cowboy hat rather than a traditional graduation cap and the two hundred graduates in attendance gave him a standing ovation as he walked down the aisle. Stan Atherton, an English professor at the University, read Tom's citation, saying, "After 'Bud the Spud,' Canadian country music would never be the same. Its phenomenal success underscored what Tom Connors had known all along: that Canadian experience, Canadian myths and sentiments could be a potent force in popular entertainment."

When Ron MacLean asked Tom about the degree during that *Hockey Night in Canada* interview, Tom replied, "They gave me

a Doctorate of Laws." He then added, "And there's a Latin word to it," acting as though it was all a little beyond him. He went on, "Some 'Honoris causa' or something. I haven't got enough dictionaries at home to figure out what it all means." But that was clearly the character of Stompin' Tom talking. Knowing Tom's intelligence and thirst for knowledge, there is no doubt that Tom Connors would have found out exactly what it meant.

Tom was so proud of the honour that he would start giving himself a producer credit on future recordings as Dr. Stompin' Tom. He even called his next CD *Dr. Stompin' Tom . . . Eh?* That recording was done with the band Whiskey Jack, who would also accompany him on a tour that summer. One of the more memorable tracks from this release was the song, "Blue Berets," about the Canadian peacekeepers who served around the world with the United Nations.

Romeo Dallaire was the Canadian general in charge of the United Nations Assistance Mission for Rwanda during the mid-1990s. In his book about the mission, *Shake Hands with the Devil*, he wrote that when his headquarters were under bombardment he would play Tom's song in order to keep up his troops' morale.

The first performance of Tom's 1993 tour was on Parliament Hill in Ottawa on Canada Day. Tom and Whiskey Jack performed in front of a crowd of 500,000, with another three million watching on television. It was the biggest crowd of their lives. Tom sang "Canada Day, Up Canada Way," to rapturous applause. After the song Tom said, "Thank you so much. This is my first time here and if there's some of you here for the first time, I sure know how you feel. It's great." The emotion is clear as Tom's voice cracks and he is on the verge of tears. He adds, "Keep it Canadian, b'ys. We need ya," before introducing "The Hockey Song" as the crowd goes wild. Their enthusiasm grew even more when the Stanley Cup was wheeled out on stage, surprising Tom. That year marked the hundredth anniversary of the cup, but even more importantly, it had been won by a Canadian team, the Montreal Canadiens, just

a few weeks before. Duncan Fremlin of Whiskey Jack said that performance was one he will never forget, writing, "There I was, a country hick from Bar River, Ontario, my banjo and my voice, being broadcast across the country to support Mr. Canada's finest moment, singing, of all songs, 'The Hockey Song.' It was my Heritage Moment."[14]

In late 1993 Tom was approached by Floyd Keefe of the Skinners Pond Improvement Council about reopening the old schoolhouse as a tourist attraction. Tom felt that as long as he wasn't involved, the school might not be the target of vandals and gave his approval. The school was renovated and opened on Canada Day in 1994.

Tom's 1993 tour was his last for five years. While his comeback was complete, his touring and recording had slowed considerably compared to his early years. In the first five years of his career, from 1967 to 1972, Tom released nine albums of original material. In the last twenty years he released just seven. Part of the reason for the slowdown was that he spent much of the 1990s writing his two volumes of autobiography. Tom's friend, John Farrington, a writer and journalist he had known since his time in Timmins in 1965, worked on the books with him. In some places he is referred to as having collaborated with Tom. In others it is said he "coordinated" the books. There are differing accounts as to how much help Tom had and exactly when he started writing.

In a radio interview with Duncan Fremlin, Farrington said that he mentioned to Tom that he should write his life story at his comeback party in 1989. John said they met shortly afterward and began work that continued for the next four years. He said that during their first meeting Tom gave him the 130 pages he had written during his retirement in the 1970s. Noting that they only covered up to the age of four, Tom said that he wanted to write a total of nine volumes. John pointed out that prime ministers only get two volumes. Tom responded, "Well, I've got enough stories, I've got nine." They eventually settled on two.

Tom wrote in *The Connors Tone* that he and John didn't first

discuss the book until November of 1993, when John took the 130 pages home to read. He says they met the following January and John started tape recording interviews, which he would then transcribe. However, on the *Believe in Your Country* CD, which was released in 1992, Tom said that he had been working with John for a while and they had over thirty hours of interviews. He says that in addition to the interviews there is "the bunch of stuff that I've already written myself over the years which will be interspersed with the autobiography." This seems to imply that John was putting it all together. He goes on to suggest that it might be ready by Christmas of 1992.

In *The Connors Tone*, Tom said he was unhappy with John's transcriptions of the interviews because they weren't chronological, so he decided he'd write everything out in long hand and then type it himself. On occasion John would bring his laptop and type as Tom dictated. Tom wrote, "As this became more and more awkward and inconvenient, it was decided I'd just finish the rest of the book myself." He says he finished in June of 1995.

On his Whiskey Jack website, Duncan Fremlin, who was friends with both Tom and John, wrote, "It was a labour of love for John. He said he never received credit as a ghost writer but by anyone's definition, that's exactly what he was."[15] Farrington is not given credit as a writer on the book, but Tom does thank him in the opening pages for inspiring him to finish it.

Farrington told the *Peterborough Examiner* that when the first draft of the transcript was done, the publisher, Penguin Books, sent it back to Tom with dozens of suggested edits. Tom simply returned the manuscript to them and said, "It runs as is."[16] Farrington continued, "He told them he could make more money in one night at Massey Hall than he would off the books for their lifetime. He said, 'If you don't want to do it, I'll take it somewhere else,' and they printed it as is." As with his recordings Tom wasn't particularly interested in spending a lot of time editing or refining.

As soon as Tom handed in his manuscript for *Before the Fame*,

he started work on a new album, *Long Gone to the Yukon*. A number of the songs were written with his old friend Gaet Lepine, the bartender who gave him his first big break at the Maple Leaf Hotel. Tom joked that using Gaet's songs was "my way of paying him back that nickel." Although none of the songs on this recording became part of Tom's standard repertoire, the album was very well received, hitting number five on the Country Album charts, the highest of any of Tom's LPs. It would also be his last album of original material to make the charts.

Much to Tom's surprise, *Before the Fame* became a national bestseller, going all the way to number one. In Canada, a book that sells 5,000 copies is generally considered a bestseller. *Before the Fame* sold more than 60,000 copies. Although Tom had referenced his childhood in interviews previous to the publication of the book, he had not gone into great depth. The book exposed his childhood in stark detail. *The Canadian Press* wrote, "What follows is a heartfelt, often achingly sad account of a childhood spent in poverty, squalor, loneliness and dejection."[17]

A review in *The Globe and Mail* described the book as "a harrowing account of growing up unloved and unwanted in pre-social-safety-net Canada." It went on, "In between goofy anecdotes about life on the road and interpretations of people's accents that do not take political correctness into account, is one chilling tale."[18]

Not all the reviews were so positive. Jim Christy noted that "the book is like the road: by turns harrowing and funny, sad, wonderful, and boring."[19] His bigger problem with the book was Tom's outsized ego, which, ironically for someone who tried so hard to create an image of the simple, humble, down-home guy, is on full display throughout the book. Christy wrote, "the book is a monument of self-obsession. The ego of the man who wrote it can barely be contained within the borders of the country about which he has written so many fine songs."

In the introduction, before his story even gets underway, Tom tells the reader that he has a much better memory than most

people, that he is unusually honest, that he doesn't care about making money, that he doesn't have the "airs and graces" that most successful people have and that "many people consider me a hero." His story is told through the lens of Stompin' Tom, the character. As Christy wrote in his review, "He is always the most adventurous, the most courageous, and never meets anyone near his equal." Clearly Tom's many fans didn't care and they were thrilled to read about the adventures of Stompin' Tom.

Early in 1996, just three months after the publication of *Before the Fame*, Tom started working on the second volume of his autobiography. That and some lengthy home renovations took up much of the next few years. At this point in his career, a great deal of Tom's time was spent accepting various honours and awards. Of the many honours bestowed upon him the one that probably meant the most was the Order of Canada. Tom agreed to attend the ceremony, which would take place in November of 1996, but one of the first things he asked was whether or not he could wear his hat.

By this point the hat was, of course, integral to the character of Stompin' Tom and he would not have wanted his fans to see pictures of him without it. There may also have been an element of vanity, as he hid the fact that he was bald. Even people who knew him for years almost never saw him without a hat of some sort.

While Tom had a variety of hats he always wore the same one on stage. Tim Hadley, who toured with Tom, said, "The hat that Tom had, he has had forever . . . If you'll notice Tom's hat is a little different than a regular cowboy hat . . . the top of it is . . . a very distinct shape. He called it the horse hoof shape."[20] He went on, "In the old days in dept. stores they used to give you paper bags with handles on [them]. And he had a couple of these old Eaton's bags that he carried the hat in. Over the years, the crew'd have to duct tape these bags . . . but everywhere he went that hat went with him."

Tom was thrilled when he got word that he'd be able to wear his hat to the ceremony, writing in *The Connors Tone*, "Now, that's

the kind of country I'm proud to live in. A country where even the governor general can make allowances once in a while for a down-to-earth country boy whose only contribution to this great land so far has been a mere handful of songs."

Tom approached Whiskey Jack to see if they would be interested in accompanying him on his 1998 tour. They declined, but a friend recommended Mark LaForme, a musician based in Hamilton. LaForme put together a band with Larry Murphy, Danny Lockwood and Steve Petrie, three other musicians from Hamilton, and they toured with Tom in 1998 and 1999. LaForme said that Tom's first question to him, before he asked him to go out on tour, was "Do you like beer?"[21] LaForme knew the correct answer was "yes." He later said, "It's like being called to serve your country."

This was typically how Tom put his band together. A video posted on YouTube shows Dave Gunning telling a similar story. In 2002, he was shocked to receive a call from Tom. He said that Tom started with, "J.P. Cormier tells me you play the bass guitar, but do you drink?"[22] When Gunning replied in the affirmative, Tom followed up, "I need to know one more thing. Can you handle your liquor?" Again, Dave said he could and Tom replied, "I just wanted to make sure you weren't one of them fallsy downsies." When Dave asked J.P. how he should prepare for the tour, J.P. replied, "Get your liver ready." Gunning joked that Tom's tour was "Liverdance."

Al Widmeyer, who toured with Tom between 2006 and 2011, said in an interview for this book that Tom didn't care how much the band drank as long as they could show up and do the show. Al met Tom at his house before joining him on the road for the first time. He showed up with all of his instruments, thinking he'd be doing an audition. The two men had a beer and chatted for a bit before Al suggested he should go get his instruments from the car. Tom replied, "There's no sense you getting your guitars. I'm just here to get to know you. I know you can play."

Al said, "Tom was a guy, who had to get to know you. He could

hire anybody he wanted for his band. He could have the best guitar players. He could have the best of the best. But no, he wanted guys who got along and who could work as a team, backing him up." Tom knew that he was going to be on the road with his bandmates for weeks or sometimes even months on end, living, working and playing together. It was imperative that they get along. Al went on, "You weren't treated like a hired gun. He wanted the camaraderie. He was a very private guy, so when he went out [on the road], he wanted to party and he wanted to make sure the guys got along. It was a big party for him to go out on the road."

Mickey Andrews, who also toured with Tom a number of times, said that Tom was "always generous with his band. He paid me well and most of the time he would pick up the cheque for meals and stuff like that." While Tom was generous, he could also be a bit of a taskmaster. He had to be in control at all times and he was not particularly interested in other people's suggestions. Duncan Fremlin wrote of Tom, "If he didn't think it was his idea he wanted nothing to do with it."[23]

Tom had a fair number of tour rules. He insisted on knowing where everyone was at all times. The band and crew had to keep a walkie-talkie on their person and have it turned on in case Tom decided he wanted them for any reason. In his book, Fremlin told a story about the band losing Tom on the highway and arriving at their motel ahead of him. They decided to go into the city to eat without Tom's permission and he was furious when they got back a couple of hours later. Widmeyer said the list of rules got longer over the years and that he sometimes felt a bit like he was on "lockdown."

Dave Gunning came to understand why Tom had so many rules. He explained in an interview, "He was an abused child. He was never going to be vulnerable again. When anybody [screwed him over] he came up with another rule or another policy." It's quite likely, for instance, that Tom's concern over knowing everyone's whereabouts was related to the time when his father was working

for him and disappeared with the equipment truck, almost causing Tom to have to cancel a show. Gunning went on, "He was alone and vulnerable for most of his formative years. He was never going to let his guard down again. When he became the king of his own castle, he was the king of his own castle."

Gunning said Tom went so far as to always sit in the "power position" in any room he was in. Tom had to know what was going on and be in control of any situation.

Although Tom wanted everyone to drink on tour, he was adamant that no one use drugs. Fremlin said if Tom so much as found a marijuana seed he would have fired whomever it belonged to. The band sometimes snuck around Tom's back and broke that rule. Fremlin said, "I assumed he didn't want us to rub his nose in it and I certainly didn't want him to catch us but there was no way he was going to control us all of the time. We had to have our pleasures, too."[24]

Although the band only performed about three nights a week, they were not allowed to go home between performances and even if they visited their hometown they couldn't go visit their family. Although these rules might have seemed unreasonable to some, Gunning came to respect them and said Tom "was an extremely kind person. And brilliant person. If he knew you weren't going to screw him over in any way. If you respected these rules he put in place . . . he reciprocated and sent you the respect back."

Gunning found this out the hard way. A night or two before arriving in his hometown of Pictou, Dave asked if he might go home to visit his girlfriend and check his mail when they got there. He was told no. That night in the dressing room, in front of everyone, he confronted Tom saying, "Tom, you must have hired a lot of losers over the years to have all these rules that are affecting me." Tom just stared at him, saying nothing. He also ignored Gunning on stage that night, not giving him the usual thumbs up that he gave all the band members. Dave knew he was in trouble. After the show he was called to Tom's room and thought he might be fired.

Dave walked into the room and was met with silence. He nervously started talking and apologized to Tom. He said, "I should have waited until we were one on one. I shouldn't have put you on the spot." He continued apologizing and still got no response. Gunning said, "He was looking at me, planning his next move. He was a chess player, right? Nobody could beat him." Eventually Tom told him to grab a beer and then said, "I know there are a lot of rules in place, but every policy has a reason. Now that being said. I've gotten to know you and I can trust you're here for the long haul. So when we get to Pictou you can go home, but don't tell anybody else." Gunning said, "He never got mad at me. I think he appreciated that I had apologized." He went on to explain, "He didn't want to have his heart broken again so for every mishap that happened he had another policy. He was protecting himself from getting hurt. He came across as an odd boss. But that's not it."

Widmeyer said Tom purposely arranged the tours so there was lots of spare time between gigs. He said, "It wasn't like 'Play, load up, drive.' Tom liked to have time to socialize." Widmeyer remembers leaving the Toronto area to drive to Thunder Bay. They left on a Sunday, even though their first show wasn't until the following Saturday. They got as far as Sault Ste. Marie and Tom decided they'd stay there at a motel he liked for a couple of days. Al said, "And do you know why he liked that motel? Cuz, if the guy knew we were coming he would cut the grass nice so we could play croquet."

Tom loved having long, involved croquet games that he took very seriously. He told *The Globe and Mail* in 2008, "It's not the old ladies' game, the way we play it. You need shin pads. If we hit your ball, it'll go right out of the park."[25] Tom also loved playing mini-golf, Scrabble, chess and checkers while on the road. He was very competitive and rarely lost, particularly at checkers.

The one rule that seemed to cause the most consternation among the band was the clause in their contract that said at least one person had to stay up with Tom until 5 a.m. every night. If Lena was on the

road she would keep Tom company, but otherwise the band members took turns. They would drink and smoke while they played games or jammed or chatted until the early morning hours.

Tim Hus told *Global News*, "For a lot of people obviously it would be the thrill of a lifetime to stay up and drink beer with Stompin' Tom, and it was. It was really great. But believe it or not, you'd be surprised once you get about six weeks into the tour and it's getting to be about four in the morning and your eyes are starting to fall shut and he's like, 'Hey, buddy, you've still got an hour left. You signed the contract.'"[26] Duncan Fremlin agreed. He said, "It was tough to do . . . One time I tried to leave and he said, 'Get back here you little prick! You're not going anywhere.' Some guys could do it. They could sit there with a guitar for hours on end, but I needed my sleep. It was tough, but it was part of the mystique. Part of the fun."

Mickey Andrews found the nights when a few band members stayed up the hardest, "I'm not a drinker and I'm not a smoker," he said. "I'm gonna tell you something: if you're in a room with a bunch of guys, after playing a concert, and you're up all friggin' night, till six and seven in the morning, you're gonna be as woozy as they are. The smoke gets in your clothes and in your lungs and everything. When I'd be with him one on one it was tolerable for me, but don't put me in there every night. I wouldn't have played with him. I would have been gone. He knew that. He knew I wouldn't be there."

Al Widmeyer talked about Tom's penchant for partying, saying, "Not too many people could drink him under the table, let's put it that way. People have tried." Steve Petrie, who was with the Mark LaForme band that did two consecutive tours with Tom joked, "I think we hold the record for consecutive tours. The rest of them are on dialysis, or disappeared. Kind of like *The Blair Witch Project*."[27]

Mickey explained why Tom wanted to stay up all night saying, "It took him a long time to come down. He was on a very big high even though it never looked like it." He added that he thought Tom

wanted everyone on his schedule, so they would all sleep late before going to get a bite to eat and heading to the venue for a soundcheck the next day.

Tom rarely flew on tour, but Al Widmeyer told the *Wellington Advertiser* that if they did fly and Tom was seated in first class he'd let a band member take his seat and enjoy the hospitality.[28] Tom was also known to buy drinks for rows of passengers. Most of the time, however, Tom and his band drove cross country. He didn't have a tour bus like most artists of his calibre do. Instead, everyone would travel in a caravan.

As Tom Jr. got older and started to tour regularly with his father, he would usually be in the lead car and Tom Sr. would be behind him. Tom told the *Alaska Highway News*, "I drive my own vehicle alone. I never have radio or tapes or anything on. When I'm thinking, I can jot down song ideas and stuff like that as I go."[29] Behind Tom was a van full of musicians and finally, the truck carrying all of their sound and lighting gear. They would keep in contact using CB radios and/or walkie talkies.

Both Tom and Tom Jr. were notorious for driving fast. And Tom insisted the others keep up. Widmeyer explained, "I really thought, 'I'm gonna die in a car wreck.' I'm a professional driver [having driven a city bus for twenty-four years]. But the way these guys passed people on the road and stuff like that. I just thought, 'These guys are maniacs.' They drive so fast and then they'd stop and have a couple of beers somewhere. You know, he'd stop and have lunch and have a couple of beer!" Tom was also well known for taking detours. He had travelled the country countless times so he'd get the band to pull into some little town he'd played years before to visit a bar he'd performed in or to drop by and say hi to an old friend.

Widmeyer recalls stopping for breakfast in a place called Blind River in Ontario. When they entered the restaurant there was only one other patron and he left before they finished eating. When Tom went to settle up his bill he was told that the other patron had paid for their breakfast on his way out. Tom asked

who he was and discovered that the man ran a little convenience store on a nearby First Nations reserve. Widmeyer said, "We went about 15 miles out of our way to find that man and thank him. Tom wanted to thank him in person. That's the kind of man he was. The look on that man's face when Stompin' Tom walked into his store was priceless."[30]

Tom may have been one of Canada's biggest stars, but one would not have known that from the accommodations he chose while on tour. His preference was for slightly rundown motels where he could pull his truck right up to the door. Fremlin explained that Tom didn't like having to walk through hotel lobbies and being exposed to strangers. He was happy to meet his fans, but he preferred doing it after a show in a more controlled situation. On Tom's later tours these slightly seedy motels were also more likely to offer smoking rooms.

Tom's taste in food was as simple as his taste in accommodations. Although he loved seafood, particularly when visiting the East Coast, some of his favourite foods were boiled wieners, Kraft dinner, clam chowder and kippers straight from the can. Tim Hus talks of staying up till 6:30 a.m. with Tom, then walking by Tom's open motel room door the next day around noon and seeing him "eating cold wieners from a can with a fork in one hand and a bottle of beer in the other. Tom looked up and said, 'Mornin' Tim! Just having my breakfast.'"[31]

Al Widmeyer tells a story about being in Quesnel, B.C., when Tom was in a particularly bad mood. One of the rooms had a little kitchenette, so Al boiled some wieners and took them to him. Al said, "I brought these goddamned wieners in and it was just like I gave him a million bucks."

Tom brightened up immediately and yelled, "Tommy, get the mustard and the bread out!" Back in his hitchhiking days Tom would sometimes exist for days on bread and bologna with a bit of mustard. Despite having enough money to eat anything he wanted now, those were still his comfort foods.

Tom was similarly low maintenance when it came to the venues where he performed. Tim Hus told a story about arriving at Scotiabank Place in Ottawa to do a show and the staff was worried because they hadn't received Tom's rider, a part of every artist's contract that details the hospitality that will be provided. After assuring them that he had sent the rider, the staff responded that all they got was a fax that said he wanted two cases of Moosehead beer. Tom replied, "Well, then you got my rider."[32] All he wanted was a case of beer for the band and another for himself. The staff had never seen an artist of Tom's stature require so little.

Despite the occasional challenges of touring with Tom, getting to share a stage with him seems to have made it more than worthwhile for the many musicians who accompanied him over the years. Al Widmeyer said, "the first tour. It was quite rough. And I didn't know if I liked it or not." But he added that when he was invited back he realized, "I missed it. I like travelling. I like seeing the world. And you're playing with a Canadian icon." Likewise, Duncan Fremlin thinks it was all worthwhile. "It's like playing Maple Leaf Gardens with Wayne Gretzky as your winger," he said. "It doesn't get any better than that. It was a difficult job in many ways, but it defined the rest of my musical life . . . I feel like I'm a pretty lucky guy for having experienced that." Gunning said, "I genuinely fell in love with the guy. I was weirded out by some of the stuff and sometimes it was frustrating, but I just knew that, 'Hey man, this guy has lived a life that I can't relate to . . . Maybe I'd be the same as Tom if I went through everything Tom went through.'"

In 1998, EMI released another greatest hits compilation called *Souvenirs* featuring twenty-five songs, which went to number twelve on the Country Album charts. It would eventually go platinum, selling more than 100,000 copies. The next year Tom recorded a new album, *Move Along with Stompin' Tom*, using Mark LaForme and his band in the studio. While many artists used session musicians for their recordings Tom tended to use whomever he was touring with. Al Widmeyer said, "He was 100% for his

band. He could have anybody he wanted for his [studio] band. But no, if you were in his band, you recorded with him."

This was Tom's first album of original material in four years and, apart from his retirement years, it marked the longest he had gone without releasing new material in his entire career. While none of the songs on this recording became Stompin' Tom staples, it did include "Confederation Bridge," which he had written in honour of the opening of the bridge that connected Prince Edward Island to New Brunswick. Tom was frustrated that, although he recorded the song in January of 1997, EMI didn't release it until late May, just days before the bridge opened. Tom felt it would have performed considerably better if it had been available earlier. It went to number seventy-nine on the Country Music charts and was Tom's last single to chart during his lifetime.

Tom continued making special appearances and collecting various honours. Early in 1999 he was asked to sing "The Hockey Song" at the closing of Maple Leaf Gardens in Toronto. That summer he played a big show in Tignish, PEI, before heading to nearby Skinners Pond where the road near his childhood home was renamed Stompin' Tom Road. In November he was given the SOCAN National Achievement Award. Tom had attended the ceremony not knowing he was going to be honoured, and was shocked when his old friend Gordon Lightfoot went to the mic and announced his name.

Tom was also asked to sing "The Hockey Song" at Wayne Gretzky's induction into the Hockey Hall of Fame. As the twentieth century came to a close, Tom was helping induct one of hockey's greatest players into the Hockey Hall of Fame by playing one of Canada's best-loved songs about the game. A song he had written.

Tom had been back on the music scene for a decade and he was now not only a legend in country music circles, but he was recognized by academia, hockey fans and the Government of Canada alike as having helped to create an identity for Canada's working class.

## Chapter Twelve
# The Myth

I am the wind; eternal wind;
Around the door between gods and men,
And if you see how I go in,
You'll have the key, and know the wind.

— "I Am the Wind"

As the new millennium started, Tom moved into the computer age when he had Mike Dunlop develop a website for him. Dunlop had been running his own fan-based Stompin' Tom site for years, and told Tom Jr. about it when he met him at a concert. Tom Jr. was impressed and eventually reached out to Dunlop to see if he would help create an official site for Stompin' Tom. It was also suggested that they invite Mike Helms, another fan who maintained a site committed to Tom's discography, to take part.

Dunlop was thrilled with the offer and said he would do it free of charge as long as he got to meet Tom. Dunlop and Helms were invited to the house to discuss the website. Tom had a room in his house that contained his many awards. Dunlop took some pictures to be used on the website, and later wrote that, "seeing all this history displayed in Tom's trophy room was proof to just how important this man was to Canadian Music."[1] The two young men went to Tom's bar where he was sitting on a barstool waiting for them. Dunlop wrote that when he said, "It's a honour to finally

meet you Stompin' Tom," Tom stopped him and said, "Call me Tom." This was typical when people visited Tom at home. Steve Fruitman said in an interview, "There were two Toms. When you went to his house one of the first things he'd tell you is 'Well, you're with Tom Connors now, not Stompin' Tom.'" Dunlop went on to design promotional material and artwork for recordings and tours for the rest of Tom's career.

Tom received his second honorary doctorate in 2000, this time from the University of Toronto. In the letter sent to Tom advising him of the honour, J. Robert S. Prichard wrote, "This degree is offered to you in recognition of your outstanding contributions to the musical and cultural identity of Canada and the Canadian people." The letter continued, "you have given voice to the common people of Canada in a way unmatched by any other composer or performer of your generation."

In his acceptance speech, Tom said, "The way I was brought up there was very little opportunity for education or even a good job or anything else."[2] He explained that there are a lot of people in the country like him and that "maybe they haven't had quite the opportunities that a lot of folks in this room today have had." He ended by saying, "I hope you really appreciate it because it's probably nicer to get a degree the way that you folks are getting it. That's the way to do it. But at the same time, I hope that the people of my ilk will see what's happening here to me today and they will say to themselves, 'If Stompin' Tom can do it, we can do it too.'" Steve Fruitman was in the audience, recording the ceremony for the university radio station. Fruitman said the doctorates meant a lot to Tom because "he was being recognized for his intelligence [despite the fact that] he didn't go to school very much and was self educated." He added, "He had tears in his eyes that day."

Later that year Tom was given a Governor General's Performing Arts Award. The award was presented by Tom's old friend Adrienne Clarkson, who was serving as Canada's governor general. The two had met years before at the CBC. Clarkson wrote in the pro-

gram for Whiskey Jack's Stompin' Tom show, "I was honoured to call Stompin' Tom Connors my friend. It was easy to be his friend because, if you didn't mind the smoking and the hat being worn all the time, he embraced you totally!"[3]

She said that Tom was, "The only man who has ever been allowed to wear his hat inside Rideau Hall throughout a ceremony and for all formal pictures. I made an exception for him because you always make exceptions for exceptional people." While she could not make an exception for Tom to openly smoke inside Rideau Hall, she did, unbeknownst to the fire department, find a spot where Tom could blow his smoke out a window. When a fellow honoree complained about how smoky Tom smelled, Clarkson told the man he would have "to put up with it," but she did arrange the official photos so that Tom was not near him.

The second volume of Tom's autobiography, *Stompin' Tom and the Connors Tone*, was released in September 2000. Although it did not sell quite as well as *Before the Fame*, it, too, was a bestseller. In an email from 2017, Tom Jr. wrote that the two books combined had sales of 120,000. Those are huge numbers in Canadian publishing.

The reviews were again mostly positive. Bob Mersereau wrote, "The good news is he's as fine a storyteller as he is a songwriter."[4] He recounted much of the book and explained the overarching theme: "The tone he refers to in the book title refers to the tone he's chosen to live his life by, choosing the right course and sticking to it," Mersereau wrote. "It's Tom versus the big guys in the Canadian music biz, and Tom winning."

A review by Mark Schatzker in the *National Post* said, "He writes like you'd imagine he speaks. *Stompin' Tom and The Connors Tone* makes you feel as though you're sitting right next to Stompin' Tom in the cab of his truck, listening to the story of his life as you cruise down a country road on the way to some far-off gig. It's a journey worth taking."[5]

Tom's writing was conversational. Both books are written

almost as stream of consciousness, with Tom speaking directly to the reader. At one point in volume two, he writes that he will probably be touring shortly after he finishes writing the book. He adds almost immediately, "Now, there's a coincidence for you. I just this minute received a fax from Brian. My first concert date will be in Tignish, Prince Edward Island, on August 1, 1999."

There was clearly very little editing, but it gives the books a unique style. Not only does the reader get to hear about Tom's past, but he also offers regular glimpses into his present. Taken together, the two books are more interested in creating the myth of Stompin' Tom than they are in providing any deep insight into Tom Connors. He recounts events in great detail, and they range from harrowing and sad to funny and triumphant. But he purposely leaves out his love life. He rarely talks about three of his four children. There is little serious self-reflection and one would be hard pressed to find an instance where he admits to having made a mistake or apologizes for anything.

Instead, the reader is subjected to an endless list of people who treated him badly. In part, the books seem like his chance to get back at anyone who has ever done him wrong. And the list is long. Tom had a remarkable memory, and as Robert Everett-Green pointed out, "Memory can also hold a grievance."[6]

Tom wrote in the introduction to *Before the Fame*, "I am not going to tell you anything just for the sake of dressing up a story." However, throughout both books there are examples of Tom exaggerating or telling stories that simply help to create the image of Stompin' Tom. Tom's long-time friend and bandmate, Mickey Andrews, acknowledged that the biographies were not based completely on the truth. Andrews said, "He put the picture in there that he wanted to put in those books. I said to Tom, 'Don't go telling me you remember when you were four years old!' I said, 'I was a baby too!'" Andrews went on, "He was creating his own history. He wanted to make sure that he was selling those books. There were little fairy tales there. That's Tom creating his thing. That's not a

bad thing." Andrews had great respect for Tom Connors's creation of Stompin' Tom, and the books were an extension of that.

Bob Mersereau explained that this was typical for an entertainer from the 1960s. "Everybody did that to a certain extent," he said. "Entertainment wasn't treated like news. The reporters were in on it or didn't bother to check. You still had people with phony names. Bob Dylan told everybody he was from different places and that he had toured and been all over North America. Finally after three or four years they did check on him and they were like, 'No, you're not. You're actually Robert Zimmerman from Minnesota.'" Things began to change in the late 1960s and '70s when journalism entered the picture, but Mersereau adds, "before that it was whatever made a good story."

The autobiographies established the story of Stompin' Tom and every word became accepted as fact moving forward. It is now part of the lore that Canada's troubadour was christened Stompin' Tom on Canada's hundredth birthday, yet this is unlikely. Every profile or biographical sketch mentions that Stompin' Tom became successful without ever having a hit song on the radio, despite the fact that he had nineteen songs make the Country Singles charts between 1969 and 1975.

Tom told the *Toronto Star* in 2002, "I made it in this country without the music industry and radio. It takes dogged determination. They'll make you in their own way, and when they feel like it, they'll break you in their own way. It's better to turn your back on all that and go it alone."[7] The author of the piece wrote in response, "That's an all too familiar refrain from Connors, the rough and ready country singer-songwriter with more than 45 albums to his credit (ironically, most of his proudly independent recordings are now in the catalogue of music giant EMI)."

With all the hit records, the many awards and the support of a major record label, it's hard to agree with Tom that he was an outsider in the music industry. Yet he always painted himself as David taking on Goliath. The establishment was always out to get

him and he was just "a small Canadian from the smallest province in Canada," as he describes himself at the beginning of the *Believe in Your Country* promo CD. This endeared him to his fans and reinforced that he was one of them, fighting "the man."

Perhaps Tom was never able to shake the feelings of being an outsider that had been ingrained over the first thirty years of his life. His itinerant childhood, as he and his mother moved time and time again, always left him in a new neighbourhood, feeling like he didn't belong. Then in Skinners Pond he stood out as "the orphan boy" in a small tight knit community. After that he spent more than a decade as the vagrant looked down upon by almost everyone he met. Perhaps he carried these feelings of inadequacy into his adulthood and career. Or maybe he knew it made for good press.

Tom was brilliant at creating and maintaining the character of Stompin' Tom. And he really was a simple guy who enjoyed a "no frills" kind of life. But when he wrote his autobiographies, he knew he was adding to the mythology of Stompin' Tom. As Mickey Andrews said of his friend, "He knew how to promote himself."

Tom toured again in 2001, and continued touring for a few weeks every year throughout the 2000s. There were no more huge cross-Canada tours, but he hit the road almost annually and generally had a new album to promote, whether it be another compilation or a CD of new material. In 2002 he was promoting An *Ode for the Road*. On Tom's last few albums he had included original material as well as new versions of some older songs. This album had new recordings of "The Peterborough Postman," "Red River Jane" and "Roll on Saskatchewan." One of the new songs was the autobiographical "Ode for the Road," which recounted his early days travelling the country, doing odd jobs.

Later that year, Tom was one of fifty guests invited to a luncheon at Rideau Hall in Ottawa to celebrate the Golden Jubilee of Queen Elizabeth II. Governor General Adrienne Clarkson said, "Over the past 50 years Her Majesty The Queen has witnessed Canada's coming of age as a dynamic, creative and inclusive soci-

ety. From celebrated artists and scientists, to renowned athletes and dedicated nation-builders, the Canadians invited to celebrate Thanksgiving with The Queen represent achievements that make us proud to be Canadian."[8]

There was one Canadian invited for each of the fifty years that the Queen had been upon the throne. Tom represented the year 1971 and his citation read, in part, "His cowboy boots, signature Stetson and unforgettable presence have graced the stages of the small-town watering holes and vast urban musical stages of Canada for three decades . . . This man knows Canada like no one else and all Canadians know him."[9] Some of the other guests that day were film director Norman Jewison, hockey player Jean Beliveau, author Farley Mowat and musician Oscar Peterson.

Tom originally declined the invitation, writing that he would be unable to attend because he knew he could not wear a hat in the presence of the queen, but he didn't feel comfortable removing it. He soon got a reply that he would be given special permission to keep his hat on. The argument had been made to Buckingham Palace that Tom's hat was like a religious headdress. In the official photo of the fifty guests, Tom stands out with his black Stetson. In a slight nod to protocol, he did wear a suit jacket.

In an interview about that day, Tom said, "When me and the wife, Lena, were sitting, toasting the Queen . . . I thought to myself, 'What the hell am I doing here?' And the first thing that came to my mind was, 'The fans put me here.' Because I coulda been singing forever on a boxcar. I coulda been singing forever in a hotel somewhere, long, gone and forgotten. I realized I was there representing all those people who put me right there at that moment. And I bowed my head to myself and I . . ."[10] He stops at this point, fighting back tears as he remembers the moment. "Men are not supposed to cry, but I did shed a tear. Maybe nobody else in the hall knew it." He takes another pause and ashes his cigarette before summing up, "That's what the Stompin' Tom fan is to me."

Dave Gunning saw his friend on TV at the ceremony and called

Tom to see how the event had gone. Dave said to him, "They must've had good food." Tom replied, "Not really. It looked seagull shit or some damn thing on the plate." Brian Edwards arranged for Tom to have a ham sandwich instead of what everyone else was eating. Gunning added, "White bread, just mustard." Tom told Dave, "I always knew which tray was coming to my table because it would be the only tray with a bottle of warm Moosehead green on it."

In 2004 Tom got his first major American exposure when Conan O'Brien brought his late night show to Canada. The other musical guests that week included Nickelback and the Barenaked Ladies. Tom performed "The Hockey Song" as the crowd in Toronto's Elgin Theatre went wild for him. That year the CBC undertook a national survey to determine the "Greatest Canadian." Tom ranked number thirteen overall, the highest ranking for any Canadian artist, beating out everyone from Anne Murray and Gordon Lightfoot to Jim Carrey. As Tom posted on his website, this ranking also meant that he was the "fifth Greatest Living Canadian of all time;" "the number one Greatest Performing Arts Canadian of all time;" and "the number one Atlantic Canadian of all time."

In May 2004 a headline appeared in the *National Post* declaring, "Skinners Pond Tourism Dream Stopped by Tom."[11] Since 1994, the Skinners Pond Improvement Council had been using the old schoolhouse as a tourist attraction. In 1998 the Tignish Historical Preservation Foundation had begun work on a million dollar project that would develop the site, creating a cultural centre that they hoped would bring in over 15,000 visitors per year. According to the story in the *National Post*, however, "Mr. Connors has mysteriously stomped away from the project." This apparently came as a surprise to the foundation. Judy Morrissey Richard, its chair said, "I'm a little disappointed, but I'm going to move on."

Gail Shea, the Member of the Legislative Assembly for the area, told the newspaper that she didn't know what was happening and they would have to ask Tom or his manager. Tom declined to be

interviewed and his manager, Brian Edwards, said there were no plans for the project beyond some vague conversations. He implied that the people leading the project were to blame, saying, "They just don't know what they're doing," but adding, "There's no hard feelings from our end."

That was all that was revealed publicly at the time, but behind the scenes the drama seemed to centre on the Aylward house. Tom owned the schoolhouse and much of the surrounding land but, according to a source familiar with the situation, the family home that sat on the property had become a point of contention for Tom. Apparently, Cora had left the home to Tom's adopted sister, Marlene, and she sold the house to someone outside the family, a man named Arthur Bernard, without first offering it to Tom. Cora had once said Tom would never own the Aylward home. Perhaps it was her wish that it not be offered to Tom. Whatever the reason, Tom and Marlene became estranged and they did not communicate for the rest of his life. She did not attend his funeral.

It appears that Tom pulled his support of the project because no one could secure the house as part of the development. The source said, "Tom got pissed off . . . because they were trying to deal with the government to get the fella that was in the house out . . . They were in dealings with him for years." Frustrated, Tom finally walked away and told Floyd Keefe to shut down the school. The source said, "I guess, probably hoping that would give the government more push to get something going. But . . . they had a hard time getting him out because, of course he wanted all this money for the house. Because he knew the government was buying." The entire project was temporarily abandoned and nothing would be developed on the site during Tom's lifetime.

In 2005, Tom released a songbook containing almost every song he had written, co-written or arranged up to that point. The book was called *250 Songs of Stompin' Tom*. Tom wrote in the introduction that people could now sing along while they listened to his music. He pointed out, "And of course the chords are there

also for anyone who sings and plays an instrument and wants to have a little fun. That's what a lot of these songs were written for; Having Fun. So Let's Party!"[12]

That year Tom was on the road again. As he approached his seventieth birthday, he didn't bring quite the energy to his performances that he had in his early years. A review from 2004 said, "he is beginning to slow down. He's shrinking a bit in stature, and is more inclined to fumble or forget lyrics."[13] The reviewer complained about the long sets played by Tom's band at the beginning of both acts. Many performers have an opening act, but few have them perform again before the second half of the show. Tom had done this pretty much since he returned to performing after his retirement, and a number of critics and fans complained about how little time they had with Stompin' Tom. Some reports said he played as little as half an hour in each act of the show.

During Tom's 2005 tour, he and his manager, Brian Edwards, arranged to have the show in Hamilton, Ontario, filmed live. The CBC had been expressing interest in airing a Stompin' Tom special for some time. Countless Canadian artists had appeared on the public broadcaster over the years, but other than his mid-1970s television series Tom had not. Connors and Edwards invested more than $200,000 in filming a high quality live concert film.

Tom, at sixty-nine, walks out on stage with his piece of plywood held high. The audience cheers as he throws it to the ground and launches into "Bud the Spud," as he always did. Early on someone shouts "Tillsonburg!" Tom growls, "Hey, hey, hey!" Then to the audience, "He's a plant." He turns back to the man and says, "When I'm done my show you can do yours, eh?" in a strong accent that has hints of Newfoundland, Cape Breton and PEI. It's an indeterminate East Coast mix and much stronger than what Tom actually talks with in interviews. The audience cheers as he launches into, "Tillsonburg."

Tom is stooped somewhat, and taps his foot as much as he

stomps, but he clearly loves performing and the crowd adores him. The bits between songs include bathroom humour, jokes about drinking and the song introductions he'd used for decades. In addition to the concert footage, the final film includes Tom talking about his life in a series of intimate interviews that are spread throughout. On stage, Tom is loud and funny and wears his black hat. In the interviews, he talks slowly, quietly and very thoughtfully, while wearing a straw cowboy hat. One feels that they are watching Stompin' Tom in performance and Tom Connors in the interviews.

When the special was assembled, Edwards sent it off to the CBC. He was told they'd consider it and get back to him soon. Two and a half months later, Edwards had still not received a reply. When he reached out to them, he was informed by email that the network was moving away from music and variety programming, so they would not be airing Tom's concert. They asked if Tom would like to perform a song on *Hockeyville* or perhaps be the subject of a *Life and Times* documentary.

Tom penned an open letter to the CBC, explaining that he and Edwards had created the special in good faith, assuming the CBC wanted it. "If this is not a complete snub to Stompin' Tom Connors by Canada's own Television Network then I'd like to know what is . . . In the last 40 years there have been many entertainers in this country, both known and not so well known, who have had Specials on the CBC. Some made money for the Network and a lot didn't. But as this would be my first Special ever, it strikes me as extremely odd that I would be turned down so unceremoniously. And without reason."

Tom pointed out that just the year before, "the CBC's own National Survey, 'The Greatest Canadian' rated Stompin' Tom as No. 13 overall, out of one hundred candidates from every walk of life, and No. 1 over all other musical entertainers." He continued writing about himself in the third person and listed the many awards he had won. Tom expected a certain level of respect based on his accomplishments. As long as he got that, he could play

humble. But when he didn't he was quite happy to sing his own praises. Tom finished the letter in no uncertain terms, writing "As far as I'm concerned, if the CBC, our own Public Network, will not reconsider their refusal to air a Stompin' Tom Special, they can take their wonderful offer of letting me sing a song as a guest on some other program, AND SHOVE IT."

For their part, the CBC said they had no agreement in place to air the special and therefore were not obligated to do so. A spokeswoman for the CBC said, "When we were told that a production was going ahead, we agreed to look at it upon completion . . . We reviewed it and made the decision not to purchase the show."[14]

CBC never did air Tom's concert. However, their competitor CTV purchased it and broadcast it the next summer. The program was so successful that it got a second airing in September of the same year. It was eventually released on DVD and went two times platinum, selling over 200,000 copies — more than any of Tom's albums. In the end, *Stompin' Tom in Live Concert* was a very successful venture. No doubt the public spat with the CBC didn't hurt.

Throughout his career Tom had a number of widely known controversies. He was quite litigious and sued or threatened to sue a number of people. He fought Bernie Bedore's family over who owned the rights to "Big Joe Mufferaw"; he began legal action against a PEI potato company called "Bud the Spud"; he sued Lulu's bar over a cancelled concert; and he threatened legal action against a man named Stompin' Tom Joyce who ran a company called Stompin' Tom's Lawn Care. Tom was extremely protective of both the name Stompin' Tom and any intellectual property that rightfully belonged to him.

In 2005, respected Canadian sculptor Joe Fafard created a sculpture of Tom riding a horse. Tom did not approve. Fafard, an officer of the Order of Canada, told CBC News, "I thought I was doing a very wonderful piece of Stompin' Tom, in the sense I was paying tribute to him. When I did get a reply . . . we were [told] to cease and desist and take the piece off the market."[15]

Tom Stewart, who managed Stompin' Tom Ltd., wrote to Fafard to say that Tom was "not satisfied with the likeness that is being portrayed of him, feeling that it is denigrating to what he stands for in this country." He also pointed out that Stompin' Tom had been trademarked and that Tom would not "grant his permission to allow the sale of such sculpture."

Fafard said, "He didn't even have a right to ask me to change the name, because if you do something of somebody that's what you have to call it. If I do Wayne Gretzky, I'm not going to call it Bobby Hull." He ended up calling the piece, "Nice Cowboy Hat!"

Fafard's art dealer pointed out that "Fafard, like Tom Connors, enjoys the same freedoms as an artist to be able to express the things that he sees in the world around him. I am not sure Tom Connors recognizes the irony there."

One project he did approve of was a play about his life. Playwright David Scott had read Tom's two autobiographies and thought they would work well on stage. He began writing to Tom, sharing his ideas for a theatrical version of Tom's life. He was given the go ahead to write a play incorporating Tom's songs. In 2006, *The Ballad of Stompin' Tom* premiered at the Blyth Festival in Blyth, Ontario. According to a post from Tom's now deleted website, "Like Stompin' Tom, the Blyth Festival creates stories about the real backbone of Canada; The men and women who work in the fields and factories, struggling to make ends meet when things don't go their way."

The show was staged as a concert with flashbacks offering glimpses into Tom's life. The first review in *The Globe and Mail* was less than glowing, offering the production just one and a half stars out of four. Reviewer Kamal Al-Solaylee wrote, "Despite the best intentions and even by the forgiving standards of summer theatre, *The Ballad of Stompin' Tom* is an outrageously superficial bio-drama and a poorly executed jukebox musical."[16] A bad review didn't matter, as the show was so successful that it was remounted the following year and by 2008 it was playing in three different

theatres in Canada. It has continued to be produced across the country.

Tom liked the show, but as he told Steve Fruitman during a 2008 radio interview, "I thought well, maybe the play was just lacking one thing."[17] He felt it would be stronger with a prologue of sorts. He suggested that the actor playing him "start off in semi-darkness just before the play begins and sing a song called 'The Ballad of Stompin Tom,'" which would recount his early years. Tom said he decided he'd write the song even though it meant he would have to "revisit my past and, you know, the odd tear had to get shed again. I had to do the same thing when I wrote the autobiographies. Nevertheless I waded my way through it and came up with a song about my life."

"The Ballad of Stompin' Tom" is one of Tom's most autobiographical songs and is no doubt the only one that allows his audience a glimpse of Tom Connors's broken heart. There are seven verses, separated by a pleading yodel that is the saddest sound Tom ever recorded. It is more a mournful cry of despair than a musical interlude. His mother is present in almost every verse as he recounts not only their time together, but being torn from her side and the nights he cried himself to sleep missing her. He sings of the day when, "the truth came like a knife, a drifter I would always be upon the roads of life." The orphan has now become the drifter, still wandering through life alone. He returns to his mother in the final verse, singing, "my song wasn't over yet, til I sang the ode for the road and the mom I can't forget."

An article in the *Alaska Highway News* discussed Tom's remarkable memory, which enabled him to "produce on demand any one of the thousands of songs he has learned and retained over the course of six decades."[18] Writer Eric Volmers points out that Tom's excellent memory also meant that "some of the darker memories he has of his childhood remain painfully clear, more than 65 years later." Tom told the interviewer, "It can be a curse. When you have to relive a lot of this stuff: being taken away from

my mother, being orphaned and all this stuff. I remember all that stuff and it's tough."

When Al Widmeyer first met Tom at his house in 2006 he asked Tom what his favourite song was. Tom replied that it was "Men with Broken Hearts" by Hank Williams. The number is less a song than a recitation with musical backing. Hank Williams could have been speaking of Tom when he wrote about "souls that live within the past where sorrow plays all parts." Tom would cover the song on his last album, *The Roads of Life*.

In *Maclean's* magazine, Alden Nowlan wrote of Tom, "The worst of his early recollections is of being forcibly separated from his mother by child welfare authorities."[19] In that interview Tom talked about the day he was taken from her. In the middle of the story he stops. Nowlan writes, "He is silent for a moment, his eyes half-closed. 'I don't think much about that,' he says," before composing himself and finishing.

Tom was clearly haunted by the loss of his mother for his entire life. At the risk of practising armchair psychology, it explains much of his behaviour. It's no wonder that the little boy who cried himself to sleep at night would later avoid sleep. It makes sense that he drank beer all day to help numb the pain. It explains why, when he was away from home and the love of his wife, he would insist that someone stay awake with him until he was ready to sleep.

Dave Gunning came to realize, "Tom was a very private guy, but he wanted people close to him with him. He didn't want to be alone. On the road his family would be the band. He wanted his family with him. He wanted his band and crew with him late at night. He didn't want to be alone."

Well into his seventies Tom did not want to lie in bed, remembering his past, waiting for sleep to come. He chose to drink himself to sleep with someone nearby who promised to stay with him through the night, even if that person was there because Tom had made them sign a contract.

"The Ballad of Stompin' Tom," completed the myth. After

immortalizing Big Joe Mufferaw, Bud the Spud, and Luke with his guitar, Stompin' Tom joined their ranks. The song not only became part of the stage production, but Tom also recorded it and made it the title track of his next album.

In January of 2007 Tom's mother, Isabel, died at the age of eighty-nine. This was around the time Tom wrote "The Ballad of Stompin' Tom." Although they had never become terribly close again, they did stay in touch and when she died he arranged to get her ashes, which he kept with him for the rest of his life.

In 2007, Tom's *Bud the Spud and Other Favourites*, which had been released in 1969, received another honour when it was included in Bob Mersereau's book, *The Top 100 Canadian Albums*. The recording held the eighty-second spot on the list. In the entry Mersereau writes, "Stompin' Tom's songs aren't complicated, they have funny lyrics, and his singing voice is as gruff as his exterior. Yet every Canadian knows them."[20] Music writer Bruce Mowat adds, "Connors is our greatest folk artist, comparable to Woody Guthrie, with one major difference. I can't listen to Guthrie (he's boring, see), but I can listen to Tom."

The Juno Awards had been hoping to bring Tom back into the fold for years — in part because they wanted to give him a Lifetime Achievement Award. Tom agreed to meet and talk with them in 2007. Three board members of CARAS, the organization responsible for the awards, went to his house for a typical Stompin' Tom meeting. It lasted late into the night and involved beer. The three board members were the head of CARAS, Melanie Berry, Blue Rodeo frontman, Jim Cuddy and the head of Tom's record label, Deane Cameron, the man who had signed Tom when he returned to music in 1989.

According to a story by Brad Wheeler in *The Globe and Mail*, Tom was prepared for the meeting and had a list of six proposals that he thought would make the Junos more supportive of Canadian artists. *The Globe and Mail* listed those six suggestions as:

- An international Juno, to be awarded annually to one Canadian artist who neither lived nor worked in "this musical community." Such artists would not be eligible for any other Junos.

- A three-Juno limit for artists in any one category. It was Connors's belief that by taking perennial winners out of the mix, up-and-coming artists would stand a better chance of being honoured.

- A "tangible prize," involving cash, promotional support or studio time. "As an incentive to the competitors to keep them working in this musical community," Connors wrote.

- Public encouragement. It was Connors's notion that the "tone" of the Junos should be more supportive and patriotic. As he explained, "Losing our talent to the benefit of the United States or any other country doesn't do a damn thing for this country or anybody in it."

- Open venues, where the public could hear, see and meet the award winners, who should, Connors believed, avail themselves to the people. "If Wayne Gretzky, Don Cherry and others of their ilk can do it for hockey and its respective fan base around the country," Connors wondered, "why can't the Juno Academy in tandem with radio, television or other people in the music industry create opportunities for all and publicize it to all?"

- Recognition of unsung heroes, geared towards regional artists and local boosters.[21]

Tom said that if they adopted just one of his proposals he would accept the Lifetime Achievement Award. Tom Jr. was quoted in the

piece, saying that CARAS didn't adopt any of them and Tom never heard from them again. Cameron said that wasn't the case. "We went through them one by one that night, and the suggestions were discussed thoroughly at the subsequent board meetings," he said. "The unsung hero idea was one in particular that we chewed over pretty good." Ultimately they decided that CARAS was already doing some of things in the list and the others were not in their mandate. Tom's feud with the Junos continued.

Tom's second last CD of original material, *The Ballad of Stompin' Tom*, was released in 2008. It contained the title track and a new version of "The Hockey Song," because Tom thought the original sounded a little "too thin." Hoping to capitalize on the success of that song, he included another hockey themed tune called "My Hockey Mom (Tribute)." Unfortunately, it did not become a hit. As a tribute to his recently deceased mother, he included her favourite song, "Cowboy's Broken Ring."

Tom was asked to open the NHL awards at Toronto's Elgin Theatre on June 12, 2008, with "The Hockey Song." Tom called up a few of the guys who had played in his band and asked them to play at the ceremony with him. He invited them to the house for a rehearsal. Al Widmeyer, who was one of the band members, thought it was odd because they had all played the song countless times and Tom didn't usually rehearse. According to Al, they gathered at Tom's house and after running through the song twice, Tom said, "Okay, boys, that's enough rehearsing. Let's get to the bar," meaning the bar in his house. Widmeyer said, "And that was it. He just basically wanted us out there to party with him. So we just hung out and stayed overnight."

Even people who didn't normally drink would when they were with Tom. At a 2015 tribute to Tom, Gordon Lightfoot told of being "on the wagon for 23 years" when he went to spend an afternoon with Tom. He said, "I'm out at Stompin' Tom's and I swear to God, I had the same (amount of beer) as Stompin' Tom in this very special — what would you call it, a living room — with

a private bar, powder room, a pool table and a jukebox with 2,500 digital selections on it. When I walked in, he played about five of my songs on this jukebox, right off the bat."[22]

Tom's partying was legendary. As Widmeyer said in an interview, "Not too many people could drink him under the table, let's put it that way. People have tried." Steve Fruitman said in an interview, "He always had a beer going . . . He'd take about 15 or 20 minutes to nurse a beer. When he had about an eighth of the beer left at the bottom of the bottle then another beer would come out." Mickey Andrews said, "I swear he had to drink at least 24 beer a day . . . The beer didn't affect him. He drank it like it was water or a bottle of pepsi. He would have that bottle of beer between his legs driving down the highway."

Tom rarely drank on stage, however, he had a regular bit in his shows where he poured himself a drink, set the glass down and then took a big swig directly from the jug. The implication was that it was booze, but it was actually water. Andrews said, despite Tom's tolerance for beer, "He couldn't drink hard liquor." He went on, "This is not a criticism, but if he drank hard liquor it was no good for him. It didn't work for him. He could get rude . . . but he could drink beer til the cows come home." Dave Gunning agreed saying, "If he got into the Crown Royal — he was a different person. The devil came out."

In addition to the ever-present beer, Tom also always had a cigarette on the go. As smoking started to become banned in public places in the late 1990s and early 2000s, Tom was reluctant to go out to bars and would sometimes skip public events.

A *Canadian Press* story from 2009 had the headline, "Stompin' Tom Stompin' Mad About Smoking Laws."[23] While discussing how difficult it was to find a place to smoke, Tom told the reporter, "If anything makes me stop touring, it'll be that. I can't smoke in a hotel, and I can't go to a restaurant 'cause I can't smoke there, and you can't smoke in the venues . . . and I don't know what the hell is going on and I'm a chain smoker so it's gonna drive me mad."

He added that he smoked about 108 cigarettes a day, and that "It's really uncomfortable to be a chain smoker and not be allowed to smoke anywhere."

While Tom smoked and drank to excess, he ate very little. He told Pierre Pascau that he normally ate just one meal a day. When Pierre asked why, he said, "I never was used to eating when I was on the road in the rough times. I still enjoy opening a can of sardines or something or a can of beans once in a while. I don't know, I eat very meagerly."[24] As Tim Hus wrote of Tom on his website, "I have never met anybody else who can go longer without sleep, eat less, or drink and smoke more than Stompin' Tom."[25] Hus, who toured with Tom in 2009 and 2010, added, "What makes it all that much more remarkable is that he is going on 75 years old!"

In 2008 Tom received word of another honour, which would be one of his proudest achievements. Canada Post announced that he was one of four musicians who would be featured on a 54 cent stamp as part of its Canadian Recording Artist Series. The stamps would be issued on July 2, 2009. The other three artists in this group were Bryan Adams, Edith Butler and Robert Charlebois. Tom told Bob Mersereau, "When the announcement came out that I was going to be elected, well, hey, I had to have a couple of beers right away. A lot of people can get a Juno, but not too many can get a stamp . . . I know Anne Murray and Gordon Lightfoot got one, I think it was about a couple of years ago they got a stamp. I never suspected in God's little acre that I'd ever be selected for one, because that's the way it goes. I don't know, these things happen sometimes and you don't expect them."[26] Tom told Greg Quill that the stamp was "almost better than a medal, because it's more visible."[27]

Tom's last cross-Canada tour took place over the course of two years. In 2009, he toured Eastern Canada, from Ontario to Newfoundland, while the next year he covered the west, going from Ontario to Vancouver. In 2011 he undertook a small eight city tour, primarily in Ontario.

Tom's last show on Prince Edward Island took place in Summerside on July 25, 2009. In the audience that night was Freda Keefe, who was celebrating her ninety-fifth birthday. She was accompanied by her entire family and they all got a backstage pass to see Tom before the show. According to her granddaughter, Pauline Arsenault, "He sang 'Happy Birthday' to my grandmother and she was up dancing when he was singing to her. It was so touching." She added, "He was soft hearted. I'm sure that night there was tears in his eyes when he saw my grandmother. You could tell he was choking up."

While Tom toured into his seventies, he was no longer able to stomp all night long. Al Widmeyer said, "If you went to a Stompin' Tom show, you know, back in the old days, he would stomp on every song. Not just on one or two. He'd stomp on all the songs. And right through. Well, it was getting to the point you know, I mean, he was getting older. His knees were starting to get older." The stomping was harder than it looked. Duncan Fremlin wrote in *My Good Times with Stompin' Tom*, "I tried to stomp my foot through an entire song one time, like Tom did night after night, and I simply could not do it. Not only did my leg tire quickly and the bottom of my foot begin to ache, but I couldn't stomp in time."[28]

Before his 2009 tour, Tom invited Steve Fruitman and Tim Hadley to his place for the evening. Fruitman said that Tom said to them, "I don't know, boys. You know, this stompin' thing, it's getting harder and harder to do every year. They expect me to stand up in front of the audience every night and just stomp my foot. It's not so easy to do, but if I don't do it people will say 'What the hell? I came to see Stompin' Tom and he didn't stomp!'" He said in an interview for his 2005 Live Concert, "if they'll forgive me for less stompin' and all that I'll probably be there til I'm a hundred."[29]

Dave Gunning felt that Tom sometimes got tired of being Stompin' Tom. He said, "He was tired of it at times . . . mentally and physically. Like physically, he said, 'You know, Dave, I'm get-

ting too old to be stomping.' He would get tired out. He would get winded... I think Stompin' Tom wore him out at times... because he had to be this character. He was almost a caricature of himself at times. And sometimes his novelty sounding songs overshadowed his incredibly well written songs like "The Bridge Came Tumbling Down." Or "Songbird Valley." That man has written some of the greatest Canadian songs ever and yet people still think of him as this caricature and everything he did was funny."

Steve was aware of this too and suggested to Tom, "Why don't you sit on a chair for a few songs and just play those old country songs? You can take a rest." Tom replied, "Oh, no, that wouldn't work." Steve pointed out that Johnny Cash was doing this, but Tom, being predisposed to disliking any idea that wasn't his, just dismissed him. Then, to Steve's surprise, "The next tour he starts sitting down and singing three or four Hank Snow songs." About halfway through his set Tom would sit on a stool, play guitar and sing some of those old country songs that had inspired him as a child, those songs that his mother loved and would sing along to.

Widmeyer said, "He wanted the people to know he could play guitar... People would say, 'Geez, I didn't know Tom could pick like that!' Well, yeah, he could play the guitar. He could pick the guitar." He added, "He wanted his audience to get to know him a little bit better. You know, that he's not just the guy that stands up there and stomps... and he'd sit there and have a conversation."

After more than four decades as a performer, Tom was letting go of Stompin' Tom for a few minutes every night and letting the audience see Tom Connors, the musician and singer; the man who would jam late into the night in motel rooms or in his bar at home. Tom finished that section of the show by singing, "The Ballad of Stompin' Tom."

Widmeyer marvelled at how the audience responded to the song. He said, "Well, every time he did 'The Ballad of Stompin' Tom,' it didn't matter where it was, he always got a standing ovation. Every time. Every time." He added, "And it's really weird.

Some of these concerts were, there's thousands of people sitting out there, and all of a sudden when he finished that song people would automatically stand up and give him a standing ovation. Oh, yeah. Tom was crying. He had tears coming to his eyes. It was emotional. He was a very emotional man."

The audience would have been aware that they were watching a legend near the end of his career. That nightly standing ovation would have been as much for the man and his career as it was for the song. And Tom's tears were no doubt a result of reliving the separation from his mother, but also knowing that he was more than just the "boots and the board."

Mickey Andrews was on Tom's last tour and witnessed his old friend slowing down. He said, "Now his last tour, he sort of had a tall stool that he would sit back and lean on because he was uh..." At this point Mickey pauses, sounding emotional and trying to think of the right words, before adding, "See, he would have to be sick even doing that last tour. If I look back at it now."

In 2012, Tom talked publicly about suffering from Chronic Fatigue Syndrome. Brian Edwards said in a 2013 interview that Connors told him he had been suffering from the illness since about 2009.[30] Despite age and illness starting to catch up with him, Andrews said that Tom managed to keep going because of his audience. He said, "I think when you're doing something really good, you draw energy, it builds you [up] and it makes you really perform."

From the time Tom started touring again in 1990, he had been auctioning off a stomping board on each tour with the proceeds going to various charities. The first board went for $1,050, with the money donated to Toronto's Sick Kids Hospital. On each tour the board went for a bit more money. The board from his last tour was auctioned off in Orillia in 2011 and sold for an impressive $15,000. The funds went to Orillia's Key Program, which helped the homeless and mentally ill. Tom felt it was a very worthy cause, saying, "I understand what it is like to go five days in a row without a meal." After nine performances in eight different locations, Tom's 2011

tour came to a close. His last public performance was on Saturday, July 16, 2011, in Kingsville, Ontario.

Despite his declining health, Tom recorded eleven albums worth of material in 2012. In addition to *The Roads of Life*, which would be the last release during his lifetime, he recorded another ten albums of traditional country songs. Steve Fruitman said the fact that Tom recorded so many albums all at once made him think that Tom knew he was sick. When Universal Music released the first batch of songs from the recordings, their accompanying press release stated that Tom had recorded the songs "as a safeguard against the possibility that he should at some point find himself unable to continue in the studio."[31]

*The Roads of Life* was a departure from most of his other albums in that only four of the seventeen tracks were new songs written by Tom. The other thirteen were either traditional tunes or classic country. He even allowed himself to record a few of those "Nashville songs," by artists like Bob Wills and Hank Williams. There were also a couple of instrumental numbers where he could show off his guitar picking.

Bob Mersereau wrote, "You gotta love Stompin' Tom. Still doing it, still making new albums, and you can tell his heart is in it."[32] He goes on to say, "There's absolutely nothing polished or fancy on this album. It's some decent musicians at best, gamely hanging on to the tempo, with a singer who is an acquired taste. Of course, we acquired that taste long ago, so it's always a joy to hear Connors have another go at it. Plus, he has something no one else has, that amazing personality."

Tom had hoped to tour in order to support the album, but he was unable to because of his illness. Steve Fruitman contacted him in August, when the album was released, to see if he wanted to do an interview. According to Steve, Tom told him, "Well, you know, I'm pretty tired right now. I'm still in recovery . . . so could we hold off for a few months?" Fruitman said this "was very unlike Tom, because if he had something to publicize he wanted to get it out

right away. He was very adept at publicity. There was definitely something wrong with him but I had no idea what it was."

Steve called Tom again in November. Tom was open to the interview, but said, "Well, I can do it, but not an hour this time. Maybe half an hour and maybe at certain times you can play a couple of songs in a row so I can go to the washroom." Fruitman, who usually had hour-long interviews with Tom, said, "I knew something was wrong because he never would say anything like that previously . . . I had no idea that he was that sick."

On December 19, 2012, Tom called in to Steve's *Back to the Sugar Camp* radio show. It would be his last interview. Tom and Steve talked about *The Roads of Life* as well as the 120 songs he recorded for ten future albums. The 120 old-time songs harkened back to the two five-album sets of traditional country music he had recorded in the early 1970s. It was just Tom and his guitar — the Gibson Southern Jumbo guitar he had bought in the United States years before.

Al Widmeyer said the guitar was a point of contention between him and Tom. He said, "Him and I had arguments on that Gibson guitar . . . We had arguments on that. You wouldn't believe the arguments! He said it was made in 1901 or 1913. I said, 'No, Tom. It's not. It was made in the '40s.'" When Tom asked how Al would know, Al responded, "Well, I know guitars. And they were built during the war. There was no steel. That's why that neck is so round. There's no metal in that neck." Widmeyer said, "Tom liked arguing. He wanted to argue. He loved to argue, but he was never wrong. Some of us are like that, right?"

Richard Flohil said, "I really liked Tom but he was contrary, he was bloody minded. He was the sort of guy that once his mind is made up, facts and logic are not allowed to interfere with the conclusion he's already made." It was this stubborn nature that enabled Tom to record almost 140 songs in a three-month period while he was obviously sick.

During his last interview with Steve Fruitman, he said, "I think I kinda overdone it. I didn't stop. I just kept pushing myself and

as a result I've had a little bit of an illness."[33] He told Steve about suffering from "the fatigue syndrome," as he called it. He added, "If I'd have taken some rest in between I mighta been okay. You know, at 76 years old I should have known enough to . . . I mighta burnt myself out a little." He added, "I mean I feel pretty good. It's just that I don't have the pep that I had before . . . It stays with some people for like you know, a year, and other people a few months. So as soon as it passes I'll probably be out there again."

Steve asked Tom if he'd had any idea, when he walked into the Maple Leaf Tavern forty-eight years before, that he'd have the career he'd had. Tom responded, "I never dreamed that when I walked in there with patches on my pants and not enough to buy a meal or anything . . . I was right on my last legs . . . I never dreamed that today I'd be sitting with the Order of Canada and three doctorates and a stamp in my honour. I don't know how many different awards and keys to cities and all these kinds of things." Thinking back over his life, Tom added, "It's just been an amazing, amazing trip. A miraculous trip."

Tom knew his life was coming to a close, but he refused medical treatment. He had a longstanding mistrust of Western medicine since he'd cured his own ulcers back in the 1960s. It's also doubtful that he would have wanted to spend time in a hospital, hooked up to machines and receiving treatments, unable to drink or smoke. Tom decided his end was near and he'd go out his own way.

Tom told very few people he was dying, but his friends who saw him in his last weeks could tell. Mickey Andrews went to visit Tom in late January of 2013. Before the visit, Mickey thought they would be touring together again that coming summer. Andrews was an artist and had done a painting of Tom that he wanted to give him. He said, "I brought it up to him. That's the first time he found out that I was an artist. And he really was taken aback." Andrews was also taken aback. He was shocked at how sick Tom looked. Andrews said, "When I saw him, he'd lost 61 pounds. The first thing I said to him, I said, 'Tom, have

you got cancer? What's going on here?' Like he looked skeletal. Like I've seen lots of cancer people. What happens [is] you lose all this weight. You get a certain look. Very gaunt. And he said, 'No, I was talking to my doctor.'" Tom offered no more than that. Andrews added, "He did not tell me that he was dying . . . he was dead within six weeks."

Al Widmeyer saw Tom on his last birthday, February 9, 2013. "He wanted me to sing a couple of songs for him," Widmeyer says. "He was sitting by his jukebox. And I knew he was sick. He was still drinking though. He was still drinking and smoking and carrying on, you know." Al said that, considering Tom's health, he thought it best not to stay late, but Tom didn't want the party to end. "Usually we'd stay til daylight you know. I wanted to leave early and he did his normal thing of 'Where ya going? What are ya, a wimp or something?'" On his way out the door Al said, "I'll see you next time, Tom," to which Tom replied, "Yuh, okay." Both men knew they would probably not see each other again.

Al wanted to reach out to the other band members to tell them that Tom wasn't doing well, but he knew Tom would be upset with him. He said, "They're a real private family. I wanted to call up all the band guys . . . and say 'You better go see Tom because you might not see him . . . he's not in good shape.' But if I'd have done that and people started calling, and they said 'Al Widmeyer called,' I woulda got the devil. That's not my business. So I didn't. I didn't tell anybody."

Tom wanted to plan his own funeral and memorial service. Mike Dunlop wrote, "The news that Tom wasn't doing well came to me by phone call. I had to make a promise that this news would remain hush, hush . . . I was told that it wasn't looking good and we needed to start the 'planning' on how we would be making this news go public when the time came."[34] He started working with the family on web graphics as well as the brochure for the future memorial service, among other things.

Tom's friend and long-time manager, Brian Edwards, was called to the house two weeks before Tom died. He said:

> *What prepared me for it more than anything was his attitude towards the whole thing. You go to sit down with somebody, very rarely, do they start working out funeral arrangements. He helped me prepare. I was in the middle of talking to a guy that knew exactly what he wanted and had his wits about him, that certainly helps. He had an attitude, 'I have no problem with dying. Don't you sweat it 'cause everything's going to be fine.' I found it very uplifting. I left my house thinking I was going to be on my hands and knees and I left [his house] with a totally different attitude completely.*[35]

Brian last spoke to Tom on Friday, March 1. He told the CBC that Tom was still "sharp" mentally, that day, but he sounded very tired.[36] A few days later Tom slipped into unconsciousness, and around 5 p.m. on Wednesday, March 6, Tom Connors died at home, surrounded by family.

Mike Dunlop uploaded the news of Tom's death to his official website. It read: "We must regretfully announce today the passing of the Great and Patriotic Stompin' Tom Connors. He died this March 6th 2013 with his Family seeing him off. His family have given us a message from Tom that he wanted passed along to all of you upon his death."

Tom had written a letter to the people of Canada as his final farewell.

*Hello friends,*

*I want all my fans, past, present, or future, to know that without you, there would have not been any Stompin' Tom.*

*It was a long hard bumpy road, but this great country kept me inspired with its beauty, character, and spirit, driving me to keep marching on and devoted to sing about its people and places that make Canada the greatest country in the world.*

*I must now pass the torch, to all of you, to help keep the Maple Leaf flying high, and be the Patriot Canada needs now and in the future.*

*I humbly thank you all, one last time, for allowing me in your homes, I hope I continue to bring a little bit of cheer into your lives from the work I have done.*

*Sincerely,*
*Your Friend always,*
*Stompin' Tom Connors*

There was a full press release attached, and at the bottom of the page was a black and white photo of Tom on stage, waving goodbye to the audience. The press release said that Tom had died of "natural causes," although the family would later say the cause of death was renal failure. In lieu of flowers, it was asked that people make donations to food banks or homeless shelters, in memory of Stompin' Tom. It was also announced that there would be a "Celebration of Tom's life," at the Peterborough Memorial Centre, an arena that seated approximately 3,600 people, on Wednesday, March 13. It was fitting that the man known for "The Hockey Song" would have his public send off in a hockey rink. Peterborough was the location, because it was where Tom Connors had become Stompin' Tom.

As soon as the news went public, the internet exploded. Prime Minister Stephen Harper was among the first to tweet about Tom's death, writing: "We have lost a true Canadian original. R.I.P. Stompin' Tom Connors. You played the best game that could be played." k.d. lang released a statement saying, "Stompin' Tom was dedicated to documenting life in Canada in a way that was unapologetic, uncontrived and uncompromisingly Canadian. We owe him our pride and respect."

At the Air Canada Centre in Toronto that night, the Maple Leafs were playing the Ottawa Senators. These two teams were largely responsible for giving "The Hockey Song" its second life and turning it into a folk anthem. A graphic featuring Tom's face as well as the dates of his life appeared on the giant scoreboard over centre ice as it was announced that Tom had passed away. Many of the 20,000 fans in attendance took to their feet as "The Hockey Song" was played.

The next day, in the foyer of the House of Commons, Member of Parliament Charlie Angus, formerly of the band Grievous Angels who had made Tom's music popular in Toronto's bar scene in the late 1980s, played guitar and led a singalong of "Bud the Spud." He was joined by fellow MP Andrew Cash and a number of other members of the NDP. On Saturday, March 9, *Hockey Night in Canada* opened its broadcast with a tribute to Connors.

Before his death Tom had planned three services. There was his official funeral, which was held at Highland Park Funeral Centre in Peterborough, Ontario, on Tuesday, March 12. This was followed by the public "celebration of life" on March 13 and then, about two weeks later, his interment at the Erin Cemetery in Erin, Ontario.

The private memorial was attended by members of Tom's family, former bandmates and special guests such as Adrienne Clarkson and Laureen Harper, wife of Prime Minister Stephen Harper. Mrs. Harper presented Tom's family with the Canadian flag that had been flying over Parliament Hill at the time of his death.

The funeral home was licensed, and the bar opened at three, with the service beginning at five. There was wine as well as beer, both warm and cold. Dave Gunning said, "During the funeral service people would put their beer down to pray. And you'd see people tipping them up all during the service."

The minister spoke, then said he was going to play a song that Tom wanted everyone to hear. The funeral home was filled with Tom's voice intoning his favourite song, Hank Williams's "Men with Broken Hearts." Many in the crowd broke down in tears as Tom sang, "You'll meet many just like me, along life's busy street, With shoulders stooped and heads bowed low and eyes that stare in defeat. Where souls that live within the past, where sorrow plays all parts, Where a living death is all that's left for men with broken hearts."

The day of Tom's celebration of life was cold and snowy, an appropriate backdrop for a farewell to a Canadian icon. The parking lot was filled with fans from across the country. A bagpiper wandered the parking lot and there were tailgate parties where Tom's music could be heard. One fan covered his van in Canadian flags, wrote "Rest In Peace Stompin' Tom, 1936–2013" on the side of the vehicle and encouraged others to sign it. In a photograph shared online, a man wearing a cowboy hat can be seen sitting in one of the back seats.

A long line snaked in front of the Peterborough Memorial Centre more than an hour and a half before the doors opened. Over 3,000 fans gathered inside and had their choice whether to be in the licensed or unlicensed section of the arena.

The ceremony kicked off with "O Canada," led by a choir called the Peterborough Pop Ensemble. Tom's coffin, draped in a Canadian flag, was brought on stage by a group of RCMP pallbearers as Billy MacInnis, who had toured with Tom for years, played the fiddle. Tom's other former band members on stage that night were Mickey Andrews, Tim Hadley, Tim Hus, Mark LaForme and Al Widmeyer.

The crowd cheered, but grew silent as Lena entered, carrying Tom's black cowboy hat, which she placed on top of his coffin. Next to the coffin was Tom's Gibson guitar and his Order of Canada medal. A stomped-on piece of plywood leaned against the coffin. Brian Edwards was the host for the celebration, which was streamed live online. There were speeches from Deane Cameron, Adrienne Clarkson, Ken Dryden and others.

Sylvia Tyson, who sang "Farewell to Nova Scotia" with Cindy Church, said, "Tom Connors was a man of strong opinions with a unique way of expressing them. He didn't mince words. He was a people's poet, a voice for those who never found words to express themselves." Tim Hus performed his tribute to Tom, called "Man with the Black Hat." Mike Plume sang a song he had written in the days after Tom's passing, "So Long, Stompin' Tom," and there were other musical performances from Dave Gunning, J.P. Cormier, Mark LaForme and Dave Bidini.

Ken Dryden later wrote in the liner notes for one of Tom's posthumous CD releases, "During the concert, when a town-name was mentioned, from one darkened part of the arena or another there would be a cheer. That was their town; they had come. Tillsonburg, Sudbury, even Skinner's Pond itself. From mines and fields, bars and hockey rinks they had come — more cheers. From love and life gone bad; above all, from a gritty, unabashed pride in Canada. They had all come."[37]

Near the end of the evening Tom's coffin was taken off stage and loaded into a hearse. Brian Edwards told the assembled crowd that Tom had warned him, "Edwards if you leave them on a down note I'm gonna come back and kick your arse." With that, the special guests and performers ended the evening with the song that Tom sang to end every show, "Sudbury Saturday Night." The crowd dispersed to drive home through the snow, with Tom's music ringing in their ears.

Two weeks later, Tom's immediate family and a few close friends gathered at his gravesite. Interments usually happen later

in the spring or early summer, but the ground had been heated so Tom could be put in his final resting place. Mickey Andrews was one of the pallbearers that day. He was surprised to see something placed on top of the coffin before it was lowered into the ground. He later said in an interview, "You know what it was? It was his mother's ashes."

Tom had chosen to end his life as it began. To quote from "The Ballad of Stompin' Tom," once again it would be "just my mom and me." Mickey said, "It took him a long time to get back to his mother." When the tombstone was placed on Tom's gravesite a year later, underneath his name was his mother's. And there, carved in stone, were the words, "Together at Last."

# Epilogue

And it doesn't matter, really where you're from,
You can spread the word around;
Wherever you find a heart that's kind,
You're in a part of my Stompin' grounds.

— "My Stompin' Grounds"

The level of respect for Tom and his music seemed to increase significantly with his death. Alden Nowlan had written in 1972 that "purists tend to respect folk music only after it's dead."[1] In the days and weeks after his death, newspaper, television, radio and online tributes called Tom an icon, a legend, a hero and Canada's national troubadour, while *Maclean's* dubbed him "our national poet."[2]

The 2013 East Coast Music Awards, which were held on March 10, included a video tribute to Tom. Per his wishes, the Junos, which were held the next month, did not honour him. He was, however, mentioned that night when k.d. lang was inducted into the Canadian Music Hall of Fame. She famously said, "I think the fact I'm standing here receiving this award actually says more about Canada than it does about me. Because only in Canada could there be such a freak as k.d. lang receiving this award. Only in Canada could there be people like Stompin' Tom Connors and Rita MacNeil." MacNeil had died just four days before the show.

That spring, Tom also had one last hit single when "The Hockey Song" climbed the charts, hitting number twenty-nine on the Canadian Hot 100.

It was more than a year later before a tombstone was finally added to Tom's unmarked grave. Mike Dunlop worked with Lena and Tom Jr. to design what Tom had envisioned. The tombstone is quite elaborate, offering clues to the things that were most important to him.

Although Tom was born Charles Thomas Connors, his name is engraved as Thomas Charles Connors. In much the same way that he christened himself Stompin' Tom, he also chose the name he would adopt in real life. The stone features a carving of Tom, his guitar slung over his shoulder, imposed over a map of Canada. The right side of the stone is a large chess piece, a nod to the game he loved so much, topped with a maple leaf that has "101" carved into it.

Writer Phil Gravelle interviewed Tom Jr. about the tombstone for a story in the *Erin Advocate*. Tom Jr. explained that the 101 did not represent the number itself, but rather a philosophy that Tom had about life. Gravelle wrote, "Instead of competing to be at the top on a 1 to 10 scale, he favoured zero as an ideal at the centre of the range of possibilities."[3] Tom Jr. said of his father, "He would always say he's a zero, because you can go on the plus, or you can go on the minus, but the zero keeps you even. Don't drift too far away off the centre because you'll become unbalanced."

Tom explained his theory to Dave Gunning during one of their all-night drinking sessions on tour. He asked Dave how he would rate himself on a scale of one to ten. Gunning replied that he thought he might be average. Tom said, "What if I was to tell you you're zero? What if I was to say to you we're all zeroes? We're all nothing? We're all the same?" Gunning explains, "He had this belief that . . . if we believed we were nothing we create this energy around us where nothing feels threatened by us. And he said, 'That's the secret of Stompin' Tom. I'm the lowest com-

mon denominator. That's why you see all people in the crowds, because I'm not trying to be anything . . . and as soon as we can understand this good things will start happening to us. When I realized I was nothing and started approaching things with this philosophy that's when things started going well for me.'"

Gunning took Tom's philosophy to heart, saying, "I feel grateful that I got so close to him. I don't take it for granted. It was really the experience of a lifetime. It made me a better person. I think it made me a better artist. I approached life and my music career differently. I became more brave and confident to be a zero . . . I feel that Tom helped me figure out the secret to life a little bit."

One has to wonder if this 101 number was part of the "series of vocal sounds and numbers" that popped into Tom's head years before, which he claimed enabled him to read the scriptures in a new way. In *The Connors Tone*, Tom said that he hoped to one day write a book about this code, but that book never came to be. Steve Fruitman said that at the time of his death Tom had been working on a book of philosophy. He added, "I'm sure he would have put it out as Tom Connors, with his law degrees afterward. He wouldn't have called himself Stompin' Tom." Gunning, too, was aware that Tom was working on a philosophy book before he passed away and that he planned to release it as Tom Connors.

Tom's tombstone also includes a quote from the book of Genesis, "And Enoch walked with God: and he was not; for God took him." Tom ended the second volume of his autobiography with this same bit of scripture. Gravelle wrote, "Enoch was a patriarch, the great-grandfather of Noah, who is believed to have been taken directly to live with God, without having died. Tom Jr. said his father read the bible frequently and considered that passage an example of becoming closer to zero."

Tom believed in reincarnation, once telling a reporter, "I don't think anybody should die happy. I think people should die without their dreams being fulfilled so maybe they can have an excuse for

coming around again." He wrote a poem, supporting that idea, which appears on his gravestone. It reads:

> *The body has returned to sod,*
> *The spirit has returned to God.*
> *So on this spot, no need for grief,*
> *Here only lies a fallen leaf.*
> *Until new blossoms form in time,*
> *The tree is where I now reside.*
> *But with this poem, as you can see,*
> *They haven't heard the last of me.*

Tom Jr. explained Tom's philosophy to Gravelle, speaking of his father in the present tense, "He believes that we come and go as a spirit. We enter a body this time around, and when the body's done, then the spirit goes back to the tree of life, so to speak, and then the tree blossoms again the next year and you become a new leaf. It's a cycle of life that he's getting at."

Tom's tombstone reveals a spiritual side of Tom that he rarely shared publicly. After his death, John Farrington told the *Peterborough Examiner*, "He didn't go to church and he wasn't a religious man, but he was spiritual. He believed in a creator, and that our lives were destined from birth to death. He didn't believe you could get an edge up on anyone by going to church or saying prayers."[4]

Dave Gunning also got to know Tom's spiritual side. Tom said to him, "I don't believe in God, I know God." Gunning said that Tom studied "every religion he could get his hands on" and that he ultimately concluded that "everybody believes the same thing, but they just don't know they do." Gunning continued, "He said all religions came from the same place in the beginning, but stories and language and linguistics got in the way. And people take things too literally now. He felt strongly that all these different religions and beliefs all came from the same source in the beginning . . . because he found commonalities in every religion he was studying."

# Epilogue

The text under Tom's name on the tombstone reads, "Arrived February 9, 1936, Departed March 6, 2013," implying his spirit had simply visited earth for a while. The stone also includes the lyrics to "I Am the Wind," Tom's favourite of his own songs, as well as his mother's name and birth and death dates. Not surprisingly, there is a flagpole near his tombstone with the Canadian flag flying over his grave.

In addition to the philosophy book that Tom left uncompleted, he told the *Canadian Press* in 2009 that he had approximately two hundred songs that had never been recorded. "The record company that I'm signed to, EMI, they only require a new album every couple years," he said. "They can't put them out faster than that. So I mean, I've got probably a couple hundred songs that I could record tomorrow."[5] It's unclear what happened to those songs after his death.

Tom also left behind the 120 traditional country songs that he recorded in the year before his death. In April of 2014, Universal Music released the first of these recordings on a CD called *Songs from the Vault Collection Vol.1*. That year the *Live Concert* soundtrack from his 2005 Hamilton concert special was also released. The second volume of *Songs from the Vault* came out in June 2015. A press release accompanying volume two stated that when Tom made the recordings, he "envisioned a 10 album set, drawn from a selection of old songs that formed the basis of his repertoire when he first began performing in the '50s. This was back when he could sing, from memory, over 2,500 songs and long before he wrote many of his own hits we all know today."[6]

Tom had gone through a period in the 1970s when he was widely perceived as a hokey country singer, but like many artists who stay true to themselves and their roots — people like Johnny Cash, Tony Bennett and Dolly Parton — the pendulum often swings back and they become "cool" again. As Glen Nott wrote in 1999, "The Tony Bennetts of the world get to hang around forever because at some point, the 'kids love him' again."[7] Tom

had become so cool that a punk tribute album to his music, called *Stomp On Wood*, was released in 1994. After Tom's death, Michael Barclay wrote in *Maclean's* that Tom was "more punk rock than 99 per cent of musicians using that term."[8]

Dave Bidini of the Rheostatics and k.d. lang, who both had a fairly high cool quotient, were big fans. A big part of being "cool," is simply being true to oneself. Bidini felt Tom had that in spades. In an interview for this book, he described what set Tom apart: "There's that fearlessness. I think a lot of great artists possess that in terms of a fearlessness to express what is inside them and who they are as a person. And not worrying about being judged. And not worrying about what the record company thinks. Or even what the public thinks. It's what makes great art. Your expression of your heart and soul. And not compromising your idea of yourself."

Dave Grohl, of Nirvana and the Foo Fighters, was an admirer of Tom's. Grohl had first heard of Tom while touring Canada in a punk band and told the United States' National Public Radio, "Punk rock was all about walking it like you talk it, and integrity was always something that we measured an artist by, and it just seemed like, how could you be more for real than Stompin' Tom?"[9]

Journalist Sheldon Birnie wrote, "It is difficult to really grasp just how big of a maverick Stompin' Tom Connors really was. Old Tom was releasing his own records, booking his own tours, doing his own promotions, and supporting and recording other Canadian talent at a time when that was far from the norm."[10]

Within days of his passing, the *Vice* website ran a piece with a headline that declared, "Stompin' Tom Connors Was Punk as Fuck."[11] Author Gregory Pike wrote, "When one thinks of Canadian musicians, the term 'badass' doesn't usually spring to mind. Rebels just aren't revered as cultural icons in the North as they are in that American James Dean kind of way down south." He pointed out that Tom was the exception to this rule, writing, "He dressed like Johnny Cash (almost always in black) and drank like Hank Williams Sr. (a lot). He was Canada's best steel-toed, blue-

collared crooner. And he was a stubborn sunnovabitch too, saying and singing anything he wanted, while doing whatever and going wherever he pleased." The article listed the many things that made Tom "punk," including the fact that he ran away from home at fifteen, that he returned his Junos and that "His music career began as a way to pay for beer." The writer also mentions that Tom "told the CBC to shove it" and that his simple songs fit the punk genre perfectly. Pike wrote, "One major reason punk rules is because you can have an awesome-sounding band that's made up of people who can barely play their instruments. That means: anyone can start a band. I'm not saying that Stompin' Tom wasn't a talented musician. He was. He just kept it simple is all. Real simple."

It was this idea of rebel Tom that appealed to Andy Curran of Canada's ole Label Group when he decided, in the spring of 2016, to see if Tom's family might be interested in licensing his music and image to the company. Curran had dealt with Tom once before. In 2006, he was working with Anthem Records, the label responsible for the *Trailer Park Boys: The Movie* soundtrack. Mike Smith, who plays Bubbles in the series, was planning to record a song called "Liquor and Whores" for the album and said to Curran, "Boy, would I ever love to do a duet with somebody really cool. You gotta help me get Stompin' Tom." Curran contacted Brian Edwards, who asked to see the lyrics. Despite the shout-out to Tom's favourite, "mustard and bologna," the rest of the lyrics did not appeal to him. Curran said in an interview that Edwards called him and said, "Tom loves the boys and thinks they're very funny, but this is not the type of lyrical content he'd be singing."

Ten years later, Curran approached Edwards again, this time about licensing Tom's music. Edwards put him in touch with Tom Jr., who was initially reluctant, but after a series of calls over a few months, finally agreed to meet with Curran and ole's CEO, Robert Ott. Curran explained to Tom Jr. that the company was hoping people might start to "think of Tom as more iconic, our version of Johnny Cash. Not just this guy who wrote these quirky songs,

but the real balladeer and somebody who talks about the history of Canada and is patriotic." According to Curran, Tom Jr. said, "I think if my dad was alive he would love the fact that this is a Canadian run company." ole also assured Tom Jr. and Lena that they would not do anything "cheesy" or "inappropriate" with Tom's image or music and that they wanted the family to stay involved in future projects. They agreed to sign with the label. According to Curran, Tyler Surst, a young man who worked for ole and had a lot of experience in cutting deals, said that, "Never in the history of any deal that he made did anybody put him through the wringer like Tom Jr. did . . . He was a real tough customer and it sounded like the apple didn't fall too far from the tree. His dad was a ruthless businessman."

In March 2017, it was announced that ole had purchased the distribution rights for Tom's "music and masters, his YouTube presence and merchandise."[12] The article went on to say that ole was hoping to rebrand Tom, focussing on his rebel image. Andy Curran said, "There's quite a story about his rebellious nature, and I think with rock 'n' roll and music that always strikes a chord with the younger generation. We're going to start exposing the more rebellious side of him to resonate with the younger audience, that's one of my goals."

Under this new agreement, ole's first release under this new agreement was the *Stompin' Tom Connors, 50th Anniversary* CD. This greatest hits compilation featured fourteen of Tom's best-known songs as well as four covers featuring The Cuddy/Polley Family Band, Corb Lund, George Canyon and Whiskey Jack. "Those were easy calls to make," Curran said. "Anybody that we called were just like, 'Yup, we're in. We want to be involved.'" The album was released on July 1, 2017, Canada's hundred and fiftieth birthday, which also marked what is considered the fiftieth anniversary of Tom becoming "Stompin' Tom." ole has updated Tom's website and they have plans for merchandise that brands Tom as an iconic rebel. There has even been talk of a documentary.

The company inherited almost one hundred of Tom's unreleased "songs from the vault."

For their first release from this batch of songs, ole hired a number of younger artists, such as The Good Lovelies, The Sheepdogs and The Washboard Union, to back up Tom. In the last few years of his career, Tom recorded his vocals and guitar lines, then the other instrumentalists would play their parts to Tom's tracks. For *Unreleased Songs From The Vault Collection Vol. 3*, that is exactly how a number of the tracks were created. The musicians added another layer to Tom's original recordings and took the production values to a new level. On the last album Tom released during his lifetime, *The Roads of Life*, he recorded a number he had written called "Skinners Pond Jig." The song was an instrumental version of "Song of the Irish Moss," which he had turned into a jig. In his last interview, he told Steve Fruitman that he hoped someday a fiddler might record the track. On volume three of his *Vault Collection*, award-winning fiddlers Natalie MacMaster and Donnell Leahy perform the number.

Curran spent months reviewing Tom's unreleased recordings and said in an interview there are tracks from artists as diverse as Dean Martin, Hank Williams and Elvis Presley. He added that there are "some really cool things that the public hasn't heard yet." ole plans to continue releasing the remaining tracks, so there will be new Stompin' Tom albums for some time to come.

In addition to the work ole is doing, Tom's music and memory have been kept alive in other ways. Duncan Fremlin and his band Whiskey Jack held a birthday celebration for Tom in Toronto in 2014, a year after his death. In the program for Whiskey Jack's Stompin' Tom show, Fremlin said, "We found a seedy bar in Toronto, one that Tom undoubtedly would have approved of, put the word out that there was going to be a Stompin' Tom birthday celebration, and holy moly, the phone started ringing off the hook. We were overwhelmed with calls from artists across the country asking if they could perform. The fans bussed in from

outside the city and the show sold out in a few days."[13]

Artists who took part in that first birthday celebration included Tom's former band members, as well as Kim Stockwood, Melanie Doane and Paul Langois of The Tragically Hip. The night was so successful that the birthday celebration has become an annual event and other artists, including Gordon Lightfoot and J.P. Cormier, have appeared over the years. Fremlin and his bandmates also turned the celebration into a show called Whiskey Jack Presents Stories & Songs of Stompin' Tom, which has toured Canada for the past few years. Tom's son Taw is also keeping his father's music alive. He has toured the country since 2016 as the Canadian Stomper, singing Tom's songs and telling stories about his father's life.

Memorials to Tom's life and music have cropped up around the country since his death. There are murals of Tom in his hometown of Saint John, New Brunswick, and Carleton Place, Ontario. A plaque was unveiled in Ballinafad, Ontario, noting that Tom lived there and that he wrote a song about the community called "The Ballinafad Ball." In 2015, a bronze statue of Tom was installed near the arena in Sudbury, Ontario, and he was inducted into the Canadian Walk of Fame in November of 2017.

In an interview with the *Toronto Sun* about that last honour, Tom Jr. acknowledged that Tom had problems with some awards, saying, "But this one, we feel, it's a good group of inductees this year. Tom had a lot of respect for [fellow 2017 inductee] David [Suzuki] and the things that David accomplished and the patriotism that he had for his own country. It's a good year being Canada's 150 . . . so I figured, 'Well, if the Walk Of Fame would like to have Stompin' Tom involved to make it all that more Canadian, then we have no problem giving them the opportunity to do that.'"[14]

In October of 2018, Tom Jr. was on hand when "The Hockey Song," was inducted into the Canadian Songwriters' Hall of Fame in Toronto before a home game between the Maple Leafs and the Winnipeg Jets. Canadian country singer Tim Hicks performed the song as part of the ceremony.

# Epilogue

After Tom's death, his old friend John Farrington had started working on a book about Tom variously called "The Stompin' Tom Scrapbook" or "Stompin' Tom's Canada." He interviewed countless people from Tom's life and was working with the family to include personal photos and memorabilia. Unfortunately, Farrington passed away unexpectedly in August of 2017 and the future of the book is uncertain. Duncan Fremlin published his book about Tom, called *My Good Times with Stompin' Tom*, in 2018.

By far the most significant memorial to Tom since his death has been the development of the Stompin' Tom Centre in Skinners Pond, PEI. After all of Tom's attempts to turn the site into a tourist attraction, a new group, called Tignish Initiatives, finally managed to restart the project and convince Arthur Bernard to sell the Aylward house. Tom knew of the plans to open a new centre and was supportive of the project. Lena told Toronto's *City News*, "He was at peace here. This was tranquil for him. He loved this area."[15]

The centre, which features a gift shop, a recording studio where visitors can sing a duet with Tom, a performance space and exhibits from his life and career, was initially scheduled to open in 2016, but "the plan fell apart briefly when Heritage Canada denied $350,000 in funding — on top of other federal and provincial money — because Tignish Initiatives isn't considered an arts or heritage organization."[16] The group scaled back their plans and opened the centre on July 1, 2017. Anne Arsenault, the general manager of Tignish Initiatives, said, "To be quite honest, we always said the grand opening for the centre would have to be Canada Day. It is a coincidence that this year, it's the 150 . . . These things happen for a reason I guess." Of course, ole released Tom's *50th Anniversary* CD that same day.

The centre hosts concerts through the summer months, giving opportunities to Canadian artists, and, in particular, local musicians. There is also a dinner theatre about Tom's life, which initially ran two nights per week, but after great success in 2018 was extended to four nights a week. It was also decided to keep the

centre open an extra month each year, going until the end of September in 2019. In addition to the centre, the schoolhouse is open for tours and there are plans to eventually add a picnic area and a microbrewery.

As part of a new initiative of Canada's Walk of Fame, called Hometown Stars, inductees get an additional plaque in a location of their choice. Tom's family chose to have his installed at the centre in 2018. Taw, who attended the unveiling, told CBC News, "I know that it was close to his heart, Skinners Pond. Not only the place and the beauty of it, but the people."[17]

Although it is not open to the public, Tom's childhood home sits on the corner of the property. A *National Post* article described the house: "The homestead, a typical P.E.I. farm house, comes complete with a wood-burning stove, a high-pitched roof and slender windows."[18] This is the home where Tom cried himself to sleep countless nights. If only that little boy could have peeked out those slender windows and into the future to see a line of people waiting to get into a centre built in his honour. He could not possibly have imagined what was in store for him or the impact he would have on the cultural life of Canada.

Tom started singing songs about the communities he visited because it attracted a local audience. He came to realize, however, that he had a greater purpose. Tom realized that he was saving Canadian stories and characters from the dust heaps of history. In *Across this Land with Stompin' Tom*, he introduces "Big Joe Mufferaw" by saying there was a French Canadian who "made himself a legend in his own time. He got buried under a tombstone for a while, until a fella named Stompin' Tom went up that way and heard a few of the tall, tall tales and wrote a song about Big Joe Mufferaw." In his song "Horse Called Farmer," which is based on a true story, Tom sings, "You may not find him in the books of history." Tom told Brent Hagerman in a 2000 story for *The Globe and Mail*, "We view our jobs, our towns and our lives as drab until we hear someone sing about them. I like to make people's towns and

work and their country come alive for them. When I'm on stage I like to see the looks on peoples' faces when I mention their towns — wow!"[19] As Robert Martin wrote in *The Globe and Mail,* "It's a form of recognition, in a small way, of immortality, for all those little places that never make the news. It puts Wawa and Timmins and Rouyn right up there on the musical map with Chicago and New York."[20]

Michael Barclay wrote:

> *Stompin' Tom Connors knew a country without culture does not exist. A country that doesn't know how to tell its own stories is illiterate and irrelevant — it doesn't matter whether that means silly songs about potatoes or sweeping historical novels. This man knew that this land was rich with lore, teeming with heroes and weirdos and folks just trying to get by. And while his peers were chasing a buck beyond our borders, someone had to stay here, dammit, and make sure the rest of us — those still living here, still building this place, still raising children here — had some songs to sing.*[21]

But Tom's impact went beyond the songs he sang and even the many artists he supported through Boot Records. His biggest impact may have been that he inspired a new generation of artists, giving them permission to sing about their homes and the people and places they knew. The authors of the book *Have Not Been the Same* wrote of Dave Bidini's experience with Stompin' Tom, "The whole adventure inspired Bidini's band to be more consciously Canadian in their songwriting and presentation; this put the Rheostatics at the vanguard of many of the profound changes of the CanRock Renaissance. 'Obviously that experience had a huge, profound impact on us playing the kind of music that we played,' says Bidini. 'That imbued the nationalism, had a huge

impact on us being a Canadian band, and made us want to carry the torch.'"[22]

In 1991, a few years after Bidini discovered Stompin' Tom, The Rheostatics released their very successful album *Melville*, and it was full of Canadian references, most notably the song, "Saskatchewan." Gord Downie, of the Tragically Hip, said, "I started realizing you could sing about Canada and about where you're from. I'd always wanted to do it, but never could figure out how . . . And it was the Rheostatics that made me think I could, specifically the song, 'Saskatchewan,' which is pretty darn beautiful."[23] Dave Bidini wrote, "Still, what this country owes to the singer from Skinners Pond can't be written on a plaque. His words, his music and his soul are buried in the deep crude loam of our nation."[24]

Tom was so influential that other artists not only started writing about Canada, but about Tom himself. One would be hard pressed to find another Canadian, living or dead, who has been the subject of so many songs. Tom is referenced by Corb Lund in "Long Gone to Saskatchewan" and Dean Brody in "Canadian Girls." Even the American country star Tom T. Hall mentions Tom in "Canadian Women, Canadian Clubs," singing, "Old Tom taught me how to stomp a tune or two."

A number of other artists have written entire songs about Tom. Whiskey Jack released a track called "If Stompin' Tom Was Our National Bird" and Tim Hus wrote "Man with the Black Hat." Bud Roberts penned "Tribute to Tom Connors," which appeared on the punk album, *Stomp On Wood*. The Canadian Beaver Band has a song called "Stompin' Tom Road," while Al Tuck wrote "Stompin'TomConnors.com" and Cliff Jewell recorded a song called "Stompin' Tom." Tom Gallant has a song about Tom called "Hero" and Mike Plume wrote one called "So Long Stompin' Tom." There are even two versions of "The Ballad of Stompin' Tom" other than Tom's song of the same name: one by Fred Dixon and another by Stew Clayton.

Perhaps the most moving and poetic of the Tom tributes is J.P. Cormier's "House of Plywood." The lyrics beautifully capture Tom's impact on Canada:

*And the stories of this country came to life beneath your hand,*
*And you built this house of plywood with a boot heel and a pen,*
*A line of ink that stretches across this country and back again,*
*Through the sawdust and the spotlight your words still linger on,*
*Last night I dreamed that Canada was a song by Stompin' Tom.*

Tom wrote songs about people real and imagined. He wrote songs about tragedies and triumphs, songs about sports and inanimate objects. They were songs about how he lived and what he experienced. They were songs about what it means to be a Canadian.

In the same way that Tom introduced audience members at different tables to one another, his songs introduced disparate regions of Canada to one another. In a *Maclean's* magazine piece called "Canada is Not a Country," Scott Gilmore wrote, "Remove the language, and there are fewer cultural similarities between Newfoundland and Saskatchewan than you would find between France and Belgium. What is more, the proportion of Regina residents who have actually been to St. John's is a fraction of the Parisians who have been to Brussels (or Berlin)."[25]

Tom brought the country together, in part because he gave them something in common: the music of Stompin' Tom. Those songs made the different regions of Canada sound like they weren't all that different from one another. In his desire to create a family for

himself, Tom created a nationwide, music-filled party where everyone's story mattered and Canadians had more in common than they didn't. Much has been made of Tom's love for his country, but it was really the people of Canada that he loved. As he said on the *Believe in Your Country* CD, "It's not about loving the geography . . . it's about loving the people . . . you don't love the rock, you love the people around the rock."

That love was mutual, and a lyric from the Broadway musical, *Chicago*, seems relevant.

> *And the audience loves me,*
> *And I love them.*
> *And they love me for lovin' them,*
> *And I love them for lovin' me*
> *And we love each other,*
> *And that's 'cause none of us got enough love in our childhoods,*
> *And that's showbiz . . .*

Tom left behind a rich legacy of stories and characters. Margo with her cargo, Big Joe Mufferaw, Bud the Spud, Red River Jane and Ben from the Pen all live on in the imagination of Canadians. So does the character of Stompin' Tom.

But Stompin' Tom was very different than Tom Connors. Duncan Fremlin wrote, "His on stage persona was low-brow. I think intentionally so. He went to great extremes to demonstrate to his fans that Stompin' Tom was not just humble and uneducated, but an illiterate country bumpkin . . . Those of us in Tom's inner circle know that he was anything but a country bumpkin."[26] Tom's friend, Steve Fruitman, said simply, "Stompin' Tom was a cartoon. Tom Connors was a human being."

The brilliance of Tom Connors was that he created believable characters that working class people felt they knew. Stompin' Tom was his greatest creation. That creation became so real that many

people couldn't see or didn't know the difference between the character and the man. And that's where most of Tom's frustration with his career came from. Perhaps the most honest thing he ever said to an interviewer was when he told Mitch Potter, "If you turn this into some joke, honest to God, it will break my heart."[27]

Bob Mersereau, who interviewed Tom by phone a number of times, said, "If you asked him one of these serious questions, taking his music seriously . . . he would switch. There would be a switch go off in his mind and he would start to get into it. You could hear the persona disappear and the thoughtfulness come into the conversation. He was showing his true colours at that point." In a 1970 interview with *The Globe and Mail* Tom said, "Canada is virgin country for writin' songs. Maybe I'm paintin' too big a picture of myself, but folks always point to the Beatles and say, 'They're English' or to Elvis Presley and say 'He's American.' I'm dreamin' that people will point to somebody like me and say 'He's Canadian.'"[28]

His dream came true, and so much more. Stompin' Tom became synonymous with Canada. After writing hundreds of songs, releasing almost fifty albums, performing coast to coast for more than sixty years, receiving countless awards and selling over five million albums, Tom's creation, Stompin' Tom Connors, was "the voice of the people" and his songs "the soul of our land."

Tom is buried with his mother, but Stompin' Tom is immortal. He lives with Bud and Big Joe, Margo and Luke. They're at a hockey game, the Gumboot Cloggeroo, or celebrating a Sudbury Saturday Night; wherever Canadians gather to share their stories and sing their songs.

Strong winds blow across Canada, carrying his songs from coast to coast, weaving this big country together.

> *I am the wind, I am the wind,*
> *Where I go is where I've been,*
> *I'm here today and gone again,*
> *On my way, I am the wind.*

# Acknowledgements

Although my name is on the cover of this book, I certainly didn't write it alone. I literally could not have done it without the assistance and encouragement of dozens of people. While all their names would not fit on the cover, their presence is felt on every page.

I want to start by thanking Formac's president, James Lorimer, for not only publishing my first book, *I'm Not What I Seem*, but for asking me to write another; my editor, Kara Turner, for her encouragement, patience and intelligent, thoughtful guidance throughout the process; my copy editor Chelsey Millen, who once again helped clarify my words and made me look like I'm good at grammar; and Susmita Dey, Dan Campbell and everyone else at Formac for all their work in turning my words into a book and then getting that book into the hands of readers.

I am incredibly grateful to those people I interviewed for giving me their time and trusting me with their words and thoughts. Many of these same people offered photos and additional source material, which helped immensely. I have listed them separately with my sources.

Thank you to the many people who gave me advice and suggestions or generally offered support as I put this project together. Unfortunately, not every tip or story led to something that I was able to use in the book, but I appreciate all of you for taking the time to reach out. Thank you Philip Adams, John Arsenault, Dave Cawthorne, John Davie, Darren DeLorme, Barry Dewling, Brookes Diamond, Andrew Ennals, Shawn Firlotte, Mike Galley, Kelly and Brian Goldrich, Lauren Hepburn, Shirley Johnson, Kandis Johnstone, Brian Lindy, Anne MacKay, Rob MacLean, Geoff Montreuil, Melissa Mullen, Casey Murray, Chris Murray, Bill Schurman, Jean

# Acknowledgements

St-Pierre, Charlotte Strathearn, Lisa Strathearn, Sherri Topple, and Roger White.

Thanks to Anita Cannon, Anne LePage, Jeff Lilburn and Laura Snyder at the Mt. Allison University libraries, Tina at the Saint John library and Amanda Lloyd at the NB Provincial Archives for their help with my research. I also want to thank the many journalists and writers who interviewed or wrote about Tom over the years and whose work I accessed. This was invaluable to me as I put together the story of Tom's life.

Thanks to everyone who helped me track down images. We weren't able to use every one, but I truly appreciate the assistance of Jonna Brewer, Bruce Cole, Margaret D'Agostino, Tyler Fauvelle, Phil Gravelle, Zachary Hudson Hogan, Mary Ann Keddy, Phil Price, Ed McCabe, George Alexander Mulrooney III, Jordan Reid, Paul Saulnier, Darren Yearsley, Cody Waite at the Alden Nowlan House, Elia Anoia at Canada Post, Cédric Lafontaine at Library and Archives Canada, Joshua Green and Lisa Lawyer at the Provincial Archives of NB and Marnee Gamble at the University of Toronto.

On a more personal note, I would like to thank the people who help me get through every day. Thank you to my in-laws, Don and Sharon MacIntyre, for their constant support and generosity; my mother, Devona Porter, for telling me I can accomplish anything and actually believing it; my parents Charlie and Judy Rhindress, for offering unending love and always being there; my four children, Bailey, Adam, Alex and Spencer, for making everything worthwhile; and Heather MacIntyre, for letting Tom take over our lives, pretending to be interested in every discovery I made, listening to Tom's music with me and making me believe I could do this.

Finally, thank you to Tom for telling Canada's stories and for living a story that was so worth telling.

# Sources

In addition to the following sources, Tom's two volumes of autobiography served as primary source material and are referenced throughout the text:

Connors, Stompin' Tom. *Stompin' Tom: Before the Fame.* Toronto, ON: Viking Press, Penguin Books of Canada, 1995.

Connors, Stompin' Tom. *Stompin' Tom and the Connors Tone.* Toronto, ON: Viking Press, Penguin Books of Canada, 2000.

Many other sources were used in researching this book, but the following are the references for quoted material.

## Chapter 1

1. Stompin' Tom Connors, interviewed by Valerie Pringle, Canada AM, 1999, https://www.youtube.com/watch?v=UjX-HSbFpA4/.
2. Amanda Onion, "When Do Babies Develop Memories?" *ABC News.* October 30, 2002.
3. Alden Nowlan, "What's More Canadian than Stompin' Tom?" *Maclean's*, August 1972.
4. Robert Everett-Green, "Still Stompin' After All These Years." *Globe and Mail*, October 25, 2008.
5. Alden Nowlan, "What's More Canadian than Stompin' Tom?" *Maclean's*, August 1972.
6. Robert Everett-Green, "Still Stompin' After All These Years." *The Globe and Mail*, October 25, 2008.
7. Alden Nowlan, "What's More Canadian than Stompin' Tom?" *Maclean's*, August 1972.

## Chapter 2

1. Alden Nowlan, "What's More Canadian than Stompin' Tom?" *Maclean's*, August 1972.
2. Alden Nowlan, "What's More Canadian than Stompin' Tom?" *Maclean's*, August 1972.
3. Robert Everett-Green, "Still Stompin' After All These Years." *The Globe and Mail*, October 25, 2008.
4. *This is Stomping Tom*, directed by Edwin W. Moody (1972; Toronto, ON: York University).
5. Tom Connors, interview by Volkmar Richter, *This is Robert Fulford*, CBC Radio, 1969, https://www.youtube.com/watch?v=mcLmj8Wh3Es&app=desktop
6. Stompin' Tom Connors, interview by Rudy Blair, 680 News, July 14, 2009, https://www.680news.com/2013/03/06/interview-stompin-tom-connors-july-14-2009/.

Sources

7. Alden Nowlan, "What's More Canadian than Stompin' Tom?" *Maclean's*, August 1972.
8. Robert Everett-Green, "Still Stompin' After All These Years." *The Globe and Mail*, October 25, 2008.
9. "Life on the Road with Stompin' Tom Connors," *Luncheon Date with Elwood Glover*, CBC TV, October 30, 1970. www.cbc.ca/archives/entry/life-on-the-road-with-stompin-tom-connors/.

## Chapter 3

1. Stompin' Tom, *Summer Supplement*, CBC Radio, 1973, https://www.youtube.com/watch?v=mcLmj8Wh3Es&app=desktop
2. Stompin' Tom, interview by Pierre Pascau, *Cross Country Checkup*, CBC Radio, 1973, https://www.youtube.com/watch?v=mcLmj8Wh3Es&app=desktop
3. Robert Everett-Green, "Still Stompin' After All These Years." *The Globe and Mail*, October 25, 2008.
4. Stompin' Tom Connors, interview by Steve Fruitman, *Back to the Sugar Camp*, CIUT 89.5 FM, 2008.
5. Stompin' Tom Connors, Steve Foote and Jury Krytiuk, *Stompin' Tom, Story and Song* (Toronto, ON: Crown-Vetch Publications, 1975).
6. "Stompin' Tom Connors," *Canadian Composer*, no. 54 (November 1970), 8, 10.
7. Dick MacDonald, "Stompin' Tom Connors," *Atlantic Advocate* 67, no. 3 (November 1976) 35.
8. Stompin' Tom, interview by Pierre Pascau, *Cross Country Checkup*, CBC Radio, 1973, https://www.youtube.com/watch?v=mcLmj8Wh3Es&app=desktop

## Chapter 4

1. Dr. Claudia Black, "Understanding the Pain of Abandonment," *Psychology Today*, June 4, 2010, https://archive.is/20140131052745/http://m.psychologytoday.com/blog/the-many-faces-addiction/201006/understanding-the-pain-abandonment.
2. Stompin' Tom, interview by Valerie Pringle, *Canada AM*, CTV, 1999. https://www.youtube.com/watch?v=UjX-HSbFpA4/.
3. Tom Connors, interview by Volkmar Richter, *This is Robert Fulford*, CBC Radio, 1969, https://www.youtube.com/watch?v=mcLmj8Wh3Es&app=desktop
4. "Life on the Road with Stompin' Tom Connors," *Luncheon Date with Elwood Glover*, CBC TV, October 30, 1970, https://www.cbc.ca/archives/entry/life-on-the-road-with-stompin-tom-connors/.
5. "The Bartender Who Discovered Stompin' Tom Connors," *Day 6*, CBC Radio, March, 2013.
6. Stompin' Tom Connors, interview by Peter Gzowski, *Morningside*, CBC Radio, Dec. 29, 1988, https://www.youtube.com/watch?v=mcLmj8Wh3Es&app=desktop.

7. "Stompin' Tom Connors interview" by Craig Rintoul, *Stompin' Tom Connors Before the Fame*, Author Interview, Sept. 17, 2007. https://www.youtube.com/watch?v=Mt1C-WIsMa4.
8. "Life on the Road with Stompin' Tom Connors," *Luncheon Date with Elwood Glover*, CBC TV, October 30, 1970, https://www.cbc.ca/archives/entry/life-on-the-road-with-stompin-tom-connors/.
9. "Stompin' Tom Connors," *Canadian Composer* (Nov. 1970), 46.
10. Robert Everett-Green, "Still Stompin' After All These Years." *The Globe and Mail*, October 25, 2008.
11. Stompin' Tom Connors, interview by Rudy Blair, 680 News, July 14, 2009, https://www.680news.com/2013/03/06/interview-stompin-tom-connors-july-14-2009/.
12. Stompin' Tom Connors, interview by Peter Gzowski, Morningside, CBC Radio, Dec. 29, 1988, https://www.youtube.com/watch?v=mcLmj8Wh3Es&app=desktop.
13. Ibid.
14. "Stompin' Tom Connors," *Canadian Composer*. Nov. 1970, 10.
15. William Echard, "Forceful Nuance and Stompin' Tom," in *Slippery Pastimes: Reading the Popular in Canadian Culture*, eds. Joan Nicks and Jeannette Marie Sloniowski (Waterloo, ON: Wilfred Laurier University Press, 2002), 243–261.
16. "Life on the Road with Stompin' Tom Connors," *Luncheon Date with Elwood Glover*, CBC TV, October 30, 1970, https://www.cbc.ca/archives/entry/life-on-the-road-with-stompin-tom-connors/.

## Chapter 5

1. "Stompin' Tom Connors," *Canadian Composer*, Nov. 1970, 46.
2. Stompin' Tom, *Summer Supplement*, CBC Radio, 1973, https://www.youtube.com/watch?v=mcLmj8Wh3Es&app=desktop3.
   William Echard, "Forceful Nuance and Stompin' Tom," in Slippery Pastimes: Reading the Popular in Canadian Culture, eds. Joan Nicks and Jeannette Marie Sloniowski (Waterloo, ON: Wilfred Laurier University Press, 2002), 243–261.
4. Doug Saunders, "In 1967, Change in Canada Could No Longer be Stopped," *The Globe and Mail*, January 1, 2017.
5. Alexandra Pope, "Q&A: Tom Hawthorn on 1967, The Year We Went Crazy for Canada," *Canadian Geographic*, May 17, 2017, https://www.canadiangeographic.ca/article/qa-tom-hawthorn-1967-year-we-went-crazy-canada/.
6. Alden Nowlan, "What's More Canadian than Stompin' Tom?" *Maclean's*, August 1972.
7. Richard Flohil, "Stompin' Tom: Canada's Unlikely National Symbol," *Canadian Composer*, no. 85, November 1973, 36.
8. Stompin' Tom, interview by Pierre Pascau, *Cross Country*

*Checkup*, CBC Radio, 1973, https://www.youtube.com/watch?v=mcLmj8Wh3Es&app=desktop
9. Stompin' Tom Connors, interview by Peter Gzowski, Morningside, CBC Radio, Dec. 29, 1988, https://www.youtube.com/watch?v=mcLmj8Wh3Es&app=desktop.
10. David McPherson, *The Legendary Horseshoe Tavern* (Toronto, ON: Dundurn, 2017).

## Chapter 6

1. Richard Flohil, "Stompin' Tom: Canada's Unlikely National Symbol," *Canadian Composer*, no. 85, November 1973, 36.
2. Stompin' Tom Connors, interviewed by with Carmen Kilburn, *Community Television*, TVNB, 1998,https://www.youtube.com/watch?v=BAln6ITB3Ak/.
3. "Interview: Jury Krytiuk," *Canadian Composer*, no. 128, February 1978, 26.
4. Ibid.
5. Alden Nowlan, "What's More Canadian than Stompin' Tom?" *Maclean's*, August 1972.6.    Library and Archives Canada, "The RPM Story," Last modified February 28, 2015,https://www.bac-lac.gc.ca/eng/discover/films-videos-sound-recordings/rpm/Pages/rpm-story.aspx/.
7. Alden Nowlan, "What's More Canadian than Stompin' Tom?" *Maclean's*, August 1972.
8. David McPherson, *The Legendary Horseshoe Tavern* (Toronto, ON: Dundurn, 2017).
9. "Stompin' Tom Connors," *Canadian Composer*.

## Chapter 7

1. "Juno Awards," *RPM Music Publications*, 10th Anniversary Special Issue, 1980.
2. *Stompin' Tom in Live Concert* (2005; Hamilton, ON: EMI Music Canada), DVD.
3. "Catching the Charisma of Tom Connors Ain't Easy," *Canadian Composer*, no. 70, May 1972.
4. Mark Starowicz, "The Saga of Stompin' Tom Connors," *Last Post* 2, no. 2, November 1971.
5. Jack Batten, "Stompin' Tom Leaves 'Em Cheerin' and Hollerin' at Massey," *The Globe and Mail*, February 5, 1972.
6. Alden Nowlan, "What's More Canadian than Stompin' Tom?" *Maclean's*, August 1972.7.
7. Nancy Southam, *Remembering Richard* (Halifax, NS: Formac Publishing, 1993).
8. "You Can't Beat the People's Choice," *RPM Weekly*, 16, no. 26, February 12, 1972.
9. David McPherson, *The Legendary Horseshoe Tavern* (Toronto, ON: Dundurn, 2017).

10. Virginia Beaton and Stephen Pederson, "Stompin' Tom," in *Maritime Music Greats* (Halifax, NS: Nimbus Publishing, 1992), 74.

## Chapter 8
1. Blaik Kirby, "Nothing Fancy, but Connors' Show Seems Sure Winner," *The Globe and Mail*, September 27, 1974.
2. Jennifer Barr, "Stompin' Tom Media Critic Champions Canadian Talent," *Acton Free Press*, January 19, 1977.
3. Morris Wolfe, "The Browser," *Books in Canada* 6, no. 4, April 1977.
4. Blaik Kirby, "Connors Curries Favor Shamelessly," *The Globe and Mail*, June 4, 1975.
5. Winifred Smith, "Stompin' Tom Moves In," *Georgetown Herald*, June 4, 1975.
6. Blaik Kirby, "Overdrive, Vanelli, Mitchell Big Juno Winners," *The Globe and Mail*, March 16, 1976.
7. Ibid.
8. Jennifer Barr, "Stompin' Tom Media Critic Champions Canadian Talent," *Acton Free Press*, January 19, 1977.
9. "New records by CAPAC members," *Canadian Composer*, no. 127, January 1978.
10. "Stompin' Tom Awaits Industry 'Blacklist'," *The Globe and Mail*, April 1, 1978.

## Chapter 9
1. "Stompin' Tom Discloses Reasons for Juno Nomination Withdrawal," *RPM Magazine*, April 22, 1978.
2. Duncan Fremlin, *My Good Times with Stompin' Tom* (Toronto, ON: Canjay Music, 2018).
3. Dave Bidini, "These Boots . . . Stompin' Tom, Man of Mystery, Man of Song," *Nerve*, no. 29 October 1986.
4. Lucinda Chodan, "Stompin' Tom Connors is Back on Record after 9 Years of Silence," *Montreal Gazette*, January 20, 1987.
5. Jane Stevenson, "Love for Stompin' Tom Went beyond Canada's Borders," *Toronto Sun*, March 7, 2013.
6. Susan Beyer, "Stompin' Tom Back on Disc to Fight Cut in Canadian Content on Radio," *Ottawa Citizen*, February 13, 1987.
7. Virginia Beaton and Stephen Pederson, "Stompin' Tom," in *Maritime Music Greats* (Halifax, NS: Nimbus Publishing, 1992), 74.
8. Dave Bidini, *On a Cold Road* (Toronto, ON: McClelland & Stewart, 1998).
9. Michael Barclay, Ian A. D. Jack and Jason Schneider, *Have Not Been the Same: The CanRock Renaissance 1985–1995* (Toronto, ON: ECW Press, 2001).
10. "Dave Bidini on Stompin' Tom," *CBC News*, March 7, 2013, https://www.cbc.ca/news/canada/dave-bidini-on-stompin-tom-1.440314/.

# Sources

11. Dave Bidini, *On a Cold Road* (Toronto, ON: McClelland & Stewart, 1998).
12. "Dave Bidini on Stompin' Tom," *CBC News*, March 7, 2013, https://www.cbc.ca/news/canada/dave-bidini-on-stompin-tom-1.440314/.
13. Dave Bidini, "These Boots . . . Stompin' Tom, Man of Mystery, Man of Song," *Nerve*, no. 29 October 1986.
14. John Doyle, "How Stompin' Tom Connors Made Me a True Canadian," *The Globe and Mail*, March 10, 2013.
15. Dave Bidini, *On a Cold Road* (Toronto, ON: McClelland & Stewart, 1998).
16. "Dave Bidini on Stompin' Tom," *CBC News*, March 7, 2013, https://www.cbc.ca/news/canada/dave-bidini-on-stompin-tom-1.440314/.
17. Gretchen Pierce, *Halifax Chronicle-Herald*, 1975, quoted in Beaton and Pederson, *Maritime Music Greats*.
18. Susan Beyer, "Stompin' Tom Back on Disc to Fight Cut in Canadian Content on Radio," *Ottawa Citizen*, February 13, 1987.
19. Dave Bidini, "These Boots . . . Stompin' Tom, Man of Mystery, Man of Song," *Nerve*, no. 29 October 1986.
20. Susan Beyer, "Stompin' Tom Back on Disc to Fight Cut in Canadian Content on Radio," *Ottawa Citizen*, February 13, 1987.
21. "Tom Connors Stompin' Again," *Vancouver Sun*, November 1, 1988.
22. "Stompin' Tom Connors Makes a Comeback — On Vinyl Only," *Montreal Gazette*, November 30, 1988.
23. Peter Goddard, "Dan Aykroyd's Stompin' for the Return of Tom Connors," *Toronto Star*, Nov. 24, 1988.
24. "Reclusive Tom Stomps in Red Deer," *Edmonton Journal*, June 17, 1989.

## Chapter 10

1. "Stompin' Tom Connors Making a Careful Comeback," *Edmonton Journal*, August 22, 1989.
2. "Stompin' Tom Connors Ends 12 Years of Retirement with New Record Release," *Mariposa Notes*, no. 6, DecemberJanuary 1989.
3. Sebastien Perth, "Stompin' Tom Remembered for Northern Roots," *Sudbury Star*, March 7, 2013.
4. John O'Callaghan, "Still Stompin' after All These Years," *The Globe and Mail*, July 31, 1993.
5. Michael Barclay, Ian A. D. Jack and Jason Schneider, *Have Not Been the Same: The CanRock Renaissance 1985–1995* (Toronto, ON: ECW Press, 2001).
6. Bruce Farley Mowat, "The Men Behind the Boot," *Cambridge Reporter*, December 10, 1999.
7. Duncan Fremlin, *My Good Times with Stompin' Tom* (Toronto, ON: Canjay Music, 2018).
8. William Echard, "Forceful Nuance and Stompin' Tom," in *Slippery Pastimes: Reading the Popular in Canadian Culture*, eds. Joan Nicks and Jeannette Marie Sloniowski (Waterloo, ON: Wilfred Laurier University Press, 2002), 243–261.

9. Michael Barclay, Ian A. D. Jack and Jason Schneider, *Have Not Been the Same: The CanRock Renaissance 1985–1995* (Toronto, ON: ECW Press, 2001).
10. Nicholas Jennings, "A Rebel's Return," *Maclean's*, May 14, 1990.
11. Ibid.
12. Virginia Beaton and Stephen Pederson, "Stompin' Tom," in *Maritime Music Greats* (Halifax, NS: Nimbus Publishing, 1992)
13. "Stories and Songs of Stompin' Tom," Whiskey Jack Souvenir Tour Program, 2018.
14. Justin Skinner, "The Late Stompin' Tom Honoured at His Upcoming Birthday Bash," toronto.com, January 27, 2016, https://www.toronto.com/news-story/6250376-the-late-stompin-tom-honoured-at-his-upcoming-birthday-bash/.
15. Brent Hagerman, "There's No Place like Home! Just Ask Stompin' Tom," *The Globe and Mail*, October 6, 2000.
16. Ruth Lloyd, "To an Icon," *Caledonia Courier*, March 13, 2013.
17. Mitch Potter, "Stompin' Tom Connors: Mitch Potter's Interview with the Legend," *Toronto Star*, March 6, 2013. (Story originally ran May 27, 1990.)
18. Ibid.
19. Stompin' Tom Connors, interview by Rudy Blair, 680 News, July 14, 2009, https://www.680news.com/2013/03/06/interview-stompin-tom-connors-july-14-2009/.
20. Tim Hus, "On Tour with Stompin' Tom," *Road Letters*, 2010, https://www.timhus.ca/road-letters/.
21. Alan Niester, "Chairman of the Board," *The Globe and Mail*, October 26, 1990.
22. John O'Callaghan, "Still Stompin' after All These Years," *The Globe and Mail*, July 31, 1993.
23. James Muretich, "He's Our All-Time Underground Artist," *Edmonton Journal*, August 14, 1993.
24. Rita Zekas, "Stompin' Tom Got Tired of Being Called on the Carpet," *Toronto Star*, June 10, 1991.

## Chapter 11
1. Ira Band, "Stompin' On Road to Unity," *Toronto Sun*, July 2, 1991.
2. Blaik Kirby, "Connors Curries Favor Shamelessly," *The Globe and Mail*, June 4, 1975.
3. "Stompin' with Connors, Perpetual Loner Still as Ragged and Crudely Hewn as Ever," *Toronto Star*, June 14, 2002.
4. Rick Salutin, "Stompin' Tom Connors Deserves a Place in the Ranks of Canada's Poets," *Toronto Star*, March 8, 2013.
5. Peter Stockland, "The Connorian Oeuvre: A Tribute to Stompin' Tom," *Convivium*, March 19, 2013, https://www.convivium.ca/articles/the-connorian-oeuvre-a-tribute-to-stompin-tom/.

## Sources

6. Ibid.
7. Stompin' Tom Connors, interview by Peter Gzowski, *Morningside*, CBC Radio, Dec. 29, 1988, https://www.youtube.com/watch?v=mcLmj8Wh3Es&app=desktop.
8. "Stompin' Tom's Hockey Song Got a Second Life in Ottawa," *1310 News*, March 7, 2013, https://www.1310news.com/2013/03/07/stompin-toms-hockey-song-got-a-second-life-in-ottawa/
9. Stompin' Tom Connors, interviewed by Ron MacLean, *Hockey Night in Canada*, CBC TV, 1993.
10. Mark David Norman, "The Good Ol' Hockey Game," hockeyinsociety.com, March 8, 2913, https://hockeyinsociety.com/2013/03/08/the-good-ol-hockey-game-the-cultural-resonance-of-stompin-tom-connors-the-hockey-song/.
11. Earl McRae, *Ottawa Sun*, Jan. 19, 1993.
12. Bob Mersereau, *The Top 100 Canadian Singles* (Fredericton, NB: Goose Lane Editions, 2010).
13. Victor Dwyer, "Poetry and Patriotism," *Maclean's* 105, no. 27, July 6, 1992.
14. Duncan Fremlin, *My Good Times with Stompin' Tom* (Toronto, ON: Canjay Music, 2018).
15. Duncan Fremlin, "John Farrington, A Great Canadian," Whiskey Jack, August 31, 2017, https://www.whiskeyjackmusic.com/home/blog/john-farrington-a-great-canadian/.
16. Rob McCormick, "Stompin' Tom Did It His Way," *Peterborough Examiner*, March 7, 2013.
17. "Stompin' Tom Tells All about Life before Fame," *Canadian Press NewsWire*, Toronto, November 3, 1995.
18. Elizabeth Renzetti, "Stompin' Out the Memories," *The Globe and Mail*, November 11, 1995.
19. Jim Christy, "His Mother's Thumb was Missing," *Books in Canada*, November 1995.
20. Tim Hadley, interviewed by Julia McKay, "Playing with Stompin' Tom like Playing with the Beatles and Grateful Dead," *QNET News*, March 7, 2013, http://www.qnetnews.ca/?p=28539/.
21. Glen Nott, "Walking the Plank," *The Hamilton Spectator*, September 15, 1999.
22. "Dave Gunning Telling a Story about Stompin' Tom," https://www.youtube.com/watch?v=-vbefa1T_WY/.
23. Duncan Fremlin, *My Good Times with Stompin' Tom* (Toronto, ON: Canjay Music, 2018).
24. Jane Stevenson, "Stompin' Tom Connors 'Bigger than Life'," *Gananoque Reporter*, December 9, 2018.
25. Robert Everett-Green, "Still Stompin' After All These Years." *The Globe and Mail*, October 25, 2008.
26. Dene Moore, "Two Cases of Moosehead," *Global News*, March 7, 2013, https://globalnews.ca/news/405601/two-cases-of-moosehead-beer-

friend-recalls-being-on-the-road-with-stompin-tom/.
27. Glen Nott, "Walking the Plank," *The Hamilton Spectator*, September 15, 1999.
28. "Bandmate, Nation Bid Farewell to Canadian Legend Stompin' Tom Connors," *Wellington Advertiser*, March 2019.
29. Eric Volmers, "There's No Storytelling Anymore," *Alaska Highway News*, August 3, 2010.
30. "Bandmate, Nation Bid Farewell to Canadian Legend Stompin' Tom Connors," *Wellington Advertiser*, March 2019.
31. Tim Hus, "On Tour with Stompin' Tom," *Road Letters*, 2010, https://www.timhus.ca/road-letters/.
32. Dene Moore, "Two Cases of Moosehead," *Global News*, March 7, 2013,

## Chapter 12
1. Mike Dunlop Graphic Artist, "Stompin' Tom Connors,"www.mykull.com/stompin-tom-connors.html, June 19, 2019.
2. "Stompin' Tom's Thesis," *University of Toronto Magazine*, September 23, 2000, https://magazine.utoronto.ca/people/alumni-donors/stompin-toms-thesis/.
3. "Stories and Songs of Stompin' Tom," Whiskey Jack Souvenir Tour Program, 2018.
4. Bob Mersereau, "Stompin' Tom Has His Say . . . Again," *New Brunswick Telegraph-Journal*, October 21, 2000.
5. Mark Schatzker, "Stomp, Stomp, Stompin' on Tom: A Gritty, Honest Canada," *National Post*, September 23, 2000.
6. Robert Everett-Green, "Still Stompin' After All These Years." *The Globe and Mail*, October 25, 2008.
7. "Stompin' with Connors, Perpetual Loner Still as Ragged and Crudely Hewn as Ever," *Toronto Star*, June 14, 2002.
8. Office of the Governor General of Canada, "Distinguished Canadians to Join Governor General at a Luncheon Celebrating the Golden Jubilee of Her Majesty the Queen," press release,October 3, 2002, https://archive.gg.ca/media/doc.asp?lang=e&DocID=499/.
9. "Luncheon with Her Majesty the Queen," *Citation for Stompin' Tom*, October 14, 2002, http://www.jacksonskates.com/html1/QueenGoldenJubilee-guests.html
10. *Stompin' Tom in Live Concert* (2005; Hamilton, ON: EMI Music Canada), DVD.
11. Nicholas Kohler, "Skinner's Pond Tourism Dream Stomped by Tom," *National Post*, May 4, 2004.
12. Stompin' Tom Connors, *250 Songs by Stompin' Tom* (Toronto, ON: Crown-Vetch Music, 2005).
13. Alison Mayes, "Rowdies Hijack Stompin' Tom Show," *Winnipeg Free Press*, August 3, 2004.
14. "Stompin' Tom Tells CBC to 'Shove It'," *The Globe and Mail*, May 23, 2006.

# Sources

15. "Fafard Sculpture Riles Stompin' Tom," *CBC News*, December 1, 2005, https://www.cbc.ca/amp/1.542681/.
16. Kamal Al-Solaylee, "A jukebox musical that plays to fans," *The Globe and Mail*, July 4, 2006.
17. Stompin' Tom Connors, interview by Steve Fruitman, *Back to the Sugar Camp*, CIUT 89.5 FM, Part 4 of 5, 2008, https://www.youtube.com/watch?v=SeK_0bIAeyQ
18. Eric Volmers, "There's No Storytelling Anymore," *Alaska Highway News*, August 3, 2010.
19. Alden Nowlan, "What's More Canadian than Stompin' Tom?" *Maclean's*, August 1972.
20. Bob Mersereau, *Top 100 Canadian Albums* (Fredericton, NB: Goose Lane Editions, 2007).
21. Brad Wheeler, "Stompin' Tom's Pro-Canadian Ideas," *The Globe and Mail*, June 30, 2013.
22. "Stories and Songs of Stompin' Tom," Whiskey Jack Souvenir Tour Program, 2018.
23. "Stompin' Tom Stompin' Mad About Smoking Laws," *Canadian Press*, July 20, 2009.
24. Stompin' Tom, interview by Pierre Pascau, *Cross Country Checkup*, CBC Radio, 1973, https://www.youtube.com/watch?v=mcLmj8Wh3Es&app=desktop
25. Tim Hus, "On Tour with Stompin' Tom," *Road Letters*, 2010, https://www.timhus.ca/road-letters/.
26. Bob Mersereau, "Stamp for the Stomper," *Saint John Telegraph-Journal*, July 1, 2008.
27. Kamila Hinkson, "Stompin' Tom Connors: Juno Awards Mum on Possible Tribute," *Toronto Star*, March 7, 2013.
28. Duncan Fremlin, *My Good Times with Stompin' Tom* (Toronto, ON: Canjay Music, 2018).
29. *Stompin' Tom in Live Concert* (2005; Hamilton, ON: EMI Music Canada), DVD.
30. Jane Stevenson, "Friends Talk Stompin' Tom Connors Final Weeks," *Sault Star*, March 7, 2013.
31. UMusic, "Stompin' Tom Connors — Unreleased: Songs from the Vault Vol. 1," press release, March 27, 2014, http://www.umusic.ca/press-releases/stompin-tom-connors-unreleased-songs-from-the-vault-vol-1/.
32. Bob Mersereau, "Music Review: Stompin' Tom Connors — And The Roads of Life," *East Coast Music*, CBC, August 24, 2012, https://www.cbc.ca/nb/mt/east-coast-music/2012/08/music-review-stompin-tom-connors---and-the-roads-of-life.html/.
33. Steve Fruitman, "Sugar Camp Music," *Back to the Sugar Camp*, Toronto, ON, CIUT 89.5 FM, Dec. 19, 2012.
34. Mike Dunlop Graphic Artist, "Stompin' Tom Connors,"www.mykull.

com/stompin-tom-connors.html, June 19, 2019.
35. Jane Stevenson, "Friends Talk Stompin' Tom Connors Final Weeks," *Sault Star*, March 7, 2013.
36. "Brian Edwards Remembers Stompin' Tom," *Q*, CBC Radio, March 7, 2013.
37. Ken Dryden, "Liner notes," *Stompin' Tom — 50th Anniversary* CD, ole, 2017.

## Epilogue

1. Alden Nowlan, "What's More Canadian than Stompin' Tom?" *Maclean's*, August 1972.
2. Michael Barclay, "Stompin' Tom: Our National Poet," *Maclean's*, March 7, 2013.
3. Phil Gravelle, "Paying Tribute to Stompin' Tom's Philosophy," *Erin Insight*, June 11, 2014, https://erininsight.blogspot.com/2014/06/paying-tribute-to-stompin-toms.html/.
4. Rob McCormick, "Stompin' Tom Did It His Way," *Peterborough Examiner*, March 7, 2013.
5. "Stompin' Tom Stompin' Mad About Smoking Laws," *Canadian Press*, July 20, 2009.
6. "Stompin' Tom Connors — Songs from the Vault Volume 2," *Cheeky Monkey*, June 30, 2015, http://cheekymonkeysarnia.ca/stompin-tom-connors-songs-from-the-vault-volume-2/.
7. Glen Nott, "Walking the Plank," *The Hamilton Spectator*, September 15, 1999.
8. Michael Barclay, "Stompin' Tom: Our National Poet," *Maclean's*, March 7, 2013.
9. NPR Staff, "Stompin' Tom Connors, Canadian Folk Hero, Has Died," *Record, Music News from NPR*, March 7, 2013, https://www.npr.org/sections/therecord/2013/03/07/173746201/stompin-tom-connors-canadian-folk-hero-has-died/.
10. Sheldon Birnie, "Retrospective Reviews," *Vice*, September 17, 2014, https://www.vice.com/en_ca/article/rpy759/retrospective-review-stompin-tom-connors-to-it-and-at-it/.
11. Gregory Pike, "Stompin' Tom Connors Was Punk as Fuck," *Vice*, March 8, 2013, https://www.vice.com/en_ca/article/3b453k/stompin-tom-connors-was-punk-as-fuck/.
12. Sara Fraser, "Stompin' Tom Connors, the 'Rebel'," *CBC News*, March 20, 2017, https://www.cbc.ca/news/canada/prince-edward-island/pei-stompin-tom-connors-music-ole-purchase-1.4033586/.
13. "Stories and Songs of Stompin' Tom," Whiskey Jack Souvenir Tour Program, 2018.
14. Jane Steveson, "Stompin' Tom Connors Stomps His Way into CWOF with Family's Blessing," *Toronto Sun*, November 12, 2017.
15. "Tiny P.E.I. Hamlet Readies Stompin' Tom Centre for 'Perfect' Canada Day Opening," *City News*, June 2, 2017, https://toronto.citynews.ca/2017/06/02/tiny-p-e-i-hamlet-readies-stompin-tom-centre-for-

perfect-canada-day-opening/.
16. Ibid.
17. Cody MacKay, "Stompin; Tom Connors Honoured with Hometown Star in Skinners Pond," *CBC News*, July 2, 2018, https://www.cbc.ca/news/canada/prince-edward-island/pei-stompin-tom-connors-1.4730847?cmp=rss/.
18. Nicholas Kohler, "Skinner's Pond Tourism Dream Stomped by Tom," *National Post*, May 4, 2004.
19. Brent Hagerman, "There's No Place like Home! Just Ask Stompin' Tom," *The Globe and Mail*, October 6, 2000.
20. Robert Martin, "Connors Important to a lot of people," *The Globe and Mail*, Jan. 22, 1973.
21. Michael Barclay, "Stompin' Tom: Our National Poet," *Maclean's*, March 7, 2013.
22. Michael Barclay, Ian A. D. Jack and Jason Schneider, *Have Not Been the Same: The CanRock Renaissance* 1985–1995 (Toronto, ON: ECW Press, 2001).
23. Ibid.
24. Dave Bidini, "A Stompin' 75," *National Post*, Feb. 5, 2011
25. Scot Gilmore, "Canada is Not a Country," *Maclean's*, April 19, 2018.
26. Duncan Fremlin, *My Good Times with Stompin' Tom* (Toronto, ON: Canjay Music, 2018).
27. Potter, "Stompin' Tom Connors: Mitch Potter's interview with the legend."
28. Oliver Clausen, "Yoo-hoo-hoo! It's Stompin' Tom," *The Globe and Mail*, January 31, 1970.

## Interviews

In addition to the sources mentioned above, I have used quotes from the following people who submitted written material for the book or were interviewed by me:

Mickey Andrews
Pauline Arsenault
Dave Bidini
Andy Curran
Carol Dennett
Lyle Dillabough
Freddy Dixon
Richard Flohil
Duncan Fremlin
Steve Fruitman

Dave Gunning
Edwin Heistad
Stephen MacIntyre
Dave McClelland
Bob Mersereau
Anne Murray
Kevin Strathearn
Larry Strathearn
Al Widmeyer

# Index

*250 Songs of Stompin' Tom*, 204, 278
*Across this Land with Stompin' Tom*, 160, 186, 238, 243, 314
ACT album/LP, *see Stompin' Tom is Back to ACT*
A-C-T Records, 97, 219–20, 224, 226, 228, 235
Angus, Charlie, 228, 231, 299
Aykroyd, Dan, 221–22
Altman, Mark, 136, 154, 219
Andrews, Mickey, 108–9, 112, 114–17, 124, 135–37, 140, 142–44, 155–56, 200, 236, 241–42, 244, 251, 262, 265, 273–75, 288, 292, 295–96, 300, 302
*Atlantic Advocate*, 62, 111, 150, 208
*At the Gumboot Cloggeroo*, 194, 220, 251, 319
Aylward, Cora, 36–41, 46, 48–49, 60–61, 110, 119–21, 144, 151, 156, 158, 186, 205, 227, 278
Aylward, Russell, 36–41, 46, 48–49, 60–61, 119–21, 144, 151, 156, 158, 186, 205, 208, 227
*Back to the Sugar Camp* (website), 47, 140, 294
*Ballad of Stompin' Tom, The*, 9, 15, 161, 285, 287, 291, 302, 316
*Ballad of Stompin' Tom* (play), 282–84
Bedore, Bernie, 127, 281
*Before the Fame* (autobiography), 10–13, 15, 19, 22–23, 26–27, 30, 32–40, 43, 48, 50–51, 54, 57–60, 63–64, 66–71, 75, 82–85, 87–88, 91, 94, 96–97, 102–3, 116, 122, 132–33, 135, 138, 143, 145, 153, 158–59, 183, 194, 201–2, 204, 208–11, 215, 249, 252–53, 257–60, 272–75, 282–83, 305
*Believe in Your Country*, 52, 89–90, 198, 230, 234, 241, 247, 249, 252, 258, 275, 318
*Best of Stompin' Tom, The*, 147
Bidini, Dave, 200, 211–15, 217, 221, 224, 231, 254, 301, 308, 315–16
*Bill Bessie Show, The*, 109–10
Black Donnellys, 101–2
(the) Boot, 105–6, 108, 15, 119, 129, 143, 165, 183, 201, 203

bootlegging joints, 73, 77, 119, 207
Boot Records, 135–38, 153–54, 157, 161–62, 181, 185, 189, 191, 195, 203–4, 206, 213, 219, 224, 235, 315
*Bud the Spud and other Favourites*, 117–18, 120, 127, 129, 142, 153, 285
Calgary, Alberta, 42, 57, 244, 251
Cameron, Deane, 175, 221, 223–24, 231, 285, 287, 301, 
Campbell, Alex, 158, 183–84
Canada, voice of, 52–53, 80–81, 90, 99–100, 111, 128–29, 136–37, 150–52, 154–55, 162, 231–32, 238–40, 314–19
Canadian Academy of Recording Arts and Sciences (CARAS), 195–98, 285, 287
*Canadian Composer*, 57, 78, 89, 117, 133, 146, 153, 194, 202
Canadian National Exhibition (CNE), 179–81, 192–93, 195, 200
*Canadian Panorama*, 123–24
Canadian Songwriters' Hall of Fame, 312
Canadian Stomper, 312
Canadian Walk of Fame, 312, 314
CanCon regulations, 137–40, 159, 200, 216–17
Capitol Records-EMI, 175, 221, 223–24, 226, 231–32, 234, 236, 253, 268–69, 274, 307
Carleton Place, Ontario, 115, 126, 228–29, 253, 312
Carter, Wilf, 14, 25, 32, 41–42, 52, 57, 79–80, 94, 147, 155–56, 186, 198, 212
Cash, Johnny, 64, 117, 139, 147, 150, 186, 232–33, 291, 307–9
*Catch the Sun* (documentary), 159–60, 183
CBC radio/television, 41, 47, 49, 63, 75, 77, 97, 106, 128, 132, 155, 157–59, 187–88, 212, 221, 237, 241, 246, 271, 277, 279–81, 297, 309, 314
Centennial, Canadian, 93, 98–100
CFGM (radio station), 122, 167
Chapman, Reg, 102, 107–8, 125
Charlottetown, Prince Edward Island, 119, 128–30, 143, 182–83, 189
childhood, 10–11, 21, 29–31, 36, 39–40, 50, 149, 242, 259, 275, 283

children, earlier, 208–11, 312, 314
Clarkson, Adrienne, 271–72, 275, 299, 301
Clohossey, Marlene, 36–37, 109–10, 119–21, 153, 191, 201, 203, 205, 278
Clohossey, Willard, 191, 201, 203, 205
code-breaking, 206–7, 305
Connors, Isabel, 9–10, 12–21, 23–33, 36–37, 43–46, 48–50, 52, 59–61, 69, 158, 181, 186, 210, 275, 283–85, 287, 291–92, 302
Connors, Marie, 17–18, 21
Connors, Nancy, 26–29, 59
Connors, Tom Jr., 193, 204–5, 208, 266, 270, 272, 286, 304–6, 309–10, 312
*Connors Tone, The*, 103, 107–8, 118, 121, 124, 127–28, 130–31, 134, 136, 141, 143, 145, 149, 152, 155, 158, 160, 180, 183–84, 191–92, 194, 197, 201, 205, 208–10, 214, 220, 222, 231–32, 237, 244, 247, 253, 257–58, 260, 272, 305
Cormier, J.P., 236, 261, 301, 312, 317
country music, 14–16, 22–27, 32, 41–42, 47, 52–53, 58, 62, 64, 72, 74, 77–78, 80, 83, 90, 92–94, 100, 103–5, 108, 111, 114, 118, 122–25, 129–31, 135–43, 146, 152–62, 166, 179–81, 187–95, 198–99, 203, 216–26, 232–34, 242, 246–50, 255, 259, 268–69, 274, 291–94, 307
Crombie, David, 159, 186
Crown Vetch Music, 203, 219
Curran, Andy, 309–11
Dillabough, Lyle, 115, 229–30
Dixon, Freddy, 161–62, 316
Dominion Records, 115–17, 120–23, 126, 134, 137, 157
Double C Resorts, 191, 201, 205, 207
*Dr. Stompin' Tom ... Eh*, 234, 256
Dunlop, Mike, 270–71, 296–97, 304
East Coast Music Awards (ECMAs), 247–49, 303
Stompin' Tom Awards, 255
Echard, William, 97, 234
Edwards, Brian, 232, 235, 244, 277–80, 292, 297, 301, 309

334

# Index

Empey, Gary, 143, 182, 231
Evans, Cliff, 215, 220, 222, 224
Everett-Green, Robert, 14, 39, 50, 273
Expo '67: 93, 98–99, 160
Fafard, Joe, 281–82
Farrington, John, 79, 86, 257–58, 306, 313
*Fiddle and Song*, 208, 220, 222, 226–27,
Flohil, Richard, 104, 113, 148–49, 234, 294
Foote, Steve, 47–48, 51, 54–56, 59–62, 64–65, 68–73, 105, 119, 135, 137, 151, 154, 187–89, 228
Fremlin, Duncan, 85, 142
Frost, "Lucky" Jim, 62–65
Fruitman, Steve, 47, 53–55, 99, 120, 139–40, 157, 185, 187, 202, 214, 228, 231, 271, 283, 288, 290–91, 293–95, 305, 311, 318
Gallant, Tom, 236, 316
*Globe and Mail, The*, 79, 141, 149, 188, 190–91, 196, 231, 239, 259, 264, 282, 285, 314–15, 319
Glover, Elwood, 44, 74, 78, 91, 132–33, 135, 185–86
God, talking to, 69–72, 220–21, 306
Grand Ole Opry, 14, 63, 108, 121, 156
Great Depression, 13, 25, 52
Gretzky, Wayne, 268–69, 282, 286
Gunning, Dave, 243, 261–64, 268, 276–77, 284, 288, 290, 300–1, 304–6
Gzowski, Peter, 75, 80, 86, 110, 162, 221–23, 251
Halifax, Nova Scotia, 27–28, 37, 69, 118, 128, 133, 150, 184, 217, 238, 247
Hall, Gerry, 108, 236
Hatfield, Richard, 152, 168, 185–86, 213
*Have Not Been the Same: The CanRock Renaissance 1985–1995* (Barclay, Jack, Schneider), 212, 224, 233–34, 315
Hawthorn, Tom, 98–99
Heinz ketchup, 87–89
Hilden, Clara, 10, 15
hitchhiking, 12, 15–17, 26, 32, 44–45, 49–71, 74, 85, 119, 133, 144, 151, 154, 189, 206, 267
hockey, 106, 108, 157, 214, 252–57, 269, 286–87, 298–99,
301, 319
Horseshoe Tavern, 108–15, 117, 121–22, 124, 131–32, 134, 136–37, 139–40, 143, 149–50, 153–54, 156–58, 160, 188, 192, 222, 228, 236
Hus, Tim, 242, 265, 267–68, 289, 300–1, 316
IMAX filming, 159–60, 184
India, 68–69, 84
Ireland, 9–10, 41, 101, 126, 145, 211–12
Juno awards, 140–41, 153–54, 158–59, 165–66, 180–81, 187, 189, 191–202, 213, 220, 229, 247–48, 285–87, 289, 303, 309
Kapuskasing, Ontario, 90–92, 101, 105
Keefe, Floyd, 257, 278
Keefe, Pauline, 172, 188–89, 207–8, 210, 290
*KIC\* Along With Stompin' Tom (\*Keep it Canadian)*, 254
King George Hotel, 93–95
kitchen parties, 23, 41, 52, 58–59, 73–74, 125, 151, 161, 207, 234, 241–42, 317–18
Kotze, Pete, 76–77, 82–83, 85
Krytiuk, Jury, 115–16, 118, 125, 129, 134–38, 141, 145, 152–55, 180, 185, 195, 202, 206, 219
Lachapelle, Florence, 209–10
lang, k.d., 220–21, 224–25, 248, 299, 303, 308
Leamington, Ontario, 87–88
*Legendary Horseshoe Tavern, The*, 111, 124
Lepine, Gaet, 75–77, 186–87, 231, 259
Lightfoot, Gordon, 159, 165, 198, 211, 269, 277, 287, 289, 312
*Long Gone to the Yukon*, 197, 205, 258–59
*Love and Laughter, see Stompin' Tom and the Moon Man Newfie*
Lucan, Ontario, 101–2
MacDonald, Boyd, 94, 96–97
MacDonald, Randy, 108, 236
MacLean, Ron, 252, 255
*Maclean's*, 150, 237, 255, 284, 303, 308, 317
MacNeil, Rita, 203, 235, 303
Maple Leaf Hotel, 75–85, 94, 96, 130, 133, 186, 209, 259, 295
Mariposa Folk Festival, 145–46
*Maritime Music Greats*, 124,
162, 211
Marks, Gerry, 35, 51
Marlene (Tom's stepsister), *see* Clohossey, Marlene
Massey Hall, 148–50, 244, 258
McAdam, New Brunswick, 21–22, 24–25, 27
McDaniel, James "Sleepy," 64
McLauchlan, Murray, 191–93, 195, 221
*Merry Christmas Everybody*, 130
Mersereau, Bob, 137–39, 219, 254, 272, 274, 285, 289, 293, 319
Messer, Mabelene, 21–24
Messer, Olivar, 21–25, 27, 125, 242
Messer, Terrence, 15, 17–27
Montferrand, Joseph, 126–27, 173, 285, 318
Montreal, Quebec, 26–27, 31, 37, 50, 54–55, 59–60, 71–72, 93, 108, 186, 221, 255–56
*More of the Stompin' Tom Phenomenon*, 235
*Move Along With Stompin' Tom*, 233, 268
Mufferaw, Big Joe, *see* Montferrand, Joseph
Murray, Anne, 130, 159, 165, 192–93, 198–99, 216, 277, 289
*My Good Times with Stompin' Tom* (Fremlin), 198, 290, 313
*My Stompin' Grounds*, 144, 211, 252, 254, 303
gold record status, 152–53
Nashville, Tennessee, 14, 53, 62–65, 103, 107–9, 111, 129, 131–32, 151, 193, 233–34, 293
Nelson, Willie, 111, 232
New Brunswick, 9, 10–14, 36, 44, 48, 60, 123, 150, 152, 182, 245, 255, 269, 312
Newfoundland, 108, 110, 148, 184–85, 235, 255, 279, 289, 317
Northern Ontario, popularity in, 74, 81, 85, 99, 107, 109–10
*Northlands' Own, The*, 93, 99–100, 157
Nowlan, Alden, 12, 14, 17, 34, 39, 42, 103, 118, 123, 150–51, 168, 202, 284, 303, 321
nuns, orphanage, 32–38, 43, 151
*Ode for the Road*, 45, 67, 249, 275
*On A Cold Road* (Bidini), 211–12, 214
*On Tragedy Trail*, 97, 105
Order of Canada, 260–61, 281,

295, 301,
orphanage, St. Patrick's, 30–40, 43, 45–46, 51, 59, 130, 151, 163; *see also* children's aid
Pascau, Pierre, 49, 104, 158, 289
Peterborough, Ontario, 93–95, 97–98, 104, 107, 232, 258, 275, 298–300, 306
poverty, 10–11, 25, 27, 30, 55, 148, 259
Presley, Elvis, 63, 311, 319
Pride, Charley, 108, 180, 195–96
Prince Edward Island, 36, 40, 42–43, 45, 60, 69, 104, 123, 129, 153, 156, 158, 181–83, 186, 207, 255, 269, 290
Prince Edward Lounge (Charlottetown), 119, 128, 143, 185
promotion, self-, 77–82, 85–89, 99–101, 105, 110–16, 122–24, 134–36, 146, 162, 198, 200, 226, 230, 233, 241, 244, 249, 275, 308
Prophet, Ronnie, 195, 201
*Proud Canadian, A*, 234, 236
punk, association with, 307–9, 316
Quebec, unity with, 238–41, 249
Queen of England, 183–84, 275–76
radio stations, exposure from, 53, 59, 78, 81, 85, 91, 100, 107, 111, 116–18, 121–24, 128–30, 138–41, 153, 167, 192–93, 200–2, 215–16, 219, 222–26, 232–37, 244–45, 252, 255, 274, 286
Rebel Records, 92, 100, 105–7, 116, 120, 134
recording, musical, 61–64, 78–81, 87–88, 91–93, 100–1, 105–7, 117–21, 125–32, 136–37, 144–47, 153–54, 157, 181 ,187–89, 192, 205, 208, 213–16, 220, 233–35, 243, 249, 256–58, 268–69, 275, 283, 285, 293–94, 307, 311
Reesor tragedy, *see* Kapuskasing, Ontario
Reid, Johnny, 119, 129, 143, 185, 189
Rheostatics, The, 211, 231, 308, 315–16
*Roads of Life, The*, 284, 293–94, 311
Roberts, Bud, 103–4, 106–7, 316
Rouyn, Quebec, 57–58, 67, 81, 93, 315
Saint John, New Brunswick, 9–10, 14, 17–20, 24–28, 31–32, 42, 44–54, 59–62, 68–72, 128, 133, 177, 181, 312

Scribner, Joe and Lucy, 12–15, 126
Skinners Pond, Prince Edward Island, 36–52, 60–61, 69–70, 109, 113, 119, 144, 158, 163, 170, 208, 210, 213, 220, 236, 242, 275–76, 316
schoolhouse, 48, 156, 164, 165, 183, 188, 191, 194, 201–6, 257, 277–78, 314
Stompin' Tom Centre, 178, 313
Snow, Hank, 16, 22, 27, 41, 47, 52, 57–58, 61–64, 70–71, 94, 102–3, 118, 128, 155–56, 198, 217, 291
*Songs from the Vault Collection Vol. 1*, 307
songwriting, 13–14, 42, 47, 61, 63, 65, 72, 77, 79–81, 87, 89–90, 104, 155, 181, 194, 199, 212, 220, 227, 250–54, 272, 274, 312
*Souvenirs*, 268
stamp, postage, 172, 289, 295
Starr, Jack, 108–9, 111, 122–23, 157
Stevedore Steve, *see* Foote, Steve
stomping, foot, 81–82, 86–87, 93–95, 100, 108–9, 117, 146, 160, 184–85, 194, 223, 225, 236, 238, 245, 253, 280, 290–92, 301, 316
*Stompin' Tom is Back to ACT*, 215–16, 220
*Stompin' Tom Connors, 50th Anniversary*, 310, 313
*Stompin' Tom Connors Live at the Horseshoe*, 131, 134, 192
gold record status, 153, 158
*Stompin' Tom Connors Meets Big Joe Mufferaw*, 126
*Stompin' Tom Connors Sings 60 Old Time Favourites*, 125
*Stompin' Tom Connors Song Folio #1*, 132
*Stompin' Tom and the Hockey Song*, 157, 252
*Stompin' Tom in Live Concert*, 281
*Stompin' Tom Meets Muk Tuk Annie*, 187
*Stompin' Tom and the Moon Man Newfie*, 146–47
*Stompin' Tom's Canada*, 187–88, 313
*Stompin' Tom Sings 60 More Old Time Favourites*, 144
*Stompin' Tom, Story & Song*, 189
*Stompin' Tom, Story and Song* (Foote), 56
storytelling, 9–13, 15, 20, 32, 35–36, 40, 126–27, 272–73,

314
St. Thomas University, 255–56
Sudbury, Ontario, 87, 93, 106–7, 111, 178, 231, 240, 243, 250, 312
Sullivan, Aloysius and Rose, 9–10
Sullivan, Thomas (Sally), 9–10, 15, 18, 20–21, 50–51, 181, 208
television appearances, 44, 68, 109, 113, 128, 156–57, 185, 197, 256, 279
The Good, The Bad and The Ugly (Horseshoe house band), 108, 115, 117, 143, 155, 236
*The Year Canadians Lost Their Minds and Found Their Country* (Hawthorn), 98–99
*This is Stomping Tom* (documentary), 40, 75–76, 154
Tillsonburg, Ontario, 53–55, 144, 279, 301
Timmins, Ontario, 74–81, 83, 85, 87, 91, 93, 107, 118, 186, 209–10, 257, 315
tobacco fields, 53–55, 74, 250–51
*To It and At It*, 181, 187
Toronto Maple Leafs, 140, 252–53, 269, 299, 312
Toronto, Ontario, 58, 61, 66, 72–74, 81, 95, 97, 107–8, 117, 120–24, 128, 137–40, 144, 147, 149, 159, 166, 171, 181, 184, 186, 199, 205, 213, 222, 231, 236, 264, 299, 311–12
*Toronto Star*, 128, 221–22, 237, 249, 274
Truro, Nova Scotia, 21, 24, 27
University of Toronto, 161, 171, 271
*Unpopular Stompin' Tom, The*, 192
*Unreleased Songs From The Vault Collection Vol. 3*, 311
Vancouver, British Columbia, 56–57, 59, 68, 74, 144, 239, 255, 289
wedding, 185–87
Welsh, Lena, 143–44, 152, 154, 158, 166, 185–86, 188, 190–91, 193, 201–2, 204–5, 208–10, 227, 249, 264, 276, 301, 304, 310, 313
Whiskey Jack, 233, 238, 256–58, 261, 310–12, 316
Widmeyer, Al, 173–74, 261–62, 264–68, 284, 287–88, 290–91, 294, 296, 300
Williams, Hank, 14, 42, 57–58, 76, 233, 284, 293, 308, 311
yodelling, 14, 16, 32, 41, 57–58, 108, 113, 283